Dear Merilyn

Barbra Leslie is a painter, art teacher and writer who lives in the Adelaide Hills. Her work has been exhibited widely over four decades, and she is one of few Australian painters able to make a living from her art.

Dear Merilyn

Barbra Leslie

Wakefield Press

Wakefield Press
1 The Parade West
Kent Town
South Australia 5067
www.wakefieldpress.com.au

First published 2003

Designed by Liz Nicholson, design BITE, Adelaide
Typeset by Clinton Ellicott, Wakefield Press
Scans by Colorwize Studio, Adelaide
Printed in China at Everbest Printing Co Ltd

National Library of Australia
Cataloguing-in-publication entry

Leslie, Barbra, 1940– .
Dear Merilyn.

ISBN 1 86254 612 6.

1. Leslie, Barbra, 1940– . 2. Painters – Australia – Biography.
3. Women painters – Australia – Biography. I. Title.

759.994

Wakefield Press thanks Fox Creek Wines
and Arts South Australia for their support.

www.ajustaustralia.com

This book is dedicated to my three courageous men – Adam, Paris and Ron –
who encouraged me to write whole-heartedly, baring all our bones.
I am proud to know them.

Author's note

Many events have been left out of this book and some names have been changed, but the following selected memoirs are true to the best of my recollection. I would like to thank Elizabeth Mansutti for her editing and support.

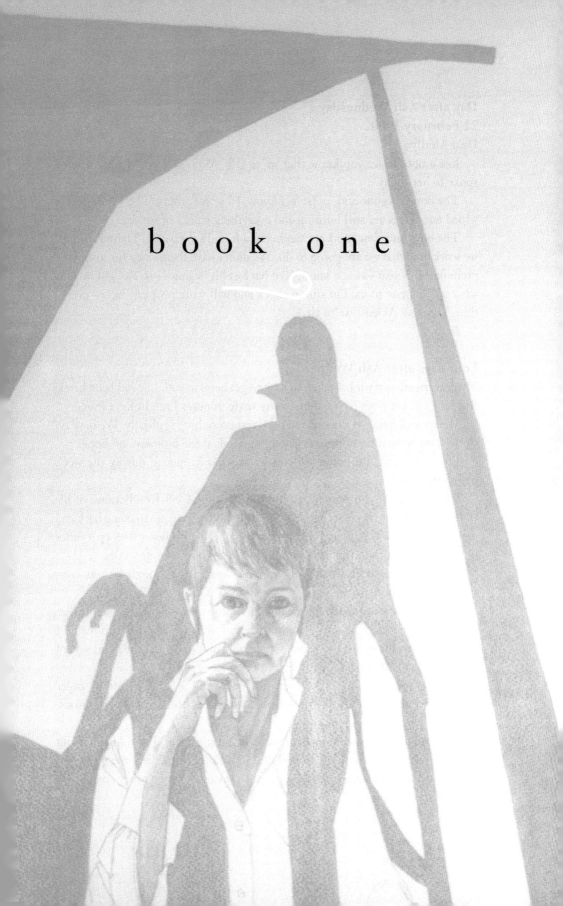

book one

Day after Ash Wednesday
21 February 1980
Dear Merilyn

Just a note to let you know that we're safe. Mum said you'd rung when I spoke to her today.

The house is gone and, as far as I know, 50 or 60 others. The whole area is wiped out. Trees are still burning and everything smells of smoke.

The boys and Ken and I are staying in a friend's caravan at Hahndorf until we work out what we are going to do. We didn't have the money for insurance premiums this year – as you know, Ken has lost his business – so I've got no idea what will happen to us. I'm still in shock and will write properly later – everything's a mess. At least we're alive.

Barb

Four days after Ash Wednesday
My dear friend, sorry it has taken so long to get news to you. Life has been hectic and Ken and the boys have eaten up any spare minutes I might have found.

We are still living at the caravan park and everything is ghastly. We have no clothes, no money, no home, no belongings and, at the moment, no hope.

Firstly, though, I'd better fill you in on what happened during the week before the fire.

I don't know if you remember, but the last time I left Ken because of his violence was about two years ago. As usual, he was begging me to come back and promising the world. Although I had stopped believing his lies, we set up a series of meetings for a round-table conference with a group of counsellors.

Ken and I saw each other only at these sessions – although he was constantly on the phone to me – and he was always on his best behaviour.

To cut a long story short, the group of us decided to make a contract. If Ken stuck to this contract he could come back and we'd try again. Deep inside I knew it was madness, but I so wanted my family unit back, and the good side of him that I knew and loved, that I agreed to go along with it.

The contract was that if he ever, just once, laid a hand on me in anger again, he would leave of his own volition, taking only his personal possessions, and never contact me again.

Well, up until last week, he never actually hit me again. I've told you about how he smashed the room up around me, and another time kept me pinned to a chair by holding a large screwdriver against my eye – but he never actually hit me, so I stuck it out.

Three days before the fire, he whacked me across the face. Hard.

The reason for this was that I'd cut his sandwiches for work with a filling of egg and lettuce. That particular day he didn't want egg and lettuce. You know the scenario as well as anybody. I bet you never gave any of your hundred other men egg sandwiches. You slut! Bitch! Whore! And so on.

I knew as soon as he hit me that it was over. It wasn't easy to be strong about it. He'd tried hard for two whole years and we'd been reasonably settled. The kids all seemed happy. Despite his occasional tantrums, which of course were terrifying, our little family unit had been plodding along quite well – even though we'd lost our house at the lake, his business, and all of our (my) savings along the way.

Ken didn't, of course, leave the same day that he hit me. He didn't seem to think that one whack counted. In a perverse sort of way, neither did I. After the beatings that I'd had previously, one whack seemed very minor. But I knew that if I let him stay this time, after all I'd taken over the previous eight years, I'd never have any pride left at all.

I stuck to my guns and told him that since he'd broken the contract he had to go.

Merry, you wouldn't believe what the next three days were like. One minute he was in tears, abjectly apologising and pleading, then, when I patiently reminded him of the promise he'd made, he would spit and swear and threaten death. He said that if he'd known I'd count one small slap as hitting, he would have whammed his fist so hard through my face that it came out the back of my head. He didn't hit me again though, and I think it was because he was sure that he'd talk me round into letting him stay. I wouldn't have. It was over.

Now all I had to do was get him to leave without killing me first. You know his favourite line: If I can't have you, no other bloody man ever will. With a maniac like Ken, it could very easily be true.

That's where we were at when the fire hit. I didn't think life could get any more terrifying, but I was bloody well wrong, as usual.

There are no adjectives to explain what the fire was like. Horrifying, terrifying, exciting, awe-inspiring, dreadful, scary. None of them touch it.

In a nutty sort of a way, though, I'm glad that I was in the middle of it. At the same time as nature makes you aware of how small and inadequate humans are, you're surrounded by acts of bravery and stoic determination.

All of the media are giving different accounts, but there were actually 70 houses lost in our area of the Hills, ranging from Heathfield to Aldgate to Hahndorf, Mt Barker and Echunga. Mylor is right in the middle and we now

have 360 degrees of black devastation as far as the eye can see. You know how beautiful this block was, Merry, the trees, the light, the shade, the colours. Now there's just black and the grey of ash. And we've lost our seclusion. You can see virtually for miles through the dead trees: houses that I never knew existed, hills that I'd never seen before, roads where I didn't know there were any.

The smell is atrocious. Ash seeps into your skin and permeates underneath your eyelids. It's on the roof of your mouth and under your fingernails. Even if you had water, you couldn't wash it out of your hair. You go to sleep with it and wake up to it in the morning. The food you eat tastes of the smell of it.

It was a bugger of a day to begin with. The heat had us on edge from the moment we woke up. The wind was fierce, bending the gums double, and the temperature was in the low 40s from early morning. It peaked at over 44 during the day, and I think the winds were recorded at over 80 miles an hour.

Adam and Ken went to work – Ad's still at the zoo and Ken's just got a job welding at Crafers – Paris went to school, and I went up to Mt Barker to teach a painting class at TAFE. Most of my students come from farms, and by mid-morning the weather was so bad that I cancelled the class and sent them home to see to their animals. I stayed at the college, since I was paid to be there, and came home at midday.

About forty minutes later our Mylor fire siren went. Through the kids' bedroom window I could see a cloud of smoke over the back hill, but it seemed a fair distance away. I was tense, but didn't feel threatened. Even though the wind was blowing in our direction, the fire seemed to be moving sideways. It won't get down here, I thought. Everyone was on the phone to each other, checking where the fire was. Are you okay, we were saying, keep in touch if any-thing changes.

One of the local mums, Helen, arrived in the big ute she uses to carry horse hay. She asked if I wanted to load any furniture or paintings or stuff into it – just in case. Helen's a wonderful woman and her lad, Nick, is great friends with Paris. I sent her away empty-handed, sure that other people in more danger could use her help, and arranged to collect her son and Paris immedi-ately, again just in case. I took them to Pam's near Hahndorf, which seemed beyond any danger. A lot of parents were at the school collecting their kids, so the boys were not unduly concerned, and didn't mind being left at Pam's since they had each other to play with.

Rumours were rife among the parents. Some were saying that homes had been burnt, firefighters hurt, and that the fire front was moving rapidly our way.

By the time I got back to the house the fire had grown to an enormous black

cloud covering the whole horizon. The air was orange. The sun was fighting its way through the smoke, casting an eerie glow over everything.

By now I was becoming very nervous, and was checking out the window every few moments to see how the fire was growing. Dirty dishes were sitting on the sink and I thought I ought to do them. But I was too agitated. If I do the dishes, I thought, and the house burns down I'll be really pissed off (you know how much I hate washing dishes). On the other hand, I thought, if the house doesn't burn down, I'll be extremely happy to do them this evening. Well, I'm glad I didn't do those bloody dishes.

Fire sirens were blasting everywhere – when you could hear them above the wind – and fire trucks and police cars were tearing past the block in all directions. Ash was starting to fall on the house.

About three o'clock, I'm not sure of the exact time, I saw the first flames over the back hill, ahead of a massive wall of thick black smoke, and knew for sure it was coming our way. I tried to ring Ken but our phone was dead. I really panicked then, and got into the car to drive either to a phone, or to his factory to get him. The roads were bedlam, with fire trucks, police and locals tearing in all directions at breakneck speed. I pulled into the home of one of my students halfway between here and Aldgate to try her phone, but it was out too, and from her place the flames seemed extremely close.

She was in a bad state of panic, and I think I lost it altogether then.

I headed off towards Crafers, intent on getting Ken to help me – I had no idea what to do – when his car passed me on its way home. I turned around and followed him back to the cottage, where we both realised that we only had a few minutes before the fire hit. The flames were over the back hill and tearing down the valley, pushing ash, wind and panic ahead of them. We grabbed the dogs and put them in Ken's big car – you can imagine how much room two Great Danes take up and I've only got that little Datsun – and tried to shoo all of the birds out of the aviaries.

I don't remember how many birds Adam had here before you left for Perth, but just now we had three aviaries full of galahs, most of which were free flying during the day and came home to the aviary at night, doves, pheasants, major mitchells and gang gangs. And we had one very old galah, Grandma Galah we called her, in a smaller cage, because she had been so maltreated before we got here that her legs and feet were deformed.

Well, the goddamn birds wouldn't leave. I guess the aviary was their safe haven. They knew something was terribly wrong, and were huddled together on their perches, terrified. I spent precious minutes trying to shoo them all out, but

the only one that left was the latest arrival, a major mitchell that we had made a point of not taming as he was young and healthy. I had to leave the rest there with the doors propped open, and hope for the best. They all died.

We couldn't fit Grandma Galah's cage into either car, so I put a piece of asbestos over the top of it with a brick and left it in the shade.

Ken had been chucking a few clothes into the boot of his car. I grabbed a couple of things from the house and we took off to Pam's. I remember thinking, I must take something for each of the boys. Later I found that I'd snatched a pair of Paris' grey school shorts, which he hated, and out of Adam's bookshelf, filled with precious, expensive bird and animal books, a stupid book about games that some well-meaning relative had given him. For ourselves I had taken a half-beer carton of odd socks and a box of bills.

Bills for Christ's sake. And odd socks! Strange how you react under the stress. I'd left the precious photographs, jewellery, irreplaceable favourite clothes and all the paintings! Left everything important and took junk. Even the clothes Ken took turned out to be his old work togs. Paris will never forgive me for leaving his train set. He is only eight, after all, and has no understanding of the state we were in. Neither have I, come to that.

We got safely to Pam's and had a large brandy while we tried to get our heads together. We knew the house would have gone and were in a daze.

I don't know how long we stayed there – not long – before we decided to go back and see what had happened. We could see from Pam's that the front seemed to have gone behind her area and was moving towards Hahndorf. We figured the worst was over at Mylor and we needed, really needed, to see the block.

Leaving everything at Pam's, Ken and I took the Datsun and went back home.

Do you remember the bus shelter on the main road just in front of our block? There's a clearing there at the edge of the reserve that butted on to our boundary, and it's a junction of two major roads. The Country Fire Service and police had set up a command post on the corner, with four or five fire units and several police cars. We had to fight our way through them to get to the track that led through the reserve to the house. We got abused by one of the cops who thought we were sightseers, and gave him heaps back, pointing out that we wanted to get to our own place.

By some miracle our house was still there, and we could go in. We left the car on the main road and ran through the trees. The valley behind the house was on fire – houses, sheds, trees, everything. But somehow the blaze had stopped along our fence line. We had cut the grass right down over the entire

block, and the back fence, which spans the end of the valley, was like a line drawn on the landscape, with an inferno on one side and our place, intact, on the other.

The wind took your breath away. The heat must have been immense, but we didn't notice. A group of firefighters was taking a break next to a fire truck parked between the house and the aviaries. You're okay, they called, There's nothing here to burn. You can come back.

The relief, Merry. I can't describe it. We were sure our property would have all been burnt.

Ken got on the roof and was filling the gutters with water. I decided to move Grandma Galah around to the back of the shed to shelter her from the radiant heat. Her cage was a bit difficult for me to lift. I was bending over the cage, one hand on each side, when one of the firemen screamed, 'Run!' Then it all happened at once. Everything went bright red. The cage. My hands. The air.

There was a gigantic roar like I hope I never hear again. The force of the air was rocketing me this way and that. Out of the side of my eye I saw, or sensed, the firemen running full-pelt toward the road. Then the big stand of tall pines behind the aviaries exploded into flames.

Somehow or other, I suppose because I had my hands on the cage, I lifted the galah and dropped the cage where I'd planned as I ran around the back of the house to get to the track to the road. Ken was a couple of metres ahead of me. We tore out to the corner, the trees exploding above us with a god-almighty roar as we ran. You would never have believed I've got a bad back, Merry, if you could've seen me run.

One moment I'm moving Grandma Galah, the next I'm at the corner where there is absolute, urgent chaos and panic. Policemen are jumping on moving firetrucks and firemen are grabbing hold of the roofs of police cars.

I absolutely knew that if I hesitated one fraction of a second to turn my head back to the house I would be dead. It was that close. The firemen had no time to help us, or even see if we survived. It was every man for himself, as they say in the movies, but this was real. With a split-second between life and death, no one hesitated to save their own skin first.

Thank God that the kids were safely away. How would I have reacted if they'd been around? I like to think I would have stopped long enough to grab them, but I'll never know.

My little Datsun started first go, thank goodness, and we took off at the tail-end of the emergency vehicles. I remember being terrified that one of those fire trucks would drive right over us, but we got away safely, and went on to Pam's.

Later I discovered that I'd had the handbrake on all the way. Needless to say, it is now thoroughly fucked.

At Pam's we loaded the kids and dogs into the cars and headed down the freeway to Stirling. I was sure the whole Hills face was going to go and advised Pam to get out too, but she didn't believe me and refused to budge. As it happened, the fire went quite a distance behind her place. It wiped out several houses in Hahndorf, but she was lucky. After what I'd seen, I was sure that nothing in the world could stop that fire before it had wiped out the entire Mt Lofty Ranges.

We got safely to Stirling with both cars, although Ken's brakes gave out just as we neared town.

People in Stirling, only a few miles from our place, seemed amazingly unaware of the danger. They hadn't seen what I had. They hadn't stood within the noise.

Sure, the wind was blowing the other way, and it is a very built-up area with only a few patches of scrub – but if the wind changed, they could have all gone. I couldn't understand their lethargy at all. I wanted everybody in the Hills to run for their lives. I was, of course, slightly off my face at the time.

We got water for the dogs from the pub while the garage had a look at Ken's car. The mechanic said he'd need to keep the car there, so we all jammed into the Datsun and headed off to the first place I could think of, the home of a friend at Blackwood, which is still in the Hills face zone but nearer to the city.

You should have seen us in that Datsun, Merry: Ken and me, both black with smoke and ash, two excited and scared little boys, two extremely hot Great Danes and a couple of cartons of odd socks and bills.

We stayed at my friend's house just long enough for the kids to have a swim in their pool, then moved on to my mates Rae and Terry's in the city. Even Blackwood was not safe enough for me. Any place with more than two gum trees was too scary!

So eventually we were safe. No home, no possessions, no insurance, no future, but safe. Adam, who I had not been worried about at all, since he was in the city working at the zoo, turned out to be the biggest concern. I rang the zoo from Rae's to let him know that we were okay and was told that he'd left work as soon as he knew there was a fire in our vicinity and headed up to the Hills. In a panic we rang the command centre that had been set up at one of the Hills high schools for everybody to register with, and learnt that he'd been there looking for us and gone out to fight the fire with a friend of his.

Merry, the kid is only 16 and had no fire-fighting experience at all. The two

boys had gone off into the inferno with only fire-fighting backpacks on – no protective clothing or breathing apparatus. I was petrified, sure they had both been killed.

I left a message for him to ring me at Rae's if he returned to the command post, then just had to wait, and wait.

He eventually rang at 3.00 am. The poor little beggar had gone straight from work to our house and found it completely obliterated, all his birds burnt. He had no idea if we were dead or alive, and was unable to get any reliable information from anyone. There were rumours going around that dozens had been killed.

Many Mylor residents had taken refuge at the local oval, but none of them had seen us, nor did they have any news of us at the command centre. Adam, thinking we were all probably dead, in a fierce state of anger had gone out to do his own battle with the killer flames.

What a day! What a night! What a fucking experience.

Rae and Terry are lending us their caravan for now and we'll take it from here. Will probably write again soon, as it helps to put it down. So glad you're not here to see the destruction of the Hills you loved so much.

Keep well my friend, life is precious and our hold on it is very tenuous.

One week after the fire

Ah, Christ, Merry. What am I going to do?

Ken nearly choked me to death in front of Paris last night. My poor little eight-year-old was just lying there quietly watching with his big eyes. How will he come to terms with having to watch helplessly as one parent tries to kill the other? I will never forget his face.

Isn't losing your home and all your toys in a fire enough for one little fella to cope with, without having to lose faith in your dad as well? And perhaps faith in your own courage?

Fucking Ken! I wish he'd get killed in a car smash, or have a heart attack. I can't kill him, but I wish he'd somehow die. It's the only way out.

We'd been over to the block yet again (we seem to have to go there all the time) to sift through the ashes and prowl around the skeleton of the house and sheds, always looking for some proof of our life. Ken, Paris and me.

For some reason Ken seemed to be more affected by the desolation than before, and needed my attention and care. But Paris had found the melted carcass of one of the carriages from his precious train set and had rummaged through the charred tin in the vicinity of his room before realising the futility

of it. He fell to pieces. It was as if the reality of what had happened hit him for the first time. So he *really* needed me.

I tried to be caring to them both, but when a small boy needs a hug to cry into, how do you give the big boy all that he wants?

There was, of course, no choice. Paris was the real child and Paris needed help.

Ken was furious. In front of the boy, while we were still at the block, he began shouting and cursing at me, making the whole situation ten times worse. We both had our cars there and he took off to the caravan in a rage.

For a few moments I tried to calm Paris down, but Ken had made it clear that he wanted me back at the caravan immediately. He refused to speak to us while I made tea, and we ate in awkward silence, the three of us crammed up tight at the tiny table.

Straight after tea I put Paris to bed with some books – we are all always tired – then I attempted to get Ken to talk sensibly about how he was feeling. Sensibly! Some chance! Out of nowhere, as usual, we were into a full-blown tirade. There was no calming him. The caravan seemed to shake with his anger.

The caravan is fairly big, with one main room that includes two bunk beds at one end and the kitchen, table and cupboards taking up the rest of it, then a smaller double bedroom. Ken had me by the throat, against the dinette wall dividing the van, and he was choking me. He was lifting me off my feet and banging my head against the wall. I felt like one of those long, skinny rag dolls.

Over Ken's shoulder I could see right down to the bottom bunk. Paris had his eyes wide open, terrified, watching, listening. You bitch, Ken screamed, You'll never leave me. You belong to me. I'll kill you first.

Perhaps I passed out for a while. I remember that my head was whizzing around, and the next thing I knew I was lying on the double bed, with Ken crawling all over me wanting to fuck. I didn't stop him, of course, although I didn't actively participate. I was far too scared and weak to try and stop him, and from past experience I knew the price I'd pay if I did, but Christ, Merilyn, I've never felt such hatred for anyone in my life. If only hate could kill people he would have died then and there.

Because of the walls in the bedroom end of the caravan, and because I was underneath, I couldn't see Paris, but he would only have needed to glance through the doorway to see what was going on. And he must have heard it. How can he have any respect for Ken anymore? How can he ever have any for me? Oh shit.

Anyway, this morning he woke up cool as a cucumber and went off to school as if nothing had happened. Probably it is all locked away in a steel box

at the back of his overloaded mind. Anything I say at the moment will probably make things worse, so I just have to leave it. But I feel wretched.

We have no phone here, of course, so you can't ring, but I can feel your compassion and know that you're with me in spirit. It's great that I can write my shit to you aware that you'll pass no judgement.

I know you've got your own heavy troubles, and when I get a spare ounce of empathy I'll send it via the stars. All my love, as always, Barb.

P.S. A brief story from the fire on a lighter note in the midst of all this disaster.

It seems there was a valuable stud bull in an open area that was burning. The farmer risked his own life to move it between paddocks as the flames ate the grass. Finally, the farmer was able to leave the bull fenced in a paddock that had already burnt and cooled, and get back to his property.

The day after the fire RSPCA workers were quickly on the job putting down hoardes of miserable animals that had been burnt, but weren't yet dead.

The exhausted stud bull had lain down for a nap in the centre of his burnt-out paddock. The RSPCA workers, seeing him there singed and motionless, quietly put a bullet through his head.

The farmer's not laughing, but the story's saved many a soul's sanity around here.

Three weeks after the fire

Merilyn, thanks for your letter. It was a bright spot in the dark.

We are, at least, back on the block. We've managed to get a government caravan on loan, free, for an unspecified but limited time. It's brand new, and much bigger than Rae and Terry's – we feel as if we've got room to move at last.

Through the welfare department we've also got two vans that were kindly offered by some farmer up the river. They are very small, but the boys are going to have one each, which is great. It gives them privacy and, more importantly, keeps them separate from Ken and me.

It's the third or fourth day back on the block – I find it hard to keep track of time. The assessors have been in, and the council has bulldozed what was left of the buildings. At least we don't have to look at that mess anymore.

So what we have is this camp of three caravans placed in a triangle in the middle of nowhere. All the white ash has blown away and we're left with this black mess that seems two or three inches thick (it's not, of course). We track it into the vans and the cars. It gets in our beds, on the pillows, on the plates, in the cups. And it stinks.

The only beauty left on our block is the dead gum leaves, silver on the black ground – but you need to catch them in the right light and when you're in a reasonable frame of mind.

Some of the biggest gums – that whacking great one in the middle of the block, for instance – have been knocked down and taken away. The roots of most of them are still burning underground, which is a worry. Paris got a bad burn on his foot when he trod through what appeared to be solid ground, but was in fact a honeycomb of smouldering ash. There are only three trees left standing and those probably will not survive, though they have a few green leaves struggling on. They are on the fence line, where the fire wasn't quite so ferocious. The rest of our two acres is completely barren.

The cement floor of the new room on the cottage sits in the middle of the block like a tablecloth at a picnic, and one tank, the steel one that had originally been a boiler, has been left on the off-chance that it might still hold water.

That's all there is, Merry.

We had to come back, though, as soon as we could. During the two weeks we were at Hahndorf, we came over several times a day, just to be here.

It's odd. We've lost our identities. Nothing that we wear, eat off, or use each day was chosen by us. Everything is someone else's cast-off – nothing to do with us at all. In a way it's funny seeing each other wearing these strange clothes. Even our personalities don't seem to belong to us. We're still traumatised.

But enough of the dreary shit. There's been good stuff too. The support we're getting from the rest of the community is great. Everybody hugs everybody else whenever they meet, those who were burnt out as well as ones who weren't. Just about everybody for miles in any direction has lost something, if not their house. Everybody is sharing and helping each other where they can.

Pam has been a bloody marvel.

Like the rest of us she is suffering from shock, but she's turned her lounge room into a collection centre where well-wishers are delivering boxes of gear. I'll have to go right through it all at some stage, but for the moment we're just grabbing plates, cooking utensils, and enough clothes to get us through.

There's another woman who has been an unbelievable help. Her name is Steve, and I met her at the information centre the day after the fire. She works for Welfare, and knew immediately that the fire was not my only problem. I go to talk to her about Ken and the boys, or whatever I choose. I've got a feeling we're going to end up with a deep friendship.

Paris's school is putting lots of effort into the kids who've lost their homes. It is collecting toys for them, for instance. Paris and Ad are holding up much

better than I would have imagined, but Ken is a mess. I don't know what I am, except that I'm still teaching two mornings a week, and managing to get through the days. My students have been bringing me gifts to ease the pain. A few of them are going to buy me a cassette player so that I can have some music. Fantastic – it will be mine, and new.

The people who own the pub I was working at (I've had to stop that job for a while – it would just be too much) gave us money and boxes of groceries and booze. One of the front bar guys made us a gift of a lobster that he won in a raffle.

Just today some little duck who I've never met before (from some church, I think) came by and left a basket of soaps, cheeses and biscuits. No religious lecture, just good wishes. I know we all get cynical about how crappy the world is and how rat-shit people can be, but at times like this you see their wonderful side. It gets you through the day.

Mind you, I could kill the fucking sightseers. They're up here in droves, and some of them drive right up on the block. I think Adam or Ken will bash the shit out of someone soon if they don't leave us alone.

Anyway, babe, we're home, for what it's worth. Even better, the big caravan, which was designed for workmen out bush, has *two single* bedrooms – so I don't have to sleep with Ken. It also has one tiny room up the other end (it's a pretty long van) with two bunk beds, so when June and Pat come up we'll have beds for them.

So glad to hear your social life is booming, though if you start dating them much younger, kiddo, you're going to have to take nappies. The job sounds great, too. You always were the *best* private secretary on the planet, and the goddamn doctor is lucky to have you.

I've put leaving Ken on the backburner for now. Life is too hard and we all need each other to survive this hell. It still must happen. But at the moment I can't even think of a place to go, and I reckon he'd lose it altogether if we left right now. Deal with that one later.

The phone should be reconnected next week, so I'll be able to ring you. We got the power on to the block the day after the van arrived, and we have one meter box with eight thousand extensions going everywhere.

Babe and Kruger are still in kennels, poor darlings, but the husband of one of my students is something or other in the government and thinks he can get hold of three small sheds for us. If and when that happens, we'll bring the dogs straight home. The kennels aren't charging us, the honeys, but the dogs are unhappy there, and we want them with us.

Mum, Annie and Tess have all been up, but somehow seem less giving and

more detached than my friends and students. Too hard to think about that one now.

Take care, my friend, and don't put yourself in danger with your various lovers. I bleed for your depression and can only say that from where I stand right now, alive is better than dead, but probably not much. Great help. Enclosed are beautiful burnt leaves. Smell them. That's what I smell like all the time.

Early March 1980

Well, I've gotta get out of here pretty quick smart. Ken's lost it, and is very dangerous. I feel like I'm living on borrowed time.

I thought my single bedroom would be a safe haven, but I'm not allowed to shut the door. He comes in talking crazy, waking me up in the middle of the night. Last night he came in at three o'clock and shook me awake. I could tell he was off the planet – he had those awful eyes. You've seen them. He kept asking me if I was sorry that I'd slept with all those men and if I was going to repent, and why didn't I ask his forgiveness. Jesus.

I ended up actually asking him to forgive me – I think I mightn't have woken up this morning otherwise. The man is mad and I have to get the boys away from him. God only knows what he's liable to do.

Steve from Welfare is looking for a house for me on the quiet, and as soon as one comes up we'll have to sneak away.

We've had some rain and the ash has turned to black sludge. It smells worse than ever. The caravan carpet is covered in it. I don't know how to get it out. I can't explain what this smell is like, Merry. It's like mouldy food, but damper. Life is getting worse every day.

Ken's girls have been up twice, but their visits were awkward because the situation is so tense. There's nowhere for them to play, and no room inside for us all. Paris hates his little van and has moved in with Adam. They're both kind of okay, but I'm worried for them. Fuck. My back has been awful. This is a rotten letter.

21 March 1980

Thanks for the card, Merry, and the earrings. Very me! I'll wear them with pleasure forever.

Forty yesterday! I'm heading toward my fifties! Christ, it's hard to comprehend. I feel like a kid inside and I'm on the way out already. Too much left to do and not enough time left. I know everybody says the same, but that's how it feels. Wait till you get there, kid. Eight years to go.

I had as good a birthday as present circumstances allow. Richard, one of our local friends, threw me a party at his house at Stirling and everybody brought food and stuff. Not a big deal – it's not a big house and it was organised in a hell of a rush – but about 35 people, and it made me feel special.

It was hard being there with Ken, though. He followed me round like a dog and I couldn't have a real conversation with anybody. I wished he wasn't there, and can hardly bear to look at him.

I have to leave very soon. He's starting to act as if nothing is wrong between us and is wanting to make plans for the future with us all together.

June and Pat have been up again, but I haven't been able to tell them yet that I'm leaving. The fire was such a big event that I don't think they could take anything else in. Besides, I've left him so many times before that they probably wouldn't believe this time it will be for keeps.

Poor little chooks. I wonder what goes on inside their heads. At least they're not *really* affected by the fire. They lost a few clothes and toys, but all their good stuff is at Katherine's and they still have their own bedrooms to go home to when they leave here. It's hard enough for them to be coming and going between their mum's and us all the time without all this drama as well. They seem to find the burnt landscape very exciting – naturally I suppose – but it pisses the boys off because they *have* lost everything, and have to live in this smelly black hell-hole every day.

Did I tell you that we have Babe and Kruger home now? That's about the best present I could have got. Ken has put some wire between two of the small sheds that we've been given. They've got a bed to sleep on, and a (very small) yard to be left safely in when we're out. The poor loves were fretting badly at the kennels, even though they had each other, and are obviously pleased to be back.

The main problem is the lack of fences – it'll be ages before we can re-fence – and they go off after every living thing that they see anywhere near the block. With all the trees burnt down, they can see for miles, and we're forever chasing after them. A lot of people are riding around on horses, checking out the damage, sometimes with dogs beside them, and as far as Babe and Krug are concerned, they're on our territory and it's on for young and old. We've had terrible arguments with the riders, but they've no concept of burnt fences. Bastards.

The dogs also keep tracking black, sooty mud into the vans. Well, we all do, but they don't wipe their feet! I don't know what the government people will say when they get their vans back. The carpet is black with muck.

We've had the first autumn rains, but instead of being a blessing they've caused havoc. Some of the land had inches of ash, which has now turned to

smelly stinking black mud that is impossible to clean off anything. At least the rain has put out some of the smouldering tree roots, which have been a constant worry with the kids.

I'm going to the marriage guidance people regularly in the city. Ken won't come, of course, but that's probably good. I can talk openly, and they are helping me decide what I'm going to do. I'll need a lot of strength to leave. He says he will kill me, and he's quite capable of it. I'm going to have to be very careful, and I'm worried for the boys, too. So far, to my knowledge, he hasn't hurt either of them, but leaving is a risk because he's said he'll kill anybody who's with me when he finds me.

The boys are both in a hell of a position, and I don't know how much more I can dump on them. They know I've said I'll leave, but until it's a reality they don't have to deal with it. Paris is especially fragile, and I'm worried how he'll handle losing his dad on top of all the rest. Adam has his job at the zoo, which he loves, and his mates and his music. He, at least, has some outlets for his despair. Paris has nothing. He is truly lost.

On the lighter side (in a gruesome sort of way) I've started drawing a dead possum. One of the dogs brought it home. It's a large ring-tail still twisted in its death agony – which must have been brief because it still has much of its fur. People say, How can you *possibly* want to paint that? but I feel as if I have no choice. It just *has* to be painted. For the moment I've started a drawing of it, and

it's good. Somehow it helps to put that image down. There's a hell of a lot around me I'd like to paint, but it seems too hard to contemplate right now.

Well, hon, this started out to be a happy, thank you letter and has ended up another dreary load of shit. But I *have* started to work, and I *did* have a good birthday thanks to all my friends, and I'm surrounded by supporting energy from all directions. Pam is wonderful, as usual, and is still collecting all sorts of fire-relief stuff in her lounge for us. Looks like a Salvation Army warehouse!

Thanks again for the prezzy. Love you mate.

Late March 1980

Merilyn, as you can see we have a new address. It's a horrible rented red-brick house in Bridgewater, Hills' suburbia. Parquet floor. Small rooms. Close neighbours. Ordinary. But away from Ken. I packed some stuff and left while he was at work. Had to leave the dogs with him as we can't have any animals here.

House that is not ours, furnished with chairs, tables, beds, that are not ours. Wardrobes full of clothes that are not ours. We are living lives that are not our own. I'm very grateful to all the people who gave us all this stuff, but I hate it. I've got a laminex kitchen table, for Christ's sake! A vinyl lounge! An Italian bedroom suite with round corners. This would sound terrible to the donors, but what we really want is our own stuff back. Especially our own clothes.

Ken doesn't know where we are, but I'll have to give him the phone number

because there's business that has to be sorted out. I'm still very scared and spend most of the night sitting by my bedroom window watching in case he should come out of the dark to get me. I've often felt sad that you've never married or, alternatively, had a permanent lesbian relationship, but right now, mate, I think it's best to be on your own. I envy you your aloneness. Anyway, we're okay for now.

Early April 1980

Hiya woman, thanks for your letter. Sorry life is rough for you, but thank God for your lovers and someone to hold you when you need it. I wish I could hop inside you for a day and leak some of my positive energy into your pores. Depression is such a cruel enemy. I'm here to tell you, kiddo, that there's something positive to be found under all the negative shit you can pile around yourself.

Strong words, I know, after the dreary letters I've been sending, but magic has been happening here and I want to share it with you. I wouldn't have believed it possible to find extraordinary beauty in this battered landscape, but lately my eyes have been opened to the breath-taking environment that has been created by that monstrous fire.

The autumn light, so much softer than summer's harsh glare, has been throwing a kaleidoscope of gentle patterns and colours over the burnt earth. Trees have become golden towers of shimmering light as the winds toss the

colours to and fro beneath the mellow sun. This gentle wavering softness contrasts with the stark, deep, black of burnt trunks. The trees cast long shadows over the bare earth – its blackness fading now as time and wind subtly transform the depths of ash – creating a surreal beauty of flat primitive timelessness.

I have to paint it. And I have to do it quickly. Winter will be on us too soon and the green of the first weeds will overpower the tranquillity. It's impossible to capture this delicacy with oils or acrylics. So, believe it or not, I'm trying watercolour seriously for the first time. This is the only way that I can hope even to partly capture the gentle nuances of light.

I had already started painting in an empty room at the college that was made available to me while I was still in the caravan. I'd been doing heavy oils with lots of black, dirty wide-eyed firefighters, or barren, round black hills with pincushion tree-trunks. Scenes of desolation. Now I want to paint the wondrous change in the land (or is it myself?), and even though basic life – money, children – is still difficult, I know I can overcome this horror – even grow from it, and with it, as the land regenerates.

In a twisted way, Merry, I wish some similar disaster could come your way and fill your life with big new lessons. Sounds cruel, but such an event certainly puts a moratorium on introspection and self-absorption. You've often said you've envied me my talent and drive to paint, and now I truly understand the value of that gift. If only you had a similar drive, my friend!

Anyway, I'm full of passion and wonder, and frightened only that I won't be clever enough to capture what I see – especially in watercolour. The laminex table has proved a godsend for trying out this new medium and I take back every rotten word I said about it.

Everything else is still putrid and I'm especially worried about Paris – he's having shocking nightmares and is torn between his loyalty and love for Ken and his love for me. Ad seems okay but he hides his feelings deep away from the world, and time will tell how he copes.

Ken is alone on the block, other than the dogs, and is an ever-present threat but life is precious and can be good, Merry. Look for the tiny gems in your world and hold them close. If I could send you my heart I would.

April 1980

Well, Merry, it's happened. Ken tried to kill himself yesterday, and is in Glenside psychiatric hospital with brain damage.

He rang me at Bridgewater the night before he did it, and told me to come over to the block and feed the dogs about nine in the morning. I knew imme-

diately what he was planning, but he would *not* talk about it, said there was nothing wrong, just to come and feed the dogs. Then he hung up.

I didn't know what to do. I wouldn't go to try to talk him out of it, although that was obviously what he wanted. I am finished playing his games.

I rang Steve, who suggested I ring Ken's psychiatrist and the police. I don't know whether I've told you that I had eventually convinced Ken to visit a shrink after the fire. He went a few times, I think hoping that he could stop me leaving, but when the doctor asked me to go in and see him, I found that Ken had, once again, been blatantly lying.

The doctor had been furious and I'd had to sweet-talk him into continuing to see Ken – but I have no idea if Ken ever went back.

Anyway, this doctor and a couple of policemen went over to the block to see if they could talk to him, but he locked himself inside the van and yelled out that he was all right. He wasn't going to suicide, he said, and would they fuck off and leave him alone.

The doctor rang to tell me what went on. He said there was nothing they could do if he wouldn't talk to them – if he killed himself, so be it. He said under no circumstances must I go over there that night, but could only go as requested in the morning – and find whatever I'd find.

I rang Pam and arranged to pick her up on the way because I was *really* scared. It could all be a set-up. He could be waiting for me with a gun. Nevertheless I *had* to find out.

Good old Pam! She took a risk coming with me, but wouldn't let me go on my own. She's been so bloody supportive since the fire that I was loath to ask her for anything more, but the cops wouldn't come unless I found something wrong when I got there. I suppose it could have been a big waste of time for them.

We went a half-hour early, taking Paris to school on the way. How bizarre. Drop the kid at school and then check if his dad has topped himself. We pulled into the desolate block at about half past eight. Ken's car was there, a brilliant orange splash on the blackened land. Was it empty? I drove right up alongside it. He was slumped over the wheel with eyes closed, but through the closed window I could see that his mouth was twitching. I looked past him and saw the vacuum cleaner hose pushed in the top of the back window, wedged in with towels.

Here we go again, I thought. Obviously he was alive, but was he unconscious or just pretending to be?

Pam was as stunned as I was, although we had both been expecting exactly this. I shoved the car quickly into reverse and backed out of the driveway. I was so scared, Merry. Perhaps he needed urgent help, but I was too bloody scared

to go anywhere near the car on foot. You know how devious he can be. What if he'd booby-trapped the car so it would blow up when I opened the door? What if he had a knife or a gun on his lap?

I drove in a panic down the road to Cooper's grain store. I was in a terrible state. What was real? Neither Pam nor I had noticed whether the car engine was running. If it was, he could have died since we'd left. What a thought.

The first person that I saw at Cooper's was a guy named Dave who used to be our neighbour at the lake. He knew Ken pretty well, and is a big strong bloke, so we felt safe enough to follow him back to the block after I'd rung 000.

Dave drove right up to Ken's car, jumped straight out and opened the door. We'd stopped a few yards back because I was still frightened, but we could see Ken turn his head and speak to Dave when he touched him.

The bloody bastard, I said to Pam, furious. He's playing fucking games again. He's okay.

Looks like it, Pam agreed. Good thing you didn't open the door yourself.

By this time Dave had Ken out of the car and the two of them were walking slowly over by the caravan. Ken looked shaky, and although it was hard to see what was going on, I gathered that he was throwing up behind the van. They stayed out of sight for some time, then wandered into view again, with Dave supporting Ken by the arm.

Ken was wandering, squatting on the ground, I supposed for a rest, and sometimes leaning against the van for support. Pam agreed that he looked crook, but I decided to wait in the car until the police arrived anyway. You can never tell with him.

So we sat watching the two men move slowly from one spot to another, talking occasionally, poor Dave ill at ease, until a police car arrived. We got out to meet the two policemen, then all walked over to Ken and Dave together.

The poor bastard had his best suit on, the one he'd bought when we got married. Somehow he'd saved it from the fire. It was a pale smoky blue, beautifully cut with white stitching on the pockets and lapels. He'd looked magnificent in it at the wedding. He looked bloody awful in it now.

He'd vomited dark red mess all down the front of it, and then must have sat in it. The inside of his thighs were filthy, and when he turned around I could see that he'd shat himself and sat in that as well. The suit was creased and filthy from top to bottom. His face was vomit-stained and dead-white everywhere else. His eyes were hollow, when they were visible – he kept putting his hands up to them with outstretched fingers and feeling them as if to check that they were still there. The walking dead.

Dave excused himself, saying he had to make a delivery. His wife told me later that he went straight home, rushed into the toilet and chucked his heart out.

Ken didn't seem to comprehend the questions that the police were asking him. He kept saying, What happened? Have I done something wrong? He looked at me and through me.

I couldn't bear to see him this way. Nobody should have to pay this price. Not even Ken. He was like a sick animal. The ambulance attendants who had arrived by now were gently trying to find out from him what he'd done. The vacuum cleaner hose in the window, still attached at the other end to the exhaust pipe, spoke for itself, but the car, it turned out, had not been running when Dave got to it, even though it was switched on. The police were acting disgusted about the whole business and even suggested that he should take a shower.

He stank of death, but like a child he asked if he was dirty. He stayed squatting on the ground, feeling his eyes, until his doctor arrived. Then he was manoeuvred onto a stretcher and whisked away to hospital. And that was that. Jesus!

God, Merilyn, I don't understand about suicide. Life dishes out rotten health and pain and affliction, but to cause it yourself is beyond my comprehension. I know that you've tried it twice now. How the fuck can you take the risk? If you could be *sure* that it would be quick and painless and *over*, perhaps I could understand the temptation. God knows, I've sometimes wished I was dead. But this was degradation beyond imagination.

It turned out that he really had tried. No games. But by some bizarre chance, the engine of the Valiant had seized just short of the final dose of carbon monoxide. The bloody fan belt had snapped. Can there possibly be a reason for all this?

They took him to Adelaide Hospital, did all they could for him there, then sent him on to Glenside. I rang today and they say he's got serious brain damage, is nearly blind and doesn't know who he is.

I had four children to tell.

Actually, I rang Katherine, and she told the girls, but I had to tell the boys. They're both pretty quiet about it and I guess we'll talk about it more when they're ready. Paris will blame me, I know, until he's old enough to understand. I don't know about Ad. He's older and has seen more. But he doesn't say much.

Sorry to dump this on you, but I had to let you know. I know you'll be pleased in a way because it means that I'll be safe now. Last night was, in fact, the first one since I left him that I could go to bed and *sleep* and feel safe. No sitting up all night watching the street. But under the circumstances I feel guilty about that.

My mind tells me that I'm not to blame, but my gut's not so sure. We both lost everything in the fire. We've both lost our partner and our family unit. We were both without our identities and facing a bleak future. But he had his freedom and an income and good health. I have two children and little income and I'm crook. We both had the same choice – to go on or not. He made a different choice than I did. A disastrous choice.

I've got thousands of questions rushing round in my head, but need to get some blessed sleep. Please take care.

May 1980

Hey, well. A cheery note. Tell you about Ken later, this is *good* stuff.

I'm off my face with the joy of painting. Even though a lot of what I am painting is miserable stuff, I can't stop. These watercolours are fucking marvellous! I don't know why I never bothered with them before. I dance around the laminex table like a lunatic while they weave their magic on wet paper. I don't understand how such happiness can come out of such misery. We're certainly strange beings.

I got a grant of $500 from the government – my sister Annie's David organised it for me; I know zilch about those things – to buy proper materials, and I've got a set of the *best* watercolours available, and I'm painting on the *best* quality paper. Makes heaps of difference. The watercolours are Windsor and Newton –

they come in little pans in the cutest black tin box. I've slept with it under my pillow ever since I got it. It cost a bloody fortune and I'd never have been able to get it on my own.

Merry, it's so good to be working again. I'm not earning-money working, but I feel like *me* again, not some hopeless lost soul. I've decided to do an exhibition about the fire and here are the first two watercolours. Sorry about the quality of my photos, hon. They're only quick snaps before framing.

May 1980

Well, woman, you won't believe this, but we've just had a car crash. Tonight. Is this life full of shit, or what?

Three months after a raging bushfire and the bloody freeway freezes over at Bridgewater. Hail coming sideways as big as marbles. Freezing cold. About half a mile of freeway was covered with ice – hasn't happened before to my knowledge – about fifty cars and trucks lost it and ended up all over the road, the median strip and up the grass verges. If it wasn't so traumatic it'd be funny. You've never seen such a mess. Semis and cars everywhere, lights blazing through the storm, people running all over the road.

I was coming home from town and had Paris and Nick with me. Nick is the lad we took into town with us on the day of the fire – his mum will probably never let him play with Paris again after this!

I was driving along listening to the radio when I heard a warning about the ice. Once you're on the freeway you can't get off, and visibility was so bad with the rain and hail that I didn't dare pull over to the side with two kids in the car. So I changed down to third and slowed to about 50, then came over a rise in the road and there it all was.

I managed to hold the road okay, manoeuvring carefully between the smashed cars. I slowed gently, but didn't brake, thanking God for the driving skills Ken had taught me. We were nearly to the Bridgewater exit when a car, obviously going very fast when it came over the rise, went tearing past me on the right. When the driver realised what was happening, he must have hit the brakes. His car did a 180-degree turn right in front of me, and slid back towards us, wiping out the left-hand side of the Datsun before sliding off the road and up the hill at the side.

We weren't hurt but the car's a mess. The couple in the other car were okay too, but it could have been a head-on. The boys, of course, thought it was really exciting.

It seems to me, Merry, that I am meant to have nothing at all to help me start my life again. After losing all my money at the lake, we had nothing but our furniture and belongings, and then they all got burnt in the fire. Remember I said that we weren't insured? Minor fact. Probably forgot in all the Ken drama. But that *one* year, the only one ever since I've owned a house, we didn't pay the premium. We'd just moved into the Mylor cottage and Ken's business had gone down the tube. He was very low and was out of work for ages. I only had a couple of classes at TAFE and had to take the barmaid's job at Hahndorf to feed us and pay the mortgage. Ken wouldn't even look for work – he'd fallen into the unemployed twilight zone – and we were pushing it to get by. When the insurance bill arrived, we decided that we could risk leaving it for a while – our luck had been so bad at the lake that we figured we were safe. We didn't have the money and reckoned that only a bushfire could destroy us. How likely was that?

Ha! Everything burnt and I still have to pay the mortgage on the house that I haven't got any more.

Actually we did have *some* insurance, but I won't get it to rebuild. You see, when we bought the cottage we got a mortgage from the guy who sold it to us. If we'd had a mortgage from the bank it would have had built-in mortgage insurance. So we had no insurance for the house or contents. Then when we

started renovating the cottage, we got a second mortgage from the bank for $10,000, and they made us take out insurance for that. That ten grand would go a long way towards rebuilding, but the previous owner has first call on the money. Ordinarily he wouldn't take it, but his own farm at Echunga was also hit by the fire. He didn't lose his house, but lost all his sheds and farm equipment, which *he* didn't have insured, so he needs the money himself to get his farm functioning again. Every difficulty possible is being thrown at me here.

The only items we saved, other than the rubbish that we threw into Ken's boot, were the two cars. We had two dollars in the bank and the cars. Ken's car, which he'd left Adam in a note we found after his suicide attempt, has had to be sold for scrap because the engine was completely seized up, and now mine is wrecked because of yet another freak of weather. There is nothing else I have to lose, Merry. Obviously I'm meant to have to start clean. At least I have the two boys, alive and well, but financially I have a hard ten years ahead of me raising Paris. Adam doesn't earn much, but he can cope on his own if necessary. I'd resigned from most of my TAFE classes last year and now have only a couple which don't bring in much, and physically I can't cope with the bar job, though I've returned to it. It knocks the shit out of my back. I hate it anyway, having to put up with filthy-mouthed drunks. Anyway, I can't afford to pay babysitters for Paris.

I'll probably be able to get a widow's pension pretty soon, and that'll make a difference. It seems that if your husband goes to jail or a mental institution you immediately qualify for this pension. It won't be much, but I'll be able to chuck the pub job and concentrate on Paris.

I'm having so many problems with my back that some days I can hardly move. I think it's only the adrenalin that's keeping me going. Thank God the old back wasn't damaged in this accident. The one I had when I was twelve that left me with the buggered back was a different kettle of fish entirely – a motorbike slamming into my pushbike and my fragile young body bouncing along the bitumen. I suppose I should be thankful I've survived. Still, sometimes it's hard to feel lucky when the bloody accidents weren't my goddamn fault in the first place.

I'll write later about Ken. It's awful, I wonder what it is I have to learn out of all this. There must be a reason for it all.

P.S. You know how much I love the dogs, but right now I could really do without them. We're not allowed to have animals here. I thought about bringing them over anyway, but there are no fences, and it's hard to hide two Great Danes! So they have to be left on the block in their shed. At least they're safe

there – though Babe has dug out under the wire twice already and it took ages to find her.

I call in when I take Paris to school each morning and give them breakfast and a cuddle and let them out for a run. On days I teach, I then rush up to Mt Barker, do my class, and then hurry back to let them out for another run. Other days I leave it until I pick Paris up at 3.30 and we both have a good play with them. At nightfall I have to go over there again with their tea, and settle them down for the night. The boys come with me most nights so they're getting as much attention as we can manage. But it's fucking tiring. I seem to spend most of the day in the car, and that's a killer for my back.

It breaks my heart to leave them. I call them into the shed and get them up on their bed, usually with a biscuit. They sit there and crane their necks around for a last glimpse of me as I close the door. Kruger looks like he's going to cry. It's awful. They're used to having acres of land to tear around on, and sleeping with us at night. They must think their world has collapsed. Thank God they can snuggle up together.

Late May 1980

Hiya kid, thanks for your cheery letter. So good to hear that you're enjoying life for a change. The new job sounds fabulous – I wonder if that doctor realises what a gem he is getting. I've always felt your abilities are wasted on ordinary people. You should be personal assistant to a king or queen or president or fantastically rich guru – at the very least an extremely handsome (or very beautiful) millionaire.

God, how do you deal with the bi-sexual bit all the time? It must drive you crazy having to choose between the husband and the wife. Makes me laugh to try to picture it.

Will you send me some photos of yourself? I'd like to see your face again and all the photos I had of you got burnt. Not that I've forgotten how stunningly stunning you are, of course, but I'd feel good having a snap to stick up on the wall somewhere. Gee I miss you.

This ghastly little suburban box has been full of people non-stop, all here to help. It's wonderful to realise how many people care about us. They turn up with boxes of clothes, bits of furniture, food, anything and everything. A lot of stuff is useless, and it all has to be sorted through, but I don't feel so alone. Steve and her crew from the bushfire welfare place have been bloody wonderful. There are three of them there (I don't know the name of the organisation, but it's been set up especially for bushfire victims): Steve, Marcia and Eileen. We get

on well and often have meals together. I know that they're doing their job, but it's more than that. I really relate to these women and, I think, they to me.

Pam is still giving me practically all of her time and energy, and since we moved here she's over here cooking for us and helping me sort through all this shit. Lyn Kilsby too has been great, as usual – did I ever mention this wonderful local mum who I've palled up with? And a student of mine from the lake, Ingrid, has become a new friend and is being very supportive. Her own house is very close to the spot where the fire started and she lost her studio and most of her garden, which was one of her passions, so she can relate to what I'm feeling. My dear old mate Anna has arrived back from Sydney and it's grand to catch up with her again.

Too many people to mention, all trying to help.

The car, by the way, is covered by the other people's insurance and will get fixed. We will also get some money from the Lord Mayor's Bushfire Appeal, and depending on how much it is, we may even be able to get back on the block. Pam and Lyn helped me clean out the caravans and they've gone back to where they came from – somewhat dirtier, but we did the best we could. The Uniting Church bought us a new fridge. Heaven! We no longer have to keep our food in borrowed eskies.

The school had a toy drive for the kids who lost their homes, and Paris has some stuff to play with at last. Unfortunately a lot of it is broken, or has bits missing, and he gets frustrated. He sleepwalks all night, has nightmares, and is going through a terrible trauma about Ken. He shouts and swears at everyone – an eight-year-old ball of anger. He's my biggest worry now. Adam is drinking too much for a sixteen-year-old and staying out too late listening to bands, but maybe that's his way of coping and I'm letting it ride for now.

I'm starting to realise that instead of thinking, How can all these ghastly events be happening to me? I *could* look at it as: Well, there had to be a bushfire in your area, and you all survived, and there had to be a car accident, but you all survived it; and you had to eventually leave Ken, but *you* survived it. How you accept stuff is just a state of mind, after all, or a choice. My boys are alive and I'm alive and I have to thank the universe for that.

I can handle this shit, Merry. I've done it before and I'll do it again – though I wouldn't mind a good back to help me.

My decision to leave Ken is seen by most people (not Paris) as a good move – but a few are being nasty about it. They don't know all the facts, of course, but that doesn't stop me wanting to punch them out. There was a rumour going round Paris's school that I'd driven Ken to suicide to get his life

insurance. That didn't help Paris's attitude. Actually I'd had to cancel both life insurance policies because I couldn't afford the premiums.

I'm painting like a lunatic. Every spare minute. I can't stop. Anna and Ria – another painting buddy – came over for lunch today. I showed them the paintings I've finished, and they were knocked out, which is very encouraging. Even though we were talking about fire paintings their input and artistic energy helped me forget the rotten parts of my life for a few hours. We got high on creation. Anna's still painting and Ria's doing a bit here and there, so we were all on the same wave-length – which is pretty rare in my life at any time, let alone now. In their company I felt constructive and active – instead of 'the victim' I am 'the artist'. I'm even working in *pastel*. Don't ask me why. I don't like pastel, but some of the stuff needed to be done in that medium. It's queer. I see a scene and it cries out, Do me in watercolour! or, Do me in oil or pastel! And I have to.

I've just started an oil of a horse on fire. I've never painted a horse in my life. But I saw them tearing frantically around burning paddocks. Didn't actually see one burning, but know it happened. Somewhere in my mind I can see it. It's going to be a strange painting because I don't even know what a horse looks like well enough to paint. We'll see.

I've definitely decided to have an exhibition, probably in the Hills at Hahndorf so that all the people who got burnt out can see it – if they want to, of course. Not everybody's cup of tea.

On the Ken front . . . no, I'll tell you about that another time. I want to get back to my work with a clean mind.

June 1980

My dearest Merilyn, I haven't wanted to write about what's happening with Ken. Too painful. But I took the boys to see him yesterday, and it's about time I tried to clarify how I feel.

Guilt is what I feel.

I know I shouldn't. I know that what he did was *his* choice, but still I feel guilty. He's still in the Glenside Mental Hospital and will be there for a long time. I've been to see his doctors several times and they say he's so badly brain-damaged that he has to re-learn the lot. They say he can't write his own name and remembers nothing at all, not even the fire. I'm not so sure.

After it happened I didn't go to see him for weeks but eventually the doctors suggested that I should, if only to make it plain to him that he can't come home to his family. He seems to have forgotten that I'd left him and expects to be joining us when they let him out.

He's in one of the big lock-up sections of the hospital, and they have to let you in and out of the building with a key. Glenside's grounds are reasonably pleasant, with lawns and tennis courts and tables and chairs in the sun. But it's full of the saddest people, all wandering aimlessly about with blank faces.

Ken was sitting out in the sun when I first went to see him a few days ago. It was exactly one month and a day since he went in, and I had no idea what to expect. In my mind he was the way he'd been before: tall, straight, well-built, strong and handsome. But the man who turned to face me when the nurse called his name was very different. He'd put on weight, and his face was bloated and blank. His clothes were not pulled straight. They'd cut his hair short, making his face look even broader, and his bearing was that of a child.

He didn't recognise me at first, but then his face broke into a tentative smile. I wanted to run away. What could I say to this broken man?

I had to say what I'd gone there to say. Hope you're okay. Hope you get better soon. Have you any plans? The boys and I are all right. You do realise, don't you, that we've split up, and I won't take you home?

He realised nothing. He wanted to hold me, and after a cursory hug I had to sit well away from him. He didn't even remember hitting me. I could never hit you, Barb. I love you. He couldn't remember the fire. Was there a fire? Have you really left me? It was ghastly.

I had to do it, though, for myself and for the boys. And for him. The doctors said it was imperative that he understand there is no more Barbara. But there I was, twisting the knife in this sad, sad man in this sad, sad place.

But even while I felt guilty, I saw glimpses that made me wonder how bad his brain damage is. It was just a look here, a phrase there, nearly hidden in the horror of his despair, but it was enough to help me be firm. The doctors are convinced he is badly damaged, but some of the nursing staff I spoke to were not so sure that it is all black and white. Some of them think he's playing games, and they deal with the patients much more than the doctors. Tests show damage and it's quite obvious that he's not 'right', but I find amid all the sadness I'm feeling that I still can't trust what I see.

As the nurses unlocked the door for me to leave, Ken stood in the middle of the recreation room shouting out 'But I love you, but I love you.' And I turned my back and left him standing there. Outside, in the waiting room, I burst into tears. A counsellor took me into her office and got me a cup of tea, but I was shaking so much that I couldn't hold it.

Just to make me feel more selfish, the counsellor helped me decide to pass his care into the hands of the Guardianship Board so that legally I didn't have

to manage his affairs or have anything to with him again. I've been sending him money for cigarettes, but someone is going to have to organise new clothes, a pension and, eventually, accommodation for him, and in the circumstances I am hardly the right person to be doing this. Or so the counsellor kept reassuring me.

So I have an appointment to go before the Guardianship Board and say why it should become his legal guardian. Ken will be taken there too, to argue his case if he wishes, but the counsellor said that they will speak for him and it will all just happen. Then they will organise a pension and social workers to help him with his clothing and personal needs while he's in the hospital. After that, who knows?

Katherine has taken the girls in to see him. I spoke to them on the phone and they said they were teaching him to play 'catch'. It must be hard for them. I hadn't let the boys go until yesterday because I had first wanted to be sure that he was safe to be with. Once I'd seen the environment he was in, I knew they'd be okay – except for their souls.

Like me, they started crying as soon as they came out. They want to keep visiting him because he's lonely and sick, but every visit will destroy them. It's a hard one to call. I don't want to stop them going, in fact I think they need to, but I won't let them visit too often or stay too long. They were quiet on the way home, except that Paris expressed *very strongly* that he wants me to bring his dad home out of that place. Adam certainly doesn't want him home again – in fact, I know he'd leave if that happened – but he doesn't know how to deal with the pain of seeing Ken locked up like that. At least Paris is letting out some anger. Adam doesn't say much, and I don't know where he's putting his pain.

On a brighter note, I've started looking for a cheap transportable (I'm talking bottom of the barrel here) that we might have enough money to buy with the bushfire appeal money. One big room would do us, but so far everything I've seen is completely unliveable. Still, at least I'm making moves to get us home on the block.

Enclosed is a photo of the horse painting – it's about as depressing as this letter. Had to do it though. Not a good horse as far as horse-paintings go, but I think a good image. Have about six on the go at the moment, several more finished. Will send photos when I get them done. Not enough time.

June 1980

Hiya kid, sorry I haven't written for a while, but thanks for your letters. I've been so busy, and every spare moment I've spent painting. See enclosed photos – the pastel is our side fence and the oil my vision of galahs.

I'm glad the job is going well and your social life is buzzing.

I'm exhausted too. Rushing backwards and forwards to the dogs every day, getting Paris to and from school, sorting through bushfire stuff, seeing counsellors about Ken, trying to keep this bloody house free of millipedes, and teaching. Also seeing caring friends, and painting when I can, as quickly as I can, before everything changes and I forget the details of the important images.

Yes, Ken is still pretty much the same. He's showing some improvement and the boys' visits are not so traumatic. They still cry on the way home. But he recognises them now, and that must mean something. Don't want to talk about that today.

Mum is okay. She's been up here a few times since the fire and we've been down to her place. She's only just moved into a granny flat at the back of Tessa's house and is busy carpeting, furnishing and so on. I think she's trying to block out our problems as she's feeling guilty about getting her new place with new things when we've lost ours. I'm very happy that she's moved in at Tessa's. She will probably stay there comfortably until she dies.

Haven't seen much of Annie. She has visited us, but is busy with her own

life. It's my friends, rather than my family, who are giving me the support that I desperately need right now. If it wasn't for them, I would feel very alone. We've talked often of the value of good friends, you and I, and by God I'm finding out the reality of that now.

I wonder how the poor buggers are getting on who don't have friends and who lost their identity in that bloody fire. Many of them are channelling their energy into legal proceedings for compensation. It seems certain now that the fire started in the council rubbish dump, and the lawyers are jumping on the bandwagon to sue. There have been many meetings, with much shouting and crying. I went to the first two and then decided to opt out. Too much wasted energy there. I'd love some money to start again, of course, but it's all going to take years and that's not the way I want to spend my life.

Anyway kid, this is a note of *good* news of mammoth proportion. We've found a building and are going *home*! Will take a while yet, but it's going to happen. I'm having a little Scotch (or two or nine) while I'm writing. Small celebration.

I'd spread the word around that I was looking for a really cheap building (I've only got five thousand dollars to spend. I'll go into that later) and someone who knew someone had heard of this transportable, so today we went for a look. The building is – or was – the lunchroom for a big cheese factory at Nairne. The factory has closed and the building is for sale.

Well, it was the saddest looking building that you could ever imagine. It was across the big yard from the deserted factory and looked very small and neglected. It consists of two rooms, one big and one small. The small room has its own outside door and we were able to unlock that and go inside. Not a bad room with three windows and reasonably tidy. There was no key for the big room – the guy who's selling it had to knock a hole in the wall to reach inside and unlock the door. The room is about 25 by 15 feet, with three windows and two doors, one front and one back. But it was filthy – dirty old lino on the floor, tatty holland blinds over grimy windows and large areas of the ceiling cladding hanging down, covered with black muck. My heart sank. It seemed *too* dilapidated to be saved.

Adam jumped up and down as hard as he could on the floor. Paris followed him around, also jumping up and down, although he didn't quite know why. Yeah, this is solid, Ad said. We could live in this.

My heart burst with pride. The average person, Merry, would take one glance at this room and say, Forget it. But not my two young men. They can see us back on the block, living in this dump – amazing after they've enjoyed the lux-

urious perfection of our last house at the lake. They displayed no hint of fear of peer pressures or snobbishness.

The guy wants $4200 for it, but Steve thinks she can get it cheaper. Anyway, we're buying the heap of shit, and we're happy as Larry about it. At least the ceilings are high, and the basic structure seems to be jarrah. It won't be long before we're out of this ghastly suburban box that we hate so much and home with the dogs at Mylor.

You'd laugh if you could see it, Merry, but we'll make it into a home, and love it and slowly fix it up. We'll be okay. Tonight I lift my glass to my sleeping children, who may never know what a gift they have given me today.

20 July 1980

Merry, Merry, Merry, it's been five months since the fire and I'm writing this letter from Mylor! We are here. Home. We moved in yesterday. The boys are asleep in the small room. I can hear the patter of rain falling on the iron roof. There is a fire burning in the new pot-belly stove and Babe, Kruger and the cat are spread out in front of it. They just about fill up all the space that's not cluttered up with our bushfire relief furniture.

The house (I use the term loosely) got dropped on the block last week. Pam and I stood in the rain and watched as men lowered the building with a crane onto the besser-blocks that act as its foundations. Just a cardboard box on cement blocks, in the middle of the burnt block, which now is greeenish among the black mud where the weeds are beginning to grow.

On the weekend Rae and Terry and a couple of their friends came up. Terry put in the pot-belly, the money for which was donated by the local Lions Club. The men nailed up the sagging ceiling panels as best they could, and knocked a doorway through to the small room.

The moving guys, who shift transportables around the country on what they call a low-loader, reckon they've moved this building before, and think it was a rural schoolroom built about 40 years ago. That would explain the two rooms and the sprinkler system that runs through the roof.

I call her Mabel. She seems warm and safe, like a Mabel. A big, warm country woman smelling of scones and soap powder.

I went into the Salvation Army to buy a kitchen sink. They wouldn't take any money and I came away with a sink cupboard as well as a separate kitchen cupboard, and have set these up in the corner of the big room. That will be our kitchen. We have no taps yet, of course, and have to bucket in water from the tank, the old ship's boiler, that survived the fire.

We had to get rid of most of the furniture that we had at Bridgewater. There's no room for it. The you-beaut laminex table had to go, along with its matching orange vinyl chairs, and the Italian marbled bedroom suite, as well as wardrobes and other bits and pieces. I'm actually sorry about the laminex table. God knows what I'm going to paint on here. The people who donated all that furniture would probably be horrified, but I had no choice. It was a great help, in fact, because I sold it to a second-hand shop and the money I got for it paid for the moving van. Every penny is hard to come by, so really those good folk helped us two-fold. I feel guilty though.

I have a single divan, with a shocking old mattress on it, next to the kitchen cupboard and can lie here propped up with my ashtray and drink on the lino cupboard top and feel warm next to the pot-belly. We even have an inside toilet – in fact a yellow plastic bucket in an alcove between the rooms with some-body's old curtain giving us privacy. We have to empty the bucket into holes every day, but we are so happy to be back here that we don't mind. There was a proper doorway between the two rooms, but somewhere along the line a wall was built about a metre into the big room, fully shelved for records or books or whatever. The men pulled down the shelves when they knocked the doorway through, so we have a cubby ready-made for the toilet between the rooms.

The other side of the doorway will be extended to make a bathroom. Terry and some of our other friends are planning to start this next weekend. Everybody wants to help, though they shake their heads in horror when they first see the place.

Jeff, who did the plumbing for the house at the lake, will let me pay him later, so soon we'll have water inside and all the luxuries of home. Well, nearly. The wiring is rotten and very dangerous. Another friend, a student's husband, is an inspector for the electricity trust and he and another neighbour, who's an electrician, are going to rewire the whole place. Fantastic! All I have to pay for is the materials. Then there's a working bee planned for *all* of them to come. The dames are going to paint the inside while the men are doing the heavy work. I can't believe how much energy and love is going into this little place.

The walls are so filthy and knocked about that I've decided to paint the whole lot dark brown. Everybody hates the idea, but it'll only take one coat to cover the marks. The walls are a pin-boardy sort of thick cardboard that is perfect for pinning up my drawings, so the brown will soon be covered with stuff. Anyway, it will make the whole place seem warm and cosy.

This description is probably horrifying you, with your immaculate cleanliness and class. But believe me, Merry, I'm so thrilled to be sleeping in my

own place again, on my own block, with my dogs beside me, and my boys tucked up warm and happy, that I could burst with joy.

Next Wednesday night Anna and Marg, another painter friend, are coming over. We're hiring a model so we can start life-drawing. Paris can walk to school from here. Ad can catch the bus to work if his car breaks down – which is inevitable. Friends are coming over to plant trees. Life is getting better by the minute, I'm surrounded by scores of caring people and I'm *home*.

Excuse me while I drink to that.

August 1980

How the fuck are you? Haven't had a letter for a while and I want to know that you're all right. Two lines are enough, or a postcard. Please. I've rung a couple of times but can't get an answer. Have you moved?

It's all go at Mylor. We've got a bathroom with water, and even a proper toilet. Jeff has done the plumbing. I bought a 3000-gallon water tank and, if we are careful, we'll be able to manage on that for a while. There's a bath with a shower above it (it's a pretty small bathroom) and we save our shower water for the trees that many good people have helped me plant. These six-inch trees are a joke in the empty dead landscape – we have to cross our fingers that some might survive. Perhaps in a few years we'll get some shade and privacy from them.

The land has really been destroyed here. Two fire fronts with the fireball as well, converged on the corner where the house stood. The area blew up with the equivalent heat (they tell me) of an eight-megaton atomic bomb. The soil is burnt down to a depth of twelve inches in most places, and has set like a rock. It's impossible to dig deep holes for the little trees, and anyway I wouldn't have water to fill them. I have no planting tools – well, a knife, fork and spoon – and couldn't dig a decent hole anyway with my back the way it is.

Thank the Lord (again) for friends. A student's wife, Mrs Marinos, comes around every week with plants that she's sponged from somewhere, and plants them for me. Sometimes I come home to half a dozen new trees. She's got a real green thumb. Her husband, Nick, has fixed up the wheelbarrow, and it's like a new toy for me. It was in the yard when the fire went through, but the tray and the metal frame were left intact, if black and pitted. The tyre had melted and I was ready to throw it in the dump, but Nick put a new wheel on it, painted the metal with some rust-proof stuff and it's as good as new. I keep going outside to look at it.

Merry, you know that I've never been much into material possessions, but every little item we get now – stuff other people take for granted – means a

great deal to us. It's a great lesson for the boys, and has certainly brought *me* back to earth.

Do you realise that it's less than a year since you were here for your last dinner before moving to the west? Back then I had that sweet little cottage here on the block. Ken and I were together and expected to be forever. June and Pat were a real part of our family. Life seemed okay in a restricted sort of way. That all seems a lifetime ago.

I've learnt so much in the last few months – and I'm very aware that I've got more growing to do. I've been reading heaps about battered wives and the complicated reasons why they stay with their abusers. I have to find the courage to dig deep to understand my own reasons, or else I'll continue to be a victim. I'm determined, though I know it will be painful and slow. For the moment, however, I'm busy simply existing. The inner work I need to do will have to go on hold.

It's six months now since the fire and friends are still offering their services. Some of them are discovering skills that they didn't know they possessed. The dividing wall had to be removed and two new walls put up to make our little bathroom. Terry and his pal, with advice from whoever else was around, built these walls even though they had no experience. We can only use the cheapest materials, which didn't make their job any easier, but the walls seem strong enough and the bathroom is functional. It still has a wooden floor, but another mate is going to tile it with materials left over from an old job.

The day that everyone came to paint was amazing. People running around like ants, all doing their bit for Mabel. It turned into quite a party – the men hammering and sawing, and the women painting and cleaning. I wasn't allowed to do anything. They all know about my back, so they made me supervise – I'm good at that. I was in happy tears most of the day.

Annie has painted a mural of three big Sturt Desert peas on the outside of the house facing Cooper Road. It's a bright red splash among the stark black trees. It's not quite finished yet – I'll have to do that myself when I get the energy – but everyone in the neighbourhood says it cheers them up when they drive past. The barren landscape spreads so far that you can see it from three different roads.

Anna, Marg and I have a life-drawing night every week. If we shut the dogs in with the boys, and the model poses on my divan, we can just squeeze in. I've borrowed an easel from the college and can use it for as long as I need. We share the cost of the model between us, and buy a flagon of cheap white. They bring bikkies and cheese and we have a bloody good time. Doing some nice drawings too. See the photos I'm sending.

The fire paintings are still on the go. The exhibition is planned for November. Colin Thiele, my old teacher who wrote *Storm Boy*, has agreed to open it for me. He is just the nicest bloke and he always attracts a good crowd. I've got a lot more time to paint now that I'm home and I should have about 35 paintings finished in time. There are so many aspects to the fire that I'd *like* to paint about 200, but there's not enough time – and there's the cost of canvases and the frames for the watercolours.

I've had a couple framed already and they look reasonable. It's always the same. When you do them they look great, then when you've done a couple more the first ones become very ho hum. I can't judge the quality properly myself, but Marg and Anna are helping me decide what to frame. I can't really afford it, but they have to be done properly.

I have the widow's pension now, plus what I get for teaching, but it doesn't go very far – especially when I have to buy paint and materials for Mabel. We need new clothes as well. We can almost manage with bushfire relief stuff, even though we hate it, but undies, socks and shoes have to be new. There's heaps of stuff that we need that you wouldn't even think of – scissors, needles, salt-shakers, hair brushes, egg-beaters. I keep going to grab something quite ordinary and then realise that it's gone.

I pay a lot for the chiropractor. It's nearly two years since I started with this guy and I've just about given up on him. I'm still in pain all the time. Sometimes I have to teach lying on my stomach in the middle of the floor. My students don't mind – they bring their work down to me – but it's frustrating. I'm going to have to stop teaching altogether at the end of this year because I feel that I can't be professional enough. I never know whether I'll be able to stay upright for three hours straight, so taking lectures seems unfair to the students. No one's ever complained, mind you, but it worries me. At least when I paint at home I can stop for a lie down when I need it.

Perhaps I'll have to start painting chocolate box tops to earn a living from home. What a thought. I can't even work in a deli, or clean houses. Everything revolves around my goddamn back.

Paris is still sleep-walking, Ad is smoking dope, there are problems with Ken and lawyers – but otherwise life is just fine.

Would love to see you, Barb.

November 1980

Dearest Merilyn, the exhibition opening was amazing! If only you had been here it would have been perfect. All my paintings hung there on the walls, the good

and bad side by side for everyone to see, and nearly everybody was crying. I can't come to grips with it yet.

It was different from any exhibition I've been to, let alone one of mine. People were walking round having a look, then hurrying outside to the lawns for a weep. At one stage I thought I'd pop outside for a quiet fag only to find about sixty people out there crying and holding each other. I had to go back inside quick smart.

There were hundreds of people there. All this publicity is good for me, of course, and bloody hard to get, but I hadn't expected it from this show – I simply had to paint what I'd seen. I expected that Hills folk might want to look at bushfire paintings, and I hoped it would help them in the same way that it helped me to do them, but people came from everywhere!

The *Women's Weekly* did a two-page article in colour a couple of weeks ago, and I suppose that brought people up. The *Advertiser* had a photo and article. Channel 7's *Current Affair* had it on last week after they filmed me painting, and did a long interview as well. I'll see if I can get a copy and send it over.

The governor and his wife came to the gallery at Hahndorf to meet me the day before the opening (and bought a watercolour). There I was trying to chat while balancing a bone-china cup and saucer in one hand and a plate in the other. You need four bloody arms. I'll never make it in the socialite stakes, but they put me at ease.

Colin Thiele had to have an operation, so he couldn't open the show in the end. Poor love has shocking arthritis. He is forever in and out of hospital getting new joints. Walter Wotzke, who runs the gallery, arranged for a senator (Senator Davidson) to do the honours instead and he was super. A lovely, straight, tall, older man, very much like my dad. His speech was caring and thoughtful.

Every bastard I know turned up! I was surrounded by friends the whole afternoon, then we came back to Mabel for drinks. I wiped myself out completely. Absolutely drunk and disorderly. Wonderful. Best of all I sold heaps of paintings! I won't find out how many until tomorrow, but I reckon at least half. There were stickers everywhere. That's going to mean *money* – enough for a front verandah, I hope.

Merry, I'm exhausted. It's been six months of hectic work. But I feel exhilarated, even while I'm sad it's over. Artists don't often get to see the responses to their work. At openings, everyone says nice words but you never know whether they're for real. Occasionally a buyer will ask to meet you, and you'll get a hit of excitement and pleasure. But most often the stuff you've sweated over – loved and hated and doubted – gets hung, sold, loved and admired (or

chucked out) far away from the artist's eager eyes. Well, this time I *saw*, and was amazed, Merry, that me, *Barbara*, could evoke such emotion in so many people.

I know the emotion came from the fire itself, but photographs wouldn't have had the same effect. That's the magic of a painting. Sometimes, if you're lucky, painting transcends reality. Shit, some of these are *badly* painted, in terms of finish, style, balance. They were done urgently – the message was more important than quality. But it didn't seem to matter.

I'll probably look back later at some of the paintings with horror. Half-a-dozen of the watercolours are good and two pastels. I think I sent photos of the best ones.

Even Paris, who hated me painting every night, seemed proud of his Mum. I hope the opening helps make the last six months more acceptable for Adam and him.

I want to keep painting the bush as it slowly returns to beauty. This will take years, and I'm getting very involved with the nudes as well. All I need is energy, space and money for materials. We'll see.

What if I couldn't paint, Merry? What if none of these pictures existed? Would those people still have unshed tears to carry forever? Would I be a mental case? Would the boys' emotional state be worse, or better? I'm forever fascinated by this painting business. Sometimes late at night after I've started a new painting, high on turps, I think that this image I've created now exists as a tangible thing, and didn't exist the day before. And sometimes I wonder why, since this thing I want to paint already exists in my mind, there's a need to actually paint it. Whoa! I'm getting over the top here.

Barb.

December 1980

Hiya kid, exhibition's finished, money has come, and new verandah is going up as I write. Sold about three-quarters of the show and can pay some overdue bills at last.

Enclosed is a review of the show. I'm quite happy with it. I think the critic was as ambivalent about the quality as I am, but even to *get* a critique is good.

Back to the nitty-gritty of life. Yahoo! A verandah! We've had no shade at all, of course, with all the trees burnt, and dear Mabel blisters and buckles in the summer heat. The verandah is just galvanised iron on wooden posts, but it'll be like a palace atrium to us. Good for the dogs too. They hate the swelter inside the house, and can't handle the full sun outside.

I don't think I mentioned that I ran into Lester the day we finished hanging

the show. I'd popped into the pub to pick up some booze for the after-opening party, and was most surprised to see him get out of a nearby car. I hadn't seen him since Paris was born – nine years – and then only briefly while I was in hospital with the breakdown. Before that it had been another five or six years since our break-up – he wasn't around for the divorce. I had thought that he was living interstate. My mind was preoccupied with the exhibition opening and it took me a second to realise who he was.

He was with his lady, a nice bird called Gwen, and he insisted that the three of us go into the pub for a drink. Gwen didn't look sure about the idea and neither was I, but we went anyway, though I made it clear I couldn't stop long. I learned that they do in fact, live interstate. They were visiting Adelaide, had seen the article about my exhibition in the paper, and had driven up for a look before the opening.

Les was quick to give me a critique of the work – smart-arse. He said in most cases that the watercolours were better than the oils. Bastard was right of course. I could have hit him.

It was an odd meeting. I felt sorry for Gwen. Lester insisted on reminiscing about old times and it was very awkward. He looks pretty much the same, but is beginning to grey, and his general attitude hasn't changed one bit. Remember so and so, he'd say, he really used to fancy you. I didn't remember so and so. You must, he said, he really *did* fancy you. And then, remember this one, or that one, he fancied you too. I remembered none of them, because to me they were unimportant. But he was still jealous and possessive Lester. Poor Gwen had to sit and listen to it all.

The bastard didn't even ask about Adam. I got a few jabs in about what a super kid he is and how well he is doing at the zoo and with his band. I wanted to shake Lester by the shoulders and scream, This is *your* son, don't you care what he's doing? All he bloody cared about was which night-club idiot might have fancied me fifteen years ago. It was astonishing. The three of us sitting there at the bar at the Hahndorf Inn, Lester, his ex-wife and his present lady, and no mention of his son whatsoever. It was as if I'd stepped back in time. Adam had not been born and Gwen did not exist. Only Lester and his obsessions.

I stayed for two drinks, then hoofed it before I lost it and gave him a mouthfull. God I'm glad I left him. Imagine being stuck in that same old boat! I wonder what Adam would have turned out like if we were still together. And I wouldn't even *have* Paris.

It's a funny old life, isn't it, Merry? Sometimes it seems as if it's all already written and you're just the poor bugger who has to go through the motions.

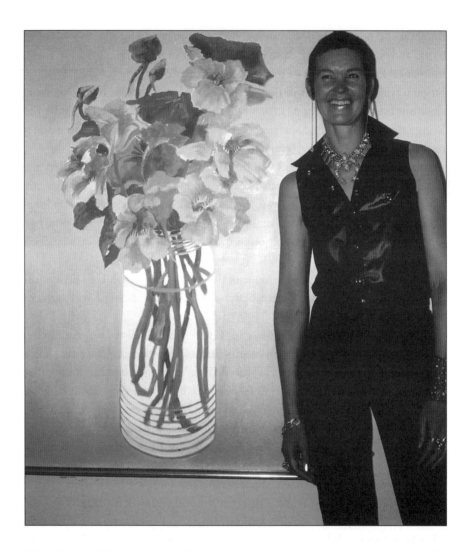

Well, I'm glad I'm finished with the Lester chapter, and I'm glad I'm practically rid of Ken. He's still in the lock-up section of Glenside by the way, and the boys occasionally visit. It's always traumatic and they inevitably come home upset and withdrawn. I don't plan on having any more strong relationships – certainly no more marriages – so perhaps now's the time to start finding out who I really am, and what I'm here for.

Wouldn't it be wonderful if there was someone we could ask? When you're young you think your parents know the answers, but you soon find out that's not the case. I'd like a God person who you could go to with, say, three questions, and know you'd get the absolute truth.

But how the hell are you? Job still good? How many lovers do you have on the go at the moment? I could do with some juicy tidbits, so write and tell me all. If only I had the money I'd come over for a week. Can hardly afford the petrol to get to the framer's at the moment.

The enclosed photo was taken at the exhibition opening – note the jewellery! I had lent the bracelet to Rita for a costume party at the time of the fire. The necklace I had on lay-by, practically paid off, so it was safely in town in a shop. I was wearing my rings on the fire day, as usual, and Annie later made me the earrings out of silver chain. Not bad for a starving artist fire-victim, eh?

The shirt is cheap polished cotton but looks good. Black jeans and sandals. The painting was for spring. I divided the show into summer, autumn, winter and spring, and these were the first flowers that I could grow in a pot. God I love nasturtiums – heaven in a jam jar. Some bastard bought it. Write to me soon and please send some photos. Love, as always, Barb.

January 1981

Merry, I'm sitting on the beach at the Coorong in the late afternoon, waiting for sunset and thinking of you. I'm down here on a painting trip with Anna, Gay and Ingrid for a few days. It's been hot as hell and working on the beach is exhausting. Even wearing our big hats, we've been burnt by the sun and wind – I think my whole face will peel off in a couple of days.

This beach is one great sweeping bay called Policeman's Point. We're staying in a miniscule cabin in a caravan park right on the edge of the sand. We're getting on really well, taking turns with the meals and dishes, then sitting around after tea admiring the day's work and getting pissed. The bunks are narrow and have crappy mattresses, but we're so exhausted (and pissed) by the time we go to bed that sleeping's no problem.

I can see the others further along the beach, each sitting alone to soak in the peace. The tide's a good half-mile out at this time of day, so there's heaps of space. I saw Anna just before, who is way out by the water, with her hips and legs in the air. She's a bloody scream. She's wearing layers of long-skirted tat, one over the other, and they were blowing over her head in the evening breeze. She hasn't got any britches on – sunning the hole of her body, so to speak. Good thing that she's out a long way. The tourists would have a fit.

It was so bloody hot today that we couldn't stay long in the sun, so we put a tent up in the middle of the beach, about an equal distance from everybody's chosen spot, and kept an esky full of beer and cold stuff in the shade. Every so often, one or two of us would rush over to the tent and collapse in the shade

with a drink for a while. The tent, one of those sharp, triangular canvases on central poles, looks beautiful stuck out alone on this massive stretch of sand with its blue and white stripes. I have already done some watercolours of it. The shadow it casts sometimes seems to stretch for miles along the beach.

Policeman's Point is one of the most beautiful places I've known. Gnarled tea-trees grow right up to the sand and there's a succulent grass that weaves its way in clumps out towards the water. You'd love it, though I can't imagine you surviving the weather. I just got a flash of you at Glenelg beach in your elegant black-lace neck to knees holding a frilly-edged umbrella as you waded through the shallows on your alabaster ankles. God, I wish I had painted you! But your soul would love this place. It's so primitive. And the sky is so big that even the flocks of hundreds of pelicans, flying in formation, take up hardly a fraction of the space.

The Coorong is a spit of inland water, about ninety miles long I think, heavy with Aboriginal legends and myths, that is separated from the Southern Ocean by a narrow strip of sandhills. This inland water starts at the Murray Mouth and follows the coast towards Robe, petering out several miles before it gets there. There's practically no tide, other than seasonally, and the whole place smells of salt, rotting rocks and age. You get the feeling that humans are just a passing whim and this sacred area will be here, with all its magic, long after we've annihilated ourselves.

I wish you could be here absorbing the healing aura. I hope this paper has absorbed the smell of the Coorong for you. I worry for you and your unhappiness. If it's possible to hold some of your spirit in my hand, you are beside me gentling down in preparation for the close of day.

March 1981

Hiya kiddo, heaps happening. In no particular order:

Some new paintings going into a small gallery at Brighton called the Jolly Sailor.

Still wasting time with the same chiro. Still hoping. (Sometimes my own positivity gives me the shits.)

Lots of visits to the lawyer, a good woman called Helen Finch, who's trying to help me get this block into my name – not easy with Ken still locked up in hospital and the Guardianship Board dealing with things.

Life drawing every week – the only really good time for me. Love it.

Trying to organise a zoo book for Axiom publishers – lots of visits to the zoo to draw, and very tiring. Think they might take it, certainly seem interested. Could mean money!

Started probably the last (advanced drawing) class I'll do for TAFE. Good class – really like teaching it, but three hours is a bit too much for this bloody back!

Seeing a bit of a local guy who's nice. Gentle fellow. No pressure. You'd be bored shitless.

Babe's not well, and I can't afford too many vet bills. She's getting old.

Not allowed to ring June and Patsy anymore. A while ago Katherine asked me not to see them – said she felt it was best for them to put our relationship behind them – but I still sent them birthday and Christmas cards. Then I found out that she wasn't giving them to the poor kids. I've been ringing occasionally to let them know I'm thinking of them, but last week Katherine took the phone and asked me not to call. They've been having a tough time with Ken's suicide attempt, though they haven't been to see him since the first visits last year when he was really bad. Katherine says my calls make them worse and they don't want to hear from me.

She *is* their mother, so I have no choice but to do what she says. Sad thing is that they'll think I don't care.

Summer's over, thank God. We nearly sweltered to death in this hot box. And I'm scared of fires, though there's nothing left here to burn.

Getting a new tank! Will have enough water to manage now I hope.

Paris and Ad still visit Ken now and then. It seems his progress is slow and

making conversation is hard for them all. They're gutsy kids to keep going there – it's a dreadful place. Recently he's been moved to a very old multi-storey building. Dark and damp. High ceilings, no colours. I had to go inside it once to tell him personally that I'm going to start divorce proceedings. The doctors thought he wouldn't believe it otherwise. Except for that, they want me to stay away.

Hell, Merry, the place is like something out of a horror movie. There was a television room just off the entrance passage, bare except for chairs arranged along each wall. A dozen or so poor bastards were sitting there in a row, faces blank.

The nurse brought Ken, shuffling along the passage, and stayed while I told him, as gently as I could. But I love you, he said, I would never hurt you again. I had to turn my back on him and leave. I wanted to hug him. I don't know how the boys do it.

I'm so relieved that he's locked up and we are safe, but I feel so guilty about it. The doctors don't know whether he'll fully recover or not. Perhaps it would have been better if he'd died in that car. Other than the boys' visits I forget about him mostly. I can't allow my thoughts to linger on his loneliness. I try to enjoy the freedom from terror that graces our lives now. Easier said than done.

October 1981

Hiya kid, great news. Barb is driving a Charger again! Boy it feels so good to be whipping around corners with that power under me. Little Richard going full blast on the tape. Comfortable, roomy and safe. I feel like my old self again.

I reorganised my mortgage in May now that it's in my name, so I don't have to find so much money each month. As you know, Ken made me sell my old Charger because he couldn't cope with the 'image'. I've felt all arse-around ever since in the little blue Datsun. It was reliable, but not my style at all. I figured that if I sold the Datsun and got an old beat-up Charger I might get some cash back, and I did. I got the Charger and a thousand dollars in exchange for the Datsun and a couple of nudes. The dealer put a cassette player in for me for an extra two drawings, so I feel pretty damn good tonight. Adam laughed with delight when he saw the car – he knows how important it is to me – and Paris likes it too.

Even though I'm sitting on someone else's chair, at someone else's table, wearing someone else's old clothes, I feel as if I've got my identity back at last. Silly, isn't it? Its just a beat-up second-hand car, but it's my *choice* – the biggest loss we suffered in the fire business, I now realise, was the ability to make our own choices.

I think, though, that if I had the choice of rebuilding a new house or keeping Mabel, I'd choose to keep this funny little box that we live in. I'm growing very fond of her. The block's looking better though, green with winter weeds. This was the second winter for some of the new trees. After surviving the frosts, they've got a chance of living through summer if we can get occasional water to them. Most of the gum trees that were burnt have got a skerrick of new growth from the trunks, which gives an impression of colour and life, though the farmers reckon they'll die within seven years anyway. Still, the view isn't quite so bleak now – but privacy's a joke.

We've been using the front verandah as another room during the winter. The kids can play under it when it's not too cold, and the dogs love lying out there on a good day.

Last month I went to the Coorong for a couple of days with Anna. The place looked gorgeous – September is one of the best months down there – and next week I'm off to Robe with a bunch of students for five days. This will be my third, and probably last trip to Robe to teach. I'll be finished altogether at the college soon, and wanted to squeeze in one last trip before I go. The other two were loads of fun, as well as hard work, and I expect that this one will be just as good. Hope I've got the energy. We stay at a big, homey hotel. After we've met for a good breakfast in the dining-room, we take a packed lunch out with us for a day of painting. Usually we spend a whole day at one spot, sometimes two, depending on how many students need extra time to finish a piece, then it's back

to the pub for a counter tea and drinks. About nine, we have a criticism session on the day's work and then I usually read them one of Balzac's short stories before we hit the sack – with yours truly completely buggered by this time. Still, it's a change – and I make good money for the week.

A student who came on an earlier trip brought me a hardback copy of *The droll stories of Honoré de Balzac* after the fire. I thought this was the most thoughtful gift anyone could give. The tradition can continue and I'll have the book forever. You should get hold of a copy and grab a laugh. They're delightful. I think they'd be to your taste. I'll probably drive the Charger to Robe – it's a four-hour journey, and it will be a good test for her. I'll find out what repairs she'll need.

Please write soon. I hope you've had a hit of something good like me. Love ya, kiddo, Barb.

November 1981

Merry, I'm writing from Sydney, where I'm staying at a hotel right in the middle of King's Cross. Sleazy but interesting. I came over with half a dozen new (erotic) paintings to see if I can find a gallery here that will take them. I've enclosed some photos. Very different – and exciting – stuff for me compared to the usual landscapes. I think all the life-drawing inspired me.

There's no way I could normally afford a trip to Sydney, and Adelaide would never show this stuff, so I didn't imagine anything could ever come of them. But a local couple at Mylor who are fairly new on the scene were taken with this new work. I was at a dinner with my friends the Kilsbys, excited and talking about this new direction, when this couple decided that the work should go to Sydney and I should go with it – so they paid my return fare. I had trouble accepting their generous offer, but have learnt from the bushfire that accepting people's gifts is important – probably one of the best lessons that I learnt from all that mess. So here I am. Trisha, the wife, is one of my students and very talented herself. Her husband, Gunther, is a university lecturer in language. They are educated folk and their support for my work was most encouraging. And that's what I need over here. Courage! It's dreadful walking into these big galleries to introduce myself and see if they'll look at my stuff. It's so frightening, Merry! They can take away your confidence with just a look. These are big-time galleries compared with little Adelaide.

Before coming I wrote and made an appointment to see a woman called Gisella Scheinberg, who runs Holdsworth Galleries. I sent the packaged paintings by truck in advance to her gallery. We met yesterday – and I came away with

a broken heart. She very nearly took them, but in the end said no, they'd been done before. I was dismissed. But it was *so* close. She dithered for ages. If only.

Tomorrow I'm taking the paintings to two other galleries and on Saturday to one more. They are big – 4 by 6 feet – so I have to organise taxi trucks to cart them from one gallery to another, and that is bloody expensive. Most of these galleries are within a couple of kilometres from here, but walking to them is hard

work for me because everything here is uphill or downhill – hopeless for my back.

I'm scared shitless even of walking into these galleries, but since Trish and Gunther paid my fare I feel obliged to keep pushing. Back in Mylor my work is special. Here it's just more stuff to be evaluated for its quality and sales potential. I've seen marvellous work in these galleries that makes me want to run home and never paint again. And then sometimes I'll see utter crap that's got a whacking great price-tag on it and a sold sticker.

The art world is hard to understand. I don't think I belong in it. All I know is that I have to paint my pictures. Realistic work is not acceptable in this world, but I like it. This new stuff is only a play-around really, I suppose, and I have to keep growing to some extent.

King's Cross, however, is full of characters – and tourists looking at the characters. Probably dangerous for a bird to be wandering around on her own, but nobody takes much notice – too into their own games. I haven't got the money to go to clubs – I don't think I'd dare on my own anyway – so I stay in my room at night, read (there's not even a telly) and worry about going to the goddamn galleries.

I wish I hadn't come. I'm only a beginner, playing at being an artist. But I don't want to do anything else. Isn't it wonderful to get an exciting letter full of bright news from Sydney for a change? Shit.

Later – at home

What a fucking disaster *that* was! I feel like a real failure. No other galleries wanted my paintings. Hogarth, a really *big* gallery, was a bit interested. The owner, or director, knows my sister Annie's work and said he'd be interested in giving us a share-show. He liked the idea of two sisters exhibiting together.

Annie, as you probably know, is growing famous now, and she's become rather precious about where she shows her work. She refuses to exhibit in commercial galleries, preferring political-type venues. That's entirely her choice, and right, of course, but for a minute I hoped that she might break her rule. No go – and the Hogarth man won't give me a show on my own. I think Annie thinks my work is crap, anyway, and she's probably right. Annie might feel he's only proposing this so that he can get hold of her work, and she's probably right there too.

A couple of galleries told me to extend these ideas and keep working at it, but I can't afford the time and the canvasses. Have to paint my straight stuff which might sell, or financially life will be even more abysmal than it is. Fuck. Going to get drunk now. Thank God I can write to you.

February 1982

Oh Merilyn, my darling Kruger has died. My dear, trusting, reliable friend. I'm going to miss not only his physical presence, but also the protection and companionship that he's given me these last eleven or twelve years. He lived a long time for a Great Dane, but he had Babe for company since he was three or four. They loved each other like humans, always sleeping or lying together with their big paws resting on each other's body, or romping about like puppies, even recently as oldies.

Poor Babe has always had Kruger around. And she's growing old herself. She's mooching around looking for him. I won't be surprised if she dies of a broken heart. The fences have not been replaced yet, and they have had the run of the valley, although they preferred to be near us.

Tonight, just after dark, Kruger asked to go out for a leak. He was gone for an hour or two, which is most unlike him, but I was painting and didn't notice the time. When he eventually came back his tummy was swollen and he was slobbering at the mouth. I was cross with him because I'd thought that he must have killed a sheep and eaten too much of its meat. He managed to get up on his couch, but couldn't lie down, and was sitting there dry-retching. The penny eventually dropped that my poor dog was very ill. I rang the vet who, after hearing the symptoms, told me that it sounded like Krug's stomach had become knotted and to get him over there immediately. But I couldn't even get Krug down off the couch – he was so distressed that I didn't know what to do.

Paris was asleep and Adam was out. Paris is too small to lift Krug, and anyway I didn't want him to see the dog like this, so I rang Malcolm, a local guy I've been seeing. He was around within minutes and between us we managed to get Krug into his car. The vet is at Oakbank, about a fifteen-minute drive away. Poor Kruger was dry retching the whole way, and I was feeling wicked for having yelled at him. The vet said that he could do an operation *immediately* to untangle Krug's stomach; but that he couldn't guarantee the results (it's a massive operation), that the anaesthetic would probably kill Kruger anyway, given his age. So we decided to put him down.

He was lying on the floor of the vet's office. I cradled his head on my lap and talked to him while he had the injection. We stayed like that until he died, and even then I couldn't stop stroking his noble head. I didn't want to leave him, but eventually Malcolm made me get up and brought me home.

What a terrible way for it to happen. Poor old Krug in immense pain and his mum growling at him for being naughty. Danes are so sensitive, Merry. Not

bright, but very sensitive. I'd hardly ever had to growl at him and he was most upset when I did. They're superb beasts to have about the house.

Krug was such a gentleman. Grand Dane Von Kruger. Big, strong, proud and gentle. Babe's always been scatty. When she's really excited or I've been away somewhere, she often jumps up on me, sometimes even knocking me over. Kruger somehow or other always knew not to do this. He was always aware of his size.

Before I met Ken, and was still working at Burns for Blinds as an interior decorator, Krug would be at home on his own while Adam was at school and I was at work. He used to take the most recently worn piece of my clothing (stockings, underwear, a dress, anything that I'd left lying around) and lie on my bed with it in his mouth until I came home. But even as a puppy he never tore anything – not even nylons.

At the old place at MiMi Road, we had a fridge that Krug learnt to open by grabbing the handle in his big mouth. He would take a plate of butter or some meat – anything he fancied – and carry it on to the bed, where he'd lie in luxury on my black furry bedspread. He could take a plate of butter from the back of the fridge to the bedroom and leave no visible signs except an empty plate on the quilt.

Once I had to take him to the vet because he was losing weight. Ken was around by this time and we hadn't got Babe yet, and I think he was upset by the tension in the house (Danes are very susceptible to stress). The vet couldn't find anything wrong with him but he asked us to keep a diary of what he ate for the next week. Well, that week my dog ate (among other things) a large piece (six or seven pounds) of uncooked corned beef, a pound of butter and a loaf of fresh sliced bread. The vet looked at the list and laughed. At least Krug knows how to make a good sandwich, he said.

Krug hated water. If he needed a leak when it was raining, he'd keep his body and three legs inside, cock one leg and pee out the door on to the lawn. Never a drop inside.

He would have protected me from anything – except Ken. Krug and Babe both stayed well away when Ken was going off. It must have been hard for them, because they loved Ken too. When he was his good self, Ken was the one who ran with them, and tussled with them on the lawn. It was probably impossible for them to choose between us, so they slunk away and hid.

Paris will be distraught when I tell him in the morning. He's grown up with Krug. Many a night he's fallen asleep in front of the telly with his head on Kruger's big chest, one arm thrown over Krug's back, snuggling into the warmth of his coat. Just another part of Paris's life that's gone.

Now I'm remembering the time that Paris brought home a kitten to the studio at the lake. It was so tiny it fitted into my hand. Kruger was sitting there like a sphinx, so we put the kitten in the hollow between his paws, where it curled up against his warm limbs and went to sleep under his nose. Dear old Krug wouldn't move a muscle. He sat there like a marble guardian, eyes drooping down to this ball of fur, afraid to twitch in case he hurt it. Eventually we had to take the kitten away. Krug was getting uncomfortable, but wouldn't move while that little bundle was so close to his big paws,

Toddlers – sometimes three of them – would go to sleep against him at parties. He'd lie there motionless until they were picked up. What a dog.

I'm really pissed off that all my drawings of him were burnt in the fire. I'd done dozens of drawings of him and Babe, including some with Russell magpie, and was planning on putting them in a book for Dane lovers. They were bloody good drawings – line drawing's my best talent – and they captured the beautiful contours of their bodies. I would love to have them now.

March 1982

Merry, I won't write much. Very sore. Just wanted to tell you that I'm off to a pain clinic and am getting some help at last. It's at Flinders Medical Centre, where they have a comprehensive team of specialists. I went there first in November last year, but was so disappointed I nearly didn't go back. There were people in my group who had endured major back operations but can still play sport and function normally without pain. The lectures were all about how to sit, stand, lie, open windows, drive, do dishes – stuff that I've been doing for years. Then I saw the (yummy-looking) orthopaedic specialist, who said that he could try fusing my worst four vertebrae, but it might not help. Otherwise, he said, he was unable to help me.

I came home in tears, too sore to paint or cook. Then I got *angry*! God, with all the resources of modern science surely they must be able to do *something*! So I wrote him a letter and said all I wanted was one pain-free hour a day to work. I stuck some photos in with it to show that I was not just a weekend painter. It was a pretty strong letter – the whole clinic had a meeting about it. Anyway, they asked me back and promised to keep trying.

As far as my bones go, there's very little wrong with my back. My hips are crooked and one leg's longer than the other, but this is not unusual. Several disc spaces are narrowed, which can cause pain, but mostly it seems the problem is with muscle spasms and jammed nerves – and they are difficult to deal with.

We tried physio, traction and manipulation, all to no avail. They put me on

a TENS unit, which alters the pain messages to the brain. It's a neato battery-operated unit which I can hook on my belt and it transmits pulses into my nerves to scatter the pain messages. That worked – great – only problem was that I felt so good I cleaned the house, mowed the grass, weeded and swept – until I actually slipped a disc. That put me out of action for weeks, into hospital in fact.

Now they're trying hypnosis. It's their last resort, but I think it's going to work! I have this great guy looking after me, a psychologist called Russell Hawkins whose specialty is hypnosis. He's very understanding of my frustration. It seems that I'm very receptive to hypnosis – he tells me most creative people are. Already I can sometimes take the pain away completely for a short time. Wow, it's wonderful!

I'm seeing Russell every week, and honing my self-hypnosis skills so that eventually I won't need him. It's a fascinating business. I'd love to have the time and money to wander around in my head to see what's in there. One day. Will let you know how it goes. Love, love, love, Barb.

May 1982

Hiya kid, once again I'm on the beach at the Coorong, waiting for the sunset and thinking of you and your sadness.

We're at Policeman's Point again, staying in a cabin. This time it's Anna, Ingrid and me. Picked up a cray at Meningie on the way down and will have a feast when we get back from the beach – by which time, after experiencing the sunset, we're always in a state of shock.

It's this place. Its agelessness and spirituality make you wonder about life, death and the universe – about what's outside *our* universe and all the gods that ever existed. You sense how small and insignificant you are, and simultaneously how unique. It's a mind-bender.

I've done heaps of work here, but it's hard going because of the wind and the searing heat. The oils become textured with sand, while acrylics are hopeless because they dry up before you can get them on to the board. Watercolour has proved the best medium, but even then the wind gets under the paper, unless it's stretched, and whips a corner up just when you're doing a delicate bit. I don't have the strength to stretch many papers; it means bending over the bath, where I soak the paper.

The other problem down here (it makes us laugh, except we're pissed off too) is that the wind picks up pencils and brushes out of our boxes and hurls them along the beach. You have to stop what you're doing and rush off to grab them, or else take the risk of losing a good sable or a favourite pencil forever.

When you get back, your chair, folders, jars and so on are tipped over and covered with sand.

We are all trying to avoid windburn. Anna, who burns so easily, is a scream. She's covered from head to toe in bits of clothing tied around each other to keep them from blowing everywhere. She wears a scarf over her nose and mouth, and an old straw hat with a scarf tied around it under her chin. The result is a bundle of billowing cloth with two little eyes peeping out under a spoon-shaped brim.

Thanks to the wind we couldn't get the tent up today, so we've had no shade at all. It's hard work, painting outside, and I wonder sometimes if I'll be able to do it for much longer. Much easier to work from sketches and photographs at home, when I can choose the moment.

I could sure do with a decent camera. I've got a borrowed one at the moment, but it isn't good enough, and anyway I'm scared to use it in case I get sand in it.

Money would be nice. I'm sitting on a borrowed chair, using the cheapest paper I can find, still wearing bushfire-relief clothes. It will be years before I can afford to buy clothes. Any money I do get goes on shoes for Paris. He's growing so quickly! It's the worry of my life at the moment: shoes for Paris. I shouldn't grizzle because he's great about wearing fire-relief clothes, and Adam's cast-offs, but jeans for him are a problem, too. Poor bugger is having a hard time, but trying valiantly to make out everything's okay.

Anyway, ducks, I didn't start out to whinge. I just wanted to send you a thought from this beautiful beach on this fabulous weekend.

Studio Z at Burnside has started showing some of my stuff now, and will probably take these Coorong paintings (I hope). The gallery is owned by an older couple, George and Zita Pollock, and they're wonderful – not the usual pompous asses who run galleries. They're going to give me a wall for the sunflower series that I've been working on, even though they don't expect that the paintings will be suitable for their clients. I think that's pretty special. Cross your fingers for me.

I can't believe that there's a chance I'll see you in June on your way to Melbourne. You know you're more than welcome to bunk down in Mabel – but it's pretty rough and remember that I'm still smoking. Anyway, let me know.

Gotta go. The sun is beginning to drop, and I don't want to miss a minute.

July 1982

Hiya, hiya, hiya! It was *so* good to see you again. I love it how nothing changes between us. We can not see each other for years – and our friendship is still there

in all its glory. This, my dear, is why I treasure our relationship so much. I won't worry now about being so far apart.

You still look very glam, ma'am! No wonder you have lovers sticking to you like bees on honey. You know all this, Barb.

August 1982

Well, my dear. Thank you very much. He is a nice bloke, and we've been seeing a lot of each other – but really! Picking up a stranger on a plane for yourself is risque enough, but scoring a fella for someone else is really cheeky.

At least I was prepared for his call after you rang. He came up to meet me a week or so later, on his next trip to Adelaide. We went out for dinner, and had a good chat and I decided I liked him. He – his name's Keith in case you didn't get that far – has to entertain heaps while he is over here. He needs a companion for restaurant dinner parties two or three times a week – which I don't mind at all. We've been to some ritzy places.

You'll be pleased to know – anxious to know, I bet – that our friendship has blossomed into an affair. We're pretty evenly matched in the sack given that there's no love or passion involved on either side. Better still, because he's flying to and from Melbourne all the time, I have plenty of time for myself and my work – and a respite for my back between visits.

This relationship will go nowhere Merry, but we get on so well that perhaps we'll always be friends. Right now, still recovering from marriage to Ken, and worries about Paris and money, I'm only looking for companionship. Keith fits the bill nicely. I'm going to Melbourne in a couple of weeks and will stay at his flat. He wants to introduce me to his friends at the yacht club, which will be a giggle – not quite my scene, but good for a change. So thanks, my girl, for this 'referral' – though I hope it's a one-off.

Adam is moving to Sydney to live. I'm going to drive as far as Melbourne with him and his mate – they're staying overnight at Keith's, too – before they head off to the big smoke and, they hope, fame and fortune in the music business.

I heard them play at a pub recently and was impressed, although they made a few mistakes and laughed a lot. I am envious of the instant feedback musicians have from their audience – musicians always know. Bad or good, they know.

So anyway, Adam is leaving Mylor far behind. He's only 19, but very mature, and will be okay wherever he ventures. My health and Paris's mood swings are not what he needs on top of bushfire and bad memories. A new start for him – but a shocking loss for me. Adam has always been my support and company, although that's not his job as a son and child. I want what's best for him, but can't help wishing he'd stay home forever.

The whole band is going over. Three of them will share a house. They write their own material, which is a bit different to the popular stuff. I don't know how they'll go, but they're all accomplished musicians so they must have a chance. It's a tough business, probably even harder than painting, but if you don't buy the ticket you can't win the prize.

Ad's been at the zoo for three years and has an amazing rapport with animals. He's been working with birds and reptiles mainly, but his magic seems to encompass *all* animals. He asked for my opinion about giving up this job, and I had to tell him to take the chance. As a mother I want security and job satisfaction for him, a regular income and the chance to save and buy some land. But as an artist and an individual I want him to have wider horizons. People are fighting to get jobs at the zoo, and he's walking out on his. It's a hard one. But Adelaide is such a small city for a lad with diverse talents.

I had the same dilemma when he wanted to leave school to take the job at the zoo – it was offered to him on a plate after he'd done a couple of weeks work experience. On the one hand I wanted him to finish his education, although he wasn't happy at school, but on the other, here was a one in a million opportunity to work with the birds he loved so much. I will miss his strength and humour. I will miss *him*!

Often, I think it's sad for you that you have no children, Merry. At times like this, perhaps you're the lucky one.

January 1983

Hiya kid, another year gone. Another year older. Time goes so quickly – and then, with life as hard as it is, it *drags*.

No, I'm not seeing Keith anymore. Don't know if I ever will again. He lost his job and probably will have to look overseas for another. Something to do with being too high up in the company with nowhere to go. He rang from Melbourne to tell me, sounding despondent. Said he'd keep in touch but it all depends on the new job.

He had everything he could want. Great salary, job satisfaction, a super sports car, great bachelor pad in the city, a yacht and large circle of friends. Plenty of dough. It all disappeared overnight. Bizarre.

He loved a watercolour that I did of myself (photo enclosed) and wanted to buy it. I didn't want to take money from him, so we agreed on a case of champagne. Unfortunately I hadn't got it before disaster hit. He promised on the phone that he'd send the booze as soon as he could, but so far I'm champagne-less. Pity about that – this cask wine that I'm drinking is foul. I told him he could send the painting back, but he said he couldn't part with it.

Paintings are like that. They get to be part of people's lives. I've come across a few of mine lately in friends' homes that are rat-shit. Stuff I did twenty years ago. Horrible, embarrassing rubbish. I've offered to swap them for new paintings, but no one will part with them. How on earth could I have charged money for them? What a cheeky girl I was.

Open house on Christmas Eve as usual. That's really *my* Christmas – when I enjoy myself with friends. Anna and Pam for champagne and strawberry breakfast on Chrissy Day, then lunch at Tessa's with the family. Glad it's over though – always costs me money I haven't got and I spend the next six months trying to catch up. Hope you had a good one!

Back's sore, must stop. Will write you a decent letter later, love, as always, Barb.

Ash Wednesday Two – 16 February 1983

Dear Merry, thanks for your phone call. Sorry I was abrupt, but the house was full of people and there was chaos outside. Boy, was I stressed. At least you knew we were all right. Are we?

I don't know if I'm coming or going. I actually feel guilty that the house

didn't burn down this time. So many people killed. So much destruction. And I'm sitting here in my house, calmly writing a letter.

The telly's on. Every half hour there's a fire bulletin. I can't switch it off. I suppose it's the same over in Western Australia. I gather at this stage that Victoria was the worst hit, but even here there are over fifty dead and there'll be more yet. It's too big to accept, even though this is how I thought the first Ash Wednesday would end up, before that fluke wind-change sent the fire back on itself. It's like a bloody live monster that can't get enough to eat.

All those homeless people with nowhere to sleep tonight, some with no family left. How come our lives were spared again? Why do I feel so damn guilty? After the first fire the counsellors said that the people who didn't get burnt needed help as well. I didn't understand them then. I do now.

God we were lucky, Merilyn. I was painting at Ingrid's when, at about 1 pm (same as last time), someone rang to say the Mylor siren was on. I called head-quarters and learnt that the fire was at River Road, where Pam lives. I rang her straight away. After a long wait she picked up, breathless and terrified. It's here, she said. In the paddock next door.

I told her I'd be right over. She's on her own, 60 years old and not terribly well. Last fire she refused to leave her house. I wanted to be sure that she got out this time.

I asked Ingrid's husband, Peter, to follow me. Halfway along River Road I spied the smoke. As I rounded the corner before Pam's valley I saw tall flames at the back of her house. There were fire trucks along the road, filling up their tanks at the dams, but they let me through when they knew I was going to get Pam out. *Then* I wondered what I was doing there – when I could *see* the fire. And I was driving towards it! But I kept going anyway.

Pam's house was still okay, but the flames were lapping her fence at the side and back. The wind, fortunately, was blowing the fire away from the building. She was standing in the yard holding the melted hose in her hand. She was dazed – shocked – but adamant that she would stay. A gust or wind-change and the whole place would be gone. Peter arrived and between us we managed to convince Pam to leave – I don't think she'll ever forgive me – and she followed us back to Mabel in her own car.

By now we could hear sirens everywhere. The main road had fire trucks tearing in both directions. Peter rang Ingrid from here. She said she could see smoke not far from their place – which is in the opposite direction from Pam's – so he hurried home. I shot down to the school to get Paris, telling him to put a

few things – anything – in the car. That kept him busy while Pam and I worked out what to do.

You have to laugh, Merry. She was *livid* that I'd made her leave, but decided in the end to go to her daughter's place at Uraidla, 20 kilometres across the Hills. I couldn't talk her out of it. There were fires on all roads out of Mylor, according to the fire station, but still nothing in sight of our house. Plenty of smoke, but no flames. Then, just after Pam left, it came over the back hill. Same direction as before.

That's when I panicked. I got Babe and Paris into the car and left. I was sure the house was going to go. But where to go now? I made a snap decision to head to Ingrid's up Leslie Creek Road, which runs from Mylor to Longwood. This meant driving directly into the wind. Not far out of Mylor we hit the fire. We had no choice but to wind the windows up and drive through it. The fire here was not really big – not like I know big – but if I'd turned around we might have got stuck. We made it through safely and headed towards town down Upper Sturt Road. That was also a big risk. Upper Sturt Road is one of the worst fire risks in the Hills, but for now it was still clear. We were, in fact, the last car they let through. Then they closed the road.

When we reached Mum's I fell in a heap in her arms. We watered Babe and kept Paris busy as best we could, keeping an eye on the television coverage, which by now was on every channel. It seemed like the whole of Australia was on fire. I couldn't get through on the phone to anybody up here, but several people, including Adam in Sydney, rang Mum's. Nobody had much real news, just rumours. Everyone was shocked by the extent of the fires.

We stayed at Mum's for tea – Tess and Kev were very supportive – then I was able to get through to the Kilsbys, who said that although the block had been burnt our house was still standing. I had to see for myself. I wanted to leave Paris with Mum, but not only did he refuse to stay, *she* wanted to come as well. So the three of us jammed in the Charger, along with Babe and the stuff that Paris had packed.

Anna and Kate had come down to Mum's looking for us – I don't even know where from – and they followed us home as well. It was amazing driving through a night that was lit up by burning trees and buildings. Yes, the house was here – and even the electricity was working. The rest of the block was burning, as was the land everywhere as far as the eye could see. The raging wind was changing direction all the time, and showers of orange sparks would flash into the night like fireworks as trees gave up the battle and fell with a crash. I was terrified that dead trees still here from the first fire would drop on the house, delivering a deadly load of flames.

Mabel was full of smoke, and the air outside was worse. Our eyes were so sore that we needed to shut them. Anna and Kate volunteered to stay the night and we rostered ourselves on an hour's lookout each so that we could each at least try to get some sleep.

Dear Paris (he's eleven now) soon collapsed exhausted. I think he has found it all an adventure – he has no idea how closely we courted danger in the car. Mum is worn out too, and now Anna and Kate have given in to the smoke. I am far too edgy to sleep, too worried about the trees.

I've spent most of the night outside, watching the burning valley. It is beautiful, Merry! Imagine a pitch black night – charcoal grey, actually, because of all the thick smoke. Everywhere trees are burning or smouldering, their flames dancing in the night. Suddenly a branch or whole tree drops, and sparks shower in the sky.

The fire trucks are prowling through the area, their weary firefighters pouring water on the burning stumps. They have been pulling into the block to say how marvellous it is to see little Mabel's lights shining amid the destruction. I have jugs of iced lemon prepared for them, and they are grateful to ease their sore throats before continuing on. They told me horrific stories of bravery, fear and death. I learnt that Mabel would have burned except that she'd been specially watched by the crews, one of which parked right next to her and sprayed her with water when the fire front went through. My thanks were unnecessary, the firefighters said, all the crews in the area are getting such a buzz from seeing her lights gleaming. It's keeping them going. The poor guys have been at it all day and are still out tonight, watching for flare-ups and dousing the last of the big trees that refuse to stop burning.

Well, Anna's awake now, so I'll stop writing and rest my eyes.

Next day

This morning by daylight we could see how close the fire came. It's truly a miracle that this frail box of a home is still here. Flames burnt the ground right up to the walls. Babe's shed is standing, but has been on fire at some stage. Everything is back to basic black. All my cherished baby trees, lovingly bucket-watered for three years, have disappeared. There is only one, out of about four hundred, that may survive with care. The few big gums that survived the first fire, and had blossomed with regrowth, are finished now, and all of the dead trees in the reserve around the block, which were dry and good fodder for a new fire, are charcoal skeletons.

I took Mum home this morning after she'd had a look around. I think she was in shock. Certainly she'd been affected by the smoke. My own eyes and

throat are terribly sore, and I hope the rain that is forecast comes soon. That should put out the last of the fires and settle the bloody smoke.

Pam's house survived, but with part of the roof burnt and her fences gone. She's still cross with me for making her leave, but a second fire nearly reached the house from another direction, so I'm very glad I did. It can be a matter of seconds between life and death, and I care for her too much to let her take that risk.

Ingrid's house was not damaged, nor Anna's, although the big pines in the next property went up. The Kilsbys' are fine, too, although their eldest son had a close call. His school bus from the city had detoured up Greenhill Road because the freeway was ablaze, and along with other vehicles it got caught in a fire-storm. Greenhill Road curls around the side of a big hill, up which the fire was accelerating at enormous speed. The kids had to get out quickly and lie flat on the road while the flames roared over them and up the hill, where it wiped out a whole suburb and took several lives. The driver of the car two vehicles back was burned to death, but the kids all got through safely. A terrifying experience for the Kilsby boy. He'll never forget it.

With these fires it seems survival is all a matter of luck. The fire that started near Pam's went on to burn down several houses nearby, then took off to Mt Barker where it burnt several more. I've heard some horrifying stories. I have to block them out of my head. Knowing the heat, the noise and the pure chance of it all makes them too real for me.

I think the reason that Mabel survived was that our particular fire – this was many fires, not just one big one – started only a couple of hills away and had not yet taken any houses. Last Ash Wednesday the fire had eaten up 40 or so houses before it got here. Fire seems to feed on houses and gain strength with each one.

My heart is broken about the land. I don't know if I can face replanting again. And the soil will be worse than before. People who don't know think that native scrub regenerates quickly after a fire, but in the last three years not *one* new piece of native scrub has surfaced in surrounding acres. Now it will be years and years longer before we have any beauty or privacy around us. Can I handle it?

I guess I'll have to. One of the main reasons why I came back to this block, was that Paris needed to stay at his own school with his own friends. That was all he had at the time that *belonged* in his life. This situation is not much different. And he's still not recovered from the trauma of that fire.

And besides, this box of a house has been so filled with love by our friends and neighbours that it has become a sort of shrine. How could I leave it now?

March 1983

Well hiya kiddo, at last I've got some free time to write. My life is bedlam. Exhibition of nudes next week. University. Life Drawing. Drawing with Ingrid. Work for Melbourne. Work for three other exhibitions. Dealing with the aftermath of the fire. Feeling edgy that Ken – he's in a hostel now – might find his way up here. All this while not feeling too brilliant physically.

Well, the good news first. Big exhibition at Barry Newton Gallery, in Unley, just out of the city, with Anna and Marg, the pick of our work from two years of weekly life drawing. All nudes, and pretty confronting. We're calling it 'Naked

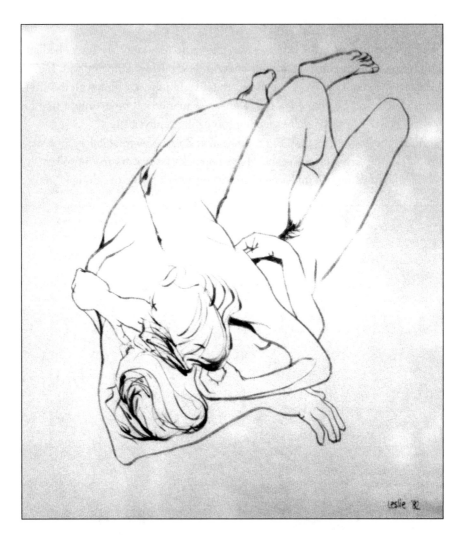

not Nude'. We were lucky to find a gallery that would hang it because Adelaide's funny about nudes. Barry Newton has been great, though, and as well as taking the risk of putting on the show he's organised all sorts of coverage for us. Anna and Marg are shy about too much exposure, which is driving me bananas, but we'll get an article in the *Advertiser* at least and an interview on university radio. (I had an interview teed up with another radio station the day after the fire, but wasn't up to it, so we lost that chance.)

We'll have 55 pieces all up, 26 mine, in a variety of media. There are plenty of male nudes too. It's an exciting show. We've had a smorgasbord of models on Tuesday nights since the week that I moved into Mabel. It's cramped for space

but we tried going to Marg's and Anna's, and it seems to work best here. We've had great fun and made some good drawings and paintings. Just hope I sell a few. At least enough to pay for the frames. But you never know with nudes – they don't sell well.

Uni is two lectures and a tutorial every week, which tends to gobble up time and petrol travelling down to Flinders. I'm only doing English II, and I don't even know exactly why I'm doing that. Thought I needed a challenge or some bullshit. I'm finding it difficult handling all the phoney discussions about why so and so wrote this and why so and so wrote that. The whole course seems to be based on supposition and personal analysis and I don't know how I feel about pulling someone's work to bits with perhaps entirely the wrong conclusions.

I know that if a bunch of students tried to pull some of my painting to pieces and find reasons for colours and style, their conclusions would be invariably wrong, so treating a poem in this way sits awkwardly with me. But that's the course, so what can you do?

Ad came home for a couple of weeks – I think he wanted to check for himself that we actually are okay. It was grand – he is so reassuring to have about the house. He and a mate drove up to some country town where Lester is running a pub – didn't want to let him know he was coming. After sitting and watching Les for a while, he introduced himself. I'm Adam. Adam who? Your Adam. Your son. Oh! He and his mate stayed overnight at the pub. Lester, of course, got totally pissed and blew it. Poor Ad, I think deep inside he was hoping for more.

God, Les is a wanker. This is the first time he's seen Adam since he was a toddler, and what's more Ad had driven all that way to see him. You'd think he'd have enough sense to go easy on the grog for just this one night. As you know, I left him partly because of his drinking, and obviously he hasn't changed – although he's still with Gwen, and that's lasted for some time. Ad likes her.

There's not much of a bond between Adam and Paris at the moment, unfortunately. Paris, at 11, is stroppy and moody, and Ad, at 19, has little in common with him. But they did go down together to see Ken at the hostel. Another gruesome visit, and unbelievably sad for them both.

They eventually had to let Ken out of Glenside. They're really pushed for room there and, as the doctors say, he's improved enough to be able to cope in a hostel. They're reasonably sure that he's not dangerous – though his own psychiatrist said that if I had any sense I'd leave the state just in case. How reassuring!

So the poor bugger's living in a ghastly dump for psych patients with nowhere else to go, under the supervision of the Guardianship Board. I haven't

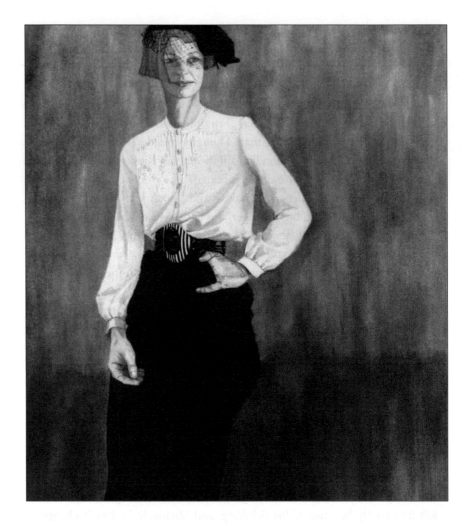

seen it, of course, as I have to keep away from him, but Ad and Paris said it was worse than anybody could imagine.

Selfishly, I can't help worrying for our safety. A doctor says he's incapable of finding his way up here – that his mind co-ordination couldn't manage it – but I'm not sure. He seems to be improving all the time, and I still think he's been playing games with the doctors and is capable of far more than he seems to be. He wrote me a letter from the hospital (it's too pitiful and heart-wrenching to describe) and sent it home with the boys. This was when the doctors told me he couldn't even sign his own name. Mind you, the writing and spelling were terrible.

When I'm standing at the front door at night – you can see for miles since the fires – I think to myself that he could be out there somewhere, watching. I've

got this inexplicable fear that he'll set a fire under the doors of the house and we won't be able to get out. Irrational, I know, but the fear is real.

Gee Merry, these lads of mine haven't had much joy from the men they've known. No good role models at all. I wish my dad was still alive – at least they'd have a decent grandfather. There's been no one. I wonder how it will all affect their lives.

I've enclosed a couple of snaps of the drawings for the exhibition, and I'll let you know how it all goes. Our nudes are not beautiful ones, and it will be a shock for little old Adelaide. Exciting times.

April 1983

Hiya kiddo – the exhibition most successful! Big crowd – sold about half, which was a surprise – and good media coverage. Looked marvellous set up in the gallery: Marg's big oils, Anna's coloured pencils and my own smaller mixed media. Very pleased. Now I'm organising a smaller single exhibition at a little gallery at Brighton. All nudes again. Great!

Had a lovely dinner with Erica Jolly. Did you ever meet her? Brilliant lady and dear friend. Good food, wine, conversation. God, I'm grateful for my friends.

Still struggling along at uni – I hate the pretentiousness of the mature age students and the stupidity of the young ones. Don't know how long I'll last, but am getting good grades so far – still very early in the year.

Your new job sounds great and I envy your energy for social life – how the fuck do you do it? Keep it up and enjoy.

June 1983

My dear friend, thank you for the fabulous drop earrings that appeared out of the blue. What a surprise! I never know what to say to you when you're as low as this – words sound so trite when they're written and the phone's hopeless. Wish I could hug you. Send you a big one anyway. I worry, of course, that you're going to try to top yourself again, but hesitate to bring the subject up in case I'm putting ideas in your head. As if you need them!

Thanks to my own breakdown I have *some* idea how bad it gets for you. I don't think I will ever forget the desperation I felt, the sense of sheer hope-lessness. So I'm not talking out of my arse when I try to be positive. Twelve or so years later, I'm grateful that I made it through and have found so much to make life worthwhile. Fuck, Paris wouldn't be alive if I'd given in. Think of *that*!

You see, hon, I remember you dancing on your tippy-toes in those amazing spike-heeled shoes. Such grace and beauty. Such rhythm and movement. Your

long, red hair piled above your creamy, piquant face. A thing of beauty. And I remember sitting by the lake with you watching the reflections, listening to the birds. I remember your love of music and your compassion for people.

You cared for me when I was off my face with my depression. How many times did I ring you in the early hours, unable to cope with one more hour of mental torture? You would jump in your car in your nightie and tear up to listen to me rabbit on until eventually I passed out. You really helped me through those ghastly years.

And Ken, you kept me going on lots of occasions. And when I found out I was pregnant with Paris.

Well, you helped me stagger my way through *my* problems and I don't know how to help you with yours. I love you, Merry. I love your zest for sex and your appreciation of people and nature. I love your intelligence and your courage. Please find some of that courage now and hang on. You are precious and an integral part of this big stupid world. A lot of people care for you. Remember that.

Life dags along over here, pretty much the same as usual. Pain clinic nearly every week for hypnotherapy now, but not getting very good results since the second fire for some bizarre reason. My back is giving me hell, which makes doing watercolours difficult since I have to lean over to work.

Just finished a few pieces for a small gallery at Morphett Vale called the Limeburners, and even sold a couple. Starting work for a big solo show at Miller Anderson's department store. I want about 40 for this show, all watercolours, but might have bitten off more than I can chew. This goddamn back – groan, grizzle, grumble.

Ken's daughter Patricia was up to stay for a few days last week. It was wonderful to see her after all this time, but we have little to talk about except Ken and the lake, and I don't really want to dwell on that past shit. She's only 14, still really a baby. I want to offer support and keep our relationship going, but it's difficult. These three years of early teens with just her mother's influence have not helped her grow, and all she can think about for the future is having a baby – which is a worry. She is going out with a man of twenty-four!

June also came to visit – she's 15 – on the back of a big motorbike (but who am I to talk?). She seems more together than her sister but keeps her pain to herself. I had a talk to her about visiting Ken again, but don't know what will come of it. It's been a long time since they've seen him.

I'm still painting every Wednesday with Ingrid, but have stopped life-drawing for a while since the nude exhibition. Probably get back to it later. There's just not time, and lousy health doesn't help.

Mabel still feels pretty barren. I don't spend much time outside because it's too disheartening, but tiny trees are going in again and at least they're getting watered by the winter rains. Hope the frost doesn't knock them off. Hang in there, Merry.

July 1983

Well, well, Ms House-owner/occupier, congratulations on joining the ranks of the rate-payers, worriers and maintainers of plumbing, gardens and hot water services. At last you have your own castle, a place to hide and be your true self. *Withywindle*. Good name. It sounds wonderful, and I'm thrilled for you. Don't worry too much about the goddamn mortgage – you paid your rent on time all these years, didn't you? One day the mortgage will be paid and no one will be able to take your home away.

I wish I could come over. I get so pissed off that I can't afford it. The photos are great, but they only show so much. I want to feel the soul of the house, watch your exquisite feeling for decor work its magic. Couldn't you have moved to a closer city?

I'm painting like a demon whenever the back will let me, and selling well, but frames cost the earth and galleries take a third in commission – there's not much left to fill the gap between the pension and all the bills.

One reason why I'm painting so much is that I still can't bear to go outside and see the skeletal landscape – it's easier to hide away in here and make pretty pictures.

Helen is once again helping with the re-planting. Her husband fixed the wheelbarrow – do you remember me telling you about that? She even brings her own water because she knows how short we are. A rare woman indeed.

Many people want to help for a few weeks after a fire, but soon forget as their own lives take priority again. And rightly so. But it seems that Helen has a mission to replant this block no matter how many fires sweep through it. One day, long into the future, I'll invite her back to see the shade and dig the worms that her trees will be able to offer the land.

You didn't say if you have trees on your block. I hope you have – to me they're the life-blood of the earth. Even on the smallest city block a tree or six does wonders.

Merry, I'm so pleased for you. Perhaps *Withywindle* will give you the stability that you've always wanted. Your life will swell and grow.

September 1983

Hi kid, I'm writing from Mannum on the River Murray. I'm here on a house-boat with Gay, Trish, Ingrid and Barb Groom. We're painting of course. Well, Barb doesn't paint, but she wanted to come, so we dobbed in for her share of the cost, and she's doing the cooking in return. Great deal. All we have to do is paint and drink. Disgustingly wonderful!

None of us can drive a houseboat, so we got the guy we rented it from to bring us down here (his wife picked him up in their car). He organised the spot for us, on the private property of a friend, and it's perfect. We're moored on a spit of land with the houseboat on the river proper, and a big lagoon on the other side. Heaps of bird-life, light and privacy. We're tied up beside a river gum. Sometime way back Aborigines cut a canoe from the bark on one side. This massive tree is home to a variety of birds, including the eagles that have built a big nest right at the top. It's heaven!

We're here for five days, three gone already, and doing heaps of work. Up early, scoff breakfast and at work by about ten. Start on the beer before lunch and then wine in the afternoon and with tea. We each brought a bottle of different liqueur and we knock a bottle off between us after tea, telling filthy stories and admiring our day's work.

You can't beat the company of a good group of women. As we've discussed many times, women en masse are a pretty shit-awful bunch. Selfish, bitchy, vindictive, obsessed with their appearance and, worst of all, liars. But when you get a good bunch like this together, all sharing the beauty and the joy of painting, wearing daggy old clothes and worrying only about the quality of their work, it's a privilege to be female. Barby Groom spends her time bushwalking or reading poetry, and so far there hasn't been one bad vibe among us.

I wonder if you can find something comparable over there. I suspect not. It's pretty rare. And so much of your own life is spent proving that you *can* be attractive. If only you could see yourself through my eyes, Merry, for I think you're one of the most stunning women I've ever met. To be told as a child that you're ugly is a cruel blow to a woman, or a man for that matter, and I can understand your obsession for undoing that statement.

I wish you could catch a glimpse now and then of the simplicity of life. If my photos come back quickly enough, I'll send one or two of the painting shots with this letter so you can see what I've been bullshitting on about. I want you to have a piece of this peace. Till later, Barb.

October 1983

Merilyn, I'm just back from a quick trip – two days and one night – to the Coorong again. We found a more comfortable place to stay. It's not right on the beach, but only five minutes drive from Policeman's Point and a quarter of an hour from the sand-dunes. This joint is more like a motel unit and has a double bed, which I really need after a day working on the beach. There's a separate bedroom with four bunks, and Ingrid's happy to have a bunk so that I can have the comfort of the big bed to stretch out on.

I've got so much work to do at the moment, and need these short trips to gather inspiration and reference material. I usually get one or two semi-finished pieces done, but mostly I bring back sketches and photographs that I can work with in the comfort of Mabel.

Gone are the days when I could lug piles of stuff to the top of the sandhills, stay there all day and finish an oil. The last time I did that was just before the first fire, and I painted two superb pieces that trip – delicate pink rippled sand and stark dark green bushes with long shadows. Both of these had just come back from the framers and were on the walls when the house went. One of them, particularly, was a beauty, and I'm really miffed that it got burnt before anyone even saw it. I'd used up so much energy getting the tent, esky, paint boxes and boards

up that bloody steep hill, and spent the day fighting off sandflies as I sat uncomfortably in the sand. I had to choose one vision to paint out of the myriad of choices up there, and then capture it. For once, I was really pleased with the result. Got it back safely, which is difficult with a wet oil, paid money to get it framed, and then, at the whim of nature, it's destroyed and gone forever. But it lives on in my mind. I can see it there. So does it still exist? Even if nobody but Ingrid, the framer and my family saw it, is it still a positive force? Or just a fleeting energy, like a soft cloud blown into nothingness before a fierce storm?

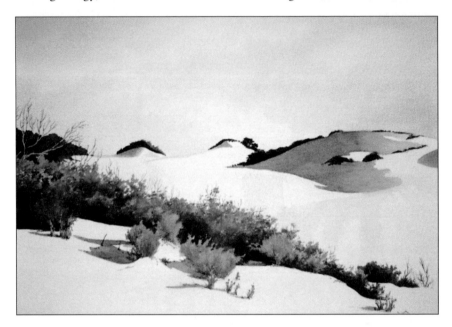

Anyway, I can't get up those sandhills anymore. I can make it part way up, sometimes, with a walking stick and a camera, but that's it. And I love those sandhills with a passion – especially just before sunset – the long shadows sweeping up and down the gentle hills and valleys of ever-shifting sand. I reckon I could spend a lifetime painting those bloody sandhills if I could only get into them. Still, the beaches are stunning too – and flat! Everywhere down there is beautiful. I'd love for you to see it all, but you'd hate the smell, the heat and the wind, so I'll send photos of a few watercolours instead.

Back here on the block the scene is fucking depressing. Even though I'm replanting again, with a lot of help, I wonder if it's worth the bother. Another goddamn fire will probably come along and burn it all down again. Every time I go out the door I get hit by this vision of desolation and destruction. The

reserve out the front of the block is a forest of black, dead trees. I can't bear it. I stay inside – I have to lie down every hour or so anyway. I don't know what the fuck's wrong with me but I'm falling to pieces. The doctor says it's stress from the fires, but I don't know if I believe him. I've been in stressful situations before, as you know, and they've never hit me as hard as this.

I miss my Kruger. Babe's still around, but she's very old now, and I think I'll have to put her down soon.

Glad to hear your social life is booming – but when do you get quiet time for

yourself? Maybe you don't want that, but since I've been on my own, I get pissed off even when I make an occasional date. I'm captive to my painting and solitude. I have two regulars now, but am trying to keep them at arm's length. The company and sex are good now and then, but I don't want anybody messing up my space.

Once again we get back to it, you and me. I have my painting and the boys, and you have yet to find your anchor. How I wish you could.

November 1983

Oh, my darling friend. Probably nothing I can say will help. You must be so pissed off that you failed yet again. I can't imagine what you must go through leading up to such an act – and then to realise that you're still alive, and have to cope with

that knowledge! The thought of you lying there, alone, for two days before being found, is so horrific that I have to shut it away. You poor sweet. I know the last thing you want is pity, and it's not pity that I send, but deep compassion.

It's impossible for me to understand your drive to die. No matter how rough life gets for me I know I'll struggle on. That's not meant as any sort of righteous judgement, by the way, and I guess you understand that. It's just the way I'm made. Something in my spirit keeps finding diamonds among the shit. Often this pisses the boys off, and to tell you the truth, pisses *me* off too. *Whatever* it is that keeps me going, I wish you had it too.

I'm crying while I write. I don't know what to say to you.

Later

Just been for a drive to the shop at Aldgate. Sun going down after an absolutely beautiful day. Mid 20s and still. Occasionally – I don't know why it happens, whether it's cloud formation or the clarity of the air – but heaven sends us a few minutes of pure golden light that turns the treetops orange and the gum trunks a delicate apricot.

I could hardly drive because of the tight pain around my heart. Eighty per cent of the landscape dull in the twilight, the rest glowing in long strips of neon orange. Beautiful is an adjective that doesn't come near the brilliant glow that will blow my mind apart one day. 'Mylor Artist Found Dead Of Too Much Beauty'.

Merilyn, this experience of the gems of the universe, given to us free, often makes me physically ill. I have to drink wine immediately to settle my soul. Did I ever tell you about the river red gums at Silver Lake in the moonlight? The turquoises and silver greens that glowed in the night like veins of gold? I had to go inside and watch television.

How can you do it kid? What if you miss seeing this light tomorrow? Or a sunset. Or a leaf in the breeze. Or a mother bird feeding its baby. Oh, I know you live in the city and suburbs, whereas I'm surrounded by nature's perpetual display, but beauty can be found anywhere – a mother breast-feeding, an old couple walking hand-in-hand, children playing. When you are – when anyone is – suffering depression you tend to look inward and miss ordinary life's charms, but you and I both know that depression passes and there *will* be a fresh shaft of light in the future.

This is your third attempt, my darling, and I know how determined you've been to get off this planet. Shit, Merry, I just can't understand. Please don't take these words as criticism of any sort. Your choice is yours, as mine is mine. If only

we could share our extremes, my highs and your lows, perhaps we could both become 'normal'. But in the long run, would either of us want that?

Mind you, I know that in my case the boys keep me grounded (well, sort of). Without them I might have gone off the rails altogether. My love for them is so strong that I'll fight like a lunatic for my next breath. I need to be here for them, at least until Paris is old enough to take care of himself. Ad should be all right now, although he'd miss me, but there's nobody who knows Paris' problems like I do. I *have* to stay alive until he's eighteen, at least.

Since both the boys' bloody fathers haven't had the balls to handle responsibility, they'd be pretty lost without me. I have children. How can I possibly understand how alone you must feel? I do remember the unrelenting blackness that plagued me during my breakdown – mostly the absence of *hope* of any sort – so I can vaguely relate to the hell you're living in. At my lowest, I even thought that the boys would be better off without me – that *anybody* could raise them better than I could. So please forgive me for finding joy in tonight's landscape, my friend – I can be insensitive at times! I feel so deeply for you that I want to give you something to hang on to – and of course I can't.

Fuck, Merry, sorry to preach. It's the goddamn teacher in me. I send you a soft kiss on the forehead.

December 1983

Dear Merilyn, I'm so glad to hear you're taking time off. You've always been such a perfectionist in your work; now it's time to keep something back for yourself. Your body must be in shock. You need tender loving care. You need to heal.

I wonder if any of your bosses have ever really appreciated your devotion. If I was a big boss I'd want you for my private secretary. I bet you were bloody hard to replace.

This will be short, because I'm not well and can't sit for long. Goddamn back, I'm sick to death of it. Anyway, hon, enjoy yourself for a change. Play with the dog. Read. Listen to music.

What will you do for Christmas? I'll have family for dinner and tea, and we still have open house on Christmas Eve. Both of the boys have friends over – it's always a good night. I like to catch up with folk who I haven't seen all year, and then, as usual, Anna and Pam will come over Christmas morning for champagne and strawberries. Probably Ingrid and Peter too, so we'll start the day well.

Adam's band is going well. You'd be knocked out to see him play. It's as if he and his bass are joined at the hip. Paris is still fragile – nightmares and sleepwalking – but he's beginning to settle down. They both go to see Ken at the

hostel whenever Ad's over. It's painful for them, especially around this time of the year. They're both upset when they get home and I think they're very strong to keep going. The girls never go anymore, and Ad and Paris are his only visitors. It's really sad.

Anyway kiddo, have a pleasant Christmas. You are needed in this world. Love and best wishes always, Barb.

February 1984

Merry, this will take a while because I'm too tired to write much at a stretch. I've put Streisand on for inspiration. Sorry, but I'm going to use this letter as therapy.

I'm absolutely stuffed. I've been crook for weeks and weeks. Can't do a bloody thing, sick of being in pain, sick of grizzling about it, nearly going out of my head in frustration at not being able to paint. I wish I had a healthy body. I've got so much I want to do, but I feel as though I'm dying bit by bit, like a flower that's got no water.

How are you kiddo? Miserable start to a bloody letter eh? Wait, there's worse.

I first got crook before I went to Sydney to see Adam for his birthday last August. I went to the Kilsbys' for a dinner party. The dear Kilsbys – Jeff and Lyn, you might remember them – put on a dinner party for seventeen (I was their seventeenth of course). The locals up here are beaut. They have dinner parties for couples and invite me on my own, which is really precious.

Anyway, I got myself seated, very loudly as usual, with a gentleman each side of me – which I always demand at these dinner parties, of course. We had a couple of brandies before tea, and I'd had a few wines. Halfway through the main course I had to go to the toilet and was violently sick.

I haven't been able to drink since. I had a few at Christmas and New Year, but other than that, even half a glass of the best quality champagne makes me sick. And I seem to have been going downhill ever since then, which makes this the sixth month. I'm like a bloody walking skeleton. I'm dropping so much weight. The GPs can't find anything wrong, they say it's stress and tension and there's not a thing they can do.

We had the anniversary of Ash Wednesday II the day before yesterday. Big ceremony on Mt Lofty, very moving, very sad. I didn't go, but it was televised. There were stories in the paper and on telly about the effect of the bushfires on people. Reading and watching them I realised that a large part of my problem could be a reaction to summer coming. I'm worried about getting Paris through another one alive. I think we've used up our survival tickets. Perhaps when summer's over I'll feel better.

I'm so fucking tired, just when I'm starting to get somewhere with my painting. I can see it happening. If only I can get well I'm going to do such good work!

I bought myself a new record player a couple of weeks ago. I'm sick of not being able to have decent music, so in my usual fashion I bought it on the never-never, like the television. Didn't have to put any deposit down, just pay it off like I was renting. I feel as though I've got it for nothing. It's nice to hear a bit better sound at last. Streisand brings you close.

Later

Sorry about the miserable start.

I'm glad to hear you got more time off – we need some now and then but I know you hate being short of money. I live like that all the while. It gets under your skin sometimes, not knowing if you're going to be in your house the week after next.

Not that this is a great place to be in. I've been doing a lot of lying around lately. I look at this place and think, pretty strange place for a 43-year-old working woman to be in. Funny old joint it is. The thought of it getting burnt down is unbearable, but, God, am I sick of not having enough room, enough cupboards, enough shelves. If I want to do a painting I have to clear everything off one table to another. Then if I want to do a watercolour I've got to shift it all again. It's too hard.

I should have a fucking big room with benches, easels and plenty of space. I've got nowhere to put all my wet paintings either – they're getting dog's hair and dust on them while they're drying. What shit-awful conditions.

I'm trying to get the garden going, but I can't carry a bucket. I have to con Paris into bucketing as many plants as possible. We hose the rest, but that's wasting water. And anyway, you've got to stand holding the hose for bloody hours, and the hose itself is too heavy. I've joined three hoses together so we can get to the trees, and when they are full of water they weigh a ton.

I pay someone to clean the house. I can't even make my bed! I've got no real income because I haven't been painting properly for fucking months. The work I have in galleries have been gradually selling and I've got bugger-all left to sell. You need about 20 paintings to keep up your chances of selling one each week or fortnight. I can't get to the framers, I can't get to the gallery, I can't pick them up from one and take them to another. Grizzle, grizzle, grizzle.

I've turned Barbara Streisand off. I couldn't bear the sound. I'm very noise conscious at the moment.

Later

Paris has been a brick. I've been so irritable, miserable and sick that I've frightened the life out of grown-ups, let alone my little boy.

My back's been so badly inflamed it goes into spasm and makes my whole body shake. I nearly pass out. For hours after each spasm I can't move or speak. It's very, very frightening for anybody watching. There is nothing they can do. I can't even nod my head to let them know I'm alive.

I'm getting a little better now – but becoming more irritable. I don't want Paris to touch the bed, rock his chair, even bang his ruler. I don't want the television on too loud. We've had a couple of teary sessions together, but generally he's been fantastic.

You ought to see him, Merry. He's started high school this year. I saw him walking out the gate in his school uniform – white shirt open at the neck, sleeves rolled up, tight grey trousers and leather sneakers – with a grey slouch bag slung over his shoulder. He looked like a young man capable of carrying all sorts of responsibilities that I've held back from him. I've had to come to grips with the fact that he's not a kid anymore. Well, he's copping a bit from me now, and wearing it well. He's going to be a very strong lad that one, physically as well as mentally.

For months after the fire he was having nightmares and sleepwalking every night. I'd be 'sleeping' on the edge of my nerves listening for any small sound from his room so that I could grab him the minute he got up. One night I heard him open the door and found him wandering around outside, and another time he got under the shower with his clothes on. He's done all sorts of odd things, with a lot of screaming and crying and being very, very frightened.

So I've been a long while without proper sleep. And then, just before Christmas, I found out that Ken's let himself out of the hostel where he was under care. He's applying, this month I think, to come out of guardianship. It seems that he's got a flat in Fullarton, in the suburbs, that he's sharing with another guy from the hostel. I think he's also got a job at the city branch of the firm he was with before the fire – sweeping and cleaning up. He rang Rita and told her all of this then said he'd been drinking at the Crafers pub which, as you know, is not far from here. I couldn't cope with that. Ken running around loose drinking in the Hills.

I don't know how the hell he's managed to do all of this – or how he remembered Rita's surname or phone number. The doctors said he had permanent brain-damage. He can't be capable of proper work and I guess the old firm has taken him on out of pity. All of this news has come via Rita, anyway, and she said it was difficult to follow his conversation.

The hostel wasn't a lock-up facility and he could go to the pub and so on from there, but as far as I knew he was still too ill to function properly. He did manage to send me a letter last year – I think I told you – a pitiful letter full of apologies, pledging love forever and begging me to come and see him. I cried when I read it but I can never give him any hope of a life together with me.

I'm not privy to what goes on with the guardianship board and the welfare workers, perhaps they've helped him get the job and flat. I'm still frightened of him and was terrified when Rita told me about him calling her – afraid that he'd come here.

Not long after he went into Glenside a letter came for him in the mail which I opened and it was an approval for a gun licence. He must have applied for it soon after I left him. I had a hell of a job convincing the police to cancel it.

Ken's a determined bastard and if he's out on his own I'll never feel safe again. I don't like to think he can come up whenever he wants, sit out in the street and watch the house. It's a horrific thought, but I've gradually adapted, and here it is, halfway through February, and he hasn't knocked on the door yet.

On the other side of the coin, I've got such good pals. Anna has been a real support, and Ingrid has been really brilliant. Barby Groom, who you don't know, is doing my washing, and Lyn Kilsby and Pam cook a meal for me when I want one. Various people are doing my shopping. I only have to pick up the phone to get something done. I try not to ring through my requests too often, only if I am really stuffed.

My old mate Ilze found out that my new chiropractor had said that I have to drink celery and carrot juice because I've got an inflamed bowel as well. She knew I needed a juicer, so she just went out and bought me one.

This chiropractor I have been seeing, at least every other day now for three weeks is 30 bucks a visit. He knows I'm broke and is doing it for a painting that we haven't even discussed yet. Not until I get better. You would think that with all of these people pushing for me that I should be instantly healed. Perhaps they *are* keeping me alive.

Later

Merry, I don't know what to say about all the people who you love briefly, or for longer periods. I would really like it, of course, if you could turn your love inwards and not have that same need for others. But as long as you are getting love from somewhere, and giving it, I guess that's the best way of coping for now.

I am feeling lonely myself. It doesn't happen often, even if I am crook, but today I'm thinking it would be nice to have a friend around to care for me, pat

me on the back, and say, There, there doll. But if it actually happened I would wish that person was out of my hair. When you are *this* sick, the only person you want to be with is yourself.

Later
Just had tea and feel brighter, but it's a bloody hot night. Big moon, very hot, very still. Tomorrow's forecast is 38 degrees with northerly winds. Not good at all. I'm edgy. Paris has gone to stay with a friend and I am not too happy about being here on my own tonight.

I was supposed to have gone to dinner with a bunch of the locals, but I can't make conversation with people and it would be too much of a hassle to get down there and be pleasant, even if I stayed for an hour. I could ring someone – Anna, perhaps – and ask them up, but I don't want to do that either. I want to stick it out on my own.

It's a funny night. The horses are toey. Babe's toey. The birds are still singing, and it's dark. One of those really odd nights!

Next day
Let me tell you about my project for the year. I want to paint a picture of the Coorong six feet high and 80 feet long. It will consist of 24 paintings joined together in a circle so that you can stand inside and see a 360-degree view of Policeman's Point. It's a mammoth project, especially for a woman who can hardly write a bloody letter at the moment, but I've had it in mind for years. Before, I wasn't good enough to do it. If I leave it for too many more years I will be past it. I have to do it *now*.

It will mean a couple of years' work, and I won't have time or energy to do my normal selling pieces. (And God knows whether I'll be able to sell this Coorong work.) But if I can get hold of some money I will do it, and it's going to be mind blowing.

How am I going to manage to paint 80 feet of canvas in this joint? I don't know, but that's my project. But I *will* paint and it *will* be brilliant.

Couple of days later
To answer your questions.

Mum is off colour. She is getting old of course, 74, this year, I think. Since I left Ken and have developed more pride in myself, I don't take her criticisms so much to heart. She seems to be aware of this. She's treating me much better so I'm happy to visit her as often as I can, take her shopping and out to lunch and so on.

Not long after I left Ken we had a ding-dong row, during which I told her how I feel about my big brother John and her non-acceptance of me. It was terrible. John, as you know, is her favourite child and she can't accept any criticism of him at all. She cried heaps and told me to leave. Tess said she didn't come out of her room for two weeks. But she has been kinder to me since then and I feel she deserves some care in her old age. After all, in her own way, she gave us all a good start in life. I think I was simply too needy.

Babe is still around, but on her last legs. The heat is knocking her about. She might (I hope) see another year out. I hate the thought of losing her.

Recently I've been learning to zap myself out. You know how much I love to dance. I can't dance, of course, most of the time, so I put on music I really like, climb out of my body into the sky through the roof and dance in the air. On Mabel's roof, or a mile up, wherever I choose! I can dance on my fingers, or upside down, or sideways, and I can *feel* myself dancing. Sometimes, for instance, I just dance with my toes. Terrific stuff! I swim a lot up there, too. Really strong swimming through the air. Sometimes I just hang there or lie there. Relaxing is my biggest problem, and this is probably the best relaxation method that I've found. I'm going to practise it.

You might want to try it, if you haven't before. Try stepping out of yourself as if you were climbing up stairs. You can test the weight of the air, and you can test going through the roof. It's so easy. You hear people talk about astral travelling and all that stuff. I don't know if that's what I am doing. It might just be my good imagination, but whatever it is, it's nice.

I *am* going to get better, of course, although it will take a long time. If I don't write for a while you will know why. Once I do start to feel healthy, every ounce of energy I've got will go into painting.

I think of you lots. I don't know why it's all so hard. I wish it wasn't for you, or for me, but there you go.

February 1984

Hiya kid, this letter is full of good news for a bloody change. Got the money to do the big Coorong painting. Yahoo!

You'd be so proud of me, Merry. I actually made a sort of business-like move, for once, and it came off. Westfield – you know, the shopping centre owners – is going to pay for my materials, and then they will display the finished painting in all their shopping centres around Australia.

It began like this. Anna was over here one day, she's been looking after me while I've been ill. She says that I sat bolt upright in bed and announced: I'm

going to do the painting, I'll do it like this, and I'll make it so it can travel. And so on, down to the finest detail. It must have been rocketing around in my head while I was out of it, and suddenly rang out clear as a bell. I was too sick to paint my toenails, but there was this grand plan, and I knew it was going to happen. Anna laughs when she describes how this skeleton suddenly leapt up and started laying down the law.

Anyway, to cut it short, I applied for a grant from the state's Arts Department and didn't get it. As part of the application I had to organise venues that would show the piece when it was finished, and one of the places I'd contacted was the huge Westfield Shopping Centre at Marion, south of the city. The marketing manager was interested. He said that not only would they take it, but they'd like to have it first and wouldn't charge for the space. Seems that display space in these shopping centres is worth a mint.

So-o, when I didn't get the grant I thought I'd try Westfield for a sponsorship. Looks simple when I write it down like that, but it was a surprising decision. I mean, Merry, that it surprised me! I've never got 'commercial' like that before – or even considered it. But I *really* have to paint this thing, and I'll move hell and high water to be able to do it.

I rang the marketing guy and made an appointment. He asked me to bring a few paintings down to show him, and that in itself seemed positive – he could have given me a straight no. So here I am, sick as a dog, can't walk without a stick, hardly able to get out of bed. Thank God once again, for friends.

Ingrid came with me. Helped me dress, carried the paintings and my albums, and drove the car. She carried the lot up to the marketing guy, Peter Simes, and I hobbled up the stairs on my stick. I left the paintings – and my stick – with Ingrid outside.

Peter turned out to be a great guy. He was interested in the concept of the Coorong painting, and liked my work generally, although he seemed a bit dubious about the size of the painting I want to do, and asked me straight out whether I really thought I'd ever be able to finish it.

Well, Merry, if he had any idea how ill I am he wouldn't have given me a chance, but I banged my fist on his desk and said, I *have* to do it. It *will* be finished. I have to paint this thing. I was amazed at myself!

He said Westfield would probably be interested in sponsoring it, on condition that I could finish it by 1986 for South Australia's 150th anniversary bash (its sesquicentenary as we're all learning to call it). He told me he had to put it to the board or whatever they have, and promised to ring me.

Well, they've agreed, and offered $5000 for all the expenses. Five grand! I

can get proper easels, decent canvas, top quality paints, beautiful brushes. I can use the money for accommodation near the beach, travel expenses and a good camera – everything, in fact, involved in doing the painting. I can't believe it. After all these years of painting over existing work because I can't afford even the cheapest canvases, I'll have as much good canvas and equipment as I need.

Even while I'm bursting with excitement, I'm scared shitless that I won't be able to finish it in time. God knows if I'll even be alive in two years, let alone still mobile and able to work. But I'm going to have a bloody good try!

This piece has been growing in my mind ever since I first got the idea for it. Besides being a stunning painting, it will also be a teaching piece (the bloody teacher in me won't go away). When I was at TAFE I realised that most of my students wouldn't go to galleries unless they had a specific invitation for an exhibition. They'll go to the state gallery, some students anyway, but not the private galleries. They're too scared. I found this not only amazing, but frightening. These people were studying art, but found galleries confronting. I figured that if I broke the pieces of the Coorong painting up into reasonable-sized panels, it could travel all over the place – country towns, shopping centres, parks and so on – where Mrs Bloggs and her kids could see and touch it. Perhaps it would stop them being so frightened of 'art'.

It's an ambitious idea, I know, but I don't see why it can't work. And I want to take art to the people instead of trying to get people to the art. Anyway, that's the plan. I haven't worked it through properly yet, but Westfield's a bloody good start. There are a lot of Mrs Bloggses who go to Westfield.

April 1984

Merilyn, thanks for the last two letters. Sorry I'm so tardy in writing but I've been busy getting this Coorong painting on the way.

Yes, summer was terrible, as always, but we got through without any big fires in the vicinity – there're always lots of little ones – and now we're into gorgeous autumn with the whole of Mylor main street a picture of browns and oranges.

What a shit that your back's playing up again. At least while you're not working you can rest when you need to. Don't worry too much about what you'll do next. You know that when you're ready to work again, the right job will turn up. In the meantime enjoy your holiday and get lots of rest and sleep. You didn't mention your shrink in your letter. Are you still seeing him, and how's it going? I know it's hard to find someone you can relate to, but you must keep in contact with someone you can talk to honestly. You are precious to so many people, Merry – you can't keep playing Russian roulette with your life. At the

very least, you're risking permanent damage to your brain, and that would be ghastly for you.

I'm glad your mother's coming to visit you. It will do you both good. I didn't find out that your father had died until you wrote, so I sent her a card, but it would have arrived late. I can understand how lonely she'll find it after 40 years together but, as you pointed out, my mum has managed and so will yours. I hope, though, that she takes on a busier life than Mum, who has sat on her own, except for family visits, ever since Dad died. It seems a waste.

I'm so pleased that you've met a wonder-woman at last! How wonderful if she's the one to bring you happiness. All these young boys you're seeing must be wearing you out. Good God woman, you're supposed to be taking it easy and having a rest. You must spend half of your life in the bedroom!

To answer your question, no, I don't feel the need to be in love. I like having lovers and feeling wanted, but I really like having my own space. After having to battle Ken for time to paint, the freedom of running my own timetable is brilliant. I can start and stop whenever I feel like it, and sit and look at what I'm working on for as long as I like without interruption. I wouldn't ever want to get married again, or even live with someone. Perfectly happy as I am.

Unfortunately my brilliant idea of keeping half a dozen lovers on the go, and only seeing them every couple of months, is not working out. It went well for a while, but one of them fell in love with me and wanted to get married (he had to go) and another one fell in love with someone else. A third is hinting about settling down, and if I don't pick up the option he's got someone else waiting. And I won't. So that only leaves three, and one of them is going interstate.

There are plenty more around, as you well know, even for a 44-year-old, but I can't be bothered re-stocking the stable at the moment. I've got my hands full with painting and keeping a sharp eye on Paris – not to mention trying to replant the block and tizzy up Mabel. And then there's my stupid health giving me grief all the time.

If I ever actually fell in love again maybe I'd think about making a commitment, but I wouldn't want to burden someone I loved with my sick body. And I'd be pretty dogmatic now about my solitude and my own needs. Can't see it happening.

Peter, Ingrid's husband, is building me a big easel so I can get on with the Coorong painting. It takes up the whole wall and has a large frame, on runners with a pulley, that will slide up and down so that I don't have to keep bending and stretching while I'm painting. I've worked out the sizes of the panels, and the easel will take three at a time, so I'll be able to rotate them and keep the flow going.

I wanted the painting to be 6 feet high, but there's some sort of rule at Westfield that displays can't be higher that 5 feet. I'm disappointed, but since they're footing the bill I have to accept it. I still can't get over how wonderful it is to have the sponsorship.

I've chosen the most beautiful linen canvas, and ultra-strong stretchers, so my giant painting will endure a lot of travel. I'm buying all the colours that I couldn't ordinarily afford, of course, and you ought to see my brushes, Merry! I've even bought a couple of expensive sables for scumbling. Shit, it's unbelievable.

I've made a small watercolour of the composition, and it's looking promising. I took ages to decide which area to work from – there are so many good spots down there – but eventually narrowed it down to three, and made miniatures to see how each would work. They were all stunning views, but I decided on the beach at Policeman's Point.

Even that decision involved much agonising, for wherever you stand on the beach the composition changes and the vista can alter dramatically if you take a step or two in any direction. The spot I eventually chose to work from is tucked up near a beautiful cluster of tea-trees. I'll be able to sit there sheltered from the fiercest winds.

I've taken hundreds of photos for reference, so I'll do most of the painting in the studio. I'd like to take each panel down the Coorong a couple of times and work on them at the site, but I don't know how I'll deal with the wind, considering the size of the canvases, and I'm really too weak to carry them so far along the beach. Even with my ever-willing helpers, Anna and Ingrid, it will present major problems, but I'll worry about that later. My health might magically improve before I get to that stage. I wish.

For the moment I can at least draw the fine details of the trees and the scrub in situ, so I can begin blocking the big bastard in. I've already done dozens of drawings, and am really enjoying the trips down there with either Anna or Ingrid. It's all I can do, with my stick, to walk from the car to the chosen spot, which is a good half mile. At the end of the day I'm too stuffed to make tea, so they cook the meal back at the unit. In the meantime, they also get in some painting time.

I always have to flop for an hour or two when we get back from the beach, then have tea and a few drinks while we look at the day's work. We always take a radio with us and plenty of tapes so we've got good music. If it wasn't for my goddamn pain, the trips would be heaven. If I stopped painting, and planting and mothering, and used hypnosis and the TENS unit regularly, I might get

some decent pain relief for a while. But you know what I'm like. I can't stop doing stuff. And then I go and organise this big painting on top of everything. It's bloody madness!

May 1984

Good news, Merry! Mabel has a new room. Actually one room and a small storeroom. Jeff Kilsby, who's been helping Peter make the big sliding easel, rounded up a few locals and they built it over Easter weekend. Only the outside walls are in place so far, but we'll gradually clad the inside a bit at a time when I get some money. Paris will have a new bedroom and I'll have a storeroom to stack the panels that I'm not working on. Now that I'm starting this big fucker of a painting it would be hopeless without the extra space.

The guys donated their whole Easter weekend to build the rooms. I had enough money for cheap timber and the outside cladding and floor. Anna contributed an old window as well as having a bash at hammering and nailing, and the Kilsbys donated another window they had lying about the place. Tess has given me a glass door, which now opens outside from Paris' bedroom.

This new addition is so like the rest of the house (and I use that term loosely) that it fits right in. Bits and pieces of stuff given lovingly. Time and labour given lovingly. What a special joint this is.

My health is so rotten that I couldn't bash in a single nail. I'm even having trouble with the housework: sweeping and vacuuming and the dishes are impossible. God knows how I expect to paint this Coorong bastard – but I will.

Ilze's daughter, Daine (Day-nee), who I guess you haven't met, is at uni this year and needs a cheap place to live. She might come and stay in the boys' old room in return for helping with the housework and cooking. She's a nice kid, and I think it might work. Paris likes her, and that's important.

And – on top of *that* good news – I met a great guy on Easter Saturday. Anna and I had to go to this party, but we were tired and planned to only stay a short while. Two tall, stunning guys arrived and the four of us clicked immediately. My guy is in the airforce, based near Sydney, and comes over often to visit his mate, who hit it off with Anna. I've seen my fella a couple of times since and he rings now and then. He's scrummy – and interstate, so won't be able to get too involved, thank goodness.

Had a quick trip to Sydney with Ilze to visit Ad last month. It made for a nice break, and I organised to send some paintings to Proud's Gallery over there, and Barry Sterns. These are both good galleries, especially Sterns, but I won't be able to produce much once I begin work on the big one. It's a good

start interstate though. Proud's are giving me a whole wall. These are ordinary paintings, not the erotic stuff I took last time, so it was much easier to find a market for them.

It's an expensive exercise taking and freighting work interstate. I have a good following in South Australia and in some ways it's stupid to try and expand. Ego, I suppose.

Anyway, the big canvases are being made now and it won't be long before I can start the Coorong painting. There's part of me that's calm about it and knows it will all work out.

So much for my bullshit. How are *you*? I'm glad you're getting such pleasure from *Withywindle*. Perhaps you need time by yourself, and I know how much pleasure you'll be getting from redecorating, but don't get too carried away with the solitude bit. God, you go from the sublime to the ridiculous. Out every night with various young studs one minute and locked away in seclusion the next. Still, who am I to talk? We both seem to run on highs and lows all the time. Do you think we'll ever be sane like the Mr and Mrs Bloggses of this world? And would we like it? Probably not.

Great to hear you've got your new dog at last. I'm without one at the moment. I eventually had to put Babe down. I miss her company, and would love to get another dog soon – trouble is, could I look after it? Won't get into that dreary old crap again, love you heaps and think of you often.

P.S. Do you remember me telling you about Malcolm, the local guy I was seeing after the fire? Well, he's been in hospital suffering brain damage as the result of too much booze. He nearly died. Don't know all the details. Malc needs visitors and care, but I can't go to see him because he might think that I'll take him back. The situation is so reminiscent of the one with Ken. I feel dreadful about it. He was so good to me. He'll end up, same as Ken, doing menial work.

Booze is deadly stuff. How you and I have managed not to end up alcoholics is amazing. Gotta have *some* luck I guess. Must admit I feel like a bit of a jinx, though. Remember what happened when I left Lester? He ended up in hospital. Then Ken and now Malcolm.

August 1984

Hiya kiddo, thanks for the photos. Love the black dress! You always look so classy.

Which reminds me – the other night Anna and I whipped into town to hear a band. We didn't decide to go until about nine – both of us had been working outside all day and had on daggy jeans and welly boots. I threw on my good old reliable duffle coat, Anna grabbed a daggy jacket and off we went. Neither of us bothers with make-up or our hair. If we had've showered and got tidied up we would've missed the band – anyway, once I do all that, I'm too buggered to go out.

We got there while a support band was still playing, and to my surprise and pleasure the singer and keyboard player was Spike, from the studio we shared when I was at art school. Haven't seen her for fifteen years. She looked sensational! She's tiny, compared with Anna or me, and has a superb figure. Her long black hair was all gelled and spiked. She wore high-heeled, knee-length lace-up boots, jazzy tights and a brightly coloured top and vest. Lots of make-up. Great voice. Good mover and pretty good on the keyboard. We felt like two great lumps of cow-shit sitting there in our jackets and wellies – a couple of scruffy farmers, plain and old. Imagine how I felt when she came over to say hello! Still, it was good to see her.

Occasionally Anna and I go to a party, but mostly it's just a quick drink to get out of the house, or to hear live music, which we both love, especially modern jazz. I really enjoy watching musos doing their stuff. I get a super charge from jazz – always makes me want to get back home and start painting. Fortunately, Anna's place is only a couple of miles from here and she's on her own like me – but with two teenage kids instead of one.

I still paint with Ingrid every week and we spend a lot of time together too.

Annie, Tess, Mum (still a good-looking woman, but getting a bit slower now – she's 74) and I go to dinner whenever one of us has a birthday, but other than that I don't see much of Annie and Tess. We're all too busy with our own lives and kids.

Paris still sleep-walks and has nightmares occasionally but not as often as before. He seems pretty happy during his waking hours and has developed a keen interest in golf. He's playing tennis as well, with the local club.

Pam's fine, Ilze's fine, Daine (Ilze's daughter) is living here now and helping keep the house running. She's got the boys' old room so I'm (still) sleeping on the divan in the studio/loungeroom. This is actually handy – I can lie and look at my work and stay in bed when visitors come.

I've started swimming regularly again, at a camp not far away. Barb and Fred, who manage the camp, have become good friends. They let me swim in the heated pool while the campers are having their dinner. I just hope it strengthens my back. They also let me set up the Coorong canvases in their rec. room and begin to block it in with turps washes. Jesus, Merry, what a sight that was! Eighty feet of blank, primed canvas. Five foot high. White and pure. An artist's dream. But scary at the same time. Very scary.

Who the hell do I think I'm kidding when I say I can finish this piece? There's so much of it! When it's set up in a circle it's got a 25-foot diameter. It's massive. I got it roughly blocked in during two sessions at the camp, then I began using the Mylor Hall, which has better light.

One of our telly stations, Seven, did a decent story about it on an evening show called 'State Affair'. They're going to do another segment when it's finished. I have to keep saying to myself that it will be finished, but who the fuck knows. Anyway, I'm well started.

Next day

Got too tired to write anymore. I don't know what the hell's wrong with me, Merry. I'm sick most of the time but the doc still reckons there's nothing wrong. I've had another one of those ghastly chest spasm attacks. Here on my own, with Paris asleep. Had to fight like a mad dog to keep breathing, then got to the point eventually where I had to give in. Slipped backwards into soft black velvet. Very peaceful. No pain. Then I had a flash of Paris finding me in the morning. It took everything I could muster to pull myself back to the living hell of trying to drag another breath into lungs so tight they didn't want to accept it. Been buggered ever since.

Here I am starting this mammoth painting. Going on TV. Mrs Big-Deal full of positive energy and guts. But half the time I can't get out of bed, and if I do, I can only function for a half-hour at a time. Stupid woman. The doctor still says I'm having anxiety attacks but I know that's not true. Had plenty of them when I had the breakdown. This is different. This is physical.

Don't you just *love* getting these miserable letters? Still, there's a bit of positive feeling around at the moment. Eighty feet around!

Oh yes, then there's Ken. He's been on the phone. Said he wanted to take Paris for a day. What the fuck was I supposed to think about that? Paris, of course, was dying to visit him, so we went to his flat in town to check it out. I thought he was sharing with another guy, but turns out he's there on his own.

This was the first time I'd seen him since he was in hospital and I was scared. Paris, who's been seeing him fairly often, thought he was fine and was keen to spend time with him. So I made the big decision and left my little boy (well, he's 13 now) with this madman for the day, arranging to pick him up after tea. He's been for three visits now and I'm still anxious about it. Paris says Ken's okay and that they just watch videos. I can only really go on Paris's reaction and trust that he's right. But it feels very strange. Very risky.

Paris has even stayed overnight at Ken's. That was scary. But there Paris was, safe and sound, when I went to collect him on Sunday.

Ken looks shocking. He's put on a lot of weight – even his face is chubby. And his hair's been cut really short. A stranger – except for his eyes and the way they look at me. Yuk.

Well, I've been rabbiting on about me, me, me again. How are you? Your letter was cheery. Life seems to be good for you at the moment. The new job sounds interesting. You do like working for doctors, don't you? Glad you found someone you can respect as well as relate to. I wish I could afford to come and visit *Withywindle*, but for the moment I send all my love. Send more cheery letters please, and more photos. S'all for now, Barb.

September 1984

Dear Merry, I'm very tired and will keep this short. Painting like a woman possessed at the moment, or resting. One or the other. From my bed (close to the pot-belly and very warm) I can see three panels on the easel. The two that belong either end are propped up against furniture. The panels have sliding hinges, which makes them easy to join together. If I need to I can set the five up on the floor if I shift stuff around. This room is getting pretty crowded!

But the main reason I'm writing – I have a new puppy. Felt so lonely seeing your photos, that I decided it was about time I got another dog. Daine and I went to look at some bitzer pups and I brought home a black ball of mischief called Raji. Some kelpie, some labrador and God knows what else. The little honey is asleep against my legs at this moment. And Streisand playing. You are very much in my thoughts.

September 1984

Dearest Merilyn, a quick note from the river. Got the houseboat for free for a week in return for a painting of it. Have Ingrid, Anna and Gay. Beautiful. To get a decent view of the houseboat tied up at the canoe tree I've been working on a chair on top of a table. This setup is semi-hidden in the scrub and other boats going down the river must be amazed when they spy this painter suspended high in the bushes.

Plenty of grog, good food and conversation. Lots of work getting done. It's good for me to have a break from the Coorong painting. Sleeping in the studio next to it is great but means I'm forever breathing in fumes from the paint and the turps. This fresh river air is doing me good. Jesus, mate, I wish you could be here enjoying the friendship and fun. I wish this peace and happiness for all the women I know.

blue-grey water
blue-grey sky
blue-green-grey foliage
yellow grass

December 1984

Hiya kid, seasons greetings and all that. Enclosed small prezzy. Hope you like it. Ilze's been doing silk painting and I think her stuff's unique. Have a couple of scarves myself and thought this one might look rather dashing against your little black numbers.

Sorry this letter's been so long in coming, and thanks for all of yours. It's always a buzz when I pick up the bills and there's a letter from you.

Your phone call has been bouncing around in my head all of last week. I'm pleased you rang me – you know I'll always be there for you, no matter what the hour – but I feel piss-weak and useless. If only I could be over there with you and hold you safe so that you didn't have to be responsible for anything for a short time. There are no proper answers to your questions, my dear friend. I suppose each one of us needs a different answer to the same question. That answer has to be hidden somewhere deep inside – but it's much too hard to bloody well find, especially when one is feeling so low.

Your call in the morning to say you were all right was like the sun coming up.

You were always there for me when I was desperate. This, I suppose, is one of the reasons why you must continue to live. You are able to offer over-whelming compassion, love and care to others. That quality is rare in this world, and desperately needed. A piss-poor reason to stay alive I know, to serve others. But we each have gifts to throw into the ring and compassion is an important one of yours.

I'm selfish, Merilyn. I want you to be alive for me. You're my friend. More than a friend, an intrinsic part of my life. Hang in there, and ring again if you get that low. I love you.

Next day

Christmas is a rat-shit time for people like us. Society says you're not supposed to be alone at Christmas. Paris and I are going to have Christmas dinner with Mum and Tess and family, and we still have open house, which has grown to quite a party. So we'll be okay.

Can't write much at a time. Also puppy chewing my pen.

Patty has been to stay for a few days. I've missed her, but she's a lost little poppet and tears at my heart strings.

Paris is coping. He's missing out a bit on attention – when I'm well enough to function I put all my strength into work – but he's got good mates and sport to keep him busy outside school.

I'm not sure about Daine living here. The place is so small and her

boyfriend's here often. They're good fun and young, which is refreshing, but it's beginning to turn into a mother-daughter relationship and that's not good. I don't want to mother her, I want her to look after me. We'll see.

Still draw occasionally with Marg and Anna, but can't afford the time and energy every week. Have to go to one of their places now because of lack of room here and often that's too much of a hassle.

Have set the big painting up several times since I wrote last, twice at the camp and once at the Mylor Hall. Either Anna or Ingrid help load, cart, unload and set them up. It's a big job, and heavy. I couldn't manage without them.

Looking back over the year I've had a lot of work about, here and in Sydney. Sold a lot, too, though the money goes out quicker than it comes in and I never seem to actually *have* any.

Next year's going to be crazy. Have to finish the big painting *and* try to get well. I wonder if Santa's got any new bodies in his big bag.

4 January 1985

Merilyn, I've just taken Paris down to Ken's flat and left him there. They are going off on a holiday tomorrow. I feel a traitor, to Paris, or a murderer. Irresponsible parent! It's midnight, but I'm so worried for Paris' safety that I can't settle to sleep. I want to rush down there and bring him home. He would never forgive me if I did. The poor kid wants so desperately for everything to be back to normal that I think he's fooling himself that it is.

When Ken first suggested the holiday I said I'd meet him to discuss details. Actually I wanted to check out how he was, and see if I could pick up on any antagonism. To my knowledge, he hasn't ever touched the kids, but who knows?

Paris was *very* keen on the idea. In his present state of mind he'd have been likely to run away if I'd said no.

Ken said he'd meet me for dinner at a French restaurant we'd been to before. There was no way I was going alone to his flat and our meeting had to be in a public place, but revisiting our past in this little restaurant was a bit off. Christ, Merry, it's been five years since I left him and I'm still so shit-scared it's ridiculous! I had to arrange to be dropped at the restaurant and picked up two hours later because I thought he might stop me leaving, or follow me out to my car, or follow me home and kill me.

Good old Anna did the chauffeuring. She was ready to come in and get me if I wasn't out of there in two hours. She understood completely how I felt and was happy to sit out the front, just in case.

I remembered finding him in the car on the block after his suicide attempt. Same dreadful fear.

Well, he was reasonable, as it happened. The episode was awkward and horrible, but somehow we both ate our meals and carried on a stilted conversation. Ken was very withdrawn.

The upshot of the meeting was that I felt that Paris would probably be okay with him, though I wasn't dead-set sure. The next weekend he pulled up in an orange Charger, same as mine, to collect Paris for a day's visit. Warning bells went off left, right and centre in my mind. But Paris was so excited that I let him go. And he was delivered home on time.

But now this fucking holiday! I've talked all of this over with Steve, my counsellor, of course, and she agreed it was risky but important for Paris. The final decision could only be mine and I pray I've made the right one.

Ken's original plan had been to take Paris to New Zealand, but that meant passports and so on – and I was afraid he'd never bring my son back! Eventually we agreed on Tasmania, where there's a big trout farm that both Ken and Paris are keen about. It's an organised package deal with a small group. Seems reasonably safe. Doesn't it? What if I've sent Paris to his death? Or, more likely, to be held hostage until I take Ken back? Or whatever. Roll on ten days from now!

I should be pleased to have ten days to myself to paint (and I am), but I think I'll find it pretty hard to concentrate until my stroppy 13-year-old is back safe and sound.

Other than that drama, life's rolling along as usual. Painting, painting, painting on the big piece. Going well. Heaps of love, Barb.

February 1985

Hi, hi, hi! Three am and just finished work for the night. Been building on the big painting in the cool of the evening. Too hot during the day. Bushfire weather – hot, with far too much wind. I'm edgy. At least this little cardboard box cools down quickly at night or I'd never get any work done in the summer.

The painting's going well, but too slowly. Of course, as usual, I have to put *every* bloody detail in. I've finished the base coat now and am starting on the good stuff. Really enjoying it. High as a kite!

Lot of pain tonight. Have to prop myself up on my walking stick with one hand and paint with the other. You'd laugh if you could see me. Or cry.

Need a couple of Scotches to unwind before I can sleep. Smoking like a chimney. Roberta Flack on the stereo. Raji passed out on the divan. I suppose every other bastard in the world is asleep and I'm wide awake. Paris is tucked up

safely in his bed – home from the dreaded holiday with Ken in one piece, with two massive fish and a few stories, although strangely quiet about the details and will not be pushed. Too sore to write much but thinking of you and simply sending a sweet hello.

12 March 1985

Merilyn, Ken is dead. Yesterday. Suicide.

What do I feel? Relief. Regret. Deep sadness. Guilt for feeling relief. I'm in a real muddle. I can't stop crying and I don't understand why I'm crying because I've secretly wished for this for years. But what a thought, to wish someone dead. And now he is.

I don't know where to start – so much has happened in these last two days, all of it painful and terrible and new. Telling the kids was the worst of it, and giving Paris the note that Ken had left him. There is trouble with Katherine and all the funeral business, and little June is pregnant. She is only fifteen. It's all too much.

Paris is in a terrible state. I made him go to school today because I think it's better for him to be occupied rather than hanging around the house, but he'll be home in a couple of hours and I've no idea what to say to him.

Adam's flying over tomorrow to be with us and go to the funeral. We need to be together although we all have different memories and feelings about Ken. The poor boys must, in a way, be closer to him than any of us. They've kept up contact by visiting him.

The cops came to the door about 8.30 in the morning. They asked if I was Ken's wife, then told me he'd been rushed to hospital. They said he'd been alive when the ambulance came but his condition was critical and they didn't hold out much hope. He'd taken cyanide.

The cops had been able to find me so quickly because he had my last letter to him on the bed and it had the address at the top. I think that was what made me decide to tear down to emergency at the Royal Adelaide. I couldn't let the poor bastard die on his own! The cops said they'd meet me at his flat after I'd been to the hospital.

Paris told me later that his school bus was passing just when the cop car was here and all the lads were making jokes about why it was here. I suppose, deep down, he must have guessed what was up. Poor boy had to wait all day to find out.

At the hospital a doctor told me that Ken had died a few minutes before. So close. Not that he would have known I was there. He'd been unconscious.

I went and sat with his body for half an hour. Strange business. I put my hand on his and he was still warm, but looked nothing at all like Ken. He was

bloated from the drugs they'd given him to combat the poison. Horrible. I sat with my hand on this lump of puffy fingers and talked to him in my head, though I've no idea what about. I'll swear he could hear me and was pleased that I was there. Wishful thinking, maybe, but I was glad that I'd gone.

I went into the waiting room, as I'd been told, and the doctor came in and gave me Ken's watch in a plastic bag. That was all he'd been wearing. I put the watch in my pocket and went over to his flat. Two policemen were there, not the ones who had come to the house. I went inside. I hadn't done that before. The flat was small and filthy. Full ashtrays everywhere, and mess, and the stink of old fat.

But worst of all was the smell of death. The same smell he'd had that time on the block.

The flat had just two rooms, a lounge-cum-kitchen and a bedroom with a small bathroom and laundry running off it. The bedroom smelled the worst. The bed was covered only with sheets and had just one pillow. The sheets were filthy, even before they'd been covered with vomit and blood. I didn't stay there long.

In the lounge the police asked me to sit down while they took down particulars in a note book. I was in a daze and simply answered their questions. They gave me two letters that had been found on the bed, one for me and one for Paris. I read them both and cried. They were the saddest notes, Merry! His writing and spelling were terrible. I'll come back to them later. Can't now.

When one of the policemen commented on how filthy the flat was, I told him sharply that this man had been brain-damaged and it was a wonder he could manage to live on his own. The cop had the grace to admit he'd been hasty and apologised. I don't understand why I cared. It was a pig-sty and I had a fleeting vision of Paris eating and sleeping on the disgusting lounge.

The police explained that Ken had taken industrial cyanide, which doesn't work quickly like the cyanide poisonings we see in movies. It's slow and horrible, but just as deadly. It seems the bloke in the neighbouring flat was woken in the early hours by screams and rang 000. The cops arrived and broke the door down to get in, then rang for an ambulance. Ken must have been in agony for ages before the ambulance people arrived and gave him medication for the pain. Don't want to think about that.

Merry, you know better than anyone how that man made my life worse than hell. The damage that he's done to me and the boys is unforgivable, but I wouldn't wish such a death on anyone. He sure has paid for his sins!

I've just had an awful thought. When we went for that dreadful dinner before I'd let him take Paris on holiday, he looked at me at once, slyly, and told me he had access to this cyanide at work. I didn't think much of it at the time –

you know what he was like, always playing games and trying to frighten me. But he must have been planning this all along.

We all wanted to get out of that flat as quickly as possible, so the police drove me to the morgue to do an identification and then to the coroner's office to get copies made of Ken's letters. The coroner keeps the originals, and I knew Paris would want to see his letter straight away.

Next they took me back to the flat to pick up my car, and I drove out to June and Patty's. I didn't want the police telling the girls and it was either them or me, so I really had no choice. Both the girls were home, but fortunately Katherine wasn't. After I'd mustered the courage to tell them about Ken's death, June, crying, said that if only he'd waited a few months he'd have been a grandfather. This was the first I'd heard about her being pregnant, and my immediate thought was: Thank God Ken hadn't known or there'd have been *real* trouble. June pregnant at fifteen. Ken would've lost it altogether and killed the boyfriend. Maybe June. Maybe Katherine. Who knows?

The girls were heartbroken. June had paid him a single recent visit, but other than that they haven't seen him for years – but he was their biological father and they'd both loved him dearly. Still babies themselves at 14 and 15. I didn't tell them all the horrible details but stayed with them for an hour or so, then had to leave to be home for Paris after school.

Now *that* was *really* hard! Telling Paris!

I hope I never have to do anything like that again. Paris had spent more time with Ken than any of the kids – they'd just been on holiday together, for heaven's sake. I wish I could carry his pain, Merry, and let him be a normal 13-year-old for a while.

Next I rang Adam. That was a little easier. For one thing, I couldn't see his face and he's 21 now, with a great sense of reality. He was probably half-expecting this news would come some day. I'm not belittling his pain one bit, but for me he was the easiest to deal with.

But those suicide notes! If you could see them (one to Paris, one to me) you'd understand my heart-wrenching emotions. The letters are so full of pain and loneliness I defy anyone to read them without feeling deeply affected and, having lived with Ken for so many years, my heart breaks for his despair. The man could be as good at his best as he was bad at his worst. Did I cause this dreadful scenario?

His letters are written on plain paper with lines of painful words sloping unevenly. The spelling is dreadful but the messages are clear. He talks of his love for Paris and instructs him to look after me, I'm loathe to say more because it's

his personal letter to his son. Mine begins with an old pet name and describes his loneliness and his inability to replace me. He says I mustn't worry about him dying. He wishes me luck and signs it, Your loving ex-husband. Poor man. I'm ripped apart by grief but how can that be when I think I'm glad he's gone? God forgive me.

What a terrible day. I was a wreck. Anna came over last night. We got drunk and I cried a lot, which helped. But now I feel like a fraud for crying. I wanted him dead. But not like this.

20 March 1985

Hiya kid. The funeral's over, Ad's gone back to Sydney and I guess we all have to get on with our lives.

Your parcel arrived yesterday. Thanks mate, lovely earrings – have never seen any hoops like that before. I will end up with the best earring collection in the state. I would have forgotten it was my birthday if not for others and unexpected goodies. Mum, Annie, Tess and I went out for dinner tonight – I feel marvellous driving home from our dinners after a nice touch of family. Mum gave me money for clothes this time and it'll be terrific to go shopping and buy something *new*, that I choose myself. Most of my clothes, five years later, are still bushfire-relief.

Paris is staying at his mate Daniel's place tonight. I'm so glad he's got a pal to spend time with. They both like golf and tennis and Daniel's mother is divorced too, so they've a lot in common. But the poor little bugger's in a hell of a state. I wouldn't let him come to the funeral – sent him to school while Ad and I went. It turned out to be a good move. I reckon Paris would have flattened Katherine right there in the chapel. It was all Ad and I could do to keep our cool, and we only managed it out of some vague respect for Ken.

Because Ken hadn't made a will since we got divorced, his next of kin was June. This meant that Katherine, on June's behalf, took over the whole shebang. I would quite happily have found, or borrowed, the money to give Ken a decent burial. But Katherine went to Social Security and got them to arrange a cheap deal since his estate was practically penniless. She organised a private ceremony at the crematorium. She didn't even tell us when the funeral was, but Pat rang and we found out from her.

Ad and I went early to the chapel, hoping we could view the body – Adam felt a need to – but of course we weren't allowed. The viewing had been at the funeral parlour and we hadn't even known where that was. The guy running the business wasn't even going to let us stay – it was a private funeral, you see. He

was surprised to find out I had been Ken's wife and Adam his stepson. Katherine, the bitch, had neglected to tell the funeral man that there was another whole family involved.

And then at the service he talked about Ken's *two* children. No mention of Adam and Paris. Ad and I held hands tightly to stop each other from getting up and thumping Kath. To top it off, before the coffin went sliding into the bowels of the crematorium, she got up there with a bloody camera and took photos of it! She was going to keep extracting her revenge to the bitter end.

Dear Patty left her family's side of the chapel and came and sat with us for the service, which helped us to hold ourselves together.

Merry, I don't know why I'm so agitated about all of this. I'm relieved Ken is dead, but I've had a strange week, fluctuating from the deepest grief to a weird sense of peace. Peace for Ken as well as myself. I guess I wanted Ken to have some dignity in death. After all, he had none when he was dying, screaming for help when he'd thought it would all be very quick.

Oh, shit. Thank God I had Adam over here to help me through. He's so matter-of-fact, puts everything in perspective. He's upset, of course, but doesn't show it like Paris. Hides it all away. Paris is confused, angry and carrying the guilt of the world on his 13-year-old shoulders. He's had a couple of shocking, bizarre nightmares this week and has begun sleep-walking again. I'm really worried about him.

The day before yesterday the four kids went to our old lake and sprinkled Ken's ashes in the water. They all decided that was where he'd like to remain. I stayed away so that they could share the experience together, and they all seemed to feel a little better afterwards. It gave Paris some sort of closure, at least. Fortunately I know the people who live there nowadays and they were very understanding about it. They let the kids wander around the property and reminisce about good times they shared there.

There is no marker anywhere to show that Ken ever lived. I would like a plaque or something, but it is out of my hands. It would mean a full-on battle with Katherine if I pursue it.

Perhaps it was meant to be this way. The police wouldn't let any of us have his personal effects. They all had to be burnt because cyanide powder might have got on them. How bizarre – everything else he ever owned was burnt in another fire. His car is to be sold to pay for a professional company to scrub the flat from top to bottom so it's safe for new tenants. There'll be nothing left of his at all.

Why do I even care? It's all such a muddle. Almost forgot – I haven't told the

police that I've got his watch. I'll have it thoroughly cleaned and give it to Paris when I think he's ready. At the moment he'd probably smash it.

We live and die and who cares in the long run? What difference does it make to anything, other than replication of the species? Feeling morbid, in case you haven't noticed.

June 1985

Merilyn, I've been too busy to write. All my time is needed for the painting. I've set the painting up several times in the Mylor Hall, which I need to do more and more often now to check the perspective and overall consistency. It fills the whole hall when it's set up in its circle and is looking good. The kids from the local primary school have been coming to check it out and the locals are excited. So am I.

Last time it was up a couple of people from the Arts Council of South Australia came for a look. They are talking about sending it on a tour of country towns once it has finished its stint in the Westfield shopping centres. This is hard for me to absorb. I've never had the backing of any arts body before, and am surprised by their enthusiasm. If it comes off it will mean me travelling with it and giving workshops. All this will be *paid*. Actual money.

Westfield are pleased with the progress, too, and are talking about taking the painting to their centres in Victoria, New South Wales and Queensland. Perhaps even one of their big shopping malls in San Diego – which would mean a paid trip for me to America. This is all airy-fairy at the moment – everything depends on budgets and financial stuff that I don't understand. I can't get too excited – have to concentrate on holding myself together long enough to get it finished. My goddamn health is still rotten and I'm losing weight like you wouldn't believe. Back and chest pain is with me always now, and standing to paint is hard work. Still, I've done more than I ever would have expected.

This painting is such a big project, Merry. If I could slap it up with a two-inch brush it would be a piece of cake, but I'm fiddling around with tiny brushes putting in every bloody detail. Can't help myself.

Enough of that, I have great news. I have a bedroom! Daine moved into a place with her boyfriend and I've taken over the boys' old room. This little house is too small for all of us and it was time for her to go, lovely as she is.

I've had a bedroom suite on lay-by for some time now. It's cheap and nasty but will do the job and is *white*. I want the whole room to be white except for heaps of green plants in white pots. The studio/lounge/kitchen/dining room is jammed full of colour and mess, and I need a quiet, clean room to rest in.

I had enough money to buy cheap carpet for the bedrooms – it's a sort of

mottled beige. I'd really like white wool carpet for my room, but that would cost more than the house is worth.

After Daine left I threw out all the old furniture and painted the walls white – they were dark brown before, remember? Ingrid painted the ceiling for me and she and Anna helped with the walls. I bought some really cheap white net curtains for the windows. You'd hate them and really so do I, but they cover the windows and keep everything white. I've shifted my old single divan in here for the moment, along with a small table and a white lamp that I bought at an op shop for five dollars. But in a couple of weeks I'll get the bedroom suite, which has a double bed. Fantastic! Even now, after sleeping in the studio for five years, I think I'm in heaven. I can shut the door when I want! I'm sitting on the floor to write this and the new carpet smells delicious. Privacy. Can't believe it.

Next day

Since Ken died Paris has been having shocking nightmares. He's fine when he goes to bed, but an hour later he starts talking, then shouting, then screaming, in his sleep. Sometimes I go to his room but even though he'll talk *to* me he doesn't seem to hear anything I say.

It's scary, Merry. I think Ken's suicide note to Paris is to blame. Part of it puts the responsibility of taking Ken's place and looking after me squarely in the kid's lap and that's unfair.

More and more, when Paris is sleepwalking he's taking on Ken's character. He looks right at me, eyes wide open, as he talks to me, often calling me filthy names, but he's fast asleep. He has no recollection next morning, just wakes up and goes to school like a normal kid. Sometimes, at night, he hides then jumps out to frighten me, and he talks all the time about suicide and killing other people. The venom that's aimed at me is terrifying. When he's really bad I'm too scared to fall asleep. I prop myself up in bed so I can see if he's crawling along the floor.

The poor kid seems to be possessed by Ken's spirit – but only when he's asleep. He uses Ken's words (heard, I suppose, as a small child sleeping in the next room) and plays out his actions. He hasn't hit me yet, but I won't be surprised if he does. It's got to the point now where I hide scissors and knives just after he's gone to bed. As soon as he's asleep, I grab his pocket knife from beside his bed. He'd developed this terrifying habit of opening it and waving it around while he was sleepwalking. If he knew what he says to me and the things he does he'd be horrified.

Sometimes he remembers portions of his dreams – devils hanging over his head, or Ken sitting on the end of the bed smiling at him. (You know that evil

smile Ken had.) When these dreams come he shrinks into the corner and screams and screams. I can't get near to hold him. He's so terrified that he hits out.

One night, Merry, he absolutely wrecked his room. Tore down his posters, ripped up school books, smashed furniture and put his fist through the plywood wall. In the morning he saw the mess, and asked what had happened. I said he must have had a bad dream and he accepted that without too much trouble. Once he's awake he's back to thinking about school and golf and so on. It's frightening. Shit, for the last five years I didn't sleep much because I was scared Ken would come, and now it's because Paris has taken on Ken's personality.

What a mess Paris must have inside his little 14-year-old head. I've been to see two shrinks about him and they both say it's healthy that he's dealing with stuff while he's asleep. They want to speak to him but he can't see any reason to go and flatly refuses.

I don't know how June and Pat are handling it because I haven't seen them much since the ashes business and the few phone conversations I've had with Pat have been stilted.

God, what a mess Ken left behind him. I wish he was alive again so that I could punch him out for what he's doing to Paris. Please put my boy in your prayers, Merry. He's always been so special to you that I thought you'd want to know what's happening. We need every positive atom that we can find to fight the evil that's got hold of him. Between all the folk that care I'm sure we can eventually beat it.

I'll try to write sooner next time and let you know how he's doing, but between one thing and another I don't seem to have much energy left for letters.

P.S. Lainee, a new friend who I met through Barb Groom, has some special psychic talents, along with many others, and she worked out a numerology plan for me. She told me that if I take the second 'a' out of 'Barbara' my luck will take a turn for the better. I've nothing to lose and was never mad about my name anyway. So, from now on, my professional name will be Barbra Leslie. Feel like I'm copying our wonderful Streisand. I should change it properly by deed poll, and might get around to it some day.

Love, Barbra.

31 August 1985

Hiya kid. Very late at night but had to write. Saturday – actually Sunday morning. On Tuesday the panels for the big painting go to the framers to be restretched before being photographed for the book on Wednesday.

Ad came up with the brilliant idea of doing a small book about the Coorong, to travel with the painting and maybe make some money. Colin Thiele will do the text for me (what a honey) and I'll illustrate it with sketches I made for the painting, and, of course, the panels. Colin is in love with the Coorong too. Yet another project I'm jumping into with absolutely no knowledge. Let you know what happens.

Today and tonight were my last chance to complete enough detail for the photographs. Only five panels needed more work, but they were the most difficult of the lot. Under the *best* circumstances, four or five hours would have been enough.

Last night, the second to last night I had available for working, Paris and I had a tremendous row and I couldn't paint at all. The air in the house was jagged with tension, even after we'd sorted stuff out and I'd explained the importance of getting these panels finished. Tonight, as he promised, he stayed in his room – apologising even for interrupting to get a drink or something to eat. Trying his hardest, but with a lost and lonely face that words can't describe. In the end, nothing got done, and I wonder if this is perhaps the major difference between men and women artists. You see, tonight was my *last* chance, for something that's going into print and can't be improved on ever again, with five panels unfinished and unsatisfactory. My last chance for fame and fortune, blah, blah, and immortality, the artist's dream. And I blew it, but in a strange way I think I won.

I had a shocking backache, still have in fact, and wanted two hours in bed after tea so that I would have the strength to work later. I was lying in my room, supposedly resting, while Paris sat in his with the television, when I got such a hit of need from him that I went and brought him into the studio, by the fire, and we talked until twelve.

I drank a bottle of champagne to help me handle the conversation, and to soothe the pain of sitting for five hours. This was a conversation to astound the experts. We communicated in a special way that is only available to parent and child on the rarest of occasions.

Had I left him in his room, miserable, and finished the all-important last touches, would we have had the same conversation three weeks from now? When an artist experiences a driving need to put down a new concept, an image exists at the end of the day that would not otherwise have existed. Try it the next day, and the whole mood has changed. That fleeting perception has been lost for ever. Well, this conversation, this need, this touching between mother and son, may be of the same importance as a painting, or

more so, or less. Either way, I chose to talk to my boy instead of completing the work that's going to be judged by thousands of people during the next year or so.

Strangely, I feel extremely peaceful about that. The conversation that we had, my adolescent son and I, was deeper than conversations I've had with adults at even the most intense times of my life. Even more amazing (to me) was that I could choose to discard the chance to perfect two years' work in favour of one night of indulgence with an edgy youngster. This painting has *become* me, yet I can still ignore it in response to vibes of yearning that come from behind a closed door.

Would a male artist give in to this pull? Would he even acknowledge it – or would his drive for perfection blind him to the presence of a greater need? Or am I just being a soppy female in talking this way?

My whole life, it seems right now, has involved juggling my work with the personal needs of my loved ones. I thought I had found a balance but tonight I was proved wrong.

I chose to teach and communicate in one medium rather than the another. A one to one basis rather than a one to thousands basis. And what we shared! Death, pain, and truth to its bitter end. Paris needed to clarify his obsessions about suicide, trust and hope. Life after death, spirituality, the universe, why we even exist. He can be difficult, my darling Paris, but I love him so.

Half-pissed, sore and tired, I am going to fall into bed, content. I send my love to you, Barb.

1 September 1985

Well Merry, the bloody thing is as finished as it's going to get for now. Why do I call it a 'bloody thing'? In a way I guess I love it – not as a painting, but as a statement of part of myself. In doing it, I have learned to love a part of myself that I had not accepted before. I don't know quite how to categorise that part. Words like pride, worth and strength come to mind. A certain knowledge about myself. As I write this I feel as if I should apologise for the egotism of it all.

After I get the monster back from the photographers I'll have six weeks to fiddle with detail before it must be left to dry, ready for varnishing. I don't know that I'll do much more to it. It's one of those works that will never be really finished – I could titivate and change and improve it forever.

I started painting it on canvas fifteen months ago and in that time I have improved my painting ability and knowledge. If I could start the work again now, it would be different. Would it necessarily be better? Just different, I suppose. I feel now, that I'm too far away from the beginning of it to be able to relate to it properly. Tonight may be the last time I'll touch it. But it needs more, here and there. I learnt so much last night with Paris about my relationship to my work, and where my real values lie, that it doesn't even seem important now if I work on it more, or not. So I guess it's done.

And I did it – against all the odds that you've heard so much about. Paris, Adam and my closest friends have seen me propped up on my walking stick at the easel, painting with tears rolling down my face, but even they wouldn't have an inkling of how hard I've had to push myself to keep on my feet, and keep that

bloody right arm up there with the brush. I would do it again, and of course will, in smaller doses, but this has been a life's effort.

How are you, and so on and so forth? Will write soon about life beyond the painting, but for now, Barb.

October 1985

Hiya kid, feeling melancholy tonight. Paris is restless, too. I can hear him muttering away in his sleep. I tried taking him to a local shrink who's supposed to be good with children, but we've had no luck at all. He did at least agree to go a few times, but said if we tried to talk about Ken or the fire he'd leave. And he did. Just walked out. He won't go back and I don't know what to do next. He's so tormented, the poor kid. It's like he's living two different lives – one when he's awake and one asleep.

I don't know how long either of us can keep it up either. I hardly sleep, and the emotion it takes to calm him when he's having nightmares is draining the life out of me. Sometimes I have to rock him for hours while he screams, cries and hits out in fear. When I eventually get back to my own room I break down and bawl – unless he's in Ken-mode, and then, terrified, I have to try to sweet-talk him back to bed.

He wouldn't hurt me when he's himself, but during the periods that Ken takes hold of his mind he's liable to do anything. His language is filthy – Ken's language. And he's very threatening, talks about killing. If he does ever hurt me while he's asleep he won't be able to live with it when he wakes up – not that he'll remember doing it.

And I told him about Dallas! He's been so sad since Ken died that I decided it was time he knew that he still had another father. Thought it might help him. I couldn't mention Dallas while Ken was alive for fear of another beating. Ken knew about him but wouldn't have his name mentioned in the house.

Anyway, I sweated over it for ages then I told him. Paris has always believed that Lester was his father (remember that I was still married to Lester when Paris was born – in those days we had to have been separated for seven years before we could get a divorce).

I don't know if I ever told you that Lester agreed to have his name as father on the birth certificate. I wanted it to be simpler for Paris – to have the same surname as Adam and me.

Les, for some reason, visited me once when I was in hospital during my breakdown and while I was pregnant. He never gave me any maintenance for Adam, so I figured it was the least he could do – and told him so. I had to tell the

judge in court Dallas' name in some secret sworn statement, so the truth is on record somewhere.

So I picked my time and told Paris that he had a living father who he hadn't met. I was dreading his reaction, but had to laugh at his response. Are there any more fathers anywhere, the kid said, Or is that it? He's some boy.

Paris said he'd like to meet this Dallas person, so I contacted him through his mother. We arranged that he would come for a visit. The meeting was awkward, of course, but went okay, and they've been out twice since, once to the Royal Show and once bowling. Dallas is bloated and gross, still as secretive and sly as ever, and I loathed him on sight. Isn't it queer how we can be involved with someone, in love even, and years later find that same person unbearable?

Beside being fat, Dallas is self-opinionated and stupid. Mind you, I was in mental breakdown phase when I met him, while he was in his early twenties and reasonably fit and attractive. I don't know if Paris likes him. It's early days yet and I think he'll be careful about letting himself care too much too quickly.

What a mess I've made, Merry. What a load of shit I've left for Paris – and Adam – to carry. It's the same old story. If I hadn't have done this and if I hadn't have done that. But if I hadn't had that foolish affair with Dallas, Paris wouldn't be here.

Here are a couple of flower paintings (oil) to cheer you up after this dreary letter.

December 1985

Merry Christmas, pal. Hope you like this year's present. Books are hard to pick for people, but I fell in love with this one when I read it and am sure you'll enjoy it. I remember you saying once that you'd enjoyed reading Jonathon Bach's *Jonathon Livingstone Seagull* so this little number, *Illusions*, should be right up your alley.

The Coorong painting is going to the State Conservation Centre to be varnished next month. Too big for me to handle.

The book's on the way too. At the printer's as we speak (write). Could be a complete disaster financially. I'm printing 3000, which is a lot, but it looks like the painting's going to do lots of travelling so I might be lucky. I'm paying for the publishing, which is costing nearly $4000, and I've borrowed $500 each from eight friends who all believe it will sell. Printing some concertina fold-outs of the painting as well. Yes, this is me, printing books and 'merchandise'. Would you ever have believed it?

Colin Thiele's text is great – it should be a nice little book. Will send copies once we get them. Have as good a Christmas as you can, my friend. Keep well and enjoy, love Barb.

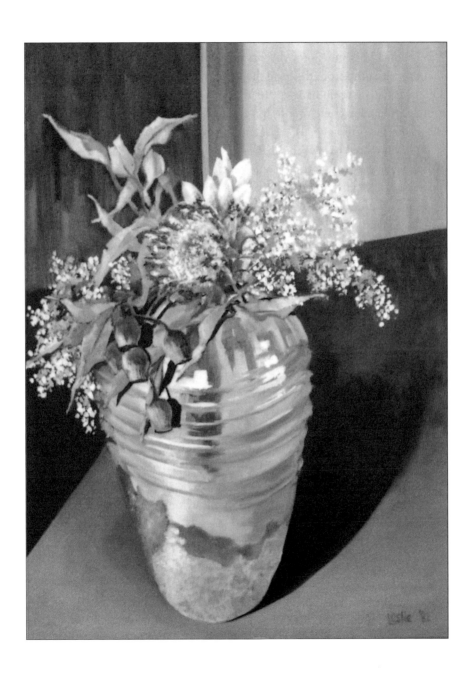

March 1986

My dear friend, thanks for all your letters and the beautiful scarf at Christmas. Nice colour! Very me. Sorry this has taken so long but lots to catch up on.

I'm writing this from the huge shopping centre at Westfield Marion. Bizarre. The painting is set up bang in the middle of the place in among the milling hoardes. Adam has come over to travel with it. He's setting it up, taking it down and so on. He's off having a break and I'm here for a couple of hours.

I feel honoured to have the chance to sit here and watch. As I've said before, artists never get to see how people react to their work. But this time I can observe – and so far the response is good.

I find it hard to believe, sitting here at the opening of the circle, that I've actually painted this bloody big thing – that I ever thought of it, and then that I ever finished it.

Next day – home

Found it impossible to write down there. Every man and his dog had a question to ask. Lots of people simply wanted to say thank you, or to buy a book or post-card. Selling quite a few.

Now. First, on Australia Day, I had the official opening at the Festival Centre. It was held outside under that big verandah at the front, and there were lots of people about thanks to the free entertainment – concerts and stuff on the lawns for Australia Day. It was a super special Australia Day this year too because it's South Australia's sesquicentenary (150th anniversary).

That opening went well, and now my painting is touring the suburban Westfields – Marion, Kilkenny and Tea Tree Plaza. Then it goes to six country centres. Six at this stage anyway. Ceduna will be the first. Adam will drive a truck over with the panels and I fly over for a couple of days to do teaching workshops.

And Merry, all this will be *paid* for. Ad's wages, the truck, Ad's accommodation and food, my plane, the motel – and so on. I guess some organised artists do stuff like this often and get paid for their time, but for me it's a new experience. The people at the Arts Council of South Australia, who send theatre, dance, art and music out to country centres have been bloody marvellous.

Now the *best* news. Paris is heaps better. He is practically over his nightmares and horror sessions. I guess I feel as if Ken has died all over again – but this time I don't have to grieve or suffer guilt, just enjoy feeling safe and free.

I was at my wits' end. The doctors and counsellors I spoke to couldn't say much since Paris wouldn't see them himself. Well, my great mate Steve (from

the welfare) recommended a friend of hers who deals with disturbed children. Paris really likes Steve and trusts her, so he was happy to see this healer with her. He didn't understand the gravity of the situation, but lately has been remembering some of his nightmares, especially the one where Ken sits at the edge of his bed. When they got back, he walked in the door a completely different person. He had an air of freedom and light about him. It was wonderful.

What had happened was a kind of exorcism. This healer asked him to 'call down' someone he knew who had died to help Ken find his way and the kid called down Babe and Kruger. What a perfect choice – the dogs adored Ken, so it was very fitting. Babe and Kruger took Ken with them so that he was not alone, and the weight that has been crushing Paris' spirit lifted immediately. Oh, Merry, I'm so happy. Relieved, for him and for me.

Paris will still have a heap of shit to sort out later in life, but for the moment, and for the first time since the fire, he can be a normal 14-year-old boy. I have thought sometimes that I will lose him to madness. Professionals have said that he'd either suicide or end up in gaol with a drug habit, anti-social and beyond help. I swore I'd never let this happen, but I seemed to be fighting a losing battle. Thank God he has a strong will and good soul.

Adam, fortunately, is in great shape. He's happy to be touring with the painting, although he's had to put the band on hold, and is pleasant to everyone. He's a real spunk, kiddo. You'd fancy him: 22, slim, wiry, broad shoulders, slim hips. About six foot two, short fair hair.

He has been living with a nice girl in Sydney for a while and seems to have life under control. Of course, I can't know what pain he carries from his childhood, the rejection by Lester and then the trauma of Ken. We talk about these issues a little, but he prefers to put problems away. It will be fun to spend time with him on this country tour. I've really missed him.

Russell, my hypnotherapist, has been reinforcing my self-hypnosis skills to help keep me fit enough to travel and teach.

Well, I'm going to bed now to *sleep*! Oh, the joy of normality. Goodnight my friend, and fondest wishes, Barb.

April 1986

Dear friend of mine, it's 12.50 am and I'm at the Wudinna Hotel (on the Eyre Peninsula) on a hot Wednesday night. We hear there are fires in the Adelaide Hills and I'm edgy – and drunk.

Had a full day teaching in Ceduna then a three-hour drive to here. I'm so knackered that I reckon I could get full on a carafe of water, let alone the

bottle of riesling that I had for tea. I just had to get my glasses because I couldn't focus to write. Thought it was because I was full rather than half-blind (half-blind?). I spent six hours today trying to jam six months of teaching into the Ceduna old darlings. They are so eager to learn and so *hungry*. I couldn't talk fast enough and they couldn't absorb fast enough.

Another workshop tomorrow with the Wudinna ladies and I guess it will be much the same. Wudinna is a small farming community about halfway between Port Augusta and Ceduna. Nice people.

I can't believe that I'm out here in the middle of nowhere getting pissed while bushfire is threatening the Hills and my darling Paris is there without me. He's staying with a mate. Once I saw the TV news I fell to pieces, then rang straight away to check that he's safe. I don't think I've quite recovered.

Tomorrow will be a full day before flying home in an incredibly small plane. Today nearly killed me – I don't have the strength to give any more. After this trip we go to the South-East: Keith, Robe, Kingston and Naracoorte. Next month to Port Broughton on the Yorke Peninsula. How will I do it? At least the *money* will be a godsend.

Can't say wish you were here because you'd hate it, but I must say the people are different to city people. Generous and caring. Grateful. Thoughtful.

Hope this note finds you as drunk as I am. Love, Barb.

June 1986

Merry, you'll be thrilled to hear I've met a man who has turned my life upside down. He's one of *us*. He can take me to the moon and back without any effort. He makes me feel young and tiny and precious. He's about ten years younger than me, a firefighter, and fit as a mallee bull. Fucks like a mallee bull too. I met him at the pub at Port Broughton when we were there with the Coorong painting.

Usually Ad stays in cheap digs so he's got more living money, while the Arts Council books me into the best motel in town so that I get a good bed. But this trip, the closest one to home, I had to drive over with Ad, so I decided to take Paris and his friend Daniel for a weekend holiday. That meant we had to stay at the cheap local pub. If I had been at a motel I wouldn't have met this fellow. Seems like we were destined to get together.

The kids had finished their tea and were out on the jetty fishing. After Adam and I finished ours we went into the front bar to have a couple of drinks. While we'd been eating, I'd noticed this man shouldering his way through the door but had forgotten about him because Adam and I had been deep in conversation. I think the only reason I'd even noted his entrance was that aura of danger about him that you and I love so much.

In the front bar Ad and I were enjoying a drink when I noticed that this same fellow was sitting on his own at the other end. On the spur of the moment, I told the barman to take him a drink – I was tired, with a heavy day coming up, and (I promise!) had no intention of trying to win this stranger. Sending him a drink was simply a way to say hi. I think.

As we've travelled around, Merry, we've drunk in interesting pubs and met fascinating people. If I hadn't sent him a drink, Ad probably would have. He was happy enough when the guy came over to join us.

We had a couple more rounds. The stranger told us he was on holidays from Adelaide and, well, to cut it short we spent the night together, and he said he'd like to come to see me when he got back to town. And he has. Twice in fact.

This relationship has nowhere to go Merry, other than bed. Which is fine. He's far too young for me and we have little in common other than sex. But in that area we're so well matched that I think all my Christmases have come at once. He's far better in the sack than Lester or Ken (and that's saying something) and I'm hoping we can continue seeing each other for quite a while. I don't want to let this go.

When I left Ken I thought that was the end of good sex, as *we* know it. I've had some good lovers since then, but none of that on-the-edge, anything-goes,

hard-as-you-can and slow-as-you-can spin-out sex. I forget about my back pain and gut ache and poverty and just fly.

Now I'm looking forward to the next phone call, the next visit, the next rapture. *You* know as well as I do how dangerous this can be. This guy, though, Michael (Mike), is a nice bloke. I don't feel any bad vibes at all. Still, early days.

Port Broughton was the last stop and am I glad it's over – I'm so sick of that bloody painting – if I have to set it up once more I'll scream. Poor Adam, he must feel the same. He's back in Sydney now, and I'm going to miss him all over again. We had terrific times together on these country trips; more like two friends than mother and son. I couldn't have found anybody better to travel with the painting. He knows how to look after it properly (because it's on canvas it can easily be damaged) and he can set it up and tear it down in a flash now. Most towns put on a reception evening with the mayor and arty folk in attendance. They were hard work, but Ad handled them with casual ease. I'm glad you're in another state or you'd be after his hide.

Anyway I can get back to normal now. I've been doing some nice, small watercolours – see enclosed photos – and hope to have an exhibition in Sydney in a couple of months. The medium for oils (turps and varnish) I used for the Coorong painting affected my lungs, so it's good to be working with water-colours again.

I'm writing this in bed on a stormy night. The wind coming down the valley is rocking the walls and rattling the windows. Rain is pelting down on the

iron roof. I feel warm and safe tucked up in my white bed in my white room. Ferns hang from the ceiling in their pots casting nice shadows. Paris is sleeping peacefully, thank God, and the dog and the cat are snoring in front of the pot-belly. I can see them from my bed. I have a lot to be thankful for. I hope *Withywindle* cossets you on these winter nights too, and that you're finding peace within her walls. Stay well and happy my friend, love, Barb.

September 1986

Merilyn, I've been tardy with writing, hon, terribly busy.

Sorry life is tough for you at the moment. Owning a house is terrific, but even the cheapest dump costs money to maintain. I don't mean your house, hon, I mean Mabel. She's a ridiculous excuse for a house, but every month there's some new problem to be fixed. It'll be worth it all in the long run, babe. It's a precious possession, that one place to go to that no one else can touch. Don't worry – it will work out.

I've just got back from a quick trip to the Flinders Ranges with Ingrid. Only two nights away, but lots to see. Not quite my painting material, a bit too pretty. Before that we had a few days in Sydney where we had a shared exhibition. Ingrid has a station wagon now, and we loaded all the paintings into the back and drove over. Forty paintings with glass! It was good fun. Ingrid had never been to Sydney so it was a major trip for her. She rarely strays far from Peter.

We stayed at the gallery owner's house for two nights then splashed out on a night at the Sydney Regent. The exhibition looked good but we didn't sell many. There was a flood on opening night – roads were closed and hardly anyone came.

Before that I went to Kangaroo Island for four days with the bloody Coorong painting. It was another Arts Council trip and I got paid for going, but I've got to the stage where I *hate* the painting. I can hardly bear to look at it, let alone talk about it to a bunch of strangers. New work is calling me – I'm really into the watercolours at the moment.

Paris is okay, but not having much luck with his new-found father.

I'm swimming regularly at the camp, but don't seem to be getting any stronger. My health is rotten – I'm thin and tire easily. My doctor still says there's nothing wrong. I sometimes wonder about looking for another doctor. Once they find out you've had a breakdown, I think, they stick a label on you. But at various times I've needed to see three different doctors at the clinic and they all say the same. So it's hard to tell. Perhaps I *am* neurotic.

Once I had a dreadful no-breathing turn while drawing here with Anna and Marg. We called one of these doctors to the house and I demanded that he put

me in hospital for the night. I was scared I'd die and Paris would wake up to Mum's dead body. Next morning the spasms had passed. The doc said, You see, Barbra, once you came into hospital your anxiety ceased. You are all right.

Pam's fine. Anna's fine. Tess and Ann are fine. Mum's hanging in there but beginning to feel her age. Too tired to write more, thinking of you, Barb.

October 1986

Merry, I've got plenty of time to write, as I'm in hospital with a bad back for a couple of weeks. A psychiatric hospital, even! The public hospital where the doctors wanted to admit me had no beds. Luckily, my friend Lainee is a big deal in this private psych hospital, which also has a pain unit, and she was able to get me in straightaway. It's a lovely hospital – so much nicer than the public one – but I'm surrounded by mad people whenever I leave my room – which isn't very often as moving is difficult.

Anyway, seeing it's a psych hospital I need to have a shrink as my specialist, as well as my back doctor, and I've been given a fantastic Chinese woman called Theresa. I'm taking the opportunity while I'm here to deal with some of the Ken shit. All these months later guilt about Ken's horrible death still haunts me. I want to put the whole affair to bed.

I'm full of pethidine and Valium, so please excuse my handwriting and my mood. I've not much to tell you, given my time here is taken up with pain and blessed, drug-induced sleep. If it wasn't for the boys, I think I'd give in and quietly die. When the spasms are this bad, death seems the easiest solution. I'm probably as crazy as all the other bods in this hospital. I wrote a letter to dead Ken the other night. You were there at the beginning, so I thought you might like to read it and share the end.

My darling Ken

I was talking today to a male nurse who used to work in Glenside while you were there. His name is Eddie. Adam, typically, has nicknamed him 'Fast Eddie'.

Porgy and Bess is playing on the tape. Remember? I loves you Porgy? Nina Simone is singing but you would remember Cleo Laine.

Anyway, Fast Eddie remembered me from somewhere and we worked out that it must have been from that first terrible lock-up place you were put in. You will be pleased to know that he liked you. I liked Ken, that was what he said. I suppose a lot of people you dealt with over those dreadful five years liked you even while they knew that it wouldn't make any difference in the long run, because the end was inevitable no matter what.

I want you to know that I loved you beyond anything and everything. Beyond

myself – or I couldn't have stayed with you as long as I did. I think you understand why I had to leave you, but you never knew how hard it was. I still loved you!

I know that you were bitter because I didn't visit you in Glenside, or that unspeakable hostel that you lived in all those years, but I didn't come because I still loved you, and couldn't risk you thinking for one moment that I might have you back, because I wouldn't.

Also, mixed in with this love, was the most shocking fear. I still feel it now, if I remember you hiding behind curtains, switching the power off and jumping out at me in the dark and coming to bed with a knife. Not to mention the terrible beatings that came out of nowhere – out of somewhere in your poor muddled head. Throwing me to the floor, spreading my legs with fierce kicks, telling me that's where I belong. Dragging me out naked in the freezing night and laying me against the frozen car until the skin on my back stuck to the ice. Making me feel like nothing, less than nothing. Not worthy of being alive. Beating me until I became begging, bloody jelly.

Yet I loved you and wanted to help you more than I can say. You were so alone and I could have made your life in that place so much easier.

I virtually made *the boys come to see you. They hated seeing you like that, in that place, and they always cried on the way home. Even Adam.*

Please don't blame the girls for not visiting you. They loved you, but were scared. You left us all in a terrible muddle, my love, and here it is 18 months since you died and we are still recovering.

June has a 12-month-old baby and is living on her own in the northern suburbs somewhere. Her life is almost wrecked, but she is strong. She may survive. Pat has just had her sixteenth birthday and her first baby and is living with an alcoholic ten years older than herself, at a terrible place in Wingfield. He will leave her and I don't know how she will survive, poor darling. Your mother died one year after you did, nearly to the day. She had nothing left to live for.

Paris, who loved you most, because he had the courage to keep seeing you, has had a terrible time, but will be okay. I don't suppose you ever realised that you frightened the life out of him with that sly evil grin of yours.

You sure left some damage, baby. Here am I, for instance, in a hospital at ten on a Saturday night, writing a letter to a dead man and trying to hold the tears back because there is someone else in the room. I resent the fact that you arranged for me to find you the first time, after the fire. Have you any idea what it was like to see you half-dead like that, blind, vomit and crap from one end of you to the other, broken, pitiful and help-less? I will never forget it. Do you know how I felt going to your ghastly flat with the police after seeing your poor swollen body at the hospital – smelling death and despair on your filthy sheets in that filthy bedroom, reading the letters you so painstakingly wrote before you took that damn poison?

And then, to know that you had my last letter on the bed with you when you died! I will never forget the smell of your death. That is one thing you didn't plan.

If only you hadn't been so sick, I would not be so shockingly lonely now. We would be together until it was the right time for one of us to die.

Sometimes I have hated you for wrecking my life, our *lives, but I'm writing to tell you that I forgive you, because I don't think you were given the strength to handle the depth of your feelings. Do I have that strength?*

I think that you grew a lot in that last terrible five years and in the end killed yourself because you were beginning to love Paris too much and knew what would inevitably happen. I thank you for that. And wherever you are, I hope you know that I am writing this letter to you and that it is all okay. I will always remember the good times, and my head on your shoulder every night.

With every ounce of love in me
Yours, Barb.

December 1986

I'm just home from an evening in town with Anna, and too high to hit the sack. We often go to a small Lebanese restaurant called Quiet Waters – maybe it was there when you were still in Adelaide. It's cheap, the food's terrific and it's BYO, so it's manageable on our miserable finances.

It's been a stinker of a day and it's still warm, even up here. The city was humid and thick, volatile. As we walked along Hindley Street I expected the busy restaurants and night spots around us to self-combust. Quiet Waters is downstairs, and we sat close to the staircase so that when the place exploded we could get out quickly. Really, Merry! It's one of those eerie nights.

How the hell are you? Haven't had a letter for a while. Hope your back's not giving you too much trouble. It's a real bastard, aint it? You have all my sympathy. By the way, did you realise that depression and back problems are related? Chronic pain, of course, can make you depressed – but you might not know that damage to the vertebrae can cause oxygen depletion to certain areas of the brain. I'll swear the majority of that fucking breakdown I had was due to problems in my neck. Ken made me go to see some healer person. I don't even remember her, but she did something to my neck and I felt a rush of blood surge from my neck up behind my ears. Since then I've never experienced that same deep, dark, hopelessness. I know you live with it most of the time. So keep it in mind, kiddo. Get yourself someone good to check out your back and neck.

Met a nice local guy the other night. He's divorced – very handy. No big deal, but he's pleasant company and not bad in the sack. Anna has met a fellow

who she's seeing quite a bit of, which is great, and this guy, Clive, is a friend of his. He's scrumptious looking.

I'm still seeing Mike the firefighter and *that* one just gets better every time. We haven't been out anywhere yet, other than the pub for lunch one day, and might never. Every time he comes we end up screwing for so long that there's no time to do anything else. Suits me! He makes me feel like I'm thirty again. Greg, the airman, has been over again and that's nice for a change, too. He's somebody that I can talk to, at least. Interesting and bright.

It sounds like I'm out every other night (or screwing every other night) but I'm not. Greg's visits are a long way apart and my fit firefighter only rings every two or three weeks. So far I've only rung him once. He works odd hours and is also seeing other people. Anyway, Merry, I don't think I could handle seeing him more often. He fucks like every time might be his last. I have to spend a couple of days in bed recuperating every time I see him. He's sensational, but I'm not strong at the moment and couldn't handle a full-on relationship.

I'm painting like a demon, mainly watercolours. Have to start earning money again. The Coorong painting didn't earn me a cent, other than touring payments. The book, however, has been selling well and I've recouped my costs with still a few left to sell. Fortunately I've got two galleries now that sell nearly everything I do. Just have to do the work.

I've been seeing Theresa, the psychiatrist that I met in Lainee's hospital, working out, or trying to work out, stuff about Mum and John. Theresa is so different from the shrink that I was seeing when I had that stupid breakdown. She's straightforward, clear-thinking and sensible. We relate well to each other. I know that every woman and her poodle is carrying some sort of shit about her mother, but sometimes I find it hard to separate mother and brother, so for me it's like fighting a team. It's slow going.

Theresa is also helping me with Paris. He's better than he's ever been since the fire, but he's still wearing anger like a monkey on his back – though he's not aware of it. Every now and then he loses his cool altogether and becomes very hard to handle. These are not just the ordinary mood-swings of a teenager. I may never find out what's behind it all – basically I think he's angry with Ken, but can't admit it to himself because of his love for his 'dad'. Deep inside this kid is a sensitive, wise, spiritual, empathic person. Sometimes I catch a glimpse of that person, and then he's got the shutters up again. It's all going to take time.

Here I am, nearly 47, and still trying to work out who I am and why I do what I do.

Couple of weeks later

Started this before Christmas and now it's nearly New Year! Hope you got my card in time and sorry about no parcel but I had a hard time finding enough for the boys this year. So what's changed?

Hope Christmas was all right for you, my friend. You've been in my thoughts a lot lately – I hope that's a good omen.

My Christmas was terrific! Adam and his new lady rocked up on Christmas Eve – the best present I could ever have. He'd said he might possibly be able to get over but I hadn't let myself get too hopeful on the strength of that. So here we all were, the usual crowd on Christmas eve, and in walked Adam and his girl through the front door.

I fell in love with her on sight. She looks like a magical, lolly-pop doll, all shy and tremulous but with an unmistakable poise. She was wearing a multi-coloured, three-tiered, gathered skirt, and make-up to match. She's strawberry blonde, stunningly beautiful and obviously very much in love with Ad. She's an actress and her name – her real name! – is Leverne. She's intelligent, inter-esting, delightful and strong. She's one of *us*, too, and I can talk to her on any level. If I had a daughter I imagine she'd be a bit like Leverne. I'd like her to be.

Ad is smitten. It's lovely to watch them together and share their joy. Ad's last lady did the dirty on him while he was touring with the Coorong painting – he went back to Sydney only to have his heart broken. I'm happy that he's found someone so soon, and someone so fucking wonderful. We had a great visit, got drunk together and talked our heads off.

My strongest wish, Merry, is that my boys find good women to share their lives with. Their young lives were full of trauma and they missed out on good family relationships. Their fathers, of course, were a joke, and they only have Mum instead of two sets of grandparents. They'll treasure memories of her, but it's not like growing up cosseted in a large family.

Speaking of fathers, Dallas is turning out to be a whopping disappointment. He sent Paris a Christmas card. Just a card. No money. No present. God, he's a stingy bastard. Paris was really disappointed. Dallas is petrified that I'm going to ask him for money if he acknowledges that he's actually Paris' father. It seems to me, Merry, that he should consider himself extremely lucky to have the chance to have a relationship with a long-lost son – especially one who is already grown and paid for. I haven't asked him for maintenance all these years and, besides the fifty dollars he gave me when he found out I was pregnant (along with a lot of promises), he's had to pay exactly *nothing* towards his son. He's divorced now and has a daughter by his second marriage. Other than that, he seems a lonely man.

As for Lester – he didn't even send Adam a *card*. Fucking idiot.

Men stink, Merilyn. I don't know why I have anything to do with them. If I could instantly turn lesbian I think I would. I'm sure women must treat you better. Unfortunately, I still love the smell of men. Their hands. Their necks. Their strong arms. At least poor old Ken did eventually try to be a good dad to the boys (even though he blew it).

Enough of all that. Paris and I went to Patty's for tea earlier in the month. The dear duck is living in a semi-detached in Elizabeth now. It's a rotten neighbourhood and the house is too small to swing a cat in, but she keeps it neat as a pin and decorates it with plants and bits and pieces. She seems in good shape and I have high hopes for her. Her babe is healthy and well cared for.

June is expecting her second child and has a new house in an atrocious new estate in the same area. She seems the stronger of the girls, but I feel she's hiding the burden of Ken, and that only her stubbornness will pull her through. Visits are painful for all of us. Ken and Katherine hang like a wall between us.

Well kiddo, must end this tome. My love comes with it.

February 1987

Hiya kid. Hic! Just a wee bit pissed and high. About 3 am, again, and definitely not ready to hit the white bed yet. My solo exhibition opened today at Studio Z, and it was a stunner. Sold lots of paintings, so will get some *money* honey!

This gallery has two massive rooms joined by an archway. The biggest room had the new paintings – 45 in all, 14 oils and the rest watercolour. The other room had the Coorong panels hung on the wall at the proper height with spotlights. It looked bloody magnificent, if I say so myself. It was in a rectangle instead of a circle, but with the panels angled across so the corners were not too sharp. This is the first time I've seen it properly displayed and I got a hell of a kick out of it.

Colin Thiele opened the show with a great speech and there were about 200 people there. I felt quite the artist today, but know from experience that the next month will be an anticlimax so I'll keep tonight going as long as I can.

The couple who own the gallery now, Annie and Brian Guthleben, have been real pals. If a painting sells, but isn't yet collected and paid for, they'll advance me money if I'm broke. This is a very good thing.

Besides this show I've also been doing sets of three watercolours for another gallery that is selling them like mad to business houses. So I'm exhausted. And crook as well.

Been seeing the fireman (came yesterday) and Clive. Greg the airman had to go. Last visit he had the cheek to say he needed to see me to recharge his batteries. Warm your hands at someone else's fire boyo!

The sex is good. Fabulous with the fireman! It's all I can cope with, but sometimes would like someone to rely on.

Paris is pretty good other than his anger. Year 10 this year. Driving soon. I've lost my baby. Mum's had a hospital visit and is getting old. Seeing quite a lot of new friend Lainee and hope that friendship keeps growing. Ilze fine. Tess fine. Annie not happy. Pam good. Anna fine. Ingrid fine. Lyn fine. Erica fine. Ad and Leverne fine.

Ah Merry, all these good friends but no one quite on our wavelength. Are we complete outcasts? Are we mad? Are we *bad*? Some of the things I do would shock the pants off even my dearest friends here. I'm lonely. I miss you. Been a busy day. Your friend, Barbra the magnificent.

May 1987

Merilyn, today I'm writing from the shearers' quarters at Paney Station in the Gawler Ranges. These ranges are flatter and more barren than the Flinders, but beautiful. I'm here for a week teaching the women from Ceduna and Wudinna. I've written to you from some odd places over the years, eh? Seems the only time I get to write is when I'm away. There's so much to do at home and by the time I'm finished I'm too fucked to sit and write.

I've had to stop reading, which is a shit. I've always loved my books, as you know, but getting into a comfy position to read is difficult. Writing and painting are difficult, too, but I can't stop those. Just have to do less.

These country women are a great bunch – and very understanding when I need to rest. There are 15 in the group, ranging in age from late teens to sixties, which isn't a large class by any means, but when they're spread out all over the side of a hill, it makes for hard-going. Teaching is draining at the best of times, but out here I have to do lots of walking as well. Thank God for the good old walking stick!

These shearing quarters are an experience. I have the best room (the cook's) with the best beds – and *they're* rough. Two single beds, wire bases, and old flock mattresses. One table, one small wardrobe. I think the other rooms have bunks.

We eat in the shearers' dining room around four long tables with plank seats. I had a few beers before tea and wine with the meal, so I was relaxed for critique and lecture time after the meal.

I'm off to Naracoorte in the South-East in a couple of weeks for a two-day

workshop there and then I think I'll have to call it quits. I'm not up to this teaching business anymore. But I like the pay and still love to teach.

Paris stays at his friend Dan's place when I go away so I know he's safe and Dan's mum is great with him.

Two more days of this before home. Can I manage it? I must.

June 1987

Hiya kid. I'm sitting by the fire with a Scotch and a fag, thinking about the frailness of women. Frail is a word that Anna uses when she talks about me, but I've never related to it until tonight.

I was driving home, after an evening at Ingrid's, along Stock Road, a narrow, winding, steep road that you can't take too fast even in daylight. A souped-up panel van came up behind me and sat bang on my tail for a couple of miles, with its lights on high beam, all the way to my driveway. I took it for granted that the driver was male, and eventually saw that I was right. Two men in the car. I was extremely frightened. There were no other cars around, and I was afraid that they were going to push me off the road. The Charger's lights are not good, and I didn't want to take risks on this of all roads.

I am still rather frightened. They know where I live. After the pub closes, they might drive around the house and hassle us.

If I were a man, I wouldn't, of course, have this nagging fear. I wouldn't be

anxious to go to bed. It underlies everything, this fear of your physical inability to cope – this fear of rape, of not being able to control what happens to your body. As if you didn't own it.

Sometimes I get sick of talk-backs, women's groups, mags and the telly programs about rape. Rape discussed, dramatised, theorised about everywhere you look. But like every woman, I have the perpetual problem of my physical inability to cope with men's violence. (Mental inability too.) And I *know* about rape. And violence. Rape of the soul more than rape of the body.

I suppose many men – small men, lonely men, deformed, ill or weak men, also have to live with the fear of physical attack. Soldiers who went through prisoner of war camps would know about it, and men in prisons. But *all* women know the fear. They carry it around all their lives like a parasite. I would like not to have it.

P.S. I'm very pleased with the big oil under the jetty. It's taken months to paint and the photo doesn't do it justice. When you're in the room with it, you catch yourself having to look at it every now and then because you could swear the water was moving.

You can't see when it's this small, but I put graffiti on the timbers. The main piece says: Passion, Passion, the Grand Vivisector. This comes from my weird association with Patrick White's book, *The Vivisector*, which is about an artist. Do yourself a favour and get a copy. It's one of my favourite books of all time, along with Henry Miller's *Tropic of Cancer*.

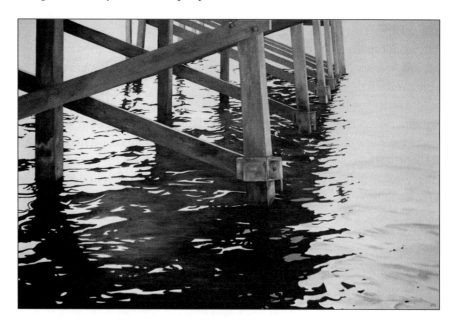

July 1987

Merilyn, I'm on a plane home from Sydney after visiting Ad and Leverne in Katoomba compliments of the last teaching stint. Got an aisle seat, damn it, so I can't watch the clouds, which I love. Do you know Katoomba? It's high in the Blue Mountains, on top of the world. Breathtaking scenery. The kids have been living there for nearly a year and *Leverne is pregnant*. I'm going to be a gran. Un-fucking-believable. I'm only 47.

They have a beaut little house on the side of a hill, decorated with junk and tat as only they can, full of books, lovely old clothes, musical instruments and atmosphere. Ad's been doing a hospitality course and has part-time waiting at an exclusive restaurant. Until recently Verne's been commuting to Sydney for a mini-series that she's acting in called *Dirtwater Dynasty*. Keep your eyes open for it, it'll be on the ABC.

We had fun. Ad drove me to the best spots and we walked (where I could) right on to the precipice of the mountains and stared down hundreds of feet.

Gee I love Ad, Merry. He's such a magic man – so at home with nature. We saw a fucking great snake curled up on the warm bitumen. Ad pulled over and went back to move it to a safer place. I got out of the car to have a look and he said, Stay back, Ma, this is a King Brown and very deadly. With that, he gently picked it up and put it in the scrub on the side of the road. It was about eight feet long. The bloody thing headed back on to the warm road again, so Ad scooped it up a second time and took it further back into the scrub. It made no attempt to bite him either time. I felt honoured to witness this. It reminded me of the times at home when he carried deadly baby browns around in his pocket and handled his two big pet pythons with such ease that they were perfectly relaxed and unafraid.

Did I ever tell you about the magpie that got tangled in fishing line? We saw it in the grass at the lake as we were leaving to drive Ad to high school. Well, Ad had to help it. He picked up the struggling bird and ever so slowly untangled its little feet, neck, body and wings. When he set it loose it couldn't walk or fly – it just flapped and rolled away into the grass, frightened and helpless.

Ad approached the bird slowly, squatting three feet away and keeping very still. He picked up a long twig and, talking quietly, began stroking the magpie with the edge of the twig. Gradually he moved closer, still talking and stroking with the stick, until he was close enough to put the stick aside and stroke the poor little thing with his hand. I say 'poor little thing', but magpies can rip off your finger if they so choose.

Eventually Ad was able to pick up the bird and cradle it in his hands. It was

completely docile. He put the magpie in one of his big aviaries and, a couple of days later, when it had recovered, he let it go.

I had been on my way to TAFE, and had with me one of my students. The student and I watched fascinated as this drama was played out. We were all late for school, but I didn't care a jot. I felt as if I'd witnessed a miracle and so did my student. I've never forgotten that morning and expect I never will.

Later

Back home now, and bright as a button. I always miss Ad, but once I see him again I'm fine for another year or so.

While I was away Paris went camping with one of his mates and the mate's dad, and really enjoyed himself. He misses out on male stuff. He's been brought up surrounded by strong, opinionated women.

I've got a potter living in the old pigeon loft out the back. It's the only out-building that survived the fires, and bit by bit the boys stripped it down and lined it out to make two rooms. The ceiling's low and it's small, but it has been a haven for both the boys. Paris has used it a lot since Ad left – he even had a small pool table in there for a while.

Well, Katie Jenkins, the potter, was stuck for somewhere to live. She's a friend of Anna's. Being a creative potter, she's got no money, of course, and is using the loft for a while in exchange for fixing it up.

I'm happy to have the company, and it gives me a chance to go out more often. The fireman comes to the house and stays overnight, but otherwise I prefer to go out when I want to play up. My white room is my sacred place and I don't want males fucking up the serenity of it (so to speak).

Wow. I'm still full of Katoomba's beauty and the news about Ad and Verne's baby-in-waiting.

I had the strangest experience driving back from a workshop at Keith not long after I'd found out Verne was pregnant. It was dusk, and I was facing a four-hour drive on straight country roads. Fairly cool and the window up, Tina Turner going full blast on the stereo. Tired, but pleased to have been teaching and earning money. Clear skies, stars coming out with the dark. Driving fast.

Suddenly I got a fucking great belt in the guts. A belt of knowledge. Out of nowhere I realised that Adam's baby is the closure of my circle and has been the reason for my life. I thought I'd discovered something wonderful. My head was exploding with the magnificence of this knowledge, but by the time I got home I was feeling sick. Next day I went to the doc. Turns out I had carbon monoxide

poisoning. There are holes in the floor of the dear old Charger and my exhaust pipe had rusted out. All the way home I'd been breathing in exhaust fumes, along with tobacco smoke, and had been hallucinating. Yet I still feel that the grandchild revelation was true.

Speaking of smoking, when I had the chest X-ray for chest pains they showed that I've got the beginning of something called Chronic Restricted Airways Disease. This can be very nasty, like emphysema, and the doc said I had to give up the fags. I've been trying really hard (really!) and had tried hypnotism to help as well as bloody terrible nicotine chewing gum. The doctors kept saying that I had to aim for *quality* of life. Well, while I was sitting on top of this magnificent mountain at Katoomba, looking for miles in all directions, I decided that *my* quality of life was to sit there peacefully and have a smoke. And I did. It's too hard for me, Merry. I'm weak as piss.

Ha, I can imagine your reaction! I know you *hate* smoking. You gave it up all those years ago because you couldn't stand the smell of smoke in your hair. I don't think I can smell myself at all, which is fortunate because I *love* every single fag that I have. If I drop dead because of it so be it. This lung disease is a slow growth one and I figure I'll still have time to bring up Paris. Yes, kiddo, I know. Not good enough!

I very nearly got to go to San Diego last week. Westfield were going to fly me and the Coorong painting over there for several weeks. I'd even started thinking about packing and organising Paris it was so definite. But at the last minute it all fell through because of some stock market fiasco. I don't under-stand all that stuff. Probably good that I didn't go. That long plane trip would kill me quicker that the fags.

Must go to collect the boys from tennis. Paris is very talented – he's playing for both the junior and senior teams. He's a natural at sport and between soccer, golf and tennis I'm kept busy doing a taxi run. Love, love and love to you. Hope all is well at *Withywindle*, Barb.

September 1987

I'm writing by candlelight in bed late at night, Merry. The candle is behind my shoulder and I'm writing in the shadow of my hand – it's like a puppet on the page. There's a terrible storm outside. The power is off. Terrific winds are beating at the walls and finding every window frame and crack. The rain is coming horizontal and hard.

Dear Paris is tucked up with the cat in front of the pot-belly stove. Light and warmth. His own room was disturbing him – too dark and noisy. I have one

candle in with Paris – I can see it from my bed – and two candles in my white bedroom with me. A glass of liqueur, a cigarette and the pen. I am counting my blessings.

This little box of a house, scorned by many and loved dearly by those who know her, shakes and creaks, and at times is gently lifted by the wind. Just enough to make the hanging plants swing lazily from their hooks. It's like floating on a calm sea in a large boat. The candlelight in my white room is pure joy. Everything I ever wanted from this fantasy of a room is mine tonight. Pale shadows of fern, upon paler shadows, upon paler ones. A delicate image.

Yesterday Rita (who bought me the sexy boots after the fire) breezed in and, with much secrecy, brought me a surprise for the white room. The beauty of it made my legs weak. On my plain white dresser (very long and low it is, with a square mirror on the top) she had arranged a pair of white, rectangular vases and a delicate white china spiked-heel shoe. The vases held a Japanese arrangement of white blossom, the longest piece being about five feet in length. An asymmetrical wonder backed by its own reflection in the mirror. Tonight, by candlelight, it surpasses definition. I wanted to share my joy with you on this stormy wild night of luxury.

October–November 1987

My dearest. Fuck, how can you be 40? Isn't age sneaky? It creeps up when you're not looking, and next minute you find you're a hell of a lot older than is acceptable.

I remember the first time I saw you – it's a picture I'll hold in my mind forever. I don't know whose place we were at – might have been that big blonde prostitute's, can't remember her name – but I was there with Annie. You walked in with Rae, a few steps ahead of her as you came through the door. Every single person in the room stopped and looked. You were wearing a charcoal-grey cape over black tights and incredibly high-heeled boots. Your shining red hair was pulled back, and up, with a big, loose, ponytail at the top of your head. Your hair like that highlighted your cheekbones and your eyes. You were stunning.

Then I watched you dance, on tiptoes and *always* holding your body straight. With those bloody four-inch heels you used to wear, you'd have to be on tiptoes to be able to dance. You were so goddamn graceful, moving like a ballet dancer.

If I was *ever* going to have any lesbian tendencies they would have surfaced that night, but as it was, instead of lusting after you, like most of the women in the place, I just wanted to get to know you. I wanted to be friends with this woman who carried herself with such style and pride. That's how I remember

you best. You would have been in your very early twenties then. And now you're 40!

I know damn well that you'll be horrified when the first wrinkle appears in your creamy skin. I wonder how you'll deal with that one. I already have heaps of wrinkles around my eyes and mouth, but I've abused my skin something shocking – too much beach sun and salt. At 47 I still haven't got into the habit of rubbing cream in once a week, let alone every night.

You've always looked after your skin, and I don't think you'll have any worries for another 20 years. But I know how much you dread old age and the loss of your beauty and active sexuality, so this birthday must be a traumatic one. Still, kid, if you can pull a 17-year-old at your age, you've got a long way to go before you have to hang up your lace suspenders.

I have to say, Merry, that my own life has been wonderful since turning 40. You'll probably laugh at that after all my dreadful letters full of pain and poverty, but emotionally these last seven years have been my best so far. There have been all the Ken dramas, Paris' problems, my constant illness, but being on my own without the shackles of a husband – and the fear that went with Ken – has given me time to contemplate and consolidate and I'm finding a whole new sense of self.

I'm sure that the old adage 'life begins at 40' is to do with the pace slowing down, enabling us to begin sorting out some of our shit and finding peace and contentment. If you ever stop partying long enough, this will happen for you, too. But what's wrong with partying until you drop dead? Nothing, I suppose. I'm talking from my own point of view, as usual, and since I have to spend so much time in bed – not quite as pleasurably as you, unfortunately – I've had heaps of thinking time and, despite the problems and the constant pain, in a strange way I'm pretty content.

I hope you and Cheryl will have a marvellous celebration. She sounds wonderful. I'm so happy that you have a stable relationship at last. From what you tell me, your minor indiscretions are purely that, and as long as they don't affect your relationship with Cheryl, and bring you pleasure, I guess there's no reason to change your lifestyle.

Celebrate you must, my love, even though 40 is a milestone that you never wanted to reach. It's a minor miracle that you've got there at all. I wish I could be with you to share the day and night. I did seriously consider popping over, but there's no way I could find the fare.

I shall sit by the fire with a Scotch, 'The Way we Were', and toast your fortieth.

December 1987

Hiya kiddo. Thanks for your letters. I've had to put most letter-writing aside, unfortunately. Any energy I can find to sit at a desk has to go into my painting. Believe that you are in my thoughts often even if you don't hear from me.

Recently the pain has been nearly unbearable. It feels like my entire back is fucked even though X-rays can only find minor problems. I'm eating well, but have lost two stone.

For me, the kids are always the reason to keep on fighting, but I don't know what helps you to hang in there. Thanks, thanks, thanks for the dresses. It was a lovely surprise to get them but they're a bit grand for me and God knows where I'll wear them. They both fit beautifully because I'm so skinny now and the cloak with the hood will cover a multitude of sins. You say that now I'm famous I'll need these dresses, but I'm hardly famous and practically never go to anything formal. Famous in Mylor perhaps.

Christ that sounds miserable. Not a nice thank you at all. I do love them, Merry, and will treasure them. I'm just having a bad day.

Later

Hi, ho, kiddo. Better day today. Lots been happening since I last wrote. Paris turned 16 in June and has been having driving lessons. He got his learner's licence and we found a little Torana for him. It was his pride and joy, but the day after he got his P plates, on the way back from tennis, he wrapped the car around a stobie pole.

He rang from a nearby house for me to pick him up. Oh, Merry, I can't describe how I felt when I came over the hill and saw the car, completely wrecked, around the pole. I couldn't see how he was alive, let alone well enough to ring me. I felt like vomiting.

Anyway, he was okay except for a few bruises and some wounded pride. These Hills roads are dangerous and it was purely lack of experience. But now we have to find another cheap car for him because he starts work next year as an electrical apprentice. He's got a promising job with a firm that contracts to different companies for short periods. This means that he'll get experience in all areas and will have to learn some people skills. Fucking Dallas was actually some help. He's an electrician, too, and gave Paris help with his CV and advised him on which companies to approach. Other than that, Dallas is a dead loss. He expects Paris to ring *him* all the time, not vice-versa and knows Buckleys about how to treat a 16-year-old. For instance, he said he'd take Paris and Dan on a fishing weekend, which sounded grand. Then he rang and asked me to go

along as well because he was nervous. A fishing expedition with Dallas sounded like hell, but for Paris I'd do anything, so I went.

Turned out Dallas had arranged for a couple of his friends to join us, and was also taking his young daughter, so you can imagine how much attention Paris got. All fuckwit Dallas wanted to do was sit in the pub and drink. He sent the boys off to fish on their own. Jeez, he's a dill. Anyway, between that and a few other disastrous outings I think he's blown it with Paris. What a wanker! He always was a self-centred bastard and I don't know why I thought he might change. It's his loss, the creep.

Gee, I love Paris, Merry. It's so hard to watch as he has his heart broken all over again.

Adam's been over for a visit, which is always a thrill. He's well and happy, as ever, and seeing him cheered me up.

My boys are going to be a special brand of fathers after the harsh lessons they've learnt. I have immense faith in them as people and know they could never perpetuate the circle of violence which surrounded their childhood.

I'm still seeing Mike the fireman, though he's nervous that I might want more than a casual affair. I don't. Remember that heroin addict you were seeing when you were living in Adelaide – how he was fun, and on the edge, when he was high, but bored you silly when he was straight? Well, our relationship's a bit like that. We always drink a bottle of Scotch and smoke some dope. He's usually stoned or had a few when he rings, so he's very high while we're together. Dancing, loud music. Wild sex. Great conversation. Next morning, sober, we've got nothing to talk about. He's really too straight. I'd be bored shitless in a week. Besides, he's still young and should find a young woman to marry and raise kids with.

The problem with us, kiddo, as I see it, is that our values – our limits – stay the same whether we're drunk or sober. I want to walk that fine line 24 hours a day and I know you do too. One night Mike said that he wants all there is all the time and I can relate to that – but I don't only want it when I'm pissed and stoned. I want it first thing in the morning, and at midday and all through the night.

Anyway, hon, here's your Christmas letter. No prezzy this year, but an envelope of love. Stick it in a drawer and pull it out whenever you need it. Oh – and watch out for 16-year-old drivers! Heaps of love, Barb.

18 January 1988

Well. You now have an official granny as a friend. Ad and Verne had a baby girl yesterday. Mother and child doing well. Baby's called Belle. Must say I don't feel

like a granny. When Ad rang to let me know, I asked Paris to take some photos
of me in my bikini.

Yours sincerely,

Grandma Barbra

Granny Barb

Grandma Leslie

Grandmama Leslie

Nanna Leslie

Nanna Barb

Barb

February 1988

Hiya Merry, I have wonderful news. I won a painting prize. Two grand! The
money didn't go far because I had to travel to Sydney to collect the cheque from
the Governor of New South Wales at the opening of the exhibition. Even if
they'd offered to post it I probably would have gone anyway – it was a chance to
see Adam, and Mum has been wanting to see the baby – so I'm not complaining.

The competition and exhibition were sponsored by the Master Builders'
Association and – surprise, surprise – entries had to feature buildings. Anna saw
the entry form and talked me into sending a couple of my watercolours over.

I hardly ever go in competitions, mainly, I guess, because I don't think I'm
good enough, but also because of the costs of entry and transport and the
nuisance of packing. Anyway, I sent two off and one of them got second water-
colour prize.

Art is a funny business, Merry, and sometimes unfair. Three hundred works
were selected for the exhibition from across Australia but only four prizes,
two for oil or acrylic and two for watercolour. First and second prizes for oils
were $26,000 and $6000. First and second for watercolour were $6000 and
$2000. Even one of the Sydney critics wrote an article about this anomaly. If
anything, watercolour is more difficult than oil and the allocation of prize
money was odd. Not that I'm about to sneeze at two grand. Or the glory.

The opening was a black-tie and champagne affair at the Holdsworth
Contemporary Gallery. Invitation only, and very up-your-nose. I was invited to
bring my 'partner', but I took both Ad and Verne, which was very daring. Shit,
do these smarmy openings get under my skin! But with Ad and Verne for
support it was fun. We drank heaps of champagne and felt very wicked among
the socialites with their one glass, dahling. *And* the critic said in his article
that my painting was 'one of the best works in the whole show'.

First off Mum and I stayed at Ad and Verne's at Katoomba for a couple of days, then we went down to Sydney where the kids joined us for two nights but stayed with friends. Little Belle is gorgeous. I got to hold her many times, but my greatest pleasure is seeing Ad interact with her. Watching them together makes life seem so simple. The more I see of Leverne the more I like her and I know she'll make a fine mother. Adam is staying home to look after Belle while Leverne keeps up her acting career. Actors need to grab each job that comes along, because it's often a long wait between drinks.

I wish you could have a grandchild too some day. Horror of horrors, I hear you say. Even getting a bit late for you to be a mother now – not that you'd ever wish to be one I imagine.

Life dags along nicely enough at Mylor. Paris has started trade school and is discovering that he's far brighter than he thought, which is very good for his self-confidence. I hope I'll be around to see Paris holding his babe one day. Seems unlikely the way I've been feeling these last years. Doubt if I'll make it to his twenty-first.

But for now, a prize is a prize is a prize. Enclosed photo of winning piece for you to admire. Yours always, Barb.

April 1988

Thanks for your letters. The only positive response I can muster is to say that it's always better in the morning. And that's not necessarily true. Life is hard work, and sad.

I'm low myself for one reason or another. Dear little Patricia got married recently, and the 'celebration' and its aftermath broke my heart. She is quite pregnant, and married the father simply to be a married woman. The wedding itself was pitiful. Ilze came with me, thank God. Couldn't have managed it on my own. The reception was revolting. John, Patty's husband, didn't speak to her the whole night, just got full with his mates. He's a drunk and a general bad lad.

The marriage lasted five days before Patricia threw hubby out. At least now she's a married woman to have her babe and that's what she wanted. Sad, sad, sad.

I seem to spend most of my life at the fucking doctor's or the chiropractor's. Achieve nothing. Still have too much pain. Paint when I can. Fortunately the swimming keeps me going physically. Have to use a stick most of the time to walk. Fitting for a grandma, I suppose.

I don't know why life is so hard for us, ducks. I meet people all the time whose only problem is what type of dishwasher to buy. And they're healthy, why not us? I have no answers. We're both good people. Not greedy. Not vicious. Don't steal or consciously hurt other people. I know there are plenty of people worse off than us – we could have been born in a third world country, or crippled, or blind. But that doesn't help one iota when you're at the bottom of that black hole, does it?

I care that you're down. And love you, Barb.

June 1988

Dear Merilyn, I have two new acquisitions – a pup and glasses. My eyesight's been going downhill over the last year and I eventually got around to seeing the optometrist (seeing the optometrist?) who said that now that I'm a granny I should be wearing glasses most of the time. Already had them for reading. Suddenly I find that I can actually *see* what I'm painting. Is this good or bad? My work is already too fucking tight. Anyway I have to wear goddamn glasses now to read *and* paint.

But the pup – that's *good* news. She's a real sweetie. Two months old and cute as a button. The last pup I got when Daine was living here, Raji, turned out to be a problem child. Whenever I arrived home, as soon as she saw the car turn into the drive, she'd tear out the back, under the fence and start madly rounding up the bloody sheep in the back paddock (I'd borrowed them from a neighbour).

One day she got the sheep all in a corner, seven or eight of them, then bunched them together tighter and tighter, biting the sheep to make them move until they had nowhere to go. When we eventually got her off the top of all these sheep we found that two of them were dead. It was actually quite funny – though not for the poor sheep, I suppose.

The guy who owned the sheep didn't demand that I put Raji down. I advertised, and found a woman who liked her and is going to train her as a farm dog.

Karma – that's my new pup – will be different, I hope, though she is a bitzer too and you never know with them. Rotty cross Lab I think. I've called her Karma in the hope that she'll bring me luck.

Had another exhibition at Studio Z last month, 34 watercolours. Sold three quarters of them and will be able to pay some bills when the cheque comes. Speaking of money, I'm thinking seriously of selling the back acre to the neighbours. The blocks here can't be subdivided because we're in a water catchment area, but we can shift boundaries. For my neighbours this would mean a much greater road frontage, and for me one acre less to mow plus five grand. Seems like five million to me. I could pay bills, buy food, put up dog fences, pay bills, stock up on canvasses and frames, and, of course, pay bills.

September 1988

Hiya kid, glad you're having such a good time. Life with Cheryl sounds like just what you need. When are you going to live together? Give all the others a miss, kiddo, and try just Cheryl for a while – you might like it.

I've had a busy couple of months, too. Not as exciting as yours, but satisfying in a different way.

In August I had two trips to Wudinna at the bottom of the Gawler Ranges. Theresa, my shrink, has just married a doctor, a fabulous guy call Des. His family are farmers at Wudinna, and he runs a small airline between there and Adelaide. Two of his brothers, or cousins, I'm not sure which, have started offering tourists safari trips through the Gawlers to supplement their farm incomes. One night when I was having dinner in Adelaide with Theresa and Des he came up with the idea of doing painting trips out there.

It seemed a great idea. I would find half a dozen students willing to pay for the safari plus tuition. They would get a good painting holiday and I would get my safari trip for nothing plus my teaching salary.

The biggest problem, of course, was my health – how would my poor back cope with camping and four-wheel driving? One week when the plane wasn't full, Des gave me a free trip to Wudinna to meet the guys, who were very enthusiastic. A couple of weeks later they took me out on a safari for four days with a group that was already booked, so that I could check it out.

I loved the country immediately, but found it hard going. The boys organised

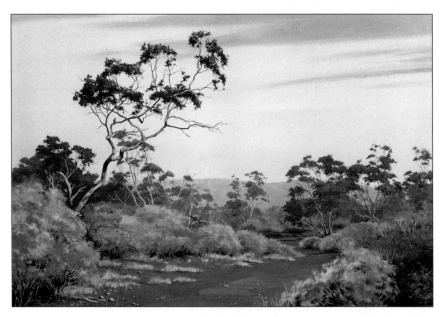

a board to go under my swag, which made sleeping more comfortable, but the driving, Merry, was a nightmare. Some days we drove for hours to see the sights and I would wind up in tears.

Otherwise, it was fantastic. Need the reliable old walking stick, of course, and found it very handy for crapping in the bush. Dig a hole with the end, lever yourself down and up and then use the crook to fill the hole in. Every camper's dream. Anyway, I've decided to give it a go. Have my first trip next month. With a painting group we won't have to travel so much, and I've picked spots reasonably close together that are good for painting.

Merry, I *love* these small plane trips, especially going over the gulfs and looking down on the shelves of land under the sea in their different colours. Flying in the late afternoon, following the setting sun as it casts long shadows across the farmland is magnificent. If my bloody back will hold up, these trips are going to be great.

Next day

Well, the bloody back wasn't holding up too well last night. I had to go to bed. Thank God for the white room. Lainee's been taking me to a flotation centre for relaxation but I've not found it helpful. Just seems to make me focus on the areas of worst pain. Could be a great experience if you were fit. Have you tried it? If so, let me know what sort of experience you had.

Went to June's twenty-first a couple of weeks ago and have decided not to go anywhere where Katherine is going to be. It's too fucking hard. One day I might punch her out – which would be unfair on the girls.

The sale of the back acre is a goer. You remember the old pigeon loft on it? – I'm going to shift it over to my block. This will cost more than it's worth, probably, but the boys love the loft and it gives us more space to live in. The contractors will lift it on to a low-loader and drop it where I want it. Peter, the neighbour, is giving me a couple of thousand now, before all the paper-work goes through, so I can get that done and have a fence built between the loft and the house. This gives me a large secure backyard for the dog.

Ad, Verne and Belle have just been over for a visit. They are all well and I love them heaps. We drank gallons of Scotch between us, and had lots of laughs.

Later

Thanks for the photos. I'm so glad you've kept that gorgeous red hair so long, though I know it must be a lot of work. I guess your mum made the dress. She knows just how to set off that alabaster skin of yours.

Merry, I can never understand how you can possibly think you're ugly. Your Grecian features are stunning even now you're over 40. I'd give anything to have your regal nose and classic beauty. As I close in on 50 – horror of horrors – I get the giggles when I glimpse my button nose in the hairdresser's mirror. It's a real baby's nose and will look even more ridiculous as I grow older.

I'm getting *very* thin, too. Many women might envy me, but it's not a healthy thin. I still wear bikinis, of course, but you could count my ribs from across the street. Doesn't matter what I eat. Can't seem to put on an ounce and I feel sick all the time.

Never happy am I? It's just that you look so fucking healthy and beautiful in your photos. Can't help making comparisons.

Painting like a lunatic when I'm well enough, and managing to sell enough regularly to supplement the pension. It's been so hard since the fire that even being able to afford fruit for myself seems a grand luxury. I've always saved the fruit for the kids and still feel guilty if I have a banana. Seems ridiculous for a 48-year-old woman who's worked hard all her life not to be able to afford the odd piece of fruit or choice cut of meat. To be honest, if I gave up smoking and the occasional bottle of Scotch I could afford a hell of a lot more fruit. But I simply can't give up the fags. Tried hard, but no will power. Hopeless!

December 1988

Hi babe, couple of newsy tidbits.

Took the Coorong painting to the Sydney Opera House for some world conference hosted by Westfield. Ad came down from Katoomba and he and a mate set it up, pulled it down and packed it again. We're both sick of the bloody thing now, but it gave me a chance to see Ad – and Westfield paid for the whole shebang.

That was in October, and in the same month I took my first painting group out to the Gawlers. I was completely buggered when I got home, but it was worth it. Everyone had a terrific time and I managed not to collapse on the job. I'll be doing it again.

Back home, the saga of the fire continues on. A bunch of people who got burnt out have been fighting all these years for compensation from our local council. It's been a nasty business that's caused bad feeling in the district. Some people are claiming millions for ridiculous stuff like fruit trees and flower gardens and the value the fruit might have had over eight years. Stupid claims by greedy people and everybody's getting upset about it.

I've refused to get involved, so far, but it looks very much now as if the

council might have to pay some compensation. I don't know how much, or how they'll work it all out, but my lawyer says to put a claim in as they'll pay everybody.

Years ago I refused to claim for personal compensation for any of us although the lawyers tried to pressure me into it. Probably could have got Paris a heap of money, but he'd be dead by now if I'd been dragging him along to lawyers' offices every week and we'd been living self-pitying bushfire-victim lives like a lot of the others.

I'll put a claim in. I'd be mad not to. But it'll be a small one, and fair. Just basic house and contents, but it could lift me out of the shit. Life could begin again without poverty and struggle.

The loft has been moved and next month I'll have the fence put up for the dog. She's a real sweetheart. Very bright, great company. Did you know we have two cats as well? One oldie and one kitten Paris brought home. So there are a lot of us living in this tiny cardboard box, but it feels good.

My love life is virtually non-existent except for the fabulous fireman Michael now and then. Too fucked (how ironic) to bother nowadays. I'm glad you're getting enough for both of us. I'll write again soon, Barb.

January 1989

Dearest Merry, I'm on the train home from Kalgoorlie looking out on the endless Nullarbor landscape. The people sharing my table in the dining car were complaining how boring it was and once again I felt like an alien on this planet. As soon as I got on the train I put my bunk down in the sleeper and have been lying here lost in the light and shade and nuances of the saltbush and red earth. I could snuggle here and watch this landscape for months. Heaven!

After tea

Night now, and nothing outside this window but darkness. Propped up with pillows on the bed. Clickety-clack. Excuse the wobbly writing. Clickety-clack.

Was just thinking, haven't been to Kalgoorlie since that ghastly visit toward the end of my breakdown – you remember, when I got off the train on my way to visit you and drove the rest of the way to Perth with two Yanks that I met in the smoking car. God, I took a risk. Thank goodness they were nice guys.

Anyway, kid, this time it was a fantastic, three-day driving trip from Adelaide to Kalgoorlie with lots of detours. I drove over with Brian in some bloody big transit van. But have I told you about Brian? I met him at one of my galleries at Brighton. Nice looking, spunky, I thought. Turned out he had a rock band, and out of curiosity Anna and I went along to a gig one night where this quietly

spoken, well-mannered, gentle guy turned into an animal on stage. Skin tight jeans, singlet, muscles, tats and a voice to die for. Gravelly, gutsy. Plays harmonica like a pro.

He drives those great big tonka toy machines in mines all over the country and only comes to Adelaide on holidays or between jobs. He's divorced and has a daughter in Adelaide who he adores. Over the last couple of years we've become good friends and he always pops in for a visit when in town. Nothing between us romantically, just friends. Mind you, he turns me on something shocking when he's singing and I'd like to kiss his tats. Good, strong, brown muscly arms. I think we get on because I paint and understand his need to create and perform. He finds creative life lonely too and we'll always have that in common.

After Christmas he called in for a quick hello before heading back to Kalgoorlie where he's working for the moment. I grabbed the opportunity to do the drive with him and see the country. It's a great friendship, Merry, and the trip will always be a treasured memory.

It reminded me of the time I hitch-hiked to Melbourne with Sabrina. I didn't want to risk hitching with a girl in case we got in trouble and I didn't want to hitch with a guy in case *I* got in trouble. Hitching with a male homosexual who was also a great friend, and who would protect me, was the best way to do it.

This was almost the same, though Brian's definitely not gay, although he has no interest in me at all other than as a really good friend. The van was huge – had a double bed in the back and we both just dropped on there at night with our clothes on.

Because Brian likes my work, he was keen to show me all the best spots on the way over – he's been across the Nullarbor several times on motorbikes (he's a state motorbike champion something or other). Thanks to him, we saw some of the most beautiful country I've ever seen. We went places in that massive bloody van that a four-wheel drive couldn't get to. I've taken hundreds of photographs and I'm high as a kite on beauty. We went from the massive bays at the edge of the Great Australian Bight, to the sparseness of the desert, to the inland salt lakes in central West Australia.

The seats in the van were like armchairs with sheepskins over them and Brian was forever looking after my health and comfort. A dream ride!

Now here I am, nearly ready for sleep. Clickety-clack. Love sleeping on trains. Clickety-clack. Head a saturated solution of beauty.

I was so close to you. The closest I've been since you moved to Perth. But Brian had to be in Kalgoorlie for work and we didn't have time to detour to

Perth. And I didn't have the money to get down to you from Kalgoorlie. Bought my train ticket home with an overdrawn credit card. God, I would have liked to have seen you. So close.

You know how people say, He drives a Porsche, so he must be able to afford whatever he likes. Probably that poor bastard is paying off his Porsche, and can't afford to buy jack shit. It seems stupid that I couldn't find an extra week and an extra couple of hundred dollars to get to you. Truth is I shouldn't even be in this sleeper – God knows how I'll pay for it. But I can't sit up for two days in the cheap seats. Not with this back.

Have got enough pictures in my head and my camera for a couple of years work. Just need the energy. Don't really think I've got a couple of years left. Going to die soon. Off to sleep now. Clickety-clack.

March 1989

Hiya kid, I'm so goddamn fucking angry with Mum that I had to write this down.

We're in Sydney, staying with Ad and Verne. Mum wanted to come over on the train for a holiday. She offered to pay the goddamn fare, and who am I to turn down a free chance to see Ad? The trip over was okay and I felt quite happy that Mum was having her train holiday. Just like me, she loves sleeping on the train.

It was my birthday yesterday, and last night Ad and Verne made a fancy dinner with lots of champagne. Mum's always a worry on the bubbly – brings out her nasty side. Anyway, we're all eating and drinking, having a nice time, when out of the blue she turns on me like a snake and announces: If I hadn't made Barbara come home to me she'd have murdered Adam, too. Can you believe it? *Murdered Adam too!*

Ad and Verne and I looked at each other in astonishment and horror. Ad and Verne both know about the abortions I had so they understood what she was referring to, but none of us could believe what she'd said. I think we might have been talking about Lester, and when I went back home to stay after I got pregnant with Adam. I'm not sure where Mum's comment came from.

Tears came to my eyes immediately, of course. I wasn't fucking crying, I wouldn't give her the satisfaction. Verne or Ad, after they'd collected themselves, changed the subject and the moment passed. *They* knew how upset I was, but Mum didn't bat an eye – just tucked into her dinner as if nothing had happened. I went to the loo for a bawl and came back and finished the meal. Mum went to bed first, not feeling well – pissed out of her brain in reality. The three of us stayed up a while and talked about it in bemusement. When it was time for me to hit the sack I found it impossible to get to sleep. I'm sharing

a double bed with Mum in the kids' spare room. That was fine for the first nights, but last night I didn't want to sleep in that bed with Mum. I could have tried their old sofa, but Mum would have carried on a treat this morning wanting to know why I wasn't in the bed. She wouldn't remember what she said – and even if we told her she would deny it.

Merry, I lay there for hours looking at her while she slept. The hatred I was feeling should have woken her up. I can't remember ever feeling such hatred in my life, not even when Ken raped me. I lay there remembering other below-the-belt blows she has given me over the years and wondering how a mother could ever treat her own child in such a way. To call me a murderer in front of Ad and Verne when it was *her* who pushed me into that first wicked abortion – what a bitch!

Ad and Verne have taken her out for a drive to get her away from me and I've been sitting here weeping. My feelings for Mum are always in flux. Sometimes I think I love her and I know I desperately want her to love me. Sometimes I think she does, and then, when I least expect it, she'll flatten me with a killer punch.

Shit, Merry, I could *never* hit my kids below the belt. Or my friends. Or anybody!

Once I did. I had a shot at Katherine about her weight. Ken and I had the girls for the weekend. We never went on to her property but beeped out the front and sent them in as soon as Katherine appeared. One bloody hot day, she appeared on her verandah wearing shorts and a little top. She's heaps shorter than I am, and pretty heavy about the thighs. As Pat got out of the car (she was about five then) I asked her to give her mummy a message for me – that she should never wear shorts in public. Dear innocent Pat did just that, and as we drove off, laughing, I could see the fury on Katherine's face.

That's about the nastiest thing I've ever said to anybody – knowingly, at least. I've sometimes, inadvertently, hurt people by making honest comments, and when I had that breakdown and was full of drugs I know I said cruel words to people. Didn't know it at the time, but it seems that I did. But *knowingly* I've never let loose with one of those comments that can haunt people for the rest of their lives. So how could my own mother do it to me?

After meeting her, friends have often asked me how I put up with her putting me down all the time. I think she's done it so often that I'm normally not aware of it.

Two more nights here and then we have to share a sleeper all the way back to Adelaide. I don't know how I'm going to do it.

Later

Still seething. Perhaps it's my own guilt about the abortion that's making me hurt so much, but I didn't need a barb like that in such a tender area.

Mum is still living at Tess's place in a granny flat. To give Mum her due, she does keep mostly to herself and tries not to interfere with Tess's family too much. But Mum and Tess have always got on pretty well. What could you pick on about Tessa, anyway? She's such a sweetie.

Annie and Mum are not close at all – not even as close as Mum and I are. Annie hardly ever visits her, But Mum would never rabbit-punch Annie like she does me. I think she's frightened of Annie. As for John – now, well there's *nothing* wrong with John! He's Mr Perfect in her eyes. These have always been the family dynamics and I guess they aint gonna change now.

I think of young, fragile, you being told you were ugly, and how you've worn that word all your life like a second skin so that you've never been able to believe the rest of the world when we tell you how beautiful you are. And I remember my own hated words. *Dirty slut.* If only they could be cut out of our bodies and minds like the cancers that they are.

Now the word *murder*, and in relation to Adam. I've tried hard, Merry, to keep learning and growing, but none of my skills so far will be able to delete that word from my brain. Thank God I can write to you whenever I need to purge. Maybe my next letter will be cheery. Love for now, Barb.

May 1989

My dear friend, autumn wind is lashing the house. Stuck in bed, crook again.

Speaking of bed, have I told you about the Marvellous Mylor Mums and our dinners together? Last month, after the Sydney trip with Mum, my health packed up and I had to stay in bed for a couple of weeks. (Same old problem. Couldn't breathe, paralysis, pain, complete exhaustion.) We were due for a MMM's dinner and the other mums wouldn't go out without me. They brought the dinner to my bed! It was a wonderful night – five of us in the white room with cloths, cutlery and crystal glasses, and me propped up with pillows getting comfortably pissed.

I've found an easy relationship with Lainee, who is one of the group. She's very spiritual and this is an area that I'm intensely interested in exploring.

Also I've been seeing a lot of Zev, who I probably haven't mentioned before. I met him at Pam's. He is a stuntman with a keen interest in art (he's discerning, too – has already bought a couple of pieces of mine). Zev's a lovely, gentle man. Early thirties and built like a brick shithouse. Greek. Nothing at all between us

except a shared respect for each other's careers. He is between jobs, so he's painting Mabel for cash.

We're painting over the mural that Annie put on the end wall – it was beginning to flake – turning Mabel a pleasant, deep green. It's like having a new house.

And, the plumber is building me a laundry under the back verandah in return for three Coorong panels! The cement's down and the timber framework started. I can't believe that after nine years I'll have the luxury of a washing machine and dryer. I've had to hand wash everything in the bath (heavy on the back) or lug stuff into Stirling to the laundromat when I could afford the coins. God, I hate that grubby, expensive laundromat.

I sold two of the Coorong panels through Studio Z last month, so I might as well sell the rest to private buyers. It's a hell of a shame to break it up. What a pity some business didn't buy it for a boardroom. As far as I know it's the only piece like it in the country. There's a panorama up at Alice Springs, set up with sand and stuff, but it's a tourist piece and painted in a stylish manner. Not a fine realistic piece like the Coorong. Not that I'm biased! South Australia's not very supportive of its artists and in years to come someone will be sorry that it's all broken up.

Did I tell you Paris is renting down in town for a while with some mates? Still doing his electrical apprenticeship (going bloody well) and when he's at home he's happier living in the loft out the back so he doesn't need his room anymore.

Later

Almost forgot to tell you that I also sold another large painting at a big charity exhibition here last month (photo enclosed). Took forever to paint. Lots of layers of transparent colour on the water. After commission, half of which goes to charity, I get two thousand.

Yep mate, life is looking up, though I'm so skinny you'd be horrified to see me. Everybody's worried except the bloody doctors, who still tell me it's anxiety. It's got to the stage where I'm beginning to believe them. I'm too weak to swim now and can't walk without my stick at all. What's the use of having a good brain if I can't look after my body? A stick of a person leaning on a stick.

But there's lots of good stuff happening and if the bushfire money comes through perhaps in the new year I'll get over to see you at last.

August 1989

So you're thinking of settling down with Cheryl at last, Merry. Sounds very much like she's the one, so go for it. Relax and enjoy. I understand your misgivings. Your habit has always been to see a string of people, and I understand your need for your own space. But give it a try, hon. What have you got to lose? Keep a spare bed for me, though, because it looks like I'll be getting some money from the bushfire *soon*. Like *any day*!

People have gone nuts over the litigation – need has turned to greed in lots of cases. Because our council, which has had to pay out because the fire started in their dump, hadn't taken out enough insurance, the district will have to fund the payouts via increased rates and so on for years. There's a lot of bad feeling around here.

I merely engaged an ordinary lawyer to put in a reasonable claim for me. With interest, though, it will be enough to pay out the mortgage, give the boys some recompense for what they lost, buy a decent car and tart up Mabel. And get over to see you, at last! We'll see in the new year with champagne, my friend.

I won't really believe it until I have the cheque in my hand. As far as I can see, on *that* day, the same on Ash Wednesday in 1983, fires would have started anyway. On their own. Spontaneous combustion. Lightning. Broken glass. Anything. We're lucky to have someone to blame, in a way. I might even buy myself some new underwear!

And I have a laundry! I put on a barbecue to celebrate. Eight or so of us here, me in a daggy old coat, socks and sneakers, and rollers in my hair. Your classic housewife in her laundry. I'll send some photos when I get them back. Good for a laugh.

Next day

Have to write a bit and rest a bit. Health getting worse. Have lost nearly three stone.

Ad made a surprise visit for Paris' eighteenth birthday party. I was in heaven with both my boys together. Paris is settling down, and the two of them are beginning to share interests, although Ad is 26 now. They both play bass guitar and love the same sort of music. They even have friends in common.

Every now and then Paris' anger still gets out of control, especially when he's been drinking and smoking too much dope. But he's improving and I have faith that he'll ride it out. He's back home living in the loft but will probably try renting again soon. His car got stolen and wrecked last time and it put him off city life.

You know how secure in himself Adam has always seemed? I believe that Paris is similarly well-grounded beneath all the crap and agro that he has had to deal with. I know that one day he'll surprise everybody, except me, by turning out to be a magic bloke.

I've been away a couple of times. Did another safari trip to the Gawler Ranges with a painting group. Marg Drew came on this trip – did you ever meet her? My old domestic arts teacher from high school. We keep in touch and she used to come up to Aldgate for lessons when I was teaching at TAFE. She's a widow now and gets lonely, so the camping trip was a lovely change for her. Leverne's dad came too. He's been coming up now and then for a lesson. He's a muso. I can't do any more of these trips though. After this last one I needed a week in bed (weak in bed) when I got back. Even putting on a front for the students is exhausting.

Early this month Zev and his mate, John, took Pam and me up to the Flinders Ranges for a weekend. They looked after me like a queen. You'd have laughed to see me wrapped up in blankets and packed with cushions on a lazyboy while they served me barbecue meals in the middle of the bush. These are nice men, Merry. We had some laughs. Good friends.

In June I had a share show at Studio Z. Only about 20 paintings, but about half of them oils. No photos for you this time, except for the one of Belle. Too buggered to be stuffed mucking around with the camera.

I'd love to try some *experiments* with paintings but can't afford the materials – or the energy. Even doing 'safe' paintings is a real effort now. What I'd really like is to do some erotic work. Maybe a bit surreal. Probably wouldn't find any gallery to hang it, but really want to do it.

Speaking of erotic, yes, I'm still seeing the fireman. He's about all I can handle at the moment. The last time I went to his place for the night I was so weak driving home that I had to lean on the steering wheel to stay upright. And then nearly a week in bed. It was bloody well worth it, though. I sometimes think that if some of my friends, or my students, knew the stuff we get up to they'd never be able to speak to me again. Take a combined list of all their erotic fantasies. Double it. Well, we already did all that. *You* know all about it. Can't wait to see you! Love for now, Barb.

September 1989

Hiya, honey – got the money! And a new car! Well, new for me. She's a Datsun 280ZX sports coupe, silver with dark blue trim, 1981 vintage and abso-fucking-lutely beautiful! She's got power steering and is a breeze to drive after that heavy

Charger. I've become so weak I couldn't pull it around corners anymore, and had to borrow Lainee's little four cylinder.

After I paid off all my debts I had enough money left either to knock Mabel down and build a small brick house, or buy a decent car and put in a heated swimming pool. So I went for the car and the pool, which might save my life. All along the doctors have been telling me to exercise in a pool, but that's easier said than done when you live up here. The pool goes in next month and I'll get solar heating for it. Can't wait to build up my strength again. Anyway, how could I possibly knock Mabel down? She's so full of the love left by everyone who's worked on her. I don't think I'll ever leave her. Everyone who comes here comments on how relaxed they feel.

Later

Please let me know the dates of your holidays and I'll make the booking now. Fuck, Merry, I'm still so goddamn optimistic. I'm making plans, yet I know, somewhere deep inside, that I'm going to die any day. The doctors say I won't and perhaps I'm being melodramatic – but I'm so certain that I've even written goodbye letters to the boys.

Then again, maybe I *am* neurotic, like the doctors say. In which case I should keep on making plans and looking to the future. All too hard to think about. Too tired.

October 1989

Merilyn, your lovely card arrived at exactly the right time. It lifted my spirits enormously. What a great friend you are. I have good and bad news. Good news first – the pool is in, and Ad and I planning to go to India next month. The bad news is that I'm too exhausted to swim and don't know how the fuck I'm ever going to manage the trip.

I went over to Sydney earlier this month to visit Ad, Verne and Belle. Because I've got some cash for once we were able to go out for meals and drinks and so on. One night we went to this terribly trendy cocktail bar. Surprise, surprise, we overdid it and the three of us got smashed. Sometime during the evening, Verne said, You guys should go to India, and we decided then and there to do it.

Sober, it still seemed like a decent idea. The doc is always telling me I'm feeling crook because I'm lonely or because I'm bored. So who knows, a trip to India might fix me up. It's supposed to be a place that changes your life.

My friend Ron (you've not met him, but we go way back) is living with an Indian woman who owns a small hotel in Goa. He comes to Australia most

years to see his children and we always have a meal together at the Aldgate Pump pub. For ages he's been saying, Come over, come over, stay with us. So we're going to.

As soon as I got back from Sydney I booked the first available seats, and we leave on November second for three weeks. Ad's paying for his own fare and food, but I'll fund our accommodation, which won't be too much because we're planning on staying in Goa for about two weeks.

Fuck, kiddo, I can't believe we're going to be doing this. But off we go in a couple of weeks. Verne's being terrific about it. Well, it was her idea! She'll be on her own with Belle and work, but says she'll manage. I think she hopes I might find some exotic cure somewhere in India. Ad will look after me and do all the carrying. I couldn't even lift a suitcase – even the thought of packing one is exhausting. I've already had shots for every bloody disease going and they didn't kill me.

I know India wouldn't be your choice. Too dirty. I'm not really sure why it's mine. Partly because Verne suggested it, and pissed as we all were at the time it seemed like a good idea. Partly because we've been invited to Ron and Kamala's hotel so many times, and partly because it's a third world country. This will probably be my only chance to go overseas, and I can't see the value of going somewhere with hotels, taxis, restaurants and theatres and so on. We already have that here. Adam feels the same way. Might as well see what real life is like in an entirely different culture.

Don't know how I'll cope emotionally, let alone physically. Shit, most days I'm too crook to drive my new little you-beaut car. How the fuck I think I'm going to get around India I don't know! Thank God for walking sticks.

At least I've been in the pool a couple of times, just to float and walk about. I need someone around in case I pass out and disappear forever under the shimmering surface that reflects the gum trees and the sky. Beautiful.

I'm sure looking forward to visiting you at *Withywindle* in January. Promise I won't smoke within a hundred yards of the house. Maybe you can get over here for my fiftieth in March. I'm going to have a big party. Got a feeling it might be my last birthday, and I've got a lot of people to thank for the good times. I've booked the Penny Rockets already – do you remember them, that sixties band? Verne's dad is the bass player. They're old now, but still make great rock 'n roll. We'll put a marquee up next to Mabel, and blow the last of the fire money. Might as well spend it. Going to be dead a long time. This has taken me four shots to write.

November 1989

Merilyn, I'm just back from India and terribly ill, though not from any disease I picked up over there. Don't think I would've made it back if it wasn't for dear Adam. One night in Goa, I couldn't sleep for the pain and the humidity. He borrowed an old guitar from the chef, and sat by the bed quietly singing and strumming for hours until I dozed off. For the entire three weeks he was my bodyguard, nurse and friend, to the detriment of his own pleasure. He is a magnificent human being. I feel honoured to have him for a son. Have enclosed a letter I wrote while in India, but didn't get around to sending it.

Bombay, India, first day of holiday

The room is immaculate, tasteful and lush. The red rose in front of the mirror is changed daily. The bed is large and comfortable with freshly laundered white sheets that have just been changed by an Indian servant dressed in immaculate white.

I am in a hotel room. It has its own refrigerator and 24-hour full bar room service, but we have with us three bottles of liquor that sit the other side of the mirror from the rose. One bottle is a litre of Scotch whisky, one is a Wolf Blass white wine and the third is a bottle of Pol Roget Champagne, which was given to us by the captain of the cabin crew on our flight over, who had taken a liking to Adam and who also gave us two bottles of champagne to drink in Singapore.

The room is beautifully furnished – a ten foot bedhead, comfortable chairs, gorgeous desk and wardrobes and a shiny new television set and music system. The ensuite bathroom is spotless. Looking down from our sixteenth-floor window I can see the swimming pool with its lounging chairs around it on green lawn, and will soon be going down to swim there. The room is air-conditioned and fresh. If I look directly out of the window, instead of down to the pool, I see thick putrid air that tries to hide the squalor and poverty of Bombay.

I am afraid to leave this safe, clean room. If I put on music or television, I can believe I am still in my normal environment. Outside is raw life. Poverty. Filth. Sickness. Death and pain. Hopelessness. Five million people live in plywood, tin and cardboard shanties so flimsy and filthy that Australian children would not be allowed to use them as cubby houses. People and dogs sleep in piles on the roadside, wrapped only in their skins. Hard to tell them apart. Thousands of skinny, curled-up bodies lined the road from the airport. Tens of thousands. Dogs and crows scavenge at night while humans sleep, for in daylight the human bodies must scavenge and leave nothing for crows and dogs.

My perceptions of life, accrued with much pain over fifty years, seem absurd. A big joke. I am a small baby, with everything to learn.

I cannot go to see the Taj Mahal as we had planned. It would be flaunting my opulence as a tourist. The Taj belongs to the Indians, but in this city alone there are at least five million people who could never afford the bus fare to go and see it. How could I have the cheek to fly up to admire it for half an hour or so and first class train it back?

I have not stopped weeping since we arrived and have not even been out of this disgustingly lavish room.

The Tamarind Restaurant, Goa, fifth day

Que sera sera, or whatever, is just not good enough. If people can't change this human carnage and neither can God, then what's the fucking answer? How can I have the gall to sit on the verandah and sketch the workers, take their photos, try to capture their souls (as if I could have *any* idea at all) in the name of art, when art is bullshit compared with what I see out of the loo window in this restaurant.

We are having our siesta. How nice. The same woman, women, that I drew working this morning, is, are, still working now. Carting rocks, sand, cement, on their heads, sweaty and exhausted – while we are all having a nice little lie down so that we have enough energy to eat our bloody dinner, cooked by servants, served by servants. Lobster, prawns, cocktails, champagne, chilled water, whatever the heart and stomach desires.

These other poor bastards work their guts out for a year for what we spend in a restaurant in one night to feed two people. Two bloody miserable dollars a day! I can't stand being in this country. I can't stand being in this upstairs bedroom with the poor buggers working below the window. I can't even go to the beach to clean my mind because on the way are the poor. The beach front teems with small tourist shops, gypsies, small boys and old women, all badgering you to buy, buy, buy so that they can eat, eat, eat.

There is nowhere to hide in India. It's not even worth writing about. Writing achieves nothing.

The sun is setting outside. The countryside is bathed in a soft apricot. The foliage is lush and green. What a wicked lie is India!

December 1989

I'm sorry, kiddo, but I won't be able to make it over to see you. My body is on the way out. I fear this Christmas will be my last. All through my back problems the doctors have been telling me to swim. Now I have a heated pool outside my

bedroom door and I'm too weak to get in it. I can see it from this bed, blue and inviting. And here at last I have the gorgeous car I've wanted for years. Too weak to drive it. Fucking cruel.

You want to die, but can't and I want to live, but can't.

I went to see the bloody doctor last week and told him that I know I'm dying. He said to me, Go home Barbra and get well, there is nothing wrong with you. I asked for a referral to see a specialist and the bastard got iffy about it. He did give me one, but it's not for nearly two months and I'll be long dead by then.

Do you think someone can die of tiredness? I don't know and am past caring. I'm sad for the boys, but I'm no use to them as I am. I can hardly get out of bed most days and I'm so thin I look like the walking dead. My hair is falling out.

Tessa will take care of Paris, so I know he'll have a good home base. As much as he loves her, his auntie can never replace his mum. Anyway, he's old enough to cope on his own now.

So this might be a goodbye letter, my dear friend. God knows if I'll get the chance to write another. Each morning I'm surprised to find myself still alive. Who would have thought I'd go before you, kiddo?

Thanks for being such a good friend to me over all these years. I've treasured our relationship for the gem that it is. I worry about leaving you without a confidante. Couldn't not say goodbye. Can't say it to anybody else. No one could handle it. Everybody's worried, I know, but I'm the only one who knows for sure how little time I've got left. Adam might guess. In a strange way I'm relieved to know that it's all going to end at last. These last few years have been too hard, with too much pain and too much struggle.

Whether you end up knocking yourself off or not, I wish you success either way. We're sure to meet up again somewhere, sometime, on some other level. I have loved your soul, goodbye.

January 1990

Thanks for the card, Merilyn. I would laugh, but I dare not. I'm too sore. Sex symbol indeed! I look absolutely dreadful. Besides having a six-inch cut down my midriff and two drainage tubes hanging out of my tummy, I've lost three stone, and look skeletal. Still, besides the pain and weakness, I feel tremendous. For the first time for years I can look forward with hope.

The operation became complicated, I gather. Some gall-bladder ops are fairly quick, it seems, and I've even heard of some being done with lasers now, and no cuts, but this one took four hours and the surgeon said he's never seen

anything like it. Thirty-three big stones. The most he's ever come across, and three more stuck in the bile duct, which was ripped and infected. I was bloody lucky this time, Merry. I wrote to you that I only had weeks left, but I might not even have made that! Bloody nitwit shithead local doctor had to assist (the specialist insisted on it when he heard the story) and I bet he felt fucking terrible. Nerves indeed!

I didn't get a chance to tell you what had happened. I gather Pam rang you.

You knew that I was in a bad way when I came back from India. Lucky I even got back at all, actually. There were two occasions over there when I was very close to the end, but we were having a hard enough time already – the place is a madhouse – and the thought of Adam trying to deal with a dead mother on top of it all gave me the strength to keep going.

Steve saw me over Christmas and was horrified. She suggested I see a doctor she'd heard of who was supposed to be good with illnesses brought back from overseas. I didn't think I'd picked up anything in India, but rang and made an appointment just in case. Good old Pam drove me down to his city office.

As you know, my local doc had made an appointment for me to see a physician sometime in the distant future. I took the referral letter along to the new doctor who saw me the very next day after I rang. After reading the letter and hearing my story, he examined me thoroughly and sent me immediately for an ultrasound. We went straight back to see him with the results and he told me that I needed urgent gall-bladder surgery and that my haemoglobin level was dangerously low. He got me an appointment for the next day with the physician, who in turn sent me straight to the surgeon and I was in here, St Andrews Hospital, the following day for the operation.

The idiot local doctor had written that I was suffering from nerves and anxiety following the bushfires (ten and seven years ago), that I tended to be of a sensitive and neurotic nature, and that my weight loss was due to anorexia. I bet he changed his bloody mind when he had to stand there and look inside my guts at the infection and mess that had been festering there for years.

You'd have laughed to have seen Pam and me coming home when we knew that I needed an operation. We were so happy, laughing with relief. Nobody ever, I'd guess, has been so pleased to hear that they need to be sliced open. Pam was more relieved than me, if that's possible. She'd had to watch me deteriorate over the years. The irony of it all was that Pam, along with all the other Good Samaritans, have been feeding me rich food to try to put some weight on my bones. Thanks to my non-functioning gall-bladder, their ministrations had only made me sicker.

Now I'm here, operation over, and just have to be a patient patient. I'll be in this joint for several weeks. Don't worry about me, kiddo. I'm going to be fine now, though the body beautiful will never be the same.

Some body! I was about the right weight at ten and a half stone, which I've kept to since I was a teenager, but at seven and a half stone and six foot, there's not a lot of me. My bum has disappeared altogether – not even a saggy flap of flesh where it used to be. When I'm standing side-on the line at the back goes straight from my waist to my knees. My bones have no padding left – no wonder they are sore.

I suppose I'll gradually put the weight back on, but even when I do I'll have to give up my bikinis, at least in public, because my midriff is going to look gross. But I'll be 50 in a couple of months and have had the luxury of a good body up to now, so I shouldn't complain.

At least the boys can stop worrying now, poor loves. They've been putting up for far too long with a sick mum who keeps thinking that she's about to die.

Hope you're in better shape than I am. Watch your diet, kiddo, and keep those inside bits as perfect as your outside bits. Heaps of love, Barb.

P.S. Lying here now, I realised what a berserk year I spent considering how ill I was. I wonder if I knew I was dying and was determined to make the most of the time. No, if I *really* knew I'd have taken Paris to Sydney and lived with Ad and Verne for my last days.

Anyway, it was a busy year for a sick chick. In January I drove to Kalgoorlie with Brian. Trained it to Sydney with Mum – oh God – to visit Ad in March. Then came the Gawler Ranges painting trips and the Flinders Ranges with Zev, John and Pam. In October I went to Sydney again, the flying visit to Ad to take him his bushfire money, and then off to India in November. In the middle of all this, 20 paintings in a share exhibition with Barbara Evans at Studio Z. No wonder I'm tired.

1 March 1990

My friend, I'm sorry I've been slow to answer all your letters. I've been recovering from that bloody operation and haven't had much to write about because I've been laying about in bed most of the time. I'm as weak as a kitten. The surgeon says I can eat practically anything now, but there's not much that I feel like, and it's a hassle to eat at all. But I must, because I have to get strong again.

The physician explained that the stones in the bile duct were causing my ribcage to go into spasm as my body tried to expel them. Because the duct was

ripped and damaged, the stones were stuck there, so my body was in constant spasm, making my back pain a zillion times worse than usual. Once I'm healed, I can expect far less pain in this bloody old back, and won't that be a joy for all.

The chiropractor who's kept me going these last few years, Kevin, kept saying that he couldn't understand the constant spasms, given that the position of my spine looked okay. And the hypnotherapist, Russell, was at a loss to understand why the hypnotism wasn't working as well as it should on such a good subject. Well, now they understand. Nothing could've stopped those massive, continuous spasms, which are the body's way of trying to heal itself.

I'm listening to Nina Simone singing 'Just like a Woman', and 'Angel of the Morning', which could very well be our song. I wish I could sing like Nina, or Streisand, of course.

My big Five-O birthday party is only a couple of weeks away. I'll still be fragile, but I'd booked the band and the marquee before the operation on the off-chance that I'd be alive – and here I still am, so I'm going to have it anyway, even if I have to sit in a chair all night. Adam and Verne are coming over from Sydney, and it will be wonderful to be surrounded by my beloved boys, and all my friends.

What a shit that you're not well enough to travel. It would be the icing on the cake to have you here. At least it's nothing serious, my sweet, and I'll be content with that.

If only I could do, or say, something that would ease your constant misery. I wish you could meet someone who gives you all that you need, who could open up the door to a life of contentment that you've not yet experienced. Anyway, sweetheart, I'll have my party with my other friends – I'm expecting between 150 and 200 – and will have a Scotch for you. My love, as always, Barb.

25 March 1990

Dearest Merry, I had a fantastic birthday even though I was wobbly on my feet. Even managed a short dance (who could resist the Penny Rockets?). Glad that you're rested and feeling better.

I have many wonderful friends, and I hope I'll never take them for granted. But with each one I have to shelve a part of myself, out of respect for their standards (and often these standards are why I value them as a friend). I'm probably not explaining this very well. My own morality seems to be different from most people's, and my sensitivity belongs on a different plane. I figure that as long as I live by my own moral standards, and *never* break them, then I'm okay, even if my standards are different to everyone else's. The guts of it, kiddo,

is that your life and your moral standards, as different as they may be from the norm, are on the same plane as mine. I can talk to you about anything. There's nothing that I have to hold back.

And then there's the twisted side of me who wants to put your 'I Love You' card in pride of place next to my bed. If someone should open it, to find a woman's name and be cheeky enough to ask who you are, I might tell them you're a close lesbian friend and leave them to stew on it. Could anyone who read our letters or knew our backgrounds believe that our relationship has never been sexual? I treasure the fact that our love for each other is so pure. Thank you.

Fuck, half my life people have thought I was butch anyway. Or bi. Six foot. Jeans. Extremely short hair. No make-up. Loud. Opinionated. It's a waste of time to try and convince anybody that it's not the case. They only believe it more. Actually, Merry, *you* are probably the one who knows best how fucking straight I am. This letter started off as a birthday thank you and has disintegrated into a pile of bullshit, as usual.

To get back to the big day, the party was great. I felt very loved. Mabel was filled to the brim with flowers and presents – I've never had so many pressies before.

Ad, Verne and Paris did all the preparation. Without them the place would've been a shambles.

Now that Paris is 19, the boys get on really well, and Verne is like a daughter to me. We're so much alike in so many ways. With all three of them here the party was a winner for me even before the guests arrived.

You should have seen the cake. Picture this. Verne's mum does cake decorating and they ask her to cover a large oval cake with all white icing. They had bought me a silver crystal waterlily that can hold a small candle. They set the lily on a flat blue crystal sheet that looks like a lake against the white of the icing. All around the lake, beautifully spaced, are flowers made of clear and blue crystals on stems of varying heights like ornamental bullrushes. A globe inserted into a hollow in the cake lights up the crystals while the single tiny candle in the waterlily shimmers. Spectacular. They lit the cake outside on the edge of the pool. It was so beautiful, and so thoughtfully planned, that I burst into tears.

But how the fuck can I be 50? My body feels like it is 110 and probably looks like it. I'm pale from the operation and have only put on a few pounds but my mind is still so young. I'm still waiting to grow up. There's so much I want to do. Shit, I haven't even begun to paint yet. But there you go. I'm 50, and nothing can be done about it.

Remember when we used to sit up all night, playing Sinatra and Streisand, drinking and smoking like chimneys, talking about the things we wanted to do? A pair of sozzled dreamers. It's so long ago but seems like yesterday. Now I'm 50 and you're 43. Two middle-aged spinsters. Yuk!

Still, with this operation behind me I can look forward to a whole new life – and I plan to enjoy every bloody minute of it. As soon as I put on a bit of weight and you can organise a few days off, I'll come over to give you a kiss on the forehead. Write soon, love forever and always, Barb.

Easter 1990

My dearest friend. My dearest dead friend. Merilyn, Merilyn. So you've finally ended it.

I can't believe that you're dead. When your brother rang to tell me, I wasn't at all surprised – you've wanted to be dead ever since I've known you – but it hasn't sunk in yet, and I have to write to you.

A big part of me is happy for you. You've told me about all those dreadful failed attempts and the embarrassment and hopelessness you felt waking in a hospital somewhere to find yourself still horribly alive. I'm relieved and pleased for you that this time, it worked. Another part of me is hurting because you didn't say goodbye, although I understand that, after all the other times. And a part of me is just plain sad, because I always hoped, deep down, that you would find a good enough reason to hang in there.

Where was I while you lay dying in your bed? What was I doing while you were making the biggest decision of your life? I was here, doing nothing important, not thinking much, achieving nothing, just existing.

Why didn't I know what you were doing? I've sensed it other times, why not this time? Your recent letters have given no hint, and your last phone call was as sweet and caring as usual. What drove you over the precipice this time? A man? A woman? A boy? Love? Or did tiredness simply make you stop the whole ridiculous game of life. Where are you now, two days later?

I feel that you're here in this room, watching me write this, slightly amused, aware of my pain and mixed emotions. I feel you suspended, relaxed and lazy, two or three feet below the ceiling, and between the potbelly and the kitchen. Why are you here?

Perhaps I'm mad. I see you in pale clothes – a long dress, or nightie, soft fabric – smiling gently, with all the knowledge of the universe. You don't seem at all uneasy about your last earthly deed. You look peaceful and knowing.

What about your poor lady? Why aren't you with her? You loved her, she

was so good to you. What a shocking experience for her. She had to call the police to break your door down – then she found you dead. Perhaps because she was your lover, and so close to you, she was prepared for your final drama, but even so, what shocking pain she must be feeling.

What about all your close friends over there? Your mother will be devastated! From your brother's call, I gather that neither he or your mum really expected this to happen. Why are you not with *them*? Or can you be with everyone you love at the same time now? I suppose I'll have to wait until I die to learn the answers. It's going to be really interesting. In a way, I envy you the knowledge.

I guess this is my last letter to you, my dear friend. Will I post it? If I post it to *Withywindle*, with no return address on the envelope, what will happen to it? Where will it go? To the dead letter office, I suppose! I can laugh at that one, my darling, but at the moment your decision to leave this earth is beyond my acceptance, let alone my comprehension. I weep for you, and myself, and all people. I'll miss you something shocking.

Ah, Merilyn,

Why'd you do it!

book two

1996

Dear Merilyn

My life has undergone some major changes since you died. I feel like a different person. Perhaps you wouldn't like me as I am now – pretty much a boring old fart. Then again, perhaps you'd like me better! Knowing you and your caring soul I do know that you'd be happy for me. Maybe, wherever you are, you had a hand in the whole business – I've no bloody idea.

Putting together the pieces and forgiving myself for my mistakes was not a simple matter. I'll go into the gory details another time, but for now I thought I'd share these memories with you. Some of them you knew, some you didn't.

I've written these letters to my inner child, who's been lost to me all these years. Life can be a ridiculous game at times – witness, for instance, this series of letters to myself written by myself. Written by who I am now to who I once was!

I'll have a drink to that. Thank goodness, I can hear you say, Barb hasn't found religion, still enjoys a drink. But I have stopped hurting inside. And that's nice. Merry, I've found a peace that I never knew existed. Perhaps some lucky bastards have this peace all their lives and take it for granted. God, life would be a breeze if that were so. I no longer have the need to prove anything to anybody and my life has lost that frenetic and dangerous edge that you knew so well.

If I dropped dead tomorrow I'd go out content. I've learnt many lessons and overcome the shit that has come my way. I'd be sorry, of course, that I've not yet begun to achieve my potential with the gifts that I've been given. These gifts, particularly the artistic view and capacity for wonder – and the humility that comes with them – have been the saviour of my inner child and my whole being.

The friendship that you gave me helped to keep me alive and fighting and I thank you for it. My love for you did not die when your body did, but will exist as long as I do, a powerful force that energises the environment, makes plants grow, brightens my sunsets. Thanks for everything, kiddo.

To my dear inner child

It's 2.30 in the morning. I couldn't sleep, so I got up for a cuppa and a fag by the fire. Have been sitting here in the soft light of the night-lamp and the glow of the pot-belly admiring the comfort of the studio.

This is the first house that we've lived in that's free from tension and bad memories. Bits of pottery, sculptures and paintings glow in the soft light, and our beloved Great Dane is asleep at my feet, soaking up the warmth of the fire on this frosty night. Life is good.

The painting I'm working on at the moment, a portrait of a 13-year-old girl

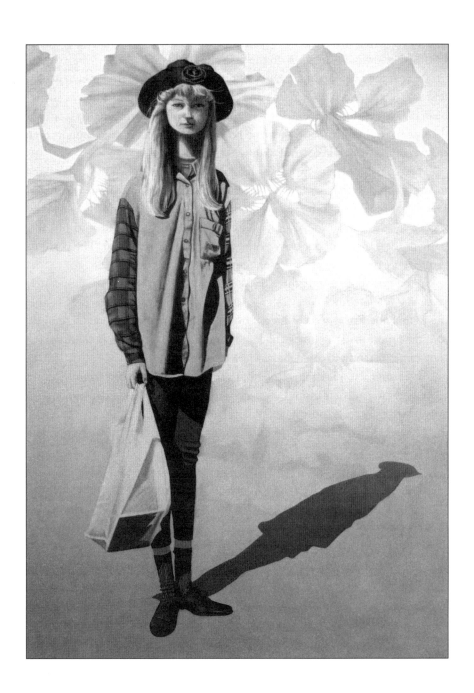

called Jessica, looks out eerily from the easel beside me. This portrait, or rather this girl, reminds me of you in many ways, or my visual perception of you, and I think that's why I wanted to do the painting in the first place.

I was at the opening of a friend's exhibition, listening to the speech, when I first saw Jessica. She was standing awkwardly amid a crowd of adults, a string-bean of a youngster with a green velvet hat and a plastic bag hanging from her delicate hand. I remember wondering how such thin ankles could support even the weight of this child's slender body.

I had to paint her, no two ways about it. To finish the portrait I'm blocking in large, soft nasturtiums as a background. The nasturtiums are definitely our flower, not Jessica's, but they fit the mood of the painting and she's not at all disturbed by their inclusion. I don't know where nasturtiums fit into our life; perhaps the gardens of our early years were bordered with them. The perfume is old in my mind; it evokes pleasant emotions.

At my first reiki session, three or four years ago now, while I was desperately searching for you, my Reiki Master gave me a very interesting exercise. She told me to imagine five aspects of myself in a physical form – the mental, the physical, the emotional, the inner child and the spiritual. This was no hard task as they came instantly to mind and each had a firm image.

My *mental* self was a tall, strong but slim woman in a tailored suit.

My *physical* was an insipid, hunched, malnourished weakling, standing so twisted that she stood only half as tall as her mental sister.

The *emotional* me was chubby, happy and smiling – a well-rounded, cheerful soul.

Spiritual Barbra was willowy, white and gentle.

My *inner child* – you, my dear – when she at last emerged from the shadows, slowly and quietly behind the others, was a tall, thin youngster, shy to the extreme, hesitant and frightened.

The reiki exercise then involved offering these five individuals a large cake of my choosing (I chose chocolate) and inviting them to take their equal share. The first time I tried this, my emotional self took her full share and ate it with gusto. The mental self took slightly less, the physical only a tiny wedge and the spiritual not quite all her portion. My inner child, you, would hardly approach the cake – after a while, the most you would do was tentatively taste some of the icing on your finger.

The purpose of this exercise was to reach a point in my own growth where each of the images could take and enjoy their own equal share of the cake. Try as I might, I couldn't make this happen at will.

Slowly, over the last two years, I've reached the point where I'm so close to equilibrium that I'm content. The physical being is now standing tall and straight, but cannot yet manage to eat the whole of her piece, though she will take it. But it is you, little one, my inner child, who has grown the most. You no longer hide in the shadows, but stand proudly with the rest, taking your cake and eating it, too.

This portrait of Jessica is close to my image of you, although the girl in the painting, besides her height and slimness, has few of our physical qualities at that age – and even less of the stubborn mien that I wore to hide the fragility of my soul.

I'm glad we're back together at last. It means I can paint this image with a clear mind instead of it ending as a cathartic mess. We are, in fact, painting it together.

Dear little inside Barb, my sweet inner self, my inner child. I heard an expert on the subject observe today that in most cases memory is not only selective, but often unreliable. My memories of you, poppet, are clouded by emotion, of course. Some of them may be out of context and of course they are only memories and perceptions in the end.

The records show that Barbara Jean Newmarch was born at Prospect, a northern suburb close to the city of Adelaide, in 1940. There are vague images of a blue laminex kitchen table, a gravel drive with a steel-framed wire front gate, and earlier, a wicker pram in which we lay listening to our mother and brother playing together. There's a blurred picture of a tall man in uniform – our father home from the second world war. His arrival at the front gate sent us tripping into the safety of the house.

Looking now at our album – it has chronological photographs from three months onwards – I see a wooden rocker, shaped and painted like a duck, and have to hold back tears of love. The duck-rocker is associated in our mind with solitude, but there are also a fish pond and a birthday party and dressing-up photographs that show a happy girl enjoying life.

Now that you have returned to me in my older age and are safely warm within, I can follow all the terrible mistakes that I made in our life and understand the reasons behind my urge for self-destruction, which has been balanced fortunately by immense stubbornness and determination to survive.

By the time we school started at five, the family was living in a lovely old freestone home in the beautiful suburb of Rose Park. The big rooms had high ceilings, and the light fittings were surrounded by patterns of moulded plaster.

A wide passage ran down the centre of the house; a verandah at the back housed the laundry and toilet.

We shared our room, which had a window overlooking the driveway, with brother John. The room, I remember, had a fireplace that was never used. Neither was the driveway, for that matter, as our mother and father were saving to build their own home and could not afford a car.

On the other side of the house, across the hallway and down the passage, was the kitchen. Here we spent most of our time indoors playing by the warmth of the old wood stove, or sitting at the table watching Mother baking and preparing meals. Chocolate fudge cakes sometimes, with criss-cross patterns etched with a fork into the rich icing. How difficult it was for a little girl to wait until the steaming cake was cool enough to beg a piece before tea! In the pantry a wooden gate guarded the steep cement steps that led down to a damp burrow below the wash-house. What a smell! On the rare occasions that visits to the cellar were allowed, we breathed in the smell of dirt and damp and ghosts and death.

Big brother John, three years our senior, was our idol then. We were never far behind him. He seemed grown-up, safe and strong, and we loved him more than anyone in the world – more than Mother even, and more than Dad, who was always at the office and was anyway an unknown quantity since returning from the war.

Dad loved us immensely, though. He took us on his knee for stories and horsey-rides singing: *I can't forget my Mary Jane, I loved her so because; she was so very good to me; she was, she was.* Barbara was his poppet and he found it far easier to relate to us than John, who had spent the war years alone with Mother. It must have been difficult for Dad to come home to a seven-year-old boy who was used to being man of the house and his mother's protector. Four years is a long time for a seven-year-old; in John's world there was really no place for Dad, so the soldier gave his love to the younger and more adaptable little girl. And that's the way it stayed.

We were a bright enough little thing, pretty even, with fair curls that Mother would roll in strips of cotton sheeting to make softly falling ringlets. We were inquisitive, loyal and loving, eager to learn and to grow as big and as wise as our adored John.

School was a delight. A short walk with John down the road and we were there at the red-brick primary school with children to play with and blackboards to draw on. We were quick to learn, and related to our teachers well.

At the end of our first year of school we were allowed to do a large drawing of Father Christmas and his sleigh on the blackboard at the front of the class.

The drawing, and filling in the whole board with the edges of broken coloured chalks, took nearly a week while the rest of the class had to do other tasks, so we felt special – and so we were! What pride we took in filling in every detail of the sleigh and the brightly wrapped presents. Our teacher, who must have been a caring soul eager to nurture our interest in drawing, even allowed us back at school two days before the others so that we could make a picture to greet the school year.

Our first big landscape – how honoured we felt! Such a little duck to do such a big drawing. Remember standing on a chair to reach the top of the board?

So life was pretty good back then, eh? Not too many cuddles from Mother, but as many as we ever needed from Dad; games with John by the stove before bed and swings from the loquat tree in the back yard after school. Good friends to play with, too, when allowed to visit – especially Helen Belle, our very best friend with whom we swapped primer covers in grade one to confirm the bond between us. Best of all, perhaps, were those walks with John to the corner shop for Mother.

Sometimes, on Saturday afternoons we'd walk with John to the nearby picture theatre to see a matinee, the spending money for Violet Crumbles and ice-cream jingling in our pockets.

Then, without warning, our small world became a nightmare. Our childhood was lost for ever along with our innocence. To outward appearances, we were still a cute, happy five- or six-year-old, but we began our adult life *then*.

Not far from the safety of that old freestone – about half a kilometre straight up the road – was a playground we would often visit with John and a group of friends, either his or ours. The playground was part of a recreation park that sported a bowling green surrounded by high, deep-green hedges like the ones that many of the houses in our long road hid behind.

At this playground one afternoon after school, John suggested to us that we should go and talk to the groundsman in his shed in the corner of the bowling green. Besides his mowers and hedge clippers, it seemed that the groundsman also kept in his shed a large collection of comics, which would be coming our way if we did as we were told.

We never questioned anything that John told us to do. He was God, and his word was law. Indeed, we were always happy to obey his command because it meant his acceptance and love in return. So we went obligingly to the shed, leaving John on the swings. Mother told me recently, when I asked her for the first time about it all, that we were only five at the time. I wonder if we might have been six, and if this is the case, ought we to have known better?

Inside the shed, which was only about eight feet square, was a table on which we were asked to sit by the groundsman who stood directly in front of us. In one corner was a cupboard, higher than we could have reached, and on top of it squatted one of John's friends. He was surrounded by piles of the promised comics.

Well, my little one, memory tells me that we left that shed numb. Not crying, not shaking, not sad, not unhappy. Just numb.

Certainly we left without any comics – which was the first thing John asked for when we met him again in the playground. And we walked home with John numb, ate tea numb, went to bed and got up the next morning numb and went to school numb.

Several days later Dad came and said that John had told them what had happened in the shed. He gave no details of what John said, and we felt nothing. There was no discussion to confirm facts with us. It was too painful for Dad to mouth the words.

Oh, my little one, we could feel nothing at all. Only, perhaps, mildly pissed off because our parents were pleased with John for telling. They sure didn't give the impression that they were pleased with us. Mother didn't speak directly about it although we knew that she was very upset. Dad always found it hard to talk about anything distasteful – he said nothing to us either.

Some discussions took place with John in the kitchen with the door closed, while we were lying awake in our bed, eyes wide open, staring at the dark ceiling. It didn't seem to have very much to do with us at all – mostly it was to do with the gardener.

It seemed that Dad was taking the whole matter over. One day soon after, he took us back to the bowling green, with Helen Belle's dad, who was a policeman. We walked towards the big green hedge with one hand in Dad's and one hand in Helen Belle's father's. We looked up at the gardener, who was very high up on top of the hedge, with very big hedge clippers in his hands.

Is that the man? asked Helen Belle's father.

Yes, we said.

The gardener waved the hedge clippers menacingly.

From that day on we always crossed the road when we came to a hedge in case the gardener was hiding up the top with sharp clippers to get us.

We went home with Dad while Helen Belle's father stayed with the gardener.

Some time later, Dad said that the man had gone to jail and the subject was closed – and never spoken of again.

We waited for our punishment to come. Nothing happened, nothing was said, but still we waited. We deserved to be punished. Whatever had happened in that shed must have been very, very bad. We knew that for a fact, because the gardener had been put in jail. We had done something very, very bad. We deserved to be punished. We waited and waited. My poor sweet inner child, we've been waiting to be punished ever since.

Helen Belle was not allowed to play with us anymore. She did not know why. We did. We were bad. Other children at school were not allowed to play with us either. They didn't know why. We did.

We don't know why John told. We've never spoken to him about it. Probably his friend, who watched the performance from his perch on the cupboard, said something to him eventually, and then eight or nine-year-old John must have fought his own little battle about whether to pass on the information to our parents.

As it turned out, and we didn't discover this for another 50 years (when I eventually asked Mother about it), we weren't the only little girl to go to that shed. It seems there was a stream of them and it would have lessened our guilt to have known this.

Unfortunately, since the subject was taboo, we were never informed.

Our mother, although we didn't know it at the time, of course, had been sexually threatened by her father when she was young. He was a wild, womanising, hard-drinking Scot and his only positive quality it seemed was a gift for playing the fiddle. His wife, who was English, but who went to live with him in Glasgow, was a small, meek woman who bore him eight children, one of whom died as a baby.

Hers was a life of poverty, abuse and hard work. She was weak where her husband was concerned and took him back after his affairs time and again – perhaps out of love, more probably for her children.

Our grandfather beat her brutally, and when his girl children were mature enough for his interest, he turned his attentions to them. Grandmother was, or chose to be, powerless to stop him.

After they moved to Australia one of Mother's elder sisters became pregnant by this brute of a man and the child was given away. The sister left home, and Mother became his next target. She spent many a night hiding from him in the chicken shed, shivering and crying, determined that he would not have his way. One night, when he came to her bed, she pushed him into the burning fire place to save herself – and has carried guilt for that for the rest of her life. It didn't seem to affect him much, though, as he kept threatening her, and when

her youngest sister was entering adolescence Mother took her, even though she was still really a child herself, away from the house to board elsewhere.

Poppet, Mother's pain was known to Dad, and when our own abuse took place, he tried to shelter her and take charge as best he could. Her own memories, still weeping wounds, made her block the incident from her mind.

Ever since she was a young child – walking barefoot through the snow to school, coming home to meagre food, or none at all, surrounded by drunkenness, physical abuse and apathy (none of her three brothers ever stood up to their rotten father) – Mother's ambition was to drag herself up out of the working classes. In our Dad, a gentle, honest, hard-working accountant from a settled, middle-class family, she found her ticket to respectability. She managed her marriage and her husband to meet her requirements.

No wonder she stayed out of our troubles. She couldn't bear to watch history repeating itself – but sadly, by doing nothing to soften her child's pain, she was repeating the actions of her own mother.

Soon another incident occurred, and this one we buried very, very deep. Forty years would pass before we were strong enough to face the memory. We were playing catch in the back yard with John, who had his back to the verandah and the laundry door. Becoming aware of an itch between our legs, and after a short scratch, as children will do, we smelt a finger. Precisely at this moment, Dad appeared from the house, standing directly behind John. As many parents would, he said: Don't do that, you dirty little girl. Our fate was sealed – the two people we loved the most, John and Dad, standing together as our accusers, put a name to the feelings that we'd been carrying since the gardener's shed. Dirty. That's what we were. Dirty.

Poor, sweet little darling.

At that moment, shying away from unbearable pain, you chose, my inner sweet one, to shut your little self deep, deep inside our psyche. Your essence of childhood hidden from me and the world under the weight of dreadful shame, too great for a five-year-old to carry. That was the end of our true childhood, our innocence lost forever. How sad that I lost you then, at five, my poppet, and had to struggle on by myself, unbalanced and lost in a no-man's land, neither child nor adult with no frame of reference. But I was determined to prove that I was worthwhile, or would be. I went stubbornly forward then, to take on the world. To show them all. To show Mother and Dad, John, Helen Belle's father, the lot of them. Even if I was dirty. I worked harder than ever at school, came top of the class, aspiring to ultimate goodness. What a heavy load for a wee soul.

Mother and Dad were building a new home at Somerton, near the beach, but until it was completed I had to stay at Rose Park Primary, and suffer the rejection of my old friends. Thank heavens for a new friend, Lesley Hood, and her mother – somehow oblivious to my questionable character. Wrapped in their acceptance I found a second family that gave me respite from home and the tightness I felt within it.

On the surface, life went on as normal, but my little antennae were picking up all sorts of tensions in the family, and it was easier to be at school or at Lesley's house, where there seemed to be no pressure at all. Lesley's father had died and she lived with her mother and elder sister in a warm old maisonette not far from home. I was allowed to walk there on my own, and the only problem involved was the number of hedges that had to be passed on the way. The joys to be found at the Hoods' were worth the risk, and I often stayed the night in the sleep-out at the back of their house.

Lesley and I had similar interests back then, but I think Mrs Hood was the one who attracted me the most. She welcomed me always with open arms and complete acceptance, liked me unreservedly. In return, I loved her with a grate-fulness that she probably never perceived.

Back home, I was feeling rejected, and became ever more determined to prove my worth. Each day Mother seemed to love John more and me less. I felt no antagonism from her, but no acceptance either. Dad was busy at work during the week, and he spent most weekends at the Somerton block, building a shed out of second-hand bricks, or checking on the progress of the new house. When I was five, Mother had a new baby, a little girl they named Ann. She demanded most of Mother's attention, as babies do, and Dad had to help with the caring as well. So thank God for Lesley Hood and her wondrous mother – there seemed to be precious little time for me at home.

At six, in desperation and with tuppence in my pocket, I ran away from home – God knows where I thought I was heading. With one penny I caught the bus to the terminus and with the other I bought fruit from a greengrocer which I ate while meandering to an acquaintance's house nearby. When I blithely told the lady of the house that I'd left home, she rang Mother, and Dad was sent to pick me up as soon as he arrived home from work. I was sent to bed without supper for that one.

Poor Mother and Dad. I must have been a worry to them, and neither had the time or insight to be able to meet my needs. It must have taken a lot of courage in those days to have laid charges against the gardener. It would have been easier, for Dad, who skirted anything distasteful, and Mother, who wanted

everything kept *nice*, to sweep the messy business under the carpet. No doubt it helped that Helen Belle's policeman father was an acquaintance.

They were a good-looking couple, my parents. With three attractive children, another on the way, a new home of their own under construction, and Dad's position in his firm becoming ever more important, they were the perfect middle-class picture – all that Mother could have ever dreamed of.

She was a tremendously beautiful woman, five foot four and well proportioned, slim with raven hair and deep brown eyes. She dressed well – smartly within the fashion of the time – even though finances dictated that she had to make most of her own clothes (and mine).

Dad was just over six foot, slim and straight as a ruler, and handsome as they come – black hair, dark eyes, strong jaw. He was always well presented in suit and tie, and was liked by his peers. Like the rest of his family, Dad was a devout Methodist, and we children went to Sunday School as soon as we were old enough, while he went to church. Mother never went to church. Obviously she and Dad had come to an understanding about that. Her childhood had convinced her there could not possibly be a God, so she stayed home and cooked the Sunday roast while we trooped off to worship.

This attitude of Mother's was unacceptable to her parents-in-law, and it was a credit to her strength that she stuck to her guns. From the beginning, Dad's parents had made it clear to her that she was not good enough for their son, or their family. They were nice enough folk, but full of the class-snobbery they had brought with them from the old country. Grandpa had been a sea-captain and had sailed many a rigger between England and Australia when he met Grandmother, who was working as a stewardess on the big, dangerous ships. Neither position indicated high breeding, but when they decided to marry and settle in Australia, their world became a fortress of good old English Methodist middle-class tradition.

Even though Mother met their handsome youngest son one Sunday night at a Methodist Church – where he found the courage to ask her for a walk around the block after the service – they never forgave her her lack of education and social graces. Mother had worked hard to improve her social skills since she had left her doomed family, and Dad loved her with a passion that never faded. Against the wishes of his parents, he courted and married this strong beauty.

Mother, at the time, was boarding with a wonderful woman called Mrs Grey, who ran a knit-wear and wool shop in a little arcade on the main north road out of Adelaide, just around the corner from Dad's family home. Mrs Grey had taken Mother in when she was only 14 and set her to work on the big knit-

ting machine that was used to make waist, neck and sleeve bands for jumpers and cardigans. Mother, a willing student, soon mastered the old machine, developing a skill that later helped her supplement Dad's income so we kids could be fed and clothed in the manner to which she aspired.

Generous Mrs Grey took Mother into her home as if she was a daughter, even though she had a daughter of her own. Although this daughter never quite accepted the relationship between the new family member and her mother, Mrs Grey's big house at Enfield became the comfortable, warm home that Mother had always longed for and Mrs Grey became her protector and teacher.

I used to go often to Mrs Grey's, visiting with Mother, and loved to curl up on the soft-cut velvet couch with its myriad of brightly coloured cushions. Mrs Grey could crochet and sew and knit. She would weave spare bits of wool into kaleidoscope cushions, rugs and tea cosies. There was always a fire burning in the hearth next to her comfy armchair and the room was full of colour, joy and accomplishment. Sometimes I was allowed to bang away on her piano and was always eager to snoop around in her Aladdin's Cave of books, plants and small round tables covered with photographs of interesting-looking old people who I didn't know.

This place had been Mother's haven and finishing school. Under the gentle guidance of jolly Mrs Grey, she had acquired the social skills that let her function in Dad's genteel social circles of Enfield and Prospect.

Once she became a wife, mother and mistress of her own domain, however, she felt able to defy her parents-in-law's expectation that she should worship a God that she had no belief in.

Dad's faith, on the other hand, was childishly simple. He believed without a trace of doubt that every word of the Bible was the absolute truth, and wanted his children to be schooled in his Methodist faith. Mother had no argument with that, so off I went each week to learn lessons that, despite my eventual doubts, stood me in good stead.

I enjoyed Sunday School for it gave me yet another chance to excel. I learned my lessons and hymns, and proudly received books and other prizes at anniversary services. On these occasions, scaffolding was stacked high above the front of the big, sombre church, Gartrell Memorial, in Rose Park and we, with all the Sunday School children, were displayed on it, the girls in new white dresses and the boys in tidy suits. Here, at six, standing high above a congregation of hundreds, I was allowed to sing my first solo.

What a plucky girl I must have been, all decked out in white, standing proud to sing Christopher Robin. Proving to them all.

Well my little one, I'm thinking of you again after an emotional phone call from Annie. She feels she was neglected as a littley, and now, at 50, feels unable to come to terms with it.

Mother gave birth to her fourth child, an astoundingly beautiful baby girl with olive skin, dark hair and dancing brown eyes, when Ann was barely 15 months old. Straight after the birth Mother became ill with septicemia and was bed-ridden. A girl was hired to help with the baby and young Ann, but unfortunately she was more interested in their handsome father, and had to be dismissed. Dad had to take on the responsibility of Ann's care, wherever possible, to give Mother a chance to recuperate. Like me, she too became Dad's little girl.

I was far too preoccupied proving myself at school to be aware of any of this. The family was divided into the oldies, John and me, and the babies, Ann and Tessa. Although the gap in years was only five, the gap in perception was far bigger. I considered myself very grown-up with a lot of important tasks to perform.

My pretty, fair ringlets had long gone. I was already gangly at nearly seven, and I wore my hair, now light brown instead of gold, in hooped plaits at each side of my head, knotted off and tied up with a ribbon. I had become a 'plain' child, which bothered me not in the least because there were more important matters on my mind. School. Achievement. Success. Acceptance.

At the end of grade three, my last year at that now painful school in Rose Park, my name was read over the loudspeaker by the headmaster as dux of our year. I remember thinking to myself: That will show them.

Then we moved into the new house at Somerton, and a new world opened before me. Nobody here knew about *it*. There were no hedges here, because this was a new housing area. I was sad to leave Lesley Hood and her mother behind (although our friendship continued for many years), but otherwise had no regrets about leaving my familiar environment.

My parents had chosen their land very wisely. The area, about two kilometres inland from the beautiful beaches along the gulf, was undeveloped at that stage, but thanks to its proximity to the sea and the busy commercial centre of Glenelg, promised to become a prime suburb.

They had bought a double block, one destined to become a tennis court when finances permitted, thus offering the dream lifestyle for their family that they coveted. Later, the spare block could be sold for retirement funds or university costs, as it was Mother's dream that at least one of her children should become a doctor – or more precisely, a paediatrician. Where this idea originated nobody ever knew, but it was the final goal in her long-term plan, and she never,

to her dying day, ceased voicing her disappointment that no paediatrician had emerged from among her brood.

The house was made of solid, double red-brick. It had four bedrooms and, joy of joys, one was for me alone. It had a window that overlooked the paddocks of tall grass and weeds at the back of the house.

The nearest main road was a hundred yards or so from the house, and so new was this neighbourhood that Dad had to clear a road himself from our block to the main thoroughfare, pulling up rye grass, purple thistles and stubborn olive trees so that the builders could get to the job. There were no other houses within cooee, which was grand. John and I built paths, forts and bike tracks in the long grass.

The new school was beaut. It lay a good mile's walk along the main road past scattered houses, paddocks with horses to talk to and a deli where I could buy square, sweet ice blocks in crisp wafer cups for a penny. Glenelg Primary was a big school full of new children and challenges. No stigma here – everything fresh, clean and ripe for the picking.

I made new friendships easily, and found classwork a pushover. Once again, I related well to the teachers and soon became the student allocated special errands and positions of authority. No one was jealous of me for this – I enjoyed the respect and friendship of the whole school as I climbed to grade seven. Prizes for initiative, drawing and excellent work were mine for the taking, and on the few occasions when I missed out on top place in the class marks, I didn't mind a jot for mostly I was bested by a close friend. The competition to excel was a game that was both important and unimportant at the same time. I loved to learn. Still do. Books were friends to be read under the blankets by torchlight when they became too exciting to leave. *The Famous Five, Biggles.* Adventure stories galore.

What of my family? I was far too busy to be too involved with *them*. John by now had a gang of boys to tear around with, and they had built in the paddocks a superb bike race track full of jumps and bends. That kept them out of my way. Ann and Tessa were just kids about the place and not to be taken seriously. Mother was always busy cooking and cleaning for six on a budget that didn't allow for quick meals with good cuts of meat. Dad's job in the city as accountant for the *Stock and Station Journal* didn't pay enough to make life easy for a man with a wife and four growing children. By nature he was careful with money and determined that he and his family would live without debt. Mother took knitting jobs to earn an extra few bob for the house or the kids.

Mrs Grey had retired by this time. Mother had bought her old-fashioned

knitting machine, and she spent every spare minute working away on it in the shed, pushing the wooden handles of the heavy machine back and forth, back and forth, earning the money to clothe and educate her children in the manner to which she'd like them to become accustomed.

Mother had learned well from Mrs Grey. She was extremely skilled at her machine, making bands for home knitters, who ordered them from a drapery shop at Glenelg to which I delivered and collected every other day after school on my bike, but also tailor-made suits and twin-sets that became quite in demand among those in the know. The machine only accepted the finest of wools, probably about a 2 ply, which Mother bought from the city on big spools. The finished garments were as fine as any of the imported ones found in the big stores, and large ladies especially queued up for one of Mother's magnificent tailored creations. Mother was a stickler for perfection. I bet that never a seam of Mother's gave way as long as the garment existed. Certainly none of ours did, and my sisters and I were fortunate enough to have pieces made for us until Mother was too frail to manage the heavy machine.

Front and back lawns with fruit trees were added to the house, with vegetable plots around the back. The spare block was now a tennis court, though it was only made of dirt that Dad had levelled and rolled damp every weekend with a heavy stone roller. He had planted almond trees, perhaps forty, around the perimeters of the court, and it was one of my jobs to pick the almonds when their furry coats had split, peel them out of their green cases, and bag them ready to be sold. It seemed as if Mother and Dad had it all planned one step ahead – a little extra here, a few pounds there, and a good education in the offing for all their children. University was not out of the question for us, and that was an option that neither Dad nor Mother had been fortunate enough to have available to them.

By the time I began high school at 12, the family was stable, affluent even, and I was pottering along nicely, the horrors of the past receding behind me. One time earlier, when I was about eight, my personal loneliness overwhelmed me and I had run away again, only to return hours later, wet and cold and defeated. Where can an eight-year-old run, after all? But generally for me and my many good friends – Anne Honey, Ann Stock, Joan Rees, Wendy Traynor, Pat Chaplin, the Stratford twins and others – life was a pleasant adventure thanks to the beach most of the year, Saturday afternoon flicks, bike-rides to new places, music and books.

Our primary school was co-ed, although the playground had a yellow line across it that divided the genders. I heard giggles from the bike shed and noticed messages being passed through the lunch-room partitions, but was

not the least bit interested in the stuff that went on between the boys and the girls. I never did play you show me yours and I'll show you mine, or gape at the dirty magazines that surfaced now and then. I was far away from all of that – too old and too disgusted, although not realising why at the time.

One of my proudest moments in grade seven came about due to Miss Wade, our class teacher. She seemed elderly to us all at the ripe old age of twelve, but probably she was only in her fifties. She was a pitifully thin woman who wore her grey hair pulled back in a bun, and had a tight, drawn face that belied the sensitivity she showed for her charges. She suffered from diabetes – and it was obvious when she was unwell because her skin turned yellow and she became disoriented.

During one lesson I became aware that she was sitting awkwardly in her chair and her skin was very discoloured. Leaving my desk, I went to her to enquire if she was all right – a bold move in 1952. She could hardly speak, so I fetched the teacher from next door. Miss Wade was to be taken home immediately it was decided, so she could take her medicine and be visited by a doctor. She refused to let any of the staff accompany her in the taxi, but insisted that I go home with her.

This was an astounding decision. I liked this teacher and had a good rapport with her, but I was a child and it was obvious that she needed competent support. But off I went with her in the taxi. I helped her inside and into bed, fetched her medicine and water and stayed with her until the doctor arrived.

I felt, my sweet, like a special person. Even to be inside a teacher's house was unimaginable for children of my age, let alone helping her undress and get to bed. I felt *valued*, grown-up. My suppressed sense of shame disappeared for a while and I felt good about myself.

Earlier that year I'd won the prestigious prize, allocated one to each school, of a free pass for the duration of the State Exhibition at the Wayville show-grounds. In those days, as well as the Royal Adelaide Show there was a bi-annual event called the Exhibition, which was similar to the Show but much less money-oriented – there were no showbags, for instance. Mainly it featured businesses exhibiting their expertise, as well as livestock, animals, flowers, and so on. It was less fun than the Show, though there were still a few side-shows, but the prize was given for initiative and I was very proud of it.

Then there was the Junior Red Cross adventure. After a woman had come to the school to tell us about Red Cross, I approached the society, with Miss Wade's blessing, to open a Junior Red Cross branch at the primary school. This involved visits to Red Cross headquarters in the city and much planning and

organisation, all of which I took on without a qualm. The club was duly formed and, as its president, I was offered the chance to go to an international camp, which was held that year in a prestigious school in Geelong in Victoria. Only five boys and five girls were chosen from South Australia, and this honour did my spirit the world of good. It was my first major excursion away from home. Ten days – quite a thrill.

I remained involved in Red Cross for several years, participating in camps and then attending them as a leader in the Adelaide Hills. My God, little one, I certainly showed some promise! Anyone not knowing my background would see me at 12 as an intelligent, creatively gifted, pleasant and attractive leader with the world at my feet. It's farcical to think that only now, 45 years later, am I beginning to get my shit together!

Speaking of shit. It was also during grade seven that the accident happened – the one that would leave me with back and neck pain for the rest of my life. I was riding home from school, right arm out to indicate I was about to turn from the main road into our street. A motorcyclist behind thought I'd indicated that I was about to go around a bus that had stopped opposite the corner. He pulled wide and accelerated to pass.

Splat. His motorcycle slammed into my pushbike at right-angles, sending me flying into the air then bouncing along bitumen until I lay bleeding on the road.

Someone who knew me ran for Mother. My only vague memories are of walking along the road leaning on Mother, a brief moment in the bathroom as she washed blood from my head, and then the sirens of the ambulance, rushing me to hospital.

I was lucky, my poppet. I could well have been killed or severely damaged. Concussion and severe abrasions kept me in hospital for weeks, but it was the hidden tissue trauma and unnoticed hip damage that would create life-long problems.

Ah now, my hidden, string-bean of a teenager – high school! The happiest days.

Brighton High School, about four miles from our house toward the southern beaches, had only been open for a year when I arrived in my beige tunic and green blazer with matching felt beret. Children often have difficulty making the adjustment from the final year of primary school to high school, where suddenly they are in a big pond, but at fledgling Brighton High there were only about 500 students all told when I started, and no established groups to bully or belittle anyone. Every student was made to feel special, and I found the changeover of schools exciting.

All of the new kids were given an IQ test on the second day and, to my pleasure, I scored well enough to go into the top class. Unfortunately, though, this limited my choice of subjects – art was available only to the commercial classes. I asked for an interview with the headmaster and got it, but was bitterly disappointed with the outcome. His name was Mr Tregenza and he was an older version of Dad – tall, straight, old-fashioned and kindly. I liked him immediately, and explained to him that I needed to transfer to a class that took art as a subject. He laughed gently. Out of the question, it seemed. I had one of the highest IQs of the year's intake and couldn't possibly be moved down to the commercial classes. Maths, languages and science were to be the go for me.

Despite this setback I threw myself into high school life and had a go at whatever became available. I played tennis and softball in the summer and hockey in the winter, and as first year rolled into second and third, I took up debating and drama as well.

Studies came easily, though I use the term *studies* loosely because I didn't actually do any study as such. I was lucky enough to pick up most lessons quickly, and soon learnt how to get by without doing homework, leaving precious hours for all my other activities. Maths, particularly, was simple for me – I loved the challenges of geometry and trigonometry. English was a favourite subject, giving scope for my creative streak, and French was a joy because of the sensuality of the language. I put up with physics and chemistry, but cared little for either, and Latin was really the only subject that I despised. I learnt only enough in Latin to get by, copied other student's homework and cheated in tests. Not interested.

My class mates included old friends from primary school plus new faces who soon became close friends. We were a lucky bunch. All of us clever, from stable homes, nurtured by the teaching staff, and with careers ahead of us pretty much for the asking. This was the greatest time of my life so far. Home became a place to eat and sleep and school was my real home. The place where I belonged.

Many of the marvellous teachers took an interest in me, seeing my potential, and desperately tried to harness my enthusiasm for absolutely everything and concentrate it on study.

Brighton High was where I first met the author and teacher Colin Thiele, who, on the first day of third-year English, burst in through the door, jumped on the teacher's desk and, arms waving, began acting out one of Shakespeare's monologues. I loved him immediately.

Other mentors included Margaret Hodges, a domestic arts teacher, petite and sweet, who married in her mid-thirties and returned from her honeymoon to see

us all through the last term before our exams, and her retirement. My relationship with her has lasted throughout my life. Dean Manuel, a maths teacher, was patient and encouraging, while our fourth-year home room teacher, Miss Harris, was always available for a one-on-one chat about any personal problem.

And then, of course, there was dear Mr Tregenza, headmaster extraordinaire, who I once hit in the face with an apple core at a prefect's meeting, the target having ducked just as the head walked in the door. His patience with my exuberance, and his ability eventually to bend the rules regarding art lessons, taught me a new slant on the power of power. There were plenty of other teachers. Much later, when I was a teacher myself in a high school, I realised how very few teachers *really* wanted to teach. Most that I worked with took the position only for reasons of job security, money and holidays.

There were nice boys aplenty at Brighton High, but not many that took my interest. I had fallen in love with Dino by second year and he remained a constant companion for several years.

Joan Rees, one of my friends from primary school, and I shared much leisure time. She was a short lass with a gentle soul and we formed a bond that lasted many years, until we slowly grew apart. It was with Joan, on push-bikes down by the sea at Colley Reserve, that I met Dino. He took my breath away – tall, olive-skinned, excruciatingly handsome with thick, black hair and rippling muscles. The perfect vision of young manhood on his racing bike with his tight little shorts.

A bunch of us spent every weekend, summer and winter, at the beach. We owned the beaches, allowing nothing to mar the pleasures of jogging through the shallows from jetty to jetty, or sitting on the lawns with push-bikes at the ready for a ride to the shops for milk-shakes and chips.

Dino, a little older than me, had left school and was learning a trade as a carpenter. His Italian family lived near the market garden area of Morphetville, and occasionally I'd visit there, always awkward because of the language barrier and the sparseness of their simple home. Dino was open and gentle. He loved his bike riding and took up racing, so I followed the race meets and watched him speed around the track, tanned leg muscles rippling in the afternoon sun, vowing to myself that I'd never love anyone else.

Mother and Dad eventually accepted Dino after voicing misgivings about his Italian background and his obvious masculinity. It soon became clear that he was no threat to their daughter and I was allowed to go to the Saturday night movies at the Ozone or the Strand, where we'd sit with a crowd of other young teens in the front rows and kiss a lot. How grown-up and precious I felt with

Dino's big arm around my shoulders in the dark. He was a very good choice for my first serious relationship. There was no question of pressure for sex. Dino was a gentleman, for all his larrikin behaviour, and I, my little sweet, was by no means ready to begin exploring even a hint of sexual behaviour, although kissing was good, and strong arms around my skin on the beach was good.

By this age, fifteen going on sixteen, several of my friends had been experimenting, some claiming to have done *it* several times. Hushed discussions took place over lunch-time sandwiches, or in the privacy of a girl's bedroom after school. But the stories varied and were suspect. And disgusting. My peers in my own elite class were all still innocent, their lives steeped in learning and achievement, and even when our physiology lessons turned to human reproduction, and poor Mr James tried to draw ovaries and tubes and sperm on the blackboard, nobody really understood the realities of copulation, and we all passed the test on the subject blissfully unaware of the act itself. Such babies we were. The top class! Educated in everything but the reality of life.

Among my friends was a girl called Wendy who lived with her widowed mother in the centre of Glenelg. She attended a different school, but our friendship had grown very deep very quickly. Many nights I slept over at her peaceful house. Wendy's mother had taken a liking to me and I had become another daughter to her.

These nights gave me respite from the growing tension at home. John was 19 by this time, a handsome six-foot-five with charisma that made him a leader of a small band of devoted followers. Now an apprenticed mechanic, he had an ability with engines that was the envy of his mates. At the same time as I became interested in boys, John had become interested in me again. For a few years he'd been so busy with bikes and cars, and his own reputation among his peers, that I'd nearly been forgotten, but he had lately taken to bullying me about my sexuality and relationships. Most of his barbs were accompanied by laughter and sneers from his companions.

Wendy's mother would often go out on Saturday nights, leaving the two of us to baby-sit each other. It was on one of these nights that I met Claude George William D'Ayers, and the word love took on a whole new meaning.

Wendy's semi-detached home fronted one of the main thoroughfares of Glenelg and on this summer evening Wendy and I were hanging over the front fence watching the world go by, well, watching two handsome young men walking together in the balmy, lazy dusk. They noticed us, we noticed them, and they loitered outside the fence for an hour while introductions were made along with arrangements to meet for a swim the next day.

I'll have the tall one, I'd said as they'd approached, and it was a fortunate choice. He was ruggedly handsome, with dark hair and a lean body. His friend, Barry, was fair, with finer features, and suited Wendy well.

The boys told us that they were from Western Australia and were travelling around the country on motorbikes. Claude was twenty, and I suppose Barry the same. They planned to look around South Australia for a while, so had rented a small flat on the sea-front.

The companionship between the four of us was instant and delightful, and we spent the next two months in each other's company. At first Wendy and I didn't dare mention the motorbikes to our parents, but as they became accepting of these gentle young men, we were officially allowed to ride on the backs of the boys' bikes.

My relationship with Claude was idyllic. He was fun to be with and liked the same activities that I did – going to the beach, walking, movies, going for rides in the country and going to the beach. Sometimes I'd go with Wendy to our boyfriends' flat, where we'd sit on their laps in the big old stuffed sofa, snuggle into their necks, and share salty kisses after swimming. These two young men, I suppose in deference to our young ages, never suggested any heavy petting, though we shared plenty of kisses and hugs along with our sandy fish and chips, coke and an occasional sip of their beer. I remember fast rides on the back of Claude's big bike, lap rug flapping against my legs in the wind. The smell of his leather jacket. His arm around me in the movies. His crooked smile. His dark eyes. I'd had crushes on one or two lads, and I loved Dino, but I was in love with Claude. And not surprisingly, for he was a real honey.

But the boys had a trip to finish. They'd planned it for a long time and had limited funds. They put off their departure, and put it off again, but eventually they had to move on. Claude was smitten too by this stage, and Wendy and Barry had become deeply involved as well, so it was a difficult time for all of us.

Young Barbara, full of love and romance and joy, decided to leave school and go with them, but Mother and Dad flatly refused. I was not quite sixteen and still very much their responsibility. Barry and Wendy vowed to be true to each other, and Barry promised to return for her in a year, but neither Claude nor I made any commitment other than to write, and it was with a heavy heart that we said goodbye.

It took me a long time to get over Claude – or what seemed a long time to a sixteen-year-old. I kept in touch until he got to Queensland, and then slowly the letters stopped and life went on.

I was not pretty at sixteen, though I was beginning to wear my woman's

body with pride, tall and straight. I'd grown five inches in third year and stood nearly six feet tall. I was slow to reach maturity and was never going to be well-endowed in the breast department, but there was something about the swing of my hips and the tilt of my head that men found attractive, and it seemed to make up for the lack of curly hair and luscious lashes. My hair was brown and straight, and I chose to wear it very short, firstly because I refused to waste time tending it, and secondly because I liked the pixie look. It was an easy style to manage. I have kept it pretty much the same for the rest of my life.

Year 11, matriculation, came as a rude shock given my complacency about study. I was extremely busy that year being a personality about the school, playing sport and running just about every club available. I won prizes for acting. I sang in the school choir. I was on the debating team. I was a prefect. Quite a personality, but not much of a student. The subjects that I'd found so easy during previous years had suddenly become more difficult. I never had the discipline for home study, and my marks began to drop.

When I sat for the intermediate exams at the end of third year, I put my name on the Latin examination paper and left the hall without even opening it. When the headmaster found out about this he sent for me, horrified, to find out the reason. He could not understand how one of his top students could behave in such a way. I explained to him that I'd never wanted to do Latin. It had no place in my world, I thought, and it was the hated subject that I felt had taken the place of art in my curriculum. Mr Tregenza was fortunately a reasonable and sensitive man. I could have received a nasty punishment. Instead, he arranged for me to sit in on art classes while the rest of my own group was doing Latin.

Now the world opened up like a poppy. Alby Smith, the art teacher who agreed to take me on, was an excellent mentor who, once he had his class underway, would show me the finer points of drawing and, later, watercolour. His time was limited but he often gave me his undivided attention.

I believe, poppet, that this was the beginning of my deep love for gum trees. Alby taught me how to observe and capture the intricacies of the gums with my pencil. One afternoon, and to this day I can remember exactly where I was sitting beneath the gums in front of the main building, he showed me how to bring three dimensions to the network of branches simply by shading the underneath branch a little darker. This has proved to be the most important single piece of knowledge I have ever been given. Instantly I had the power to turn a two dimensional piece of paper into a three dimensional image. The possibilities this opened up seemed boundless.

If only Alby Smith realised the gem that he'd given me – or was it the devil's tool? I instantly knew the path that I'd eventually follow, and it has proved a lonely road through a life full of self-criticism, frustration and poverty. But it has lead me to life's greatest pleasures, and at times to a true sense of identity and peace.

Drawing became my consuming passion, eating away at the small amounts of study time that I tried to jam into my busy life. Maths and science slipped way down the list of priorities. French was a language still to be enjoyed for the sensual sound of the words but English, purely because of its creative possibilities, was my only true interest among my 'set' subjects.

Joan Rees had left school to take an office job after intermediate and my long, easy friendship with Anne Honey (since grade 4 at Glenelg Primary) became much closer during this year. Anne, a very sensual being, loved the sound of French, and the pair of us spent hours practising the words and nuances of Eartha Kitt's French songs and Charles Trenet's 'La Mer', riding our bikes together, singing at the tops of our voices. Anne ended up with the Alliance Française prize for the state in the matriculation exam, as well as top marks in several other subjects.

We were both tall and attractive, both intelligent and questioning. There could have developed between us a destructive rivalry, but 40 years later, we still love each other deeply. Anne and I had competed for the top spot in the class since grade 4. As we moved through high school, Anne continued to excel while my own varying interests took their toll. The two of us started a school newspaper together and shared similar interests in sport, but Anne was far more dedicated than me and took life more seriously. She was invariably the captain of a team, while I was vice-captain. This suited me well and our friendship grew. When I was made a prefect, Anne had the honour of being head-prefect, a situation we both accepted with ease. We were different, but complementary, personalities. Anne's dedication would lead her into a secure and respected position in the teaching field of English and creative writing, whereas my enthusiasm for everything would lead to nothing but trouble.

My social life changed dramatically during this matriculation year. I became involved, for a while, with a group of motorcycle fanatics. There were 50 or 60 riders in the gang, ranging in age from 18 to 30-odd. This was the year, 1956, that Marlon Brando's *The Wild One* became a cult movie, and it felt good to be part of this excitement. I was far too young and innocent to be socially acceptable in the group, although the man I eventually rode most with was the oldest in the gang – number five bike, a 650 Triumph – who was nicknamed Sugar Daddy in honour of his 30 or so years. He was a gentle guy who respected my

right to say no, and for months I rode with him each weekend. We would lie kissing on the lawns by the beach on warm summer nights.

This nice bunch of bikers looked after me like brothers. I've never forgotten the thrill of the wind in my hair, the security of belonging in a fraternity, the throb of the bike-motor beneath me, or the smell of sweaty leather under my nose. Many years into the future, poppet, when my son bought a big 750 Katana, I sat astride its gleaming silver body and whimpered for my lost youth.

With my time devoted to bikes, drawing, school activities and talking and wondering with sweet personal friends, mostly Joan and Anne, my grades slowly dropped, and at the end of the year, everybody except me was horrified to learn that I'd failed the matric exam. Only two subject passes out of six. English, of course, and Maths I. This was not much of a surprise to me at all, or even a great disappointment. The year had been a good one, with many lessons learnt that were as important as those taught in class.

My only real concern about the results was that they affected my immediate future plans. I had known since a very early age that I would be a teacher of some description, and had tentatively applied for a study course that would lead to a teaching post in the native area of New Guinea. I had been accepted for this dependent on my exam results, so that was now a lost opportunity.

There were several other choices available, one of which was a post as a junior teacher in a primary school while I studied part-time, and then re-sat my exams. This could then lead to a three-year course to become an art teacher in secondary schools. That path looked rosy to me because I'd be given a good deal of art tuition.

So junior teaching I went, leaving the high school that had given me the happiest and most fulfilling four years of my young life. I'd grown in confidence and discovered many hidden abilities. I left Brighton High with an easy acceptance of myself in relation to my elders, teachers and peers. Any past problems had faded into insignificance and I stepped out into the world with joyous confidence.

Oh, my sweet little one, how naive I was as I strode into the world at 16. Sex had become an issue by now, of course, for me and my peers, and I'd set myself a strict set of rules. Quite definitely, I was going to be a virgin when I married.

I knew about teasing. The girls talked about it and the boys reviled it. So they should, I thought. Teasing was unfair. So I flatly refused to participate in anything but kissing, which I loved. No hands were allowed on my breasts, either inside or outside my clothes, and definitely no touching anywhere else. I had been extremely lucky up to this point with my boyfriends. They had all

accepted my rules without question and had treated me with a respect that by now I took for granted. Thanks to them, I had learnt to trust men. I'd set my own boundaries and that was that!

I wonder how much of this decision was influenced by the gardener's shed, long forgotten by this time in the joys of life and learning, hidden deep in my psyche. My conscious choices, as far as I could tell, were to do with honour and pride in my morality. Only my closest friends knew about this strong sense of morality, and the rest of the world, it seemed, including my own family, took it for granted that I was playing fast and loose. After all, I was never without a boyfriend in tow, sometimes a couple at a time, and I had run around with the bikie gang and older men.

And, I wore bikinis on the beach. In those days this was unheard of.

Once, my fondness for risqué bathers nearly cost my grandmother her life. In the draper's shop where I delivered Mother's knitting, I saw on display a pair of black-and-white, leopard-skin-patterned, two-piece bathers and immediately I *really* wanted them. These were hardly the socially acceptable floral numbers with fully-shirred backs that girls were wearing at the time, and Mother, of course, refused to buy them for me. I hated the conventional one-piece swimsuits which, as I grew ever taller, proved to be uncomfortably lacking in length, so the two-piece seemed a must.

I saved my lunch money at school, two-bob a day, and put a deposit on these patterned bathers of my dreams. My mates, good friends that they were, shared their lunches with me for many months so that my coins eventually reached the amount needed for the bathers.

The bottoms of the bathers were waist high – bikinis had not reached Adelaide at that stage – but I cut them down to the hip. They were nowhere near as brief as today's bikinis, but pretty shocking for those days.

On the beach one day with three of my girlfriends, we were spotted by a photographer who took a photo of the four of us splashing through the water hand in hand, and a very large photo of this appeared across the centre page of the evening newspaper. Grandmother had a minor heart attack. The relatives were horrified and Mother was ashamed.

That was my first pair of bikinis. I found them so comfortable, with the sun on my bare skin an added bonus, that I began making my own out of scraps of material and continued to wear them into my 50s. Although I was not big-breasted, I had enough shape, with my long limbs and flat tummy, to wear them well and I could see nothing wrong with them at all.

To Mother and John, though, these bathers cemented their shared opinion

that I was of low moral standing, and they began to use the word 'slut' in their scathing critiques of my behaviour. 'Sex-mad' was another biting criticism. (You always have been sex mad, they would say. Always?) These were hurtful, damning words, and no matter how much I denied their charges, I was *never* able to change their opinion.

Dad said little, certainly nothing so painful, but he was disappointed about the bathers and unable to talk about sexuality under any circumstances, so I felt that he, too, agreed with the general consensus.

Stubbornly, I refused to change my lifestyle, refused to wear one-piece bathers and refused to date boys the family thought 'suitable'. I knew that I was doing nothing wrong and that was enough for me, though many a night I'd cry myself to sleep at the unfairness of my family's superficial judgements.

To make matters worse, particularly among the local boys, my nickname was 'Screw'. John had acquired this name at primary school, where his pals had converted our surname of Newmarch to 'Screwmarch' to 'Screwball' to 'Screw'. When the kids began calling me 'Screw' as well, I was pleased. He was my big brother, and this sharing of nicknames was precious. He gradually shed the moniker, but mine stayed.

I had no idea whatsoever of the slang meaning of 'screw'. No one ever told me, and among my contemporaries it never had any sexual connotation. My friends' parents called me Screw with affection and it never occurred to me that the word was anything but a derivation of my surname. So, proudly, I wore the nickname, John's, on the streets, on the beach and among the young men and women of the district. And wondered why people called me slut. What a babe in the woods!

When I left school and began junior teaching, I was placed in a small primary school at Edwardstown under the care of a buxom, motherly grade 3 teacher. Half the day I was to spend in the library, studying by correspondence for my matriculation exams. The rest of the time would be in the classroom, working as teacher's helper. Before long, when other staff were off ill I took over their classes, and this experience soon confirmed for me that teaching was indeed my vocation.

I needed three more subjects to matriculate and chose Maths II – a piece of cake if I put my mind to it – French, which I loved but had not worked hard enough at, and art. There was a problem with art, however. It seemed that I was not allowed to sit for matric art unless I'd passed intermediate art – which, of course, I'd never been allowed to do. Stubborn and determined to the end, I persuaded the powers that be to let me sit for both exams in the same year, and

this I did, passing both easily along with Maths and French. So I was set to go to teacher's college the following year to begin training as an art teacher.

My emotional life, however, my sweet, had not been running as smoothly as my academic one. Anne Honey and Bette Snowden and a few other close friends had already begun university, so I saw less and less of them. Joan Rees was still a constant companion and we met new friends as we got about. The local Saturday night dance was a major event, with big bands pounding out the rhythm and the boys in bunches by the door checking out the girls seated along the walls of the big Town Hall. I loved to dance, and still do.

This dance was the accepted place to meet new young men socially, and parents didn't mind dropping us off and collecting us later. Mothers took pride in making taffeta ballerina dresses or fancy skirts and frilly blouses. The young men were not allowed in unless dressed in suits or slacks and jacket. Ties were essential.

These dances, held in town halls all across Adelaide, were the weekly version of the big balls that were so popular at the time – fundraising balls, debutante balls, masquerade balls, all streamers, balloons, flowers and glitter. Tuxedos, bow ties and extravagant gowns of satin, taffeta and tulle. You had to be able to dance correctly, in case an invitation to a ball should arrive, and the local big band dance hall was the place to practise.

Most Saturday nights I went to the dance with Joan, or whoever else was available. And most Saturday nights I met a new man. Some I dated, some I didn't. A walk on the seafront at interval, or a drink and a kiss in the back of a car, decided which ones I would see again. These young men were different from the boys I'd dated previously. They were more sophisticated and dangerous. They expected more than just kissing and grew surly and sour when they didn't get their way.

This year, Mother would tell everyone for decades to come, I dated over 60 boys. I never understood why Mother kept telling this story. Was it pride or envy or disgust? So hard to tell. Some men I dated half a dozen times, some just once, always looking for a nice man, a good man, a man to have fun with. Without sex.

This was nearly impossible. These were generally working men of the world, men who were used to having their way with women. Most of the girls who went to these dances were also in the work force and on the lookout for husband-material. My innocence and morality made me a fish out of water in this group, but still I went, to dance, hoping the next man I met would be suitable. Where were the Claudes? Or the Dinos? Or even the bikies?

Mother never understood, although I tried to tell her several times, that the reason I dated so many men that year was because each of them dropped me like a hot cake when they realised I absolutely meant it when I said no. Some of them broke my heart, because I genuinely liked them, but no sex, baby, no relationship. They called me tease, and lesbian and bitch. And they didn't ring again.

Still, I was a gregarious little beast chasing a whirlwind social life – but apart from the Surf Lifesaving Club parties there was not much else on offer besides the dance. I'd realised long before that the sport-oriented men were a boring lot, and that exclusion alone limited my options. I met nobody through junior teaching of my age. I studied alone in the library, and since most of the girls I could spend time with all went to the dance, so did I.

Even after many disappointments I still believed that there must be good men out there, and continued to put myself at risk stupidly. Sometimes, having spent most of the evening dancing with the same man, liking him and judging him to be all right, I even risked a lift home. This practice was quite accepted at the time, but was a dangerous business. Many a night I had to fight my way out of a car and walk home in the dark, lonely and crying. Many times I barely escaped being raped.

My first really serious escape left me very confused. It was the first of many, and to this day I find it hard to understand why it happened to me so many times but never to other young women I knew. Was it because I somehow gave out signals that I was unaware of? Did I inadvertently wear the sign 'Victim' on my forehead? Or did I simply choose the wrong men all the time? Obviously, had I been sexually active, there would have been no need for such frustration in the men, but I believed so strongly that I had the right to say no, and be respected for it, that I kept putting myself in situations that turned ugly.

All of these incidents were what is now called 'date rape'. None of them were random attacks on the street, and in all cases I had put myself at risk. It would be terrible to have to think that you can never trust any man enough to get in a car with him, and it didn't occur to me to think that way. Most of the girls from the dances went home with new acquaintances and, as far as I knew, they didn't end up being nearly raped.

The first disaster occurred after I met a new fellow at the dance. Tall, fair and good looking, he asked me for practically every dance. He was a sailor in the merchant navy just back on leave from America, and had some of the latest records at his flat round the corner – would I like to hear them sometime? He'd very much like to take me home, and see me again. We could stop in for a coffee on the way and listen to a few records if I'd like.

This fellow was well spoken and polite and I agreed to his proposal. Once we were in the flat, he threw me on a bed and, ripping my clothes, attacked me with a vengeance. He was a big man, and heavy, and I stood little chance of keeping him from penetration. But I fought like a wild thing under his weight, and after a silent battle that seemed to last for hours, I managed to push him off and run out to the street.

I was bruised and bleeding, with torn clothes hanging like shreds from my shaking young body. I'd lost my shoes and, barefoot, began the two-mile walk home in the dark, hiding behind a tree or fence every time a car went past. In those days the street lights all went off at one o'clock and it was a terrifying walk.

Naturally I didn't tell Mother and Dad. They were asleep when I got home and would perhaps have said I deserved it – well, not Dad, but Mother – and I didn't need that.

Another time, also after the dance, an Italian boy detoured into a market garden and became violently, sexually aggressive. I scratched his face and ran. Another long walk home in the dark, disillusioned and frightened.

There were more attacks like this – not simply 'play my game or walk home', but violent assaults on my body and my spirit.

Later, a lad who I'd been seeing for a couple of months and had given me no trouble, took me to the drive-in and brought a mate. They were drinking heavily and I was sitting between them in the front seat. Both of them were trying to touch me, and I got cross and asked to be taken home. Instead they took me into the foothills, behind a church, and started to get really rough. Fortunately the boy I'd been dating thought better of it once I started screaming. He hesitated long enough for me to push him out and make a run for it. Once again, I was bleeding and ripped clothes were trailing off me. I managed to find a last tram, empty but for the driver and conductor, on its way back to the terminus. I'd lost my purse in the fight and had no money, but the two men were concerned for me. Once we reached town, they called a taxi and paid my fare. Thank God for Good Samaritans.

I lost my shoes again, but I had so many that no one ever noticed the depletion of my shoe collection. Shoes were my love, and I spent all my money on them. All colours and textures.

A year later I nearly lost my life because of a frustrated rape attempt. Coming home late from a party in the city, given a deadline by my parents, I was waiting for the last bus on South Terrace when a car stopped and the driver offered me a lift. Bad end of town for a young woman to be alone, he said.

No thanks, but if you really want to help you can find me a taxi. No problem, he said, where to? Glenelg. Oh yeah, he said, I'm going past there to Brighton, hop in. And I did. Trusting. Stupid. But when he turned into the wrong road and I queried it he sped up and said, Jump out if you want, you'll be killed and nobody knows that you're with me.

Into the Hills at Blackwood he sped, very fast, then down a dirt road. He stopped, one hand grabbing my coat to hold me still. I pulled the coat free and ran back down the dirt road, wobbling on my high heels but with no time to kick them off. I remember his feet thundering behind in the dark and his arms catching me as he threw me to the dirt where we fought like animals in the dust and the stones.

He was smaller than me, but determined. Not as determined as I was, however, and he could not have his way. Eventually, finding myself on my feet and facing him, I lifted my arm to swing at his head. Don't – you – dare. And I didn't. I suddenly knew about madness. A fear took hold of me that nearly made me give in, but I fought on until we were both exhausted.

Next I remember I was lying alone on the road, barely conscious and unable to move. He was gone. I could close my eyes and sleep.

I was lying there like a dead thing when I heard thunder in the dirt beneath my ear. Slowly opening my eyes I saw his car hurtling down the track, nearly upon me. With a mammoth effort, I rolled to the edge of the road, cheating death by a second. Huddled in a culvert, I pulled my brown coat over my tightly curled body in the hope that his headlights would not pick me out in the mud and scrub.

Back and forward he went, swinging the car from verge to verge in search of me. Each time he stopped to turn on the narrow track, I crawled closer to the main road. Slowly I got there and made a dash for the nearest house, where I fell against the door, banging and screaming. The creep saw me then, and parked across the road, waiting. Someone was home, thank God. Lights went on, the door opened and I saw his car speed off into the night.

What a sight I must have been for the fellow who opened the door, mud-covered, coat hanging off one shoulder, white sheath dress torn and covered with blood, face, arms and legs grazed and bleeding. But no police, I said. Please, a taxi. What would Mother say if the police were dragged into this?

But she knew this time that something had happened. She was awake when I got home and called me into her bedroom. I had wrapped my coat well around the stained dress by this time, but my face and hands were still bloody and I had no shoes, hat or bag. Can't talk now, I cried, tell you all in the

morning, and fell into the security of my own bed. A car accident, I said next day, too shocked to talk about it last night.

Mother didn't believe me, but she really didn't want to know.

Not surprisingly, I was becoming very scared of men. I never accepted a lift from a stranger on my own again, but I still felt safe in the company of others. Sadly, this proved to be unfounded. A couple of months later, with Ilze from college and another girl, after a movie in the city, I got in the wrong car yet again. Four boys in the car, one a good friend and one an acquaintance of Ilze's family. They were driving around with nothing to do and were pleased to give us a lift home.

Seven of us jammed together in the car, laughing and friendly. Ilze was dropped off first at Hendon, then along Tapleys Hill Road to Glenelg, for my house. But on the way, a golf course, and in they pulled among the trees. Two dragged the other girl out of the car and two started in on me. I started screaming hysterically, hitting out wildly. Crazy. I couldn't take any more and would have killed if need be.

The other two men came running back at the noise, bringing the girl and making her beg me quieten down. I'd reached a limit and a dam of tears and screams had broken, too deep and strong to be quieted. In a panic, for lovers used the golf course at night, they drove quickly out of there but had to get this six-foot, flailing, mad-woman out of the car. Safety, I wanted, safety, and thought of my friend Pam five minutes' drive away. Take me there. They did, and threw me onto the road and roared off into the night – to Mount Lofty, I found out later, where the four of them took turns with the other girl.

Pam, who I'd not known for long but with whom I'd formed an instant bond, opened her door to find me on my knees and on the point of collapse. She gave me a couple of good slaps on the face, a brandy and tucked me into bed. Realistic and caring Pam made a phone call and a lie to Mother, then sat on the bed with me until I slept.

Pam was 31, to my 17 and knew a thing or two about life and men. She had been twice married, and now was on her own with two young daughters. She was a strong, gutsy, determined survivor and I turned to her often when I needed to talk to someone. This night would not be the last time she would prove to be my saviour. On many occasions in my future she was to be a staunch support and loyal friend, particularly during the dreadful years after the bushfire.

This was my last brush with rape until much later in my life, for I'd eventually learnt not to be so free with my trust. I was coming to realise that the battle to hold onto my virginity was going to be a difficult one. Hearing the

word 'slut' from the mouths of so many men seemed the cruellest irony of all.

But I was a survivor. I had the resilience of youth, a strong, healthy body and a zest for exploration and challenge. And there was always the beach, where I spent every spare minute, summer or winter, walking the shallows and replenishing my spirit. A great healer, the beach.

I was settling into my long lean body by this stage, and felt comfortable with my height. The troubles that I had had with men only cemented the growing knowledge that this body of mine held a power. There was something about the litheness of my long limbs that men wanted to control, and I was learning that I had a weapon. That indeed I *was* a weapon.

Dearest inner child, during this period of around two-and-a-half years (one of which was spent junior teaching), life at home had become practically unbearable. Dad, by now the leading accountant for several companies, was always busy at work, and Mother and John seemed to have a vendetta against my very soul.

John had bought a big hot-rod which he'd souped up and adorned with a massive spotlight. He loved this car, spending all his leisure time driving it around the district, always accompanied by one or two of his followers, and he took great delight in following me when I was in a car on a date. If I was foolish enough to park out the front of our house for a goodnight kiss, invariably he'd be there behind us, spotlight shining. Shouts of 'Get inside you slut' would ring through the night. He'd follow me along the streets, shouting taunts. Once he drove on to a dirt footpath and nudged the back of my legs with his bumper bar. Laughter. Stupid slut.

Even in my bedroom I couldn't escape his taunts. He had to pass my room to get to his. One evening, reading on my bed, I looked up to see John and his cohorts standing in the doorway. Oh, the slut's on her back again. Laughter. Go away, John. But he didn't. He strolled to the bed, threw himself on me and kissed me fully on the mouth, while his mates laughed in the doorway. He kissed me long and deep, open-mouthed, then left me there, stunned. For the first time since he'd started calling me dirty, I really felt dirty. Violated. Shocked.

He probably wouldn't even remember it, but now there was no love left anywhere in my sad heart for John. Over the years, he'd been eating away at the adoration I'd carried for him. His filthy derision had been heart-breaking, but I'd always made excuses for his atrocious behaviour thinking that perhaps – perhaps – he was trying to protect me. This incident not only wiped out any residual love that I felt, but was the birth of a deep loathing and disgust that stayed with me for many years.

My perception of Mother and John of course belonged only to me. Perhaps an outsider would have read it all differently. I'm sure that neither of them was aware how deeply their behaviour affected me, and I was unable to tell them.

Possibly John, who'd heard all the dirty details of the gardener's shed from his friend, looked at me differently from that time on, through sexually-coloured glasses. He probably knew more about what went on in that shed than I'd ever be strong enough to remember. It would have been difficult, one could suppose, for him to see me in any other light after that fateful afternoon. Not knowing how to handle that knowledge, learned at the age of nine, his treatment of me could perhaps only be such as it was.

So for me, my sweet inner child, this was a difficult time. I was still friends with Dad, though we were no longer so close now that I was growing up, and I'll never forget dancing with him, in the middle of the night.

Mother and Dad belonged to a social club of eight couples who met once a fortnight to go dancing. Mother, still stunning at 47, wore beautiful dresses to these evenings, and Dad, tall and straight, cut a dashing figure, too, in his dark suit.

There was one single fellow in the group, a real oil-can-Harry. He was a marvellous dancer and the women all flirted with him. The last dance each evening was always the romantic modern waltz and the women vied to be his partner. He usually danced with Mother, and that left Dad broken-hearted. Dear, darling, strait-laced Dad couldn't dance for quids. He was stiff as a board, still marching in the army. He wanted desperately to waltz with Mother but she didn't have the patience to teach him,

So Dad would wait up when I'd been out for the evening – Mother would have gone to bed – and beg me for a lesson. The two of us would stagger about the lounge while he counted one-two-three-four and I'd tell him how much he was improving. He would never be a dancer, but he tried night after night to master it for his lady. Unfortunately, she still chose to dance with Mr Sleaze, and I wondered how she could treat Dad's love so wickedly.

Those nights of dancing alone with Dad are precious to me. They still make me smile.

All I ever really wanted from Mother and Dad was their acceptance, warts and all. But the older I got, and the more different I became from everyone else's nice teenage princess, the more the disapproval grew. I was a stubborn girl, with strange ideas. I wanted to wear slacks instead of skirts. I insisted on very short hair. I read dubious books. I spent hours drawing and painting. I walked through the main shopping area with bare feet. And, of course, there were the bikinis!

But I didn't smoke, drank very little, and kept my body to myself – except for showing off as much of it as possible to the whole world. Lying was not on my agenda. Indeed, I spoke the truth, as I saw it, too bluntly and too often. I was loud, excitable and disliked politics, sport and religion. I liked the wrong music. Elvis Presley's 'Heartbreak Hotel' was released at that time and I danced to it by myself barefoot like a native.

Shit, kiddo, it would have made life a hell of a lot easier if I wasn't so hell-bent on keeping myself pure. Recalling my late teenage years now, I can see the outlandish, rebellious, loud, six-footer who not only horrified my poor parents, but flaunted an image of immorality to everyone. Approve of me, despite all, I screamed. And continued to wear unacceptable clothes and behave in an unacceptable manner.

What a complex character I was. Had I chosen to dress, and behave, like the accepted members of my age group, life may have run a lot more smoothly for me, but I had no desire then (or now), to be the same as everyone else, for I had found out that everyone else wasn't perfect underneath the facade anyway. So I continued to be outlandish and rebellious, fighting the system every step of the way.

This was the late 1950s and new forces were shaping up against the strict postwar mentality. There were others of my age rebelling against their tight environment, and I encountered kindred spirits when I entered Teacher's College.

Straight away, I grabbed the attention of my peers and lecturers when the college hosted an evening welcome for incoming students. Some bright organiser had got hold of miniature bikes and planned a race around the inside of the big hall as an ice-breaker. Everybody was standing around nervously, and there were no takers when it came to volunteers to make fools of themselves. Bugger it, I thought, I'll have a go, and stepped forward, but no one else joined me. The big race seemed doomed until one of the lecturers, Bronte Bunney, filled the void and turned it into a challenge race. He was a small man, much more suited to the tiny bikes than I was, but the race was on, three laps of the hall. I won it in a flourish of skirts, petticoats and long limbs. Everyone was roaring with laughter at the sight of the two of us, long and short, speeding around on the tiny bikes, and the awkward silence was broken. My entrance to the college had been noted.

That was 1958, when the Teacher's College was housed in a beautiful old building on Kintore Avenue in the city and a myriad of transportables that were tucked away behind it. Art teaching students did approximately one-third of their studies here, one-third at the South Australian School of Art down the

road on North Terrace, and the rest at Adelaide University, which backed onto the college itself.

The Head of School, Dr Penny, was like an older version of Mr Tregenza, my old high-school head, and similarly reminiscent of Dad. Bronte Bunney, though, was a whole new experience. Although still quite young, perhaps in his mid to late twenties, he seemed to me one of the most *whole* people I'd ever come across. He was gentle-faced and easy to talk to – he specialised in psychology – and was sensitive to my problems. With Bronte's encouragement and wisdom, I became ever more committed to teaching, and couldn't wait to get out into the school system. I'd always known that I would teach, and was excited to feel that soon, at last, I could prove my worth in society. The means were at my fingertips.

But did I study as I should have? Did I attend all of the lectures and become part of all that college life offered? No, no, no. Instead, I fell in love with art school, and the wild, free students, and the joy of painting. I spent too much time hanging around with the art students and less and less time working at college commitments, sabotaging the desirable future that could so easily have been my salvation.

I made a few friends at college, but not many. Ursula, a member of our home group, was a close companion for most of the first year there. She was a country girl with a zest for life, blonde and buxom. The two of us had fun together, and she even met with the approval of Mother and Dad, who let her spend many a weekend at our home since she was boarding with relatives in the city while at college.

It was on one of these weekends with Ursula that my virginity disappeared in a haze of drunkenness and our friendship began to cool. Mother and Dad were away for the night with Ann and Tessa, and John was busy elsewhere – perhaps he was even married by then – so we had the house to ourselves. As usual, we went off to the Town Hall dance together where we came across a boy named Jimmy Brown who I'd been admiring for months. He hung around in a group of six or so young men and had previously asked me out for a drink at interval, when he'd been most upset by my refusal to play. I wanted to see more of this boy, but thought he would never ask me to go with him again.

This night, however, offered a chance to spend time with him without the rules of the back seat, so I decided to invite the group home for a party after the dance. Other girls were keen to come as well, so in the end about a dozen young folk arrived, with flagons, for a good time.

But did Jimmy Brown talk to me? No, he sat drinking across the lounge room, watching my every move. Unsettled and disappointed, I began to drink too, and watched him in return until, inevitably, when I was inebriated beyond control, he walked across, picked me up and took me to Ann and Tessa's room where he succeeded in doing what nobody else had so far achieved. It couldn't have been a very rewarding experience for him because I was on the point of passing out. Well, I really asked for that. I wasn't an active participant in the deed, but I certainly set it up. Of course, if Jimmy Brown had been any sort of a gentleman this episode wouldn't have taken place, but none of these young men were gentlemen – at that age they were ruled by their penises rather than their heads.

I passed out for a while, then went into the lounge room to look for Jimmy Brown only to find him lying on top of Ursula. Well, little sweetheart, what did I expect? Was this not more proof that I wasn't worth any respect?

I was desperately hurt by Jimmy Brown's disregard for my feelings, but sadly I was not terribly surprised. The pain that was hardest to bear came from Ursula's behaviour, which I saw as a shocking betrayal of friendship although for her it was probably only a drunken flirtation.

I went into the back yard and cried in the dark until everybody left and

Ursula had gone to bed. I didn't speak of it in the morning, but the friendship with Ursula was damaged beyond repair, and gradually we drifted apart.

What a mockery I had made of my battles in cars and flats, my bruises and cuts and shame and fear. And what a mixture I was. So full of passion and pride and spirit. Battling always against the deep certain knowledge of my wickedness, but undermining my own efforts every step of the way.

My dear little one, I've been down to visit Ilze today, and we were reminiscing about college days and our foolishness. We are still great friends 40 years on, and enjoy a meal together when we can. Ilze has always been placid. She is completely non-judgmental about the bad choices I've made, and is ready to offer a shoulder to cry on.

This tall, finely boned, Latvian-born blonde, one year ahead of me in college, became a staunch friend in 1959. With her I spent far too much time lolling about in coffee lounges and restaurants, missing lectures and jeopardising our careers. The Tropicana, in Rundle Street, and Paganas, in Hindley Street, where you could get an excellent bowl of minestrone for two bob, were our favourite haunts. On pay day we'd order steak diane, very chic in those days.

The Education Department paid us three pounds something each week in exchange for our agreement that we would teach for three years in government schools on completion of the course. After board and bus fares, there was not a lot to spend on clothes, cigarettes or restaurant meals, so normally we would sip a cup of coffee, or order a bowl of soup when we went out on the town.

Ilze reminded me today of one of her favourite memories. It seems, and I had forgotten all this, that we met a couple of sailors in town and enjoyed an evening of drink and conversation. They were American and their ship was only in port for a couple of days. They quite obviously had different expectations of the night than we did, and when they asked us to go back to look over the ship we were unsure whether to take the risk.

Realising that the ship would be full of people, and curious to see it, we eventually agreed. Once they'd showed us around the vessel, these Yanks began to put pressure on us to stay the night in their cabin. It seems that I suggested they should come home to my place for the sake of privacy. Ilze was horrified at the suggestion, but went along with the idea as she guessed that I had some devious plan.

And I did. Firstly, I knew that we had to get off that ship safely. Secondly, somehow, with no money, we had to get the fifteen miles from Port Adelaide to home in the early hours of the morning after the buses had stopped.

The expectant sailors hailed a taxi, and off we headed home. When we

reached Glenelg, still a good walk from home, but manageable, I asked the driver to stop in front of a house near my friend Wendy's. I knew that a lane ran behind these houses and had planned our getaway along this route.

I asked the poor sailors to take off their shoes and wait in the taxi for five minutes while we tiptoed inside and opened the door for them. Then, I said, they should come quietly to the side door and we'd let them in.

I didn't even know whose house this was, but Ilze and I hopped over the fence and ran around the back, out the back gate and off down the lane, towards home, doubled up with laughter. We would loved to have hidden and watched what happened, but dared not take the risk. These young Americans had become pushy and would not have treated us too kindly if they'd caught us.

Anyway, that's Ilze's favourite story and I must admit it's a good one.

My little lost soul, I have just returned from a weekend in Melbourne, visiting Adam, who is now 33 years of age. He is a fine young man, though still scarred slightly from the pains of his youth, and I am proud of him. He stands six feet two inches tall and is lean and strong with often troubled blue eyes and the firm square jaw and straight back that I loved so much in my father.

Adam brought out a photograph of himself with his father, probably the only one he has. The poor kid has recently made another attempt to connect with his dad. He drove up to visit Lester in northern New South Wales, but once again Lester got smashed and blew it. I don't think Ad will make the effort again. Anyway, it unleashed a flood of memories I need to tell you about.

The Lester in the photograph was an old man, with white hair and a silver-grey drooping moustache, several inches shorter than Adam. Shrinking now, at 62, with a face etched with the excesses of his life. The Lester I knew, and fell in and out of love with so long ago, stood slightly taller than me and had a rich mop of black, wavy hair to match his dark brown eyes. He wasn't handsome in the accepted way – his nose was too sharp and his chin jutted too far forward – but he was dashingly attractive in a man-of-the-world sort of way. I fell for him immediately and without reservation.

I was living with Spike in the studio just up the road from art school at the time, enjoying my first taste of freedom away from the stifling atmosphere of home. I was 19, going on 20, a dangerous age under the best of circumstances.

Spike and I had been at the studio for a few months, much to Mother and Dad's horror. It was not the sort of home that they had pictured for their daughter and Mother had left in tears the day that they had brought my belongings from home. Spike's mother never even came to look, which made her either

better or worse off, depending. No parent could have approved of the Studio. It was sordid beyond belief. We loved it.

Spike wasn't my friend's real name, of course, but no one called her Yvonne. She had been at Brighton High School a year ahead of me and, although she had mixed with a different crowd there, I had noticed her because she was different. She was a real pixie, bony but beautifully proportioned, with long jet-black hair framing a pointed face that was filled with her black, soulful eyes.

We'd met up again at art school, and had become close friends although she was still a year ahead of me. She was tremendously talented artistically, with a rare individual style that I admired, and I agreed readily when this exciting, exotic woman who studied black magic and believed in demons suggested that we should move into this studio together.

The studio was situated at the eastern end of Rundle Street, near Adelaide's major markets in those days. Trucks loaded with produce would rattle along the

lane underneath one of the first-floor rooms which seemed to hang precariously between two buildings. The main storage area for market produce was directly behind our old building. Our studio was upstairs, two rooms facing Rundle Street, one of which had access, through a window, to a dilapidated verandah, and the other room was above the lane.

The building was condemned. It was completely empty when Spike discovered it and the Chinese fireworks shop below our rooms was boarded up. Somehow or other, we discovered which land agents were in charge of the neglected wreck of a building. Two attractive, sweet-talking young art students, studying just down the road, had no trouble getting their way with the land agent, and with a small rent agreed upon, and a pointed warning that this was studio space *only*, not living space, we were in.

There were actually five rooms above the old Chinese shop. Once word got out that we had two of the rooms, two other students, one a music buff from the university, and the other, Naomi, another girl from art school, took over the other rooms. Unlike us, they stuck to the agreement, and only used their rooms during the day.

You entered the building from an alley at the side of the fireworks shop. There was no door handle on the outside, just a keyhole. Once inside, we felt quite safe – who could get in without a key? – though I realise now it must have been a shocking fire trap.

The rooms were filthy and bare, but once our mattresses were on the floor and our easels and paints spread out on fruit boxes, Spike and I felt at home – or I did, at least. Spike wasn't comfortable until she had draped garlands of garlic around the window frames to ward off demons.

Visitors could only get our attention by throwing objects onto the balcony or against the cracked glass of the windows. We would run down the stairs to open the door, rescuing them from their perilous situation amid the traffic. Behind the glass, we could choose to be at home or not as the mood took us, and this gave us a grand sense of freedom. We could go out or stay in. We could go out at three in the morning and come in at seven. We could sleep all day and go out all night. We could do anything.

From home I brought my beloved German Shepherd dog Jedda to share my life with Spike. Jedda was big, well-bred and well-behaved, and she seemed happy to squeeze into the tight space. The shaky balcony became her toilet – it was just a step through the window away – and it's a wonder that the balcony didn't collapse under the weight of her leavings during the six months we were there.

So, we've moved in, got the dog, driven out the devils. How do we keep clean?

The building housed a bathroom that left a lot to be desired. There was a filthy toilet – at least it still flushed – and a stained wash-basin with a functioning cold water tap, but the hot water had long been disconnected, as had the shower nozzles and fittings.

Spike learnt somehow that there were showers for a few pence you could use at the city railway station, which was about a half-mile walk away through Adelaide's main shopping precinct. The two of us would march over there through the throngs with our towels slung over our shoulders, Jedda at our heels. In 1959 no woman went shopping in the city without hat and gloves, but Spike and I obeyed no rules except our own. She generally wore black dancing tights and black T-shirts with embroidered vests on her thin, bony frame, while I donned tight, black, men's work jeans and black work shirts covered in shiny zips. We walked barefoot. Heads turned and mouths dropped open.

The women who took the money for showers at the railway station and handed out the soap soon got used to us, however, and before long we were having our showers for free, while Jedda stayed tied up at the door securing pats and biscuits.

She was a gentle, friendly, handsome dog, and few could resist her charm. For a city dog she got plenty of exercise, what with romps on the lawns by the nearby River Torrens, long nocturnal walks through the city, and, of course, the shorter stroll to art school, where she became as much a part of the institution as me and Spike.

What did we eat? Food proved more difficult than cleanliness. Although Spike and I could live on hot chips, and milk stolen from the doorsteps of sleeping shops, Jedda needed meat every day. So we needed to find money not only for our fish and chip man, art school fees and painting materials, but also for dog food.

Fortunately, just a few doors away from the studio there was a seedy upstairs night spot that gave me a few nights work a week as a waitress, with a good feed thrown in. Between the pay from there and an occasional modelling job for life class at art school, I had enough to scrape by on, and even managed to buy a flagon of cheap wine now and then. Spike had some money and we shared whatever we had.

The studio rules were that visitors brought the booze. If Spike or I had a flagon on hand when friends called in we would stash it under the loose floorboards. By the time our visitors arrived, the place would be dry and they would have to share their goodies. All of the empties went under the floorboards, too,

to save room, and we had a great laugh when the building was demolished – God knows what happened to those dozens of empty flagons.

The walls, too, would have bemused the wreckers. We painted messages to each other in oils, sometimes in letters a foot high, using whatever colours were left on our palettes. The place was due for demolition soon, after all, so why should we keep it nice?

Nor, we decided, need we pay rent – hadn't our law student acquaintances told us that it was illegal to rent out a condemned building? Whether this was true in law or not, we never paid a penny besides our first two weeks rent in advance. The land agent would knock on the door while we sat giggling quietly at each other.

Oh, we were winners! And we were getting heaps done. This was my first experience of living with my work. The first thing I'd see when I awoke was last night's efforts, and straightaway I'd be impatient to correct my work or start again. We took turns to model for each other on quiet days, and the rooms were full of finished pieces and works in progress.

Spike was better at going to lectures than I was. My nightclub work left me tired – the staff used to move on to a later-closing club after shutting shop – and I was drinking and smoking far too much.

I was also mixing with some dodgy people. These were the days in Adelaide, the late 1950s, when every second man in a nightclub was wearing a shoulder holster. Naive students, prostitutes, policemen and charming, dangerous thugs jammed together dancing in the clubs.

My life belonged to me at last and so did the city at night. Spike and I would stroll barefoot through the empty streets, singing and talking and playing with Jedda, while the buildings slept. Despite its netherworld of drugs and silk-shirted villains, Adelaide seemed a sleepy place. There was no need to fear gangs of fearsome youths – or if there was, we weren't aware of it. We'd meet a stray cat here and there, or a sleepy old drunk mumbling his way home, but felt safe as houses in our city. We got to know the police patrol cars and their occupants, and the early morning street-sweepers with their big swishing vehicles. We shared the streets with them, acknowledging their presence with a cheery wave, and receiving a beep of the horn in return.

The only place in the city's square mile where life flourished in the wee small hours was at the other end of our long street, where the name changed to Hindley Street and where nightclubbers, old Greek men, and taxi drivers filled in their time at the late-closing, seedy cafes. There was also a fish café that stayed open until five, and Spike and I often walked the mile down the long empty road to buy a takeaway feed in the early hours.

It was on one of these sorties that I discovered Lester. We met bang in the middle of Hindley Street at two o'clock in the morning – I was crossing to the fish shop, while he was making a beeline for a club. He made a complimentary remark, and we stopped a moment to talk in the quiet street. He worked, he told me, at the club to which he was headed, the Bay Ganew, and I promised to call in some time to say hello.

I was flattered by this charming older man's attention. He was wearing a tuxedo, and in the dim night lights looked dashing with his black hair and dark eyes. I decided to go to the club in the very near future. He carried an aura of danger that I found intriguing. So I found myself at Bay Ganew, one of the biggest clubs, with Lester waiting on my table. He stopped work long enough to dance a couple of numbers with me and we arranged to meet at the studio after he finished work.

He arrived as promised, and after a few drinks with Spike, the pair of us went walking in the quiet of the city. On the lawns beneath the gums of Hindmarsh Square he kissed me and asked me to go home with him. Woah! He was fast, and I suggested perhaps another time. I like what I want, when I want it, he said, and I want you. Tonight!

I went, and I was hooked.

Lester travelled everywhere by taxi, which added to his allure. (Later I discovered that he'd lost his licence for deliberately driving into a brick wall, and had refused ever since to drive a car.) We took a slappsy maxi to his sister's house, where he had a room. I was surprised to learn that he didn't have his own smart, modern flat, and more so to discover the house where he lived was drab and in a dreary neighbourhood near Port Adelaide.

I entered the house to find that the only furniture in his room was a single bed, a small wardrobe and a stocked bookshelf. The trainline to the Port ran in front of the house, and the rattle of the trains shook the room whenever they trundled past. But who was I to judge? I was living in two filthy rooms, with no bathroom. The difference was that my studio was a temporary experiment of youth, while this room was the chosen environment for a single person earning good money. The studio, ratty though it was, was full of paintings and music and student visitors solving the problems of the world. It hummed and banged and clattered and sang. This room of Lester's had died long ago.

Warning bells rang at the back of my head. I was not a snob, but this didn't seem right somehow. There was a lack of *care* here. What a pity I didn't listen to those bells. They always know the score. But I was swept off my feet by this experienced lover – and so, into the small bed and up to heaven.

The following morning, when Lester was sober, heaven was better still. He'd been drinking heavily the night before, but woke with dancing black eyes and a fetching grin. His body was perfect, lean and strong. He was well-endowed and sexually skilled. I discovered new, exciting feelings and emotions.

For the next two weeks Lester and I spent every spare moment together. We'd go swimming, to the movies, wining and dining, listening to jazz at the Cellar, but mainly we'd be coupling like animals until we dropped.

At the end of that fortnight, Lester rolled over and sat with his back to me at the edge of the big mattress on the studio floor.

I think we ought to finish this now, he said.

I was stunned. What on earth for?

Because it's been so good, he said. If we keep going, one of us will get hurt. If we stop now, then it'll stay good forever.

I argued, of course, until he reluctantly agreed to give it a go for a while.

If only I had known it, Lester had given me the first indication of his inability to carry responsibility for *anything*, even his own happiness. Any commitment to any sort of future was far too hard for him to contemplate, and he was panicking.

Not me. I knew what I wanted. I wanted *this* for the rest of my life.

And for now there were good times, plenty of them, as we trawled the night among the jazz musicians, the club owners, entertainers and villains.

Pubs shut at six o'clock in Adelaide in those days, and most of the city was tucked up by the fire at night listening to the wireless or – for the affluent – the newfangled television. The city's drinkers, having swallowed as much as possible as quickly as possible during the six o'clock swill, were either passed out in their favourite sitting-room chair, or boozing on at home.

Home entertaining was the go, and there were parties galore on Saturday nights for those who were not interested in the formal balls or dance halls. Nightclubbers were almost a breed apart, although there was a good selection of clubs available, with excellent music and top-notch entertainers.

The clubs could serve alcohol legally until ten o'clock if you ordered a meal, but many would supply watered-down liquor, poorly disguised in coffee cups, until the early hours of the morning. The vice squad made frequent raids, but since many of the police were friendly with the club owners, the raids were usually preceded by a phone call that gave patrons time to down their drink or pour it on the carpet. As a result, the clubs stank, and by daylight they were in atrocious condition. But at night, under dim orange lights and with

long-legged girls wiggling their way through a show, or cool jazz heating up the crowded dance floors, they became places of cosmopolitan magic.

Most of the waiters, resplendent in their tuxedos, were professionals who were in great demand. Lester was an extremely good waiter, and could turn his hand to cooking in an emergency. Sometimes he would sit in on the drums with the band, and I loved to watch his sensitive, elegant hands keeping the beat.

Most nights I'd go down to the club at 2 am, watch him work until whatever time he finished, then we'd both go with the musicians to the basement bar, a sort of semi-private, sly-grog dump. Most of the drinkers were jazz musicians. Lester was merely an amateur who could keep the beat, but he loved jazz and could talk for hours with the musos about this clarinet player or that saxophone solo. A frustrated muso, he should have learned an instrument and found an outlet for his emotions and frustrations. But he didn't have the dedication. Instead, he drank.

Lester's drinking would prove the undoing of the relationship and marriage that produced my first-born, precious Adam.

My dearest inner self, I sometimes wonder what my first child would have been like, but find the question too painful to contemplate for long. The sadness that will stay with me forever.

Abortion, I think now and have always thought, has to be the choice of the carrying mother. I would never castigate anybody for choosing abortion, but I don't think it's right for me. Never have. I *wanted* that child. I wanted many children. But I gave in to the pressures around me and had a backyard abortion at seven months. It's a miracle I survived the makeshift operation.

For all my education and good mind, my knowledge of the basic facts of life was meagre. I knew absolutely nothing about contraception and somehow the relationship between making love and getting pregnant never crossed my mind. About six months after meeting Lester, by which time I'd left the studio and moved in with him at his sister's, I began to realise that something was wrong. It seemed a while, suddenly, since I'd had a period. I never did keep track of those things, but eventually it became conspicuous by its absence. I was feeling crook in the mornings, but that was not unusual given the amount I was drinking.

Weeks passed and still my period didn't come. I mentioned this, in passing, to someone at art school who suggested that I might be pregnant. My tummy is still as flat as ever, I scoffed. But I began to worry. More weeks passed, and still no period.

I mentioned my concern casually to Lester, and he told me that it was

impossible for me to be pregnant because he didn't want any children. No discussion. No concern. Absolute denial.

Well, poppet, I didn't know what to do or how to handle it so I wiped it from my mind and went on with life. I was attending only the occasional lecture at art school by this time, and doing precious little work away from class. The majority of my time was spent either copulating or drinking.

During the five-and-a-half years that Lester and I were together we broke eight beds. The one in his sister's front bedroom went through the floor, which admittedly was rotten with white ants. So little study was getting done. And now, since Lester had found out I might be pregnant and had quit his job in rebellion (no money, no baby), I spent more time modelling at art school than drawing. One day in life class our model didn't turn up, so I had offered to pose – standing nude in front of a class didn't bother me at all. After the session, I was surprised to be offered payment. In desperate need of food money, I offered to model whenever possible.

So came the day that I fainted on the model's rostrum. Ruth Tuck, a fabulous water-colourist and teacher, was very caring of her students, and packed me off to a doctor for a check-up. His diagnosis was that I was pregnant and seriously malnourished. Ruth gave me a lengthy lecture about taking care of myself and refused to let me model again until I was fit – so I did no more modelling, for without the modelling fee there was no money for food. I became weaker and weaker, while my tummy grew rounder and rounder.

Eventually, now that I knew for a fact that I *was* pregnant, I visited Mother to tell her the news. Perhaps she might have a magical solution to the problem, I thought. Other than to feed me, she had nothing to offer. She was shocked, worried and disapproving.

Lester still insisted that there would be no children and absolutely refused to discuss the matter further. If I tried to introduce it into the conversation, he would leave the room. His sister was not allowed to be told, but of course guessed, and sometimes when her husband and Les were out of the house she would guiltily ask me to have a meal with her – thereby keeping me alive, barely. The fruit trees out the back of the house provided most of my nourishment.

Slowly time passed in our little bedroom, a creeping nightmare of uncertainty and fear. Lying about with books and sex. Occasionally, a trip to Mother's and a meal, until one day she said, Stay away from now on. You're beginning to show. What might the neighbours say? Horrified, I confronted her, but she was not to be moved. It's for the best, she said.

Back to the single room, and Lester and his books and his silence.

One day when I was quite big and I told him I was worried about having sex because of the baby, he said there was a woman who dealt with such matters. I would have to go. It would cost money. I would have to find the money. What a poor, stupid girl I was. I was hoping all the time the problem would go away, but this one I could not bury deep inside my head. It was growing there in front of me, for all to see. My shame.

In desperation I risked a trip to Mother. Nowhere else to go. Sick. Hungry. If Lester knows a woman, Mother said, perhaps it's the best way to make the problem disappear. The money could perhaps be borrowed from Mother's sister. I should ring and ask.

Dad, I hoped, might be a last chance, but when he arrived home from work and was told of the situation, he went quietly away by himself. Later, when Mother and he drove me back to Lester's sister's he quietly said, Perhaps your Mother's right. You should do as she says.

Ah, the despair.

Was I sure, asked Lester's sister. What choice did I have? I wanted the baby, but how could I do it? Lester would leave me, or rather throw me out, with a baby. Mother wouldn't have me home with a baby. There was no government help available, and I was too ill to work even without a baby, and had not a penny to my name. Sadly, I was sure.

So that was that. I made an appointment for the following week.

I went, on my own, on the bus to Port Adelaide, found the little old house, harmless enough from the outside, and knocked to meet the little old lady, also harmless enough on the outside.

Of the whole experience – lying on a sheet on the floor of one of the bedrooms, eyes tightly shut and making out to be somewhere else – the most hurtful part of all, way above the physical hurt, was the old woman's observation: Lester sends all his girls to me.

Then it was back to the room and Lester to wait. I had no idea what I was waiting for, not having been told by anybody what to expect. The crone had given me a jar of Ford pills to take and told me to do lots of walking. Lester walked around the block with me – and, poor simpleton that I was, I felt grateful to him for that.

Hours later the pain began. I had to go to bed when spasms overcame the little strength I had. A night of hell followed, and all the time Lester lay reading on the other side of the two single adjoining beds. Not a comforting word, not a tender stroke. Once, when a groan forced its way through my tight lips, he gave a warning: Shh, my sister and her husband might hear you. Cry quietly.

My motto was set for the rest of my life: Cry quietly.

Time and the world became lost in a black vortex of pain, until the baby left my tortured body and lay with its heart beating against the inside of my thigh for a horrible one or two seconds. Had I wanted to try to save its life I couldn't have. There was no strength at all left in my body. I had no choice but to lie there, semi-conscious. Yet another incomprehensible mistake between my legs. It was many hours before I had the energy to move. I was cold beyond belief both in my mind and my body, which lay drenched in the bed full of blood.

Lester lay there asleep behind his book. He didn't help me pull myself out of the bed; didn't watch as I dragged the sodden bedclothes into a pile and dropped them beside the bed before crawling back in, shivering, to sleep.

The next day, my little one, I can't write about in detail even to you. I find it hard now to comprehend that I managed to stay alive given the burden of horror and guilt that I wore. I gently placed the small newspaper package into the incinerator in the back corner of the yard, and I spent most of the day doing penance, my arms up to the elbows in blood and tears as I washed the sheets in a cement trough.

In the weeks that followed Lester didn't see the floods of my tears or didn't feel my unspeakable grief and guilt. He was, as it turned out, too full of self-pity at the time to be near me. At some point during the night I had whispered, it seems, that nothing was worth this pain. Lester took this as a personal slight and it was weeks before he would hold, kiss or touch me. He was punishing me for not thinking him worthy of the sacrifice.

But who really knows what he was feeling? If he was suffering pain for me or the lost child, he may have been unable to admit it to himself. Now, nearly forty years later, I might give him the benefit of the doubt, but back then all I had to go on were his actions and words and they left me out in the cold.

I suppose I could have gone home now that I didn't 'show', but I was terrified of what Mother might say in a bad mood. I wasn't strong enough for that. So I stayed in our bedroom, mostly alone since Lester would go out and leave me, and lay in that same bed and looked at the ceiling. Sometimes I dozed or fell into blessed semi-consciousness.

I was a very ill girl, and getting sicker by the day. I barely ate, and was bleeding constantly. Lester's sister, who guessed what had happened but was not allowed to mention it, continued to feed me when both the men were out. She was worried for me, thought I should see a doctor, but when the men were around would only say whatever was expected of her by her husband. She was a sad woman, but without her I may well have died.

This experience fortified the self disgust I'd carried since the gardener's shed. Nobody mentioned the abortion – not my parents, not Lester, not his sister and brother-in-law. It was as if it had never happened. If only.

What can I say to you now, my inner child, that will change anything? I made a terrible mistake. I was young, naive, in love, ill advised, but the final decision was mine, and I made a mistake. I was unable to forgive myself then, or for many years after. But I have forgiven myself now, for all my mistakes.

———

My dear little inside person, Lester was a mistake, but he would eventually give me my first-born son. I could not imagine life now without Adam as an integral part of the pleasures around me. So, my sweet, there is little use in moaning about the past, when, without it, the present would not be so rich.

Even after the abortion I was off my face in love with Lester. I was so determined to have my man that I practically bulldozed him into marrying me, even though he had often told me he was not ready for marriage.

It happened like this.

Bronte Bunney had been following my progress after I left Teacher's College and had become aware of my declining grades and poor attendance at art school. He had supervised my teaching skills as they developed while I was at college, and hated seeing my talent wasting away through the foolishness of love in the fast lane.

I had stayed at Teachers College for eighteen months instead of the required three years. Art School, with its full-time art study and the bohemian attitudes of the students had seemed a far better option to me. I still wanted to teach some day but at the time found the opportunity of making art all day too good to miss. It proved to be a foolish decision, for not long after leaving college I moved into the studio and subsequently met Les, and my prospects for future employment seemed lost forever. And Mother and Dad were stuck with repaying my college allowance. Needless to say they were not pleased with my decision.

However, not long after the abortion, Bronte approached me with the offer of a probationary teaching position – on the proviso that I left Lester all together, found a place of my own and attended night classes three times a week to pass the three subjects I still required for the most basic teaching certificate. Even I had realised that I could not rely on Lester to look after me. I had no intention of stopping my relationship with him, of course, but a place of my own was an attractive notion. The room at Lester's sister's house was cursed with memories.

So it was that in 1970 I began teaching at Thebarton Girls' Technical High

School. I was in my element, an art teacher at last, with a home class of second year girls who I loved.

Once I was established in both a rented house at Flinders Park and my new teaching position Lester more or less moved in with me. After school, or evening lessons, I would meet him in the city for drinks and then go on to one of the clubs for the evening. Les was not working full-time and was free to socialise and gamble as much as he wished, depending on how much cash he had in his wallet.

One night I was feeling unwell and said that I couldn't stay out too late. This didn't suit Les, who earlier in the evening had bumped into an acquaintance from interstate. With a few other cronies in tow, the pair of them had settled for a long night of drinking at the Bay Ganew. Lester, of course, could sleep all the next day if he wished, but I had to be on deck early, and sober, for a day of teaching.

We had no car in those days, and the buses stopped running at midnight, which would soon be upon us. The house that I was renting was in a new housing estate and was a long, scary walk from the bus stop. I didn't fancy trying to get home on my own and, on top of that, Lester wanted me to stay with him. So did all his mates, who were enjoying the female company. Eventually, after much quiet pleading, I decided that I might as well drink along with them and make the best of a bad situation.

So there we all sat, seven men and me, drinking and talking until the early hours of the morning. There was much joking about how Lester had been caught at last. When is the wedding, someone asked. Les's old friend, who was in town for only a few days and had taken a liking to me, began to push for a commitment from Lester. As night turned to day others began making suggestions and plans for our marriage, demanding that it must happen immediately.

At 5 am, when the first of the city hotels opened for the winos, the group, now enlarged by musicians from the band and staff from the clubs, moved to an old hotel on Hindmarsh Square. Here there was beer, a refreshing change from the cheap spirits served at the clubs, and the drinking began in earnest. There were about 20 men all told, and one other woman besides myself, a musician's girlfriend. We were all well under the influence and very jovial.

Lester's friend, who knew someone who knew someone at the Registrar of Marriages, Births and Deaths, hatched a plot. Suddenly it seemed that plans were in motion for our marriage that same day. Lester was probably as stunned as I was, but, caught up in the party, he gave no objections. And I, silly baby,

having been after this marriage for a while now, was pleased as punch, although this wasn't quite the wedding that I'd had in mind.

At nine someone rang the source at the Registrar's, and an appointment was made for 11 am to deal with the preliminary matters.

Several of the revellers accompanied us to the offices and waited outside while Lester and I gave all the required details to the proper person. Then, with the wedding set for three o'clock that same afternoon, we all tripped back for another drink.

Just how this marriage was arranged is still a mystery to me. As far as I knew, other than in times of war, the law said a ten-day waiting period must elapse between an application for marriage and the wedding. At the time I was too drunk and happy to worry about such details, of course.

There was a lot to be done in four hours, some of which had been squandered already at the pub. I rang the school with the story, and the headmistress insisted I take two days off. I phoned the coaching college where I taught twice a week – one of my lessons was due that evening – and the head, who didn't believe my story, sacked me over the phone.

Next came a scary bit. I was only 20, and needed my parents' signature of approval before I could marry. I rang Mother, who burst into tears. She was dead-set against the mad plan but, knowing my stubbornness and my love for Lester, eventually agreed to meet us at a hotel in town across the road from the Registrar's office. She said she would contact Dad at work, but could make no promises that he would turn up. Lester was 26, and needed no signatures so he decided to leave telling his family until after the deed was done.

Between Lester and me we scratched together a total of three pounds and a few shillings, which bought us the cheapest wedding rings Rundle Street had to offer. At a shop in the same street I had on layby a beige dress with a matching coat, and I sweet-talked the owners into letting me take the coat for the day – I was getting married after all. As we traipsed through the city we invited every acquaintance we met to my house for a party that night.

Armed with the coat and the rings Lester and I shot home in a cab to shower and tidy up, both of us still drunk. We were sobering up, but it was too late for doubts: the stage was set, and all either of us could do was follow the play.

At 3 o'clock, the bizarre day peaked in the Registrar's Office as Lester and I exchanged vows. Mother and Dad were both there, unwilling participants and witnesses to their eldest daughter's marriage. Mother and I had cried on each other's shoulders in the ladies' toilets in the pub, but for different reasons, while Dad, desperately short of words, had a shandy to Lester's whisky. Not sur-

prisingly they chose not to attend the party back at my house. They went home to wonder and worry. What a disappointment I must have been.

As it happened, I wasn't at the party much myself. The house was full of strangers, and I spent most of the night in the bedroom with an insatiable new husband. I remember guests banging at the door, laughing and making dirty jokes. Each time Lester finished, I'd wander out among the partying throng only to be grabbed again and carried back behind the locked door.

There was no love-making involved, but a fierce animal statement of ownership, which I didn't really mind. By the time we both left the bedroom, the house was quiet and empty. Then he began again, like a dog marking its territory, in the lounge room, along the passage floor, into the kitchen. Against the fridge and over the sink. Eventually, exhausted, we both lay on the kitchen floor – and opened our eyes at the sound of a discreet cough to find the interstate instigator of our ridiculous wedding quietly sipping a drink and watching. He left soon after and I never saw him again. I don't even remember his name.

Dearest, lost, inner child, I suppose my best memory of Lester would be the lettuce soup.

We were living at Flinders Park, west of the city, at the time, not long after we were married. Lester was without a job and I was still teaching at Thebarton Girls' Tech. Despite hospital care and medication I was still fighting a vicious womb infection after a second abortion. The long walk to the bus stop, a day of teaching, and the long walk home would leave me weak. The money I made from teaching was barely enough to pay for rent, food, drink and cigarettes.

Often, if there was any extra money around, I'd return to an empty house. Lester would have gone to town to drink, socialise and gamble. Depending on his luck with the latter it could be days before he returned, which only happened when he ran out of money. We had no phone. I had to sit and wait until he decided to come home.

Once, I remember, this nearly cost me my life. Colleagues at school, realising I was extremely ill, had sent me to the local doctor. He had diagnosed pneumonia and advised instant bed rest and care. When I arrived home, feeling absolutely dreadful, Lester was out. I assured my fellow teacher Erica Jolly, who'd kindly done the chauffeuring, that he'd be home soon and once she'd got me tucked up in bed with a drink at my side, she went back to school.

Well, Lester didn't come home for four days. After the first day I was too weak to even crawl to the toilet or the kitchen for food and water. My temperature skyrocketed and I lay there in a feverish sweat, my only comfort my

beloved Jedda, who never left my side even though she, also, had to go without food and fresh water.

Fortunately, good old Erica, who knew Lester and his unreliability, decided to call around the next day to check on me. Once she saw the state I was in, she immediately moved in to our house. She fetched medication and nursed me back to some semblance of health until Les eventually slumped home.

Erica was a senior school mistress who had a deep love of language and the arts. We had become firm friends. She was single and lived with her mother. Without her care, Lester may have returned to find me dead.

Now, about the lettuce soup. Later, after I recovered from pneumonia, there had been no money in the house for some days. Every last packet of flour had been poured into scones and the cupboards and the fridge were empty. There's a good chance he'll be home, I thought, as I trudged from the bus. He needs money to go out.

I walked in the front door and was pleasantly surprised to find the kitchen table was set beautifully for two, flowers from the garden and candles to eat by. Eat what? I wondered. On the stove I spied a lidded pot simmering away. All was revealed when Lester sat me down like a queen, towel over his arm and waiting table at his best, and served up a generous bowl of lettuce soup.

There was not even an onion in the house, but Les made a meal from the sole contents of our fridge, a heart of lettuce. He'd flavoured the soup with whatever herbs were around the place, and although the soup itself was tasteless, the manner in which it was presented was not.

Now I'm remembering another pleasant occasion. This time, on coming home from school one hot day to our house at Morphettville where I'd left Lester and baby Adam while I was teaching, I was surprised to find a lazyboy covered with cushions set in the shade of the willow tree. Adam was there in his cot, asleep, and Les produced a meal for me on a small table, once again beautifully set and thoughtfully decorated, set up next to the lazyboy.

These two incidents perhaps help explain why I clung to Lester for so long. For all his faults, and mine, there was magic between us.

Take Adam's birth, for instance.

I had been living at Mother's, having left Lester when, a couple of years after we married, he refused, once again, to accept any responsibility when I fell pregnant. The first time I fell pregnant I was nineteen and it ended in that horrific abortion. The second time I fell pregnant was not long after we were married, and he had again given me the choice between himself and the child. Still very much in love and carrying a nasty womb infection after the first abortion, I ran to Melbourne, where Spike was living, and terminated the pregnancy in the early stages. I believe the termination was done by curette, but can't be sure because I was anaesthetised. However it was done, it caused shocking damage to my already infected organs. Within a day I was lying in agony on Spike's big bed, neither of us knowing what to do. I was certainly far too ill to cope with the 14-hour train trip home, and had no money for a plane fare. In desperation, days later and seriously ill, I rang Mother, who sent John over to fetch me in the car. Sick at heart, I lay along the back seat of his big Ford all the way home.

I went home to Flinders Park, but was soon in hospital where I was told that I'd never be able to have children.

No children. The words rang like the bell of doom. And it was my own fault. Broken, distraught and ill, I lay stunned in the hospital bed. Lester, bearing red roses, came and held my hand while I cried. Mother and Dad came and stood at the end of the bed and Mother said, Choose: Lester or us.

Ultimatums, ultimatums.

With my husband's red roses next to the bed for all to see, I chose Lester. How could I not? But no more babies – that was the price I must pay for my sins, along with an operation too to replace the womb in its correct position. It had been torn loose by two abortions, ignorance and love.

Somehow, thanks to the grace of God, the goodness of the universe and the strength of my own will, I was allowed to bear children as it turned out, and I've never stopped giving thanks for that miracle. One year later I fell pregnant again.

Full of joy at this wonderful news, I ran to Les, sure that this time he'd be as happy as I was.

The baby or me, he said. The baby or me.

So I left. I was determined to have this miracle child, and even losing Lester wouldn't change that.

I was teaching now at Woodville High School, again in Adelaide's western suburbs, but had no savings. Mother, having softened her stance, said I could come home to have the baby and get on my feet financially. I moved in with her and Dad, Ann and Tess, but continued now and then to see Lester, who still had a hold on my heart.

I taught until two weeks before Adam's birth, and was fit, well-fed and healthy for the event. The evening that my waters broke, Mother and Ann, who was old enough now to drive, took me to the hospital.

As my labour pains intensified, Ann rang Lester to let him know. Surprisingly, he arrived at the hospital and, ill at ease, he stayed with Mother and Ann until the spasms grew further and further apart and then stopped. False birth pains, said the doctor, even though my waters had broken. Probably not due for a couple of weeks. Well, I was very small in the tummy. My height and big bones hid the baby neatly between my hips and many of the 80-odd staff at the high school had not even noticed that I was pregnant.

Because of the excitement and the lateness of the hour – it was about ten – the doctor decided I should stay in hospital for the night. He gave me a tablet to help me relax. Mother, Ann and Lester left, none of them half as disappointed

about the anti-climax as I was, and all expecting me to return home the next morning and sit it out a couple more weeks.

I woke with labour pains again in the middle of the night and gave birth to Adam at five minutes past two, holding tightly all the while to the hand of a nursing sister who raised my head to see his strong, precious body as he was lifted from my own.

He was perfect: eight pounds and one ounce and smooth and beautiful. They put him straight into my arms, and as I lay there nursing him, a nurse popped in to say that my husband had just rung and she'd given him the news.

Lester came to see me the next day. Our relationship was very dicey. He told me that he'd been drinking with a group of friends in the Paprika night club when suddenly, just after two, he'd stood up and said, I'll just ring the hospital. I think Barb's having the baby. She's in the labour ward, a nurse had told him. Hold on. And the nurse came back to the phone and told him I'd just given birth to a boy.

Once again, poppet, Lester had surprised me with his magic. And I had my baby, at last.

Little inside person, Adam and I stayed on at Mother's for three or four months after he was born. Unfortunately I was unable to breastfeed him which was a shame, but it did make babysitting easier. I returned to teaching when he was three weeks old, leaving him with Mother, who loved him dearly – her first grandson.

It was a draining time for me – a day's teaching, Adam's bathtime and three nightly feeds left me little time for sleep. Also, I had to keep young Adam as quiet as possible before and after feeds so that the household would not be disturbed. Ann and Tessa, now 18 and 17, were both working and had to be considered as well as Mother and Dad.

I was still seeing Lester occasionally, taking Adam in his bassinette, and this caused problems with Mother and John, who did not approve. There was a dreadful fight about my going one evening and I decided it was time to get a place of my own.

I found a suitable two-bedroom house on Cross Road at Plympton, and moved in with my new baby and Jedda. Once settled there my life became easier. Night feeds were spent sitting by the gas fire with lights, music and no one to worry about. I could enjoy the time I spent with Adam now rather than constantly worrying about disturbing the family.

Ilze, who lived a suburb or two away, was a great help with babysitting. She had married a pleasant Italian man and had a baby girl not much older than

Adam. We shared many afternoons, and often a meal, while we played with the babies after school. Eventually I found a creche down the road and decided to leave Adam there full time while I worked.

My house on Cross Road had a large family room which I set up as a studio and began painting again when I had time and energy. There were lots of baby paintings, of course, with Adam being the perfect model, and mother and child studies. It felt good to be working again. Once Ad began sleeping through the night I started teaching a couple of private classes in the studio lounge room to supplement my income which was being depleted by rent and childcare.

My life was becoming more bearable. I felt in charge at last with my gorgeous baby, teaching and painting. My precious income from school was assured since I had passed the subjects required for my teaching certificate. Sometimes I spent an evening with Lester, who was showing interest in getting back together now that the house, job and baby were organised. Unsure of how I felt, I was wary of further commitment, but he *was* Adam's father and still had a tenuous hold on my heart. We'd been separated for about 12 months when we decided the marriage was worth one more try, so Lester moved in with me and Adam.

Lester loved little Adam and showed surprising patience and care where he was concerned. So I had my family at last – mother, father, baby and dog. Adam, the cutest baby ever, was smart as a whip and walking at 11 months. He was blond and beautiful with enormous, inquisitive blue eyes. The light of my life.

But God knows what Les was feeling about me. Motherhood had changed my attitudes; I was no longer the carefree party girl he'd been attracted to in the beginning. I was finding his drinking, mood swings and gambling ever more difficult to handle. Once I'd found them exciting. Now they were problems.

After moving in with me Lester had taken a job at the South Australia Hotel, next door to the Gresham where he'd worked previously. Both these lovely North Terrace hotels have since been knocked down. The old 'South' was a magnificent building: beautiful stained woodwork, rich panelling and tasteful, traditional decor. Most important visitors to South Australia had stayed there, including the Duke of Windsor.

Les, after I badgered him, had got a job there as a night porter. His shift either started or finished at two in the morning – which was a bugger of a time to have to pick him up or take him in (he still refused to drive). Either I woke Adam up and packed him in the car, or risked leaving him alone in the house with only Jedda for protection. Each night the same difficult decision had to be made. My own sleep was always broken, and by the time I got up at seven to get ready for school, I was knackered.

But worst of all, at around this time my beloved father suffered a brain haemorrhage while running a meeting at the local church – not a move on God's behalf, considering Dad's devotion to Him. Dad went into hospital for tests, but he was eventually sent home with a clean bill of health and instructions to get on with life. The poor darling had dreadful headaches, but made himself go to work. It turned out that he had a brain tumour. Somehow the doctors had missed noticing it in the initial X-rays, and they only diagnosed it months later, too late for any treatment. Dad was sent home to die.

Lester was of no comfort whatsoever. He refused flatly to visit Dad with me. He did care, he told me, it was simply that he chose to remember Dad at his best. That sounded like a cop-out to me. Dear Dad would have loved to see the two of us together, and coping, before he went.

Since I'd met Lester I'd not spent much time at the family home. I simply expected that dear old Dad would always be there, watching over me.

Once, early in the piece, Dad had gone into town to confront Lester at the nightclub where he was working. It was the Moulin Rouge in Hindley Street, a sleazy dump of a place, but popular. Dad had never in his entire life been to a nightclub, but he went inside and asked Lester to step out on the street. Then he told Lester to treat me better, or he would knock him down.

I'd seen Lester pick up troublemakers by the scruff of their collar and the seat of their pants, lift them high above his head, march them out of the night-club, and throw them into the gutter. I knew what he was capable of, and there was dear old Dad, threatening to knock him down!

Lester told me the story with a wry smile. He liked Dad and knew how much courage it must have cost him to come to the club. Dad would never have hit Lester, but the moment remains a precious one for me.

And now Dad was dying. How could I live with that?

His illness changed him. That damned, fucking tumour playing games with his brain. I was spared most of the horror. Poor Mother, who nursed him at home for some months before his death, had to bear the brunt of it as Dad shot arrows of despair, unfounded anger and spite at her. Ann and Tessa, who still lived at home, walked softly past his bedroom door.

I remember a day when Mother had set up Dad on a lazyboy in the after-noon sun. This was on the back lawn, underneath the clothes hoist that he had cemented into the earth. I sat beside him on the lawn and fiddled with the crocheted blanket that covered his thin body.

The bed, he told me, must always be made when your husband comes home from work. And the dishes done. A clean sink and a made bed will always

make the house seem tidy even if other things have been let go. Remember this one rule, Barbara, he said, and your marriage will have a firm foundation.

Marriages have come and gone, my poppet, but I've always tried to follow his advice. The dishes have often stayed in the too-hard basket, because of my bloody back problems, but the bed has always been tidy and inviting.

What a loss Dad was when he at last went to his God on 1 March 1965. I was 25, but still felt in need of his strengths, and Ann and Tessa were younger still. He was a passionate man, but gentle. He could no more have kicked a dog than fly to the moon. He was incapable of lying and stayed forever true to his beliefs. At 52 he stood as tall and straight as he had in his army uniform in his twenties. The war had been the worst experience of his life and he never talked of it. The only weakness he had, if you could call it that, was his blind love for Mother. His early death left me bitter and angry with his beloved God.

When Dad was taken ill I had been working on my first solo exhibition. With Adam recently arrived and Lester back with me, I was besotted with the ideal of the family, and had painted a series on this theme, along with lino-cuts

and line drawings of life studies. My studio in the family room of the house at Cross Road had become a busy space with my classes and my own work in the hours I could find away from full-time teaching, precious time with Adam and the never-ending chore of chauffeuring Lester to and from work.

The exhibition was to be held in the Adelaide Hills at the Hahndorf Institute, where a couple of years earlier I had shared my first show with Jackie McBeath and Barrie Goddard from Teacher's College. Walter Wotzke, who ran the Hahndorf gallery, was a great supporter of young artists, and he'd taken a shine to me. He continued to show my work until he retired and sold the gallery. My painting was *very* raw in those days. My drawing skills, fortunately, had always been good, and they saved the day. I was painting on masonite then and making my own frames. The results must have been abysmal. The few classes that I'd had in oil painting had barely introduced me to the craft.

I shudder to think of the quality of that show. Dad's illness had been on my mind, and much of the work needed more time spent on it before it could be called anywhere near finished.

Earlier in my relationship with Lester, the two of us had shared a big house among the market gardens of suburban Lockleys with a couple named Gina and Kurt. Kurt was a waiter, and Gina, who was big with her second child, used to be left at home at night with a toddler and me. We appreciated each other's company, and Gina had agreed to model for me while I struggled with oil paints. These studies, bold and rough, fitted well with the general family theme and I included them in the exhibition.

I'd celebrated my twenty-first birthday in that house at Lockleys, and recovered there after the operation to adjust my womb. I was living there during my second year of teaching at Thebarton Tech., and I spent much of that year too in the company of an artist named Charles Bannon, whose son, John, would later become premier of South Australia. At this time I loved nothing better than to sit about Charles' studio at St Peter's College with Lester, and often my friend Erica, drinking and discussing the ways of the world and the nonsense of art.

Dear Charles was grieving for a son lost in the Flinders Ranges whose body had not yet been found, and he was living on an inconsolable, slightly insane edge that really appealed to Les. The two of them got on famously. From the start Charles was very encouraging about my work. His kind words about my line studies helped ease my endless self-doubts.

The opening of the Hahndorf exhibition took place a few days after Dad's funeral. I was pale and drawn, still in shock. With Lester's help I'd been banging make-shift frames together the night before, and the quality was dreadful.

An architectural firm bought all the line drawings, which was a buzz, but nothing else much was sold. Still, I had got my first solo exhibition out of the way. Drawing and painting then took a back seat while grieving, work and family consumed my energies.

Family life had, in fact, been running fairly smoothly since Lester had returned. We hosted parties and went to dinners and evenings with friends. Lots of drinking, lots of sex.

Adam, a cherubic, round toddler full of laughter and learning, grew strong and healthy. He was 18 months old when Dad died and wonderful company. He was beginning to utter complicated sentences, looking seriously into my eyes as he attempted real conversation. It was hard not to smile when he made a mistake, but I knew that would hurt his feelings.

Boy, did I love my son. Lester was good with him, too, when he was home, and a nice rapport built between the child and his father.

I was enjoying the challenges at work, as well. Woodville High was a big school of about 40 male staff, 40 female staff and nearly 2000 students. Although I taught art classes up to third and fourth year, my home class, the one that I supervised in the morning for roll call and general school business, was generally a group of second-year girls. The only subject I taught them was art, but I suppose my position was similar to that of den-mother. One of these home classes was lucky enough to be in my charge the year that the Beatles came to Adelaide. Locals still remember the mob scenes in the streets of the city.

As it happened, Lester was working at the South Australia Hotel while the Beatles were staying there. North Terrace, the wide street that fronted the 'South', was constantly jam-packed with screaming teenagers. They were hanging off lamp-posts, overrunning the steps of Parliament House opposite the hotel, and climbing the verandah posts in search of a glimpse of the fab four. Girls slept there in the street, hoping for a miracle. Teenagers skipped school.

One of Lester's drinking buddies was among the staff delegated to service the rooms in which the Beatles and their entourage were staying. Although none of the rest of the staff was allowed on that floor, everyone who worked at the South, including Les, was besieged by adoring fans. Please take my letter to Paul (or George, or John), they'd beg.

Lester's mate, as well as scoring us a signed program each, was also able to get hold of a half-empty cigarette packet of (I think) George's, and a packet of Paul's razor blades. I still remember the night he called in to drop them off. From his pocket he produced letters that had been pushed on him as he entered the hotel. We read the notes together, smiling at the declarations of love, until

I realised that one of them, by some fluke, was from one of the girls in my own class. Somehow the fun went out of it then.

I decided to split up the souvenir loot between the 20 girls in my class. We cut up one of the programs so that there were eight half-signatures, then chopped the cigarette packet in half. The other ten girls would get a cigarette or a razor blade each.

Distributing the bounty proved quite a business. The girls had to get a note from their parents to say they were allowed to have a cigarette or a razor blade. Then we held a lottery, with names pulled out of a box, to decide which girl got what. I was certainly the most popular teacher in the school that week!

Another class of girls each received an autograph from Australian rockers Johnny O'Keefe and Lucky Starr. Les and I had been at a musicians' party when J.O'K – the 'Wild One' – and a few of the other stars of the television show 'Six O'Clock Rock' arrived. I bailed Johnny and Lucky up and made them write 20 signatures each for my girls.

Most of our social life was in the company of musicians. It was a bond that kept Les and I together. We both loved these guys, and their music.

Just before I left Les to have Adam, we were renting a rambling bungalow at St Peters on Lambert Road. On Sunday nights, the only night that the musicians didn't have to work (*nowhere* was open on Sundays in Adelaide in those days) a bunch of musos, together with their women and their instruments, came to the house for a jam session. All of these guys were modern jazz fanatics, but they often had to play other stuff for survival, and a good jam together on Sundays was as good for them as it was for us. Everybody called our place the Lambert Roadhouse.

Among our group were Bobby Jeffery (sax, clarinet and bass) and his lady Jackie, Father Bayliss (vibes) and his lovely wife, Joan; Billy Ross (drums), Darcy Wright (bass), Jazza Hall (guitar) and many other talented musos. The Ox and Morrie Rothenberg, who ran the after-hours booze club, drinkers and supporters of anything to do with jazz, would be there too, enjoying the buzz.

We enjoyed week after week of fabulous sessions. Booze, music and dancing on the backs and the arms of the big old stuffed lounge suite.

So, now I think about it, there were many good times with Lester – but never enough to quell the sense that I might be discarded at any moment for a game of poker or a booze-up. And now, at Cross Road, just when my dream of having a proper family was becoming real, the same old problems began to arise. Gambling. Alcohol.

Mind you, I was no saint myself, even now that motherhood had me firmly

in its grip. I drank along with everybody else, danced and drank my way through life.

Then, after Dad died, Mother gave each of her children £500 from Dad's superannuation. Now I had the chance to buy a home of my own. Life became very serious, and our marriage even more tenuous.

———

Dearest little inside person. It's Christmas 1995, and I've just returned from Tessa's open house at the old home at Somerton, which Tess and her husband Kevin bought from Mother. Driving along Morphett Road I passed the first house I ever owned. It has hardly changed, and a flood of memories hit me.

It's an ordinary red-brick, three-bedroom house, but when Lester and I bought it in 1965 we thought it was marvellous – and for a first home it was good value for money.

As soon as Mother gave me the money from Dad's estate, I was determined to put it towards my first home purchase. Five hundred pounds wasn't enough for a deposit, but Tessa kindly lent me her share and the combined amount just scraped it in.

Tess had left school after third year and had a good job at the South Australian Tourist Bureau, where she worked as a comptometrist. She was still living at home with Mother, and had been able to save her own little nest egg. Annie, who also left school after third year, had worked unhappily in a chemist shop for two years then decided to return to school to matriculate with a view to following in my footsteps and becoming an art teacher. Mother and Dad, still smarting from the disappointment of my mess-up at college, had not been pleased by this decision, but grudgingly consented to support her. She was in her first year at Teacher's College when I moved into the red-brick house at Morphettville.

Lester's gambling habit nearly cost us, or nearly bought us, that house, depending on which way you look at it. On the evening that I got the money from Tessa, with settlement due to take place the following day, Lester rang from work with a sure thing at the races. The odds were long, but if we bet all the deposit money, the winnings would be enough to buy the house for cash.

Les was furious when I refused to hand over the money. I had lived with his sure things for years. He was more furious when the bloody thing actually won and it was a long time before he let me forget what he saw as my stupidity.

Our first little home cost us just under £10,000. There was a waiting list for mortgages back then, so we secured a bridging loan – at a high interest rate – from the bank, and expected to wait at least a year for our turn.

Les had stopped working at the South and spent time unemployed until eventually he took a job at a hotel at Glenelg, a few miles from home. But even then his drinking and gambling remained out of hand. Pay-days were a worry. Once he had money in his pocket, he would pop into town for a few drinks and a game of poker – often not returning (sometimes for days) until he was broke, filthy, and stinking of stale cigarettes. Then he'd start pawing at me and declaring his love.

I had reached the stage where I couldn't handle being told by my slurring, groping, blind drunk husband how much he loved me. I tried explaining to him when he was sober how much I was beginning to loathe him when he was drunk. Even Jedda would slink out of his way, having been picked up one night and wrapped around his neck like a fox tail. She was a ten-stone dog, so this was no mean feat. But Jedda hated it. It was so undignified. Little Adam, too, stayed as close to me as possible when the father that he knew and loved changed into a monster.

One night, at my wit's end, I sat Les down and told him that I was just about ready to call it quits. I told him how much I loathed his drunkenness. It was really important, I said, for him to think carefully about the future. Well, he did. He went down to the pub and sat thinking about it until he was completely smashed and then came home wanting to hold me, declaring undying love yet again.

Oh, poppet, my deep passion for this man had been slowly eaten away. When I thought of all that I'd put up with from Les because of my love for him, it seemed farcical that I could seriously consider leaving the relationship forever simply because of his drinking and gambling. But I didn't love him anymore. Suddenly, one day, the love had disappeared, and I was as surprised as anyone.

As my attitude hardened, so his drinking became worse. And the bloody gambling! Money was disappearing left, right and centre – and we had the house to pay for now, as well as the bills. My teaching salary was not enough to cover all the accounts, and the stress was making me sick. I realised that something had to change.

One day by chance, I saw an advertisement in the paper offering a gigantic income. I wrote off, and was called to an interview for a job selling life assurance. The bosses gave me a written test, chatted to me, then pronounced themselves most impressed. They offered me the position above many male applicants.

I saw this as a win, of course, and decided to consider the offer seriously. The training course was starting soon, so I would need to act quickly. The benefits were tempting. I'd be paid a salary equal to what I was already earning while completing a training course. Then I'd be working on a gigantic com-

mission (it seemed) on each policy I sold. I believed in life assurance, and thought I'd have no trouble selling the right policy for the right situation. Selling assurance, it seemed to me, was just a different form of teaching. I'd be helping people safeguard their families and their future. There was only one other woman in the state doing this job, and I've always relished a challenge.

The glittering lure, of course, was the money. Envisaging truckloads of cash coming in and all my problems solved, I gave notice to the Education Department and left my job at Woodville High within two weeks. In hindsight, of course, I should have left *Lester*, not teaching.

I made the wrong decision, poppet. I stayed with the company for 12 months, earning just enough to get by on, but I was no saleswoman. Once I had an appointment to see an interested customer I could sell him the right policy for his needs, and feel good about it, but I couldn't go knocking on doors looking for clients. It seemed like an invasion of privacy.

But there was another reason I left teaching, and it had to do with chewing-gum. The school rules banned children from chewing gum in class. It was a sign of my role of teacher gradually becoming more that of disciplinarian. I didn't see anything wrong with kids chewing, especially if it helped their concentration in art class. However, there were many difficult children especially at Woodville and I found myself gradually begin to change my tune. If you must chew, I would say to a class, please stop doing it whenever the Head comes in. Then later: If you must chew in my class please have the decency to keep your mouth shut. Then, horror of horrors, one day I heard myself yell at a student: How dare you chew gum in my class!

Fuck, I thought, I'm turning into one of those tight-lipped, fuddy-duddy School Marms. Maybe it's time to get out.

If I'd stayed, little one, growing more righteous by the minute, I wonder how I'd have turned out. I would be a senior by now and on a good, regular salary. I might even have scored my dream job, teaching tertiary students at the South Australian School of Art. I'd applied for this position a couple of times. Even though I didn't have my diploma, I was a practising artist, and the inspector had said he approved of my teaching methods. Ironically, the day after I left Woodville High, a letter came offering me an interview for the job. It was too late. Bad luck or bad judgement?

Writing about my life with Lester, my dear inner child, I'm dwelling too much, I suppose, on the dark side. Of course I had enjoyment and pleasure in his company, besides the ever present all-exclusive sex, which remained an ongoing

occupation right until I told him that the relationship was finished and he must leave the house at Morphettville and his two-year-old son.

To be fair, I'd said many times before that the relationship was over, and then changed my mind. But this time I kept repeating it – yet he flatly refused to leave. I could not live with his refusal to carry any responsibility any more. I was done.

Lester stayed for three months after I called it quits. He would *not* go, and nor would I abandon the house to him. Lester would never keep up the loan payments by himself, and my chance to purchase a home would be lost forever.

Back in 1965, a woman could not get a mortgage on her own unless she was headmistress of a big school or in some similar position. Men, or married couples, were eligible for mortgages, but certainly not a woman on her own with a child. I knew I needed to hang on to the house, or Adam, Jedda and I would be banished forever to the renting masses. But Lester *wouldn't* leave. Week after week of tension passed, with the situation becoming scary.

My sister Annie had recently come to live with us, her relationship with Mother having deteriorated further since Dad's death. Now that she was at college and art school she was no longer happy to be beautiful miss debutante dressed in wonderful satin gowns that Mother made for her. She'd cut her lustrous hair tomboy short like mine, practically a crew-cut, and dressed like an art school student. She had become, in fact, a younger version of myself. Mother was forever at odds with her, expecting the worst.

Annie had one bedroom, while baby Adam was in the small one next to the main bedroom. This left me nowhere to sleep except in my bed, which Lester shared. Once the relationship was dead in my heart, I slept as close to the edge of the bed as possible, my back to him.

There was no easy sleep for me until he left. Often he'd slide over to my side and cup his big hands around my neck. If I can't have you, he'd say, no one else will. In the circumstances, I couldn't laugh at hackneyed words. I lay there too scared to move, unable to speak. He never tightened his grip, but kept his hands there for hours. I'd pray for sleep, wondering whether I'd wake up alive.

At last, after three months of my cold refusal, Lester packed some clothes, rang a taxi and sat waiting for its arrival in the lounge. One wonderful day in December, he was going. I held my breath as I waited for that taxi.

While we were waiting, unbeknown to me, Annie was doing batik. She had put a saucepan of paraffin wax on to melt then popped down to the shop. The first I knew about it was when I saw flames leaping from the saucepan. Turning the gas off, I yelled for Lester who ran in and tried in vain to extinguish the

flames with the saucepan lid. Deciding to get the flaming pan out the back before it set fire to the kitchen, he shuffled carefully backwards out of the kitchen into the passage. Just as he reached the door to the laundry a draught blew flames two-foot high against his bare chest. This was a hot day, and Les was wearing only a pair of shorts. His feet were bare.

The pain sent him running through the laundry, where the burning paraffin spilt down his legs. Screaming now, he tripped through a pool of burning wax and out the back door, where he threw the empty saucepan onto the lawn and collapsed, still screaming, at the edge of the verandah.

I ran to him, arriving just in time to see the fleshy skin on his left foreleg curl up like bacon fat, roll down the length of his leg and fall on the lawn. It was spitting like pork crackling, and the smell was unmistakable – burning human flesh.

The poor bastard sat there rocking and screaming. The hair on his chest was singed, as were his eyebrows. His feet looked okay, but they were obviously causing him immense pain. The front of his left foreleg was burnt raw to the bone.

I rang the family doctor, who told me not to wait for an ambulance but to drive Lester straight to the burns unit at the Royal Adelaide Hospital. Somehow Lester managed to walk the few yards to the car and we began the nightmare 20-minute drive to the city. Every time I braked, he groaned in agony.

I rushed through the hospital's emergency entrance to grab a wheelchair and an orderly. Soon poor Les was given painkillers and taken to the burns ward.

For the next few days I was busy ferrying his belongings to the hospital and visiting when allowed. I took him a bottle of whisky – which the nurses impounded as soon as they discovered it. At first the doctors thought that his feet would heal quickly, but after a few days the soles fell off. It was months before he could walk again.

It was Christmas, he was badly burned, and he'd been ordered to leave his home and family. What could I do but visit? But the visits were strained. Eventually Lester asked me not to come again. It was too depressing, he said, to see me knowing he was not coming home. When he left the hospital he went to his parents' to convalesce, and there he stayed for the next year. It was over.

Once Lester was out of hospital, poppet, and staying at his parents', the phone calls began. Be here within the hour or I'll kill myself. Bring Adam *now* or I'll do it. And I went, of course, and took Adam with me. He was missing his dad, and asking for him.

What a mess. Lester would be hobbling around on sticks, thin and pale, crying as we left. As soon as Adam saw Les crying, he would start up too.

Then I would join in. I'd drive home each time in shock, trying to be cheerful for my two-year-old son. Lester looked terrible. His mother told me that he refused to eat and would drink only coffee and water. He smoked incessantly; read and smoked. Each time I saw him he was thinner. Lester was capable of starving himself to death. He was stubborn enough, I knew that. And he could go berserk.

Once at the Gresham I'd seen a blazing example of this. He went to the head of a table to collect the first of the finished plates from a group of 20 diners, and was *furious* to see that the customers had passed their plates along and scraped the scraps onto the top one, ready for him to collect in one simple movement. To Lester, such behaviour was gross. It was *his* job to collect each plate and discreetly whisk it away. He was so pissed off that he picked up the nearest champagne glass and took a bite out of its delicate edge. Then, after some more chomps, he dropped what remained of the glass on the floor and calmly walked out of the dining room. The customers were frozen in their chairs.

By the time I got to him he was out the back having a Scotch. I never did find out whether he'd swallowed the glass. He refused to talk about it and the matter was closed.

This reminds me of another episode, one that took place years after I'd left him. I was due to attend a Christmas dinner at the Paprika night-club. Murphy, a bachelor with whom I'd once had a brief fling, was my escort. I wore a long, backless, olive-green frock, matching it with a shoulder-length auburn wig to highlight the glow of the satin. This was the late 1960s, and wigs were in style. I had several.

I walked into the foyer on Murphy's arm, and who should I spy but Lester in his waiter's outfit. He saw me, too, and stopped in his tracks for a moment to look me up and down. I was terrified. This was the first time that Les had seen me with another man. But he went on about his business and we took our seats without incident.

I was greatly relieved when another waiter, one I'd known for years, began taking orders at our table of 30 or so diners. But when he got to me, he whispered that Lester had asked him to swap tables. Now comes the funny part. It seems that Les had approached him and said, I've just seen the first woman I've fancied since Barb, and I want to work her table. Well, Les hadn't seen me for years, and I guess a long wig and backless frock can change a woman.

The waiter had felt obliged to tell Lester that this woman he fancied was, in fact, good old Barbara, his ex-wife. But having worked with Les on and off for years, he realised that he had no choice but to swap as requested.

Les came to our table and stood between my chair and Murphy's. Got enough to drink? he asked. Need anything else? And with each word he picked up a glass, starting with Murphy's, and drop-kicked it across the restaurant. Glasses were hurtling in all directions, smashing against tables, belting people's chairs.

Murphy was all for tackling Les on the spot, but I'd seen Lester in action and knew it was time to vamoose. I apologised to my work mates, grabbed Murphy's reluctant arm and got out of there quick smart.

Anyway, back to the time he spent at his parents' after we separated. He continued to lose weight, refusing to go anywhere even when his feet had healed, playing on my pity for all he could get until, after nearly a year of suicide threats and tears, I refused to visit anymore. I'd long since given up taking little Adam with me.

Miraculously, Lester began to eat and heal. Nearly a year to the day since he'd left, he even came to visit Adam, bearing promises of fishing trips and promises of gifts. Promises, promises. Once he realised that I was not interested in his visit, he never came back. And never, for the rest of his life, even sent Adam a birthday or Christmas card. Bastard!

But he kept ringing me, pushing, pleading, promising, until, at my wit's end, I agreed to meet him. Spend one night with me, he said, and I'll leave the state and stop bothering you. In desperation, I agreed. How bad could it be? I had loved this man with a passion once and, besides, here was my chance to find out if there was anything left in my heart for him. We met at a motel. I swallowed as much beer as I could stomach, but it didn't help.

I felt truly ashamed. This one-night stand was virtually prostitution. I slept with Lester not out of love, nor even healthy lust, but purely for profit – the profit of peace. Strange to think that a lusty night with a stranger would be acceptable to me, when this loveless encounter with my legal husband was wicked, wicked, wicked.

Next morning when I was leaving, I asked, Will you go now, will you go interstate?

No, he said. I lied.

I never took his calls after that. Eventually he stopped ringing, and my life was mine again.

With just Annie, Adam and me in the house, the tension lifted, little one. On warm days I'd sit on the back verandah, Adam on my lap after a bath, and brush his blond hair until it gleamed like sunshine through a summer shower. And on winter nights, when Adam and I were home alone I would set out a silver tray

replete with teapot, cup and saucers, sugar bowl, milk jug and a plate of biscuits. Ad and I would set the tray in front of the ghastly little gas heater and, sitting on the floor, have a formal little tea party before his bedtime, chatting about the day. He had milk in his cup, which he managed very well for a three-year-old, while I'd have tea and a fag.

No one told us in those days that smoking around children was dangerous for their health. Adam, and then later Paris, grew up surrounded by clouds of second-hand tobacco smoke: Ad developed intermittent asthma and Paris became prone to pneumonia. I can only hope my smoking habit was not wholly to blame for this.

Annie, settled into the house by now, felt free to entertain her friends there. She was doing well at Teachers' College and had no intention of following in my disastrous footsteps where her career was concerned. I was only just beginning to know my young sisters. Tessa,19 when Lester left, was engaged to a pleasant young butcher and on her way to marriage. Annie was 20. I was nearly 26.

Les had left me with a mountain of unpaid bills, and I was finding it tough to turn a quid in life assurance. I had to contact my creditors and negotiate payments over longer periods – except for the house finance, that was priority number one. I began looking for another job. Before long I saw an advertisement for an interior decorator. How difficult could that be, I thought, especially with my background in art?

I clicked immediately with the woman who interviewed me, Rae Simister, the business manager for the area concerned. The company, I learnt, was called Burns for Blinds, and was owned and run by Bob Burns and his wife, Marie. Marie's sister, Kath, was in charge of the newly opened curtain section, where I would be working. The work involved getting out and about to houses with fabric samples to advise, measure and quote. I soon learnt the ropes thanks to the guidance of my bosses and their staff. I began to make some money for once, too, and started slowly to clear my debts.

The true bonus, however, were the lasting friendships I made with Rae and Kath, two wonderful women. Bob Burns, too, was a tremendous boss. He helped me through many a bad patch and made allowances for my bohemian ways (I think he found me a bit overwhelming at times!).

I was never short of female friends in those years at Morphett Road. Ilze always kept in touch though she herself was separating from her first husband and, fairly soon after, moving in with an older man and his young son. Pam was back in the picture now there was no Les to guard me so jealously. A new mate, Rita Peters, and a couple of other single mums became like sisters to me.

We shared the same problems, but also the determination not to join the ranks of the sad and lonely.

This crew of women, plus Annie, spent many Saturday afternoons at the Esplanade Hotel at Brighton. There was always a band playing, and the atmosphere was casual. We could take our toddlers, have a drink or nine, enjoy the music and pick from a smorgasbord of young men.

Rita was my favourite among this bunch of women. She is still a mate today, though I don't see her often. After the bushfire dear Rita dragged me into David Jones and demanded that I let her buy me the most stunning pair of high-heeled, knee-high black leather boots on display. Barbara Leslie without long black boots is not a complete unit, she declared.

Rita didn't drink, but she was bursting with effervescence. She went to the pub with her hair in rollers and didn't give a toss what anybody thought. She was as generous with her laughter as she was with her friendship.

There were plenty of men prowling the parties we went to, but my latest male friend posed no sexual threat. Harvey, who lived around the corner and had been interested in my house because of the big sculpture on the front verandah, was a window dresser and wonderfully gay – proud and loud about it. I liked him on our first meeting and he became a frequent visitor to the house. Annie and I found him delightful company thanks to his flair for the unusual and aesthetic. Harvey, Annie and I met a new, interesting crowd and attended wonderful gay parties where we could talk and dance with everybody, male and female, without the sexual pressure of the heterosexual world.

It was at one of these parties that I met the magnificent Merilyn. Our rapport was instant, and she too became a frequent visitor to the house on Morphett Road.

Annie had grown tall and straight like me, and often we wore similar outfits. Usually that meant jeans and duffle coats or hipsters with bare midriffs but I remember that we had identical, fireman-red, stretch jump-suits, which we'd wear with high black boots. We made quite an entrance together as we swanned in to parties, and people would whisper that we were incestuous lesbians. Neither of us cared what anybody thought.

Eventually my group of single-mum party girls grew sick of having to solve the babysitter problem. That's how the wonderful Morphett Road parties began, where we could pop our children in the bedroom. Dozens of times since those days I have met people, strangers as far as I know, who tell me they used to come to my parties. A hundred or so people would jam into the house each Saturday and dance squashed together. Loud, loud music, everybody happy:

Johnny Young's 'Step Back', Sam Cooke's 'You Send Me', Aretha Franklin's 'Respect'. The Beatles, The Rolling Stones, Elvis.

What with my friends and Annie's friends, *their* friends, and the friends of their friends, the house was home for the night to a grand mish-mash of society. Policemen rubbed shoulders with prostitutes. Business tycoons danced with students. Gay men and women danced with everybody. Lawyers, actors and entertainers all relaxing and swinging along. Fabulous.

The old 45s were the go then. Whoever was nearest the record player would grab half-a-dozen and whack them on. There were no tape recorders yet, or not among our mob at least, and often next day we'd need to wash the records clean of spilt drinks and food scraps. But they still played.

Tessa and her fiancé, Kevin, often came to these parties and slowly a wonderful friendship grew between Tess, Annie and me. For the first time I felt we were really sisters.

Yep, my sweet, they were good, easy times. No possessive, demanding husband, the easy companionship of Ilze, Erica, Pam, Rita, Merilyn, Honey, Kath and Rae. Seances by candlelight, flagons of hock drunk with lemonade on hot summer nights, birthday parties for Adam, with children and jelly and cakes and games on the back lawn. Dates with various suitors, none husband material but good for a pleasant night out and sex. Outings with Adam to visit my girlfriends and their children – company for me and playmates for Ad.

I'm sure that all the dancing I did helped my back enormously. The way I used to twist and turn and the pleasure it brought my body and soul must have strengthened every bit of tissue I possessed. But daily bending, lifting, sweeping and so on still caused me pain, and at work I hurt my spine badly several times lifting cases of fabric samples. Often, I'd need a day or two in bed to allow the inflammation to ease – and had it not been for the dancing, I reckon I'd have needed a walking stick even back then.

Radio blaring, I danced when I vacuumed, danced when I gardened. I danced on bar stools, on table tops, on the arms of chairs. I danced in my underwear, in bikinis, or naked, with or without company.

One night I was lucky enough to dance with Bobby Helpmann, both of us naked and each holding the end of a red silk scarf as we twirled around Miss Pam Cleland's sunken fireplace at her home in the foothills. I had met the wonderful Miss Cleland and her husband Fred Thonneman, the brother of my friend Ron, and was invited to intimate dinners where I met rebels, geniuses and celebrities including the young and breathtakingly handsome television

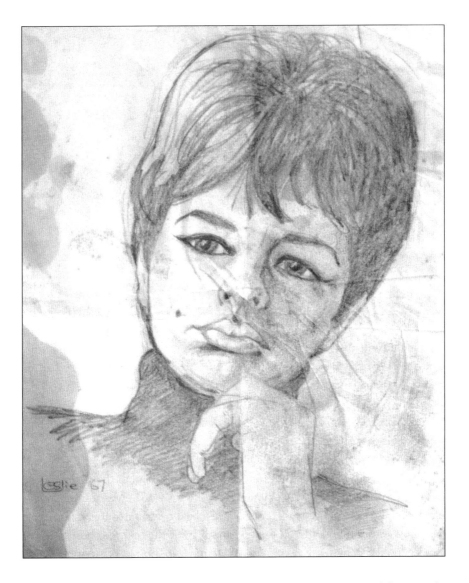

presenter Clive Hale, and the tremendously talented painter Clifton Pugh. Pam herself was a painter when she wasn't lawyering or wandering through her fabulous garden wearing nothing but spike-heeled shoes. I will admire her forever.

I even found time to paint and draw during those easy years. I set up an easel in my bedroom, and still remember a portrait of Ilze that I painted. I spent hours playing about with my beloved line. Models were available for the asking.

I had another solo exhibition, this time at the Miller Anderson department

store gallery in the city. I was still an amateur with oils, but once again my drawings kept the show from being a complete disaster. And I *did* sell an oil painting – a self-portrait, painted by candlelight. It was poorly executed and poorly formed, but a stranger was willing to pay good money for it. Good days indeed! What a beautiful piece of young womanhood I must have been, smelling of wine, cigarettes and turpentine!

My dear little sad spirit. When Les left he had agreed to sign the house over to my name if I promised not to seek alimony. He always was a magnanimous soul – after all, there were only a few occasions when he'd contributed to the household cash flow rather than frittered it away, and if I was the one who borrowed the deposit money from my sister and still had to repay it – hey, was that his problem? I knew full well that Lester would never pay maintenance. Besides, I didn't believe that a man should pay the costs of maintaining a family that he couldn't enjoy. I'd offered Lester full access to Adam, but he chose to ignore his son.

I had my mortgage by now, though it had been a bitter struggle. When my turn in the queue had eventually arrived, the bank, in all its wisdom, said that now that Lester had left, I no longer fitted its criteria. I tried to point out that my husband had been a liability rather than an asset, but the manager smiled politely and said sorry. My repayments on the temporary finance that I'd kept up to date for a couple of years now amounted to nearly twice as much as

mortgage payments would be. I pointed this out, too, but got the same pleasant smile and the same refusal. Married couples only. Bank policy.

Horrified at the thought of losing my house and Adam's security, I took my long legs, my courage and my anger into the Savings Bank of South Australia and demanded to speak to the managing director. Eventually I got to talk to an underling in the top office, but still no success. Furious at the unfairness I kept going back, week after week, banging my fist on desks, until some top executive eventually gave in and, in 1966, I got my mortgage – a big win for me.

I have many favourite memories of the swinging sixties as hippies appeared on the street and pounds changed to dollars, but what really reminds me that these were different days was that smoking was the in thing and oh-so sophisticated. Remember Sobranies? Cocktail cigarettes in pastel colours that came in a round box.

Until I went to art school I'd never tried a cigarette, although most of the kids at high school experimented behind the toilets, of course, and many of my friends had become addicts. Every second ad on television or radio was for cigarettes, and movie stars all smoked. But I couldn't be bothered with it until I had my first fag in the change rooms at art school and was hooked.

Frustrated by how quickly cigarettes burned when I was painting, I bought a pipe, and I loved the feel, smell and taste of it. I kept that pipe for many years. Lester wouldn't let me smoke it in public but didn't mind me puffing away at home. Ken demanded that I throw it away, so I hid it in my underwear drawer until he found it one day and threw it in the fire. No lavender bags among my knickers, my poppet, just a smelly old pipe!

Other drugs – grass, uppers and downers, heroin and coke – became popular in my 'arty' circle, but fortunately I was never tempted, content with fags, alcohol and my own natural highs and lows.

These were days when anything seemed possible. One weekend, on impulse, Annie, a pleasant (male) art student and I decided to hop in her red mini and drive to Sydney to see Les Girls, the daring new drag revue that had tongues wagging. With the three of us driving non-stop we figured we could get to Sydney, via Melbourne, stay one night in Kings Cross and be back in time for work and classes on Monday.

We rotated every couple of hours as one of us slept squashed along the back seat, one drove and the other kept the driver awake – for two thousand miles. We had hired a motel room in Sydney between us so we could have a decent sleep, but as it happened none of us got any shut eye. There was too much to see and do in the Cross. And Les Girls were fantastic. So beautiful. So

graceful. I'd seen drag queens and strippers before, of course, in the night-clubs of Hindley Street, but none so finished, so polished, so perfect.

Mother, whose house was not far from Morphett Road, was minding Adam these days while I worked at Burns. She was quite happy to have him for an extra weekend while Annie and I had a holiday.

Usually when I had a date in the evening Annie would be home studying and I could leave Ad in his own bed. As I didn't want him to become used to his mother with too many men, I became accustomed to evenings in motels if my lovers didn't have their own flats.

There were a few memorable relationships during my time at Morphett Road – young Bob, old Bob, Jerry, Kim, Murphy – but mostly, not ready for commitment, I had brief affairs and one-night stands.

Merilyn became a constant companion around this time. She was a kindred spirit, and although I'd made it clear that our friendship could only ever be platonic, we delighted in discussing our sexual adventures and experimentation and the heights of passion.

Merilyn was a wild thing, but she was also a bright woman who worked as a private secretary at executive level, gorgeous to look at as she strode like a puma and tossed her long red hair in the air. The two of us were a dangerous combination. We could drink most men under the table and smoked liked chimneys. We both used men for sex, although Merilyn treated her female lovers with more care.

I was still a beer girl. Sophisticated, well-heeled Merry liked her spirits. Most Saturday nights before a party, she'd drink a full bottle of Pernot while doing her hair, nails and make-up. She'd take a second bottle with her to the party and drain it dry there. Merry carried herself with such poise nobody guessed she was blotto.

But she was not a happy girl. Like me, she carried some painful virus deep, deep inside. She talked about suicide as if she were deciding whether to go to this party or that one. This worried me silly at first, but I relaxed over time when she showed no signs of actually topping herself.

There was a complete acceptance of each other as well as a shared knowledge of over-indulgence in everything, especially sex, and the relief too, of knowing that the other was balancing on the same fine line between sanity and madness.

Dear poppet, I was 28 when I bought MiMi Road, my first house in the Hills. It was no more than a partly completed holiday shack – I called it The Shed – with two small bedrooms, a large lounge and a small bathroom. It had no real

kitchen, just an alcove off the passage with a sink and room for a plug-in hot-plate or electric fry-pan. But after the clutter of the suburbs, it was my own piece of heaven – seven acres of it – surrounded by good old Aussie scrub. The Shed stood on the high point of a valley, overlooking miles of scrub, above it miles of sky. I was surrounded by beauty. A glance through the window, beauty. A walk to the gate, beauty. A trip to the woodshed, beauty. What a place to paint. What a place to breathe. And so secluded that I could walk around the block in the nude if it took my fancy.

One day I was working outside shovelling gravel. Three tons had been delivered for me to spread over the clay drive. It was a hot day so I decided to strip off for the job, leaving on my Wellington boots against the centipedes and a wide-brimmed hat against the sun. Tall and skinny, small boobs swinging, I must have made a picture atop the gravel pile as I shovelled the stuff into my wheelbarrow.

I'd bought the block on impulse one day while doing a job for Burns in the Hills. The customer happened to be a land agent and I mentioned idly that if a quiet acre with a shed became available, I might be interested. Immediately he took me to see the MiMi Road property – and I signed the papers for it before returning to work.

With absolutely no money to back the purchase, of course. I was a shocking impulse shopper, but MiMi Road turned out to be the best impulse buy that I ever made. Once I'd stayed there for a couple of weekends it seemed foolish to ever return to the suburbs. So I sold Morphettville, practically immediately, and with the small amount of profit that I made on the house I was able to get myself out of the serious mess I'd created by buying a property with no deposit and obtaining finance from a credit company at colossal interest.

The Shed had obviously originated as a couple's dream holiday home, but it had never been completed and was pretty rough, by anybody's standards, when I bought it. I set about making the few improvements that I could afford, using my creative resources to titivate the interior so it would become a comfortable home for Adam and me.

Merilyn spent time there with us and she, along with the neighbours, painted the entire outside of the house (cream) with well-protected coats of gloss (brown) on all the window frames. Gradually I added a large back verandah, which served as a carport, two big tanks to supply our water requirements and later, a studio. The lounge room had wall-to-wall, ceiling-to-floor curtains made of a bright orange patterned cotton that I bought cheaply from Burns. Floor coverings were financially out of the question, so I scrubbed boot polish

into the pine floor boards and polished them until they shone with warmth. Already the house had a fireplace, and there was plenty of wood on the block to keep a friendly fire burning on cold nights.

So I had my place in the sun. And then one day, for no reason I could think of, I started crying and couldn't stop. Looking back now, I think that my psyche simply collapsed in rebellion after I'd been forging ahead to the limits of my endurance. My breakdown didn't come about for one reason, but for many.

At the time, after much introspection, I thought that my sense of guilt over the first abortion was paramount, along with the anger at my foolish weakness for staying with Les after such an episode. In the middle of all that was my lack of desperately needed love from Mother and John. Strangely it didn't occur to me that the gardener's shed might be part of the reason for my collapse, having buried the incident long ago, so deep that I couldn't recognise it as a problem.

Over the years my lack of achievement had begun to horrify me. Annie, as it happened, had ended up with the teaching position at Art School that I'd coveted. She'd been a brilliant student and was a talented artist in her own right. After just two years of secondary level teaching she'd got the job as lecturer (and is lecturing there to this day). I was pleased for her, but it reinforced my feelings of failure. At school I'd shown such promise. Since then, I'd done *nothing*! Given birth to a precious son, of course, and held a couple of mediocre exhibitions – but I'd need to achieve much more to feel satisfied. I also began to worry that I'd been too promiscuous over the recent years. I'd had my fair share of lovers, but I think now that this was just good old Methodist guilt kicking in.

Good God, poppet, it was the sixties, and I was a free agent and an attractive woman. I could have had a different man every night if I'd wanted. But when I fell down that black well of depression, I grabbed any bit of loving I could find. Far too many men to remember – if I *could* remember.

Adam and I had been living at MiMi Road for about a year when the shit hit the fan. The dear boy was only six, and I hate to think now what irreparable damage he sustained as I collapsed into depression and spiralled downwards at a fast pace. I was eventually unable to work for Burns, or work at all in fact, and had to accept an invalid pension in order to afford the bare necessities of life. The mortgage ate up most of this pittance.

Not long before I moved to the Hills Mother sold her house to Tessa and Kevin and moved to Christies Beach, quite a distance down south along the coast. Adam had been staying there during the week while I worked, and coming home for weekends. This hadn't worked out well at all. Mother, widowed and lonely, wanted to raise Adam herself. Probably without thinking –

but who knows? – she began to shake Ad's faith in his mother's love by making comments like, If your mother really loved you, she wouldn't go to work and leave you.

Once I moved to MiMi Road, taking Adam to Mother's involved a seventy mile drive before I started work each Monday at nine. At the beginning of the breakdown, when I was still trying to work and taking heavy doses of anti-depressants, this made for a dangerous journey. It was Adam's job while we were driving to watch my eyes and poke me if they started to close. I was *so* sleepy.

The final straw came when Adam started school at Christies Beach. He hated the place. I couldn't bear to see him so unhappy, so I brought him back to MiMi Road full time, much to Mother's sorrow, enrolled him at the local Mylor school and found a wonderful farming family to mind him after school. The Warburtons, who lived just down the road from us, had a youngster about the same age as Ad – and lived in a ramshackle house stuffed with children, dogs, drying nappies, scones and laughter. They kept pigs. Later Paris, too, would be warmly nurtured by the Warburtons while I worked.

Once I became too ill to work, however, Adam spent most of his time after school around our house. I was off my face on heavy drugs most of the time, and it was up to this little person, at six, to make the meals and get himself dressed and off to school in the mornings. Mylor school, fortunately, was only a half mile walk away and the area was a safe one. But it must have been a sad time for Ad: no dad to turn to and his mother in hospital, asleep, or acting very strangely. The pair of us ate mainly baked beans and toast in those days. It was an easy meal for a young boy to fix. What a trooper.

My dear inner child. Myself. For a young woman who until that time appeared strong and in control, I fell into such a heap of despair and misery that it shocked everyone who knew me. I had always been a girl who refused to cry in front of anybody, but I sure managed to make up for lost time in the first year of that breakdown. I couldn't say hello without bursting into tears, and I didn't know why. I couldn't control it, hard as I tried.

Practically overnight I turned from a functioning adult into a cowering child. Often I stayed in bed for days on end, too scared to move, only speaking to Adam when necessary. It became impossible at times for me to shop, terrified that someone might speak to me. Other times I'd sit up all night talking to whoever would come and listen, too scared to go to bed. A mixture of tangled emotions.

Pam, good old Pam, proved to be a major force in getting me help and caring for me. God only knows how she managed to remain a friend after my

Adam
watching
telly 68

treatment of her during this time. Amazing now to think that I remained friends with anybody!

Most of my memory of that dreadful period is lost in a blur of pain, cheap wine and medication – did those drugs leave me with brain damage I wonder? I can remember only a little of the more bizarre episodes of the whole sad mess.

I was a wilful piece and, once set on an idea, impossible to budge. Often, unable to drive because of the drugs, I'd beg Pam to take me to a party. She'd always give in, because she knew I was at risk. Once I'd mixed a heap of alcohol with my medication, I was uncontrollable. I would dance on tables, strip off, make loud passes at married men. All of that.

One night remains crystal clear in Pam's memory, but only vague in mine. She'd reached a point where she'd had enough of my abuse. When I refused to leave a party this night after I'd been flaunting myself, she threatened to leave me there and go home on her own. At once, I broke into tears and begged her to take me with her, terrified to be alone.

Pam, older than me, in charge and obviously looking after me, was often mistaken for a lesbian. If only people knew – Pam was a man's woman from way back. But she understood the humour of it, and remained a wonderful friend. It was Pam, in fact, who managed to get me to see a shrink.

I was teaching an adult art class one night a week, which usually I'd find a piece of cake. When it got to the point where I couldn't go to class without Pam coming with me and sitting at the back of the room for support, she knew I needed to see a doctor. At first, stubborn and frightened, I flatly refused, so she organised a psychiatrist friend to come for tea one night. Once I'd chatted with him socially, I agreed – grudgingly – to see him as a client. For all his faults, Dr Karl not only managed to keep me alive during this terrible period, but made sure that my hospital visits were in private rooms in private hospitals. I have a lot to thank him for. If I had ended up in a state mental hospital I might have been branded a mad-woman and set on the treadmill of permanent institutionalisation.

As a back-up to Karl's care, I was lucky enough to have an excellent local GP, Dr Hill, who would pop me into the local hospital when I couldn't cope on my own anymore. Here, at Stirling, the kindly matron took me under her wing. Sadly, Dr Hill left the district soon after my breakdown was under control.

I was lost in such a deep black hole that it seemed impossible that I'd ever be able to climb out again. I feared each day and longed for death – not by my own hand, but some natural cause. Merilyn, also, was a staunch friend during these terrible three years. Time after time she'd answer my midnight phone calls and

listen sympathetically for hours to my maudlin drivel. If she felt it was necessary, she would drive the twenty miles up to comfort me. Sometimes, terrified to be alone for one minute more, I'd demand that she come immediately, and she'd throw a coat over her nightie and fly through the night to calm me.

The names and faces of many of the people who helped keep me going through those dreadful years have been lost to me. I know that a woman came to stay for a couple of weeks after Karl had prescribed such a heavy dose of medication that he wouldn't allow me out of hospital without someone to take charge. I'm told that this woman, an acquaintance of a friend, and obviously a caring soul, stayed with me, cooking, cleaning and nursing until either I returned to hospital or took a turn for the better. I hope, if she ever needs it, that someone will be around to give her the support that she so generously gave me. A lesbian couple, fond acquaintances, heard of my circumstances and arrived one day to stay for a couple of weeks. May their lives also be blessed.

I remember a complete stranger took the time and energy to care. I have no idea when any of these episodes occurred, but I'd guess that this particular one happened early into the breakdown. The drugs I was taking made me very sleepy and I was afraid that I might not wake up in time to get Adam off to school. So I rang for a wake-up call and told the operator to keep ringing if I didn't answer because I'd taken a lot of drugs and was ill. I must have had quite a long conversation with him and told him a lot about myself (which wasn't so unusual in those days). Instead of ringing me at seven, the operator arrived at my house and banged on the door. He made breakfast for us and organised Ad's lunch. Once he was satisfied that I was not going to overdose but was simply trying to cope with my medication, he left.

It's amazing how often during this shocking period that people were drawn to me to help. This telephone operator, once Adam had headed off to school, was alone with me in an isolated house. I was obviously only half with it and very vulnerable. But this Good Samaritan, who'd left work early to come up to me because he was concerned, and who lived many miles in the opposite direction across town, treated me with respect and care. His wife, he said, was a police-woman, and he had told her what he was going to do. Bless them both.

Towards the end of the trauma, perhaps a couple of years later, another fellow, the father of one of Merilyn's friends, saved my beauty, my faith in my fellow man, and probably my life. I'm ashamed to say that I don't remember his name either.

Paris had not long been born, only a month or two I'd say, and I fell right down that rat-hole again. Dr Karl told me it was either back to hospital for me,

or off on a holiday, but I must have a break from the responsibility of the children. Merilyn, who had moved temporarily to Perth, suggested I go over to stay with her for a while.

I've no idea where the money came from, but my return ticket was purchased and off I went, leaving baby Paris and Adam with Mother. The train trip was a two-day number with a sleeper and I was quite looking forward to it. I loved train travel and had missed Merilyn's company.

On the train, I met a couple of American fellows in the club car, one of whom I took a shine to. I spent the first night with him and stayed in their company throughout the day. They were businessmen who were out here looking for opportunities, and they decided to leave the train at Kalgoorlie, stay a night there and look around the town, then hire a car and drive the rest of the way to Perth. When they asked me to join them, I agreed without thinking. They'd treated me well, and I felt safe with them.

After a pleasant drive from Kalgoorlie, they delivered me right to Merry's door. I knocked, only to find her furious and out of her mind with worry. She'd gone to meet the train and of course couldn't find me. No one knew where I was. One of the guards thought I might have got off the train with a couple of fellas at Kalgoorlie, but couldn't be sure.

My friend had every right to be cross. I hadn't even thought to ring her about my change of plans. We hadn't arranged that she'd meet the train, but knowing Merry like I did, I should have realised she'd be there. But the drugs had made me useless.

Anyway, this pair of Yanks said they would ring me at Merry's and take us out to dinner. They did meet us, but had to fly out of the country urgently because of some currency crisis. Unstable still, I was upset that my new found Texan had to leave, and became morose and difficult – again.

During the previous 18 months, I'd begun to cut myself with razor blades – long criss-cross cuts on my arms and legs. One of my lovers, Dallas, had sowed the seed when he said, If you really love me you'll carve my name on your stomach with a razor blade. Sitting desolate and alone in the early morning, I made the first cut, long and deep in my upper leg. I sat there in tears and watched the blood pour from the wound as if my body was weeping too.

These moments of panic and despair were completely overwhelming. I couldn't envisage any decent life for myself and my children, one of whom was still in my womb at the time. I thought that anybody would be a better mother for them – especially Tessa, who'd agreed to take them in if anything happened to me. But I was unable to take my own life. Somehow that was out of the

question. Cutting myself was the best – or worst – I could do and it became quite a habit for me. Unbelievable *now*.

Merilyn, who had been still in South Australia at the time, was horrified by my actions, as any sane person would be. In Perth now, staying at Merilyn's flat, I decided once again I needed to buy razor blades. Merry tried valiantly to dissuade me, until, frustrated and angry, she went out to meet a friend for dinner. I'd been invited to join them but wouldn't go.

Merry's friend's father, a Perth businessman, was at the hotel when Merry arrived. In desperation she told them about my foolishness and explained that she felt unable to help me anymore. The father, alarmed, rushed to the flat and found me a terrible mess, my face slashed to ribbons by thirty or forty cuts. Swollen and bleeding from forehead to chin. I'd sat in front of a mirror, writing to whoever might read, cutting and watching the blood drip onto the page. The most desperate plea for help I could make. Destroying my beauty. Disfiguring that which I could not bear to look at.

This marvellous gentleman took me immediately to an all-night chemist, who suggested rubbing Savlon into the cuts every half hour to prevent infection and limit the scarring. Then my saviour took me back to his flat and made a bed for me on his couch. I'd taken heaps of tablets and needed to sleep. Every half hour through the night he woke me to rub the cream into my war zone of a face. In the morning he fed me and took me with him in his car as he did his rounds as a salesman. Every half hour he made sure I used the cream.

He rang Karl, who suggested I should be sent home as soon as possible, so my guardian angel cashed in the return train ticket and, using his own money, made up the difference to buy me a plane ticket for the following day. That night he woke me again every half hour for treatment and next day he drove me to the airport and put me on the plane.

This was 26 or 27 years ago. Perhaps this superb man is still living somewhere. Alive or dead, I hope that his kindness is being rewarded. Never again did I feel the need – or give in to the need – for self mutilation.

Back in Adelaide I took a taxi to Tessa's to collect my car, and stood in awe beside my sister's new baby as she lay in her bassinette. A light went on in my fuddled brain. I also have a babe. He needs me. And so does my other son. What am I doing?

At Mother's, holding baby Paris in my arms, I found strength inside me that I'd thought I'd lost altogether. I knew it wasn't over yet, but felt convinced at last that this madness would pass. A miraculous and solid knowledge.

Tess must have rung Mother to warn her about my shocking appearance, for

she coped well. But I won't forget how tears welled in eight-year-old Adam's eyes when he rushed in to welcome me home and saw my monstrous face. A car accident, I said, don't worry. It will heal. But Adam knew.

My sweet, hiding child, I've left out Dallas so far. I sure made a mess of things, but he played a part in the saga too.

I'd met Dallas during the early days of my breakdown when, hoping that new direction might clear my head, I'd begun to study English at Flinders University. Mini-skirts were just becoming popular and this day I was wearing an ultra-short, brown mini, teaming it with gold sandals that, Roman-style, had straps up to the knee. I'd stopped at a deli on the main road near the university and heard someone beeping madly. Turning, I saw a car pull over to the kerb and a man waving his arm out of the window. Must be someone I know, I thought, and wandered over.

To my surprise I discovered a young man, a stranger, who said that as soon as he saw me he couldn't help beeping and stopping. I was flattered, and curious.

He was a well-spoken, younger man, and posed no threat as far as I could see. When he invited me to stop for a quick drink, I agreed to meet him at a nearby hotel for one only.

This period, this first year of the breakdown, was a bad one where men and I were concerned. My need for love was overpowering and I'd become promiscuous, mixing up sex and love, once again, willing to sleep with a man for the holding and the kissing. I was 29, at my physical best, and men were attracted to me like bees to a honey pot. I regarded their use of me as my due while I was ill – in fact, expected nothing less. My need for punishment was beginning to surface, but with no memory of it's original source.

Anyway, I went for a drink with this young man and found that I liked him. He told me that his name was Greg, and that he was 22 and an engineer. We parted that day after one for the road, but the next week I invited him up to my house, and that's where our affair began.

As I got to know this Greg he told me that he worked on special missions for the government and often had to move quickly interstate. He wouldn't always be available. That was okay by me – I was seeing plenty of other men as well.

This whole year, fortunately is blurred in my memory. It was not one of my finest. I'm not even sure how long I was seeing this guy before, becoming disgusted with my promiscuity I decided to give men, the lot of them, a miss and become celibate.

Memory suggests that I saw some nice fellows during that period, but

eventually got it through my thick head that the few cuddles that went with the sex were not worth the self-loathing that I experienced afterward.

I vaguely recall a couple of jewellery parties, with everybody naked except for beads. Good parties. Laughter. I hope Adam wasn't home. Dallas, or Greg, came to one of these parties. I have very few memories of him otherwise.

And so, to *celibacy*. A conscious and definite decision. No men, no cuddles, but plenty of medication, feeling better about myself. No contraceptive pills, either. No reason for them. Then, somewhere in the middle of the following year, Greg rang, wanting to visit.

No, I said.

He told me he'd just come out of hospital after a car accident. Pieces of glass were still finding their way to the surface of his skin. I only want to talk, he said. You're the only one I can really talk to.

That got to me. Come on up, I said. But I'm celibate, okay?

Thank you, he said, and came.

He didn't take my celibacy seriously, of course. What did I expect? Such a simpleton. He was all over me like a rash.

I kept pushing him off. No, I said, I don't want to. No. But he wore me down and, eventually, tired and full of drugs, I said, If that's what you want, help yourself, and lay like a rock while he did what he'd come to do.

Next day I went to Dr Hill to tell him what had happened. Too soon to tell, of course, he said, but if I lay so unresponsive I may well be pregnant. And I was.

I'd never have known that the guy I knew as Greg was really a guy named Dallas if he hadn't swanned around town boasting of his conquests. One of his mates, disgusted by his behaviour, rang me months later to tell me Greg's real name, where he lived, and his phone number.

I rang the number, got Dallas's mother, and eventually spoke to the man himself and told him I was pregnant. He wrote me letters promising care and support and sent $50 to help with baby things. Best, he said, not to tell anybody. I will help. Please don't let my church or sports club know or I'll be in trouble.

Well, poppet, I was the one in trouble! But I couldn't see any point in making problems for him. I certainly didn't want to live with such a self-centred pig and if he helped financially that was all I would ask. But that $50 was *it*! He never sent another penny – and I was on an invalid pension, with one child already and hardly enough money for food. And he knew that. I spoke to his mother, who told me it was God's will that I raise the child myself. Thanks a million.

Some time later, I found out that Dallas (Greg) had been married for three weeks when baby Paris was conceived. The bastard! Much later, when I realised

that I needed Dallas's medical history for Paris's benefit, I rang his mother again. She supplied the information I wanted, but worried all the time that I was ringing for money, money, money.

So that was bloody Dallas! At least he gave me Paris. My job, I knew, was to be a good enough parent to both my precious boys that they didn't need the fathers who had abandoned them. Paris and Adam are the prizes God gave me for my courage and my spirit and my pain.

To my sweet inner child, lost within me. My decision to carry the pregnancy through to full term, however, had not been a simple one. My own Dr Karl was away when the local doctor confirmed my fears that I was pregnant. In desperation I went to the out-patient clinic at Glenside Hospital, a public psychiatric facility. The doctor I saw there was young and eager to quote the text books. Still, I needed professional advice, and he was all that was available at the time.

I continued to see him weekly and if I had not been such a stubborn piece of work, he might have destroyed me altogether. He seemed to be obsessed each visit by my choice of clothes, saying, Oh, we're Lady Macbeth today, or, Hmm, we're dressed for a fight this week. He just didn't get it. What I wore was dictated purely by my finances and the weather. He nearly succeeded in convincing me that I was *really* potty.

His text books had not educated him in the dangers of drug excesses, and he continued the regime of heavy doses that Karl had begun. Even in my muddled state, I queried these doses during a pregnancy, but was told, very firmly, that he was the doctor. Best to do as I was told.

This man, this so-called specialist, told me not only that I'd never make a go of running my own art school (a new plan), but also that I'd never survive a full-term pregnancy and would probably suicide before the nine months was up. At that time, the early 1970s, abortion was illegal in South Australia except when two specialists agreed that it was necessary to save the life of the mother. This young male doctor decided, with the support of another colleague, that my situation fitted this bill. I didn't agree. Sure, life looked *very* dismal at the time. I was unable to care properly for Adam, let alone myself. Another baby, with no money and heavy depression, seemed an insurmountable problem.

Nevertheless, riddled with guilt over the first dreadful abortion, my psyche rebelled at the doctor's suggestion. Strangely, the second abortion I'd had hardly worried me at all, morally. I didn't see the tiny child for one thing, but also I instinctively knew that with my womb infections and haemorrhaging I had little chance of carrying to full term. This time, however, was different. The

doctors were adamant and I was booked into the Queen Elizabeth hospital before the safe three-month period was up. I found it difficult to fight them. The drugs made me feel unsure and vulnerable, and these guys were *doctors*. They were the ones who knew. But I had no plans to commit suicide, even though life promised nothing but pain and worry. I had a sense that this baby might help me make up for my earlier mistakes – but how could I know what was right when the doctors were so emphatic?

As it happened, the day that I was to be admitted to hospital was the day I was due to sit an English examination at the university. Disappointed in the attitude of some of my tutors, I'd long since stopped attending lectures, although I'd done reasonably well in the assignments I'd completed. Creativity, it seemed to me, was something that needed to be *done*, not *observed*, and I'd eventually left the course with the intention of putting my creative energy into my own painting. In the middle of all this mess I'd managed to do a little. Not much, not often and not well, mainly still life because I didn't want to leave the security of my own little house, now and then a life drawing if a friend would agree to model for me, but at least I was trying to keep in touch with who I was.

In the circumstances I'd been surprised to receive a letter from the university advising me of the exam. I'll sit it, I decided. It's at nine, I'll book in to the hospital after it's finished. So on that day, everything set in motion by the doctors with me as the puppet, I walked in to the exam room with a pen, sat and wrote for three hours, and walked out.

With a clear head! With a mind that had somehow broken through the drug haze and the doctors' pressure to my real self. Of course I would not abort my baby. My *baby*! It would be hard. I would have to get better. I would have to get well enough to look after my children.

I drove home feeling stronger than I had for years. Still depressed and drugged, but determined to fight, and determined never to see those doctors again. I'd see Karl when he returned. Maybe. I'd wean myself off the medication and build up my art school. I reckon, looking back now, that if I'd gone into that hospital and had that termination I may never have recovered. My hatred for myself would have been overwhelming.

Annie and Tessa were pregnant with their first babes while I was carrying Paris, so once again there was a wonderful sense of sisterhood and shared experience between us. Ann had settled down with one of her professors from university and Tessa was happily married. They were both well settled and content, looking forward to the births of their first children with confidence. But I was settled with nobody and looked towards the future with trepidation.

Poor Mother, happy that Ann and Tessa were about to bless her with grand-children, found it difficult to show any enthusiasm about my expected. She had found it difficult to understand my breakdown, and in fact could never take it seriously. Dad had been dead for six years and she was lonely without him. John had married and had two young girls. I was, again, a big disappointment. But my hospital room, when I had Paris, was bursting with flowers sent by friends from all areas of my life. It was as if my whole world rejoiced at Paris' birth (and so they should have).

Paris was born a healthy eight pounder. He arrived with the umbilical cord around his little neck and no nurse in the room with me, which made for scary moments, but this was soon rectified and, apart from being a little blue and swollen for a couple of days, he was as cute as a button – and precious beyond measure.

Dear Adam, eight now and old beyond his years, showed no jealousy when Paris arrived. He hadn't had me as a proper mum for two years now and so had very little to be jealous of, but jealousy was never part of his nature anyway. He accepted his baby brother as a precious gift to be watched over, though some-times I caught a glimpse of sadness in his eyes. He had been too often over-looked in the struggle for daily survival.

Fortunately Adam had a great friend in one of the boys up the road, a quiet lad called George. The two of them were inseparable, George always one step behind Ad, like an adoring disciple. They built tree houses and cubbies in the scrub, collected lizards, frogs and snakes and got up to the mischief that eight-year-olds do.

Adam displayed his affinity with nature from very early on, as if he was seeking a saviour from the shambles of his home life. He was happiest walking barefoot through the scrub, afraid of nothing, and nothing afraid of him.

Ah, poppet, how sad it is now that all these memories of my breakdown years are so jumbled that I can't put them into order. Half-arsed memories surface willy-nilly, punctuated by complete blanks. Sometime about the middle of my breakdown, the decision to remain celibate made, I realised that I had to plan ahead for financial survival.

Barely able to force myself up in the morning, it seemed to me that taking classes at home would be the easiest way for me to ease back into the responsibility of teaching. So I decided to start my own art school at MiMi Road. I shudder now to think of the financial risk I took. There was not enough room in my tiny home to take even the smallest class so I decided to build a

studio specifically for teaching. With my usual aplomb, dragged out from behind the depression, I approached a finance company for a loan, and somehow convinced a manager that my studio would be a money-making concern.

One of Ilze's relatives, a builder, advised me where to build, what to build with and what size I could afford. The result was a 60 by 40 foot room with two walls of windows overlooking the valley and surrounded by gums. Fantastic.

I advertised my classes in the local paper and began with two small groups of three or four students. How I managed this is a mystery to me, but my students seemed happy enough. I salvaged a dozen old school desks and chairs from somewhere and a couple of friends gave tables.

With the studio furnished and functioning I approached the Education Department about obtaining a licence so that I could teach larger groups. When I was teaching students at Cross Road I'd found out that there was a class size limit for home teaching, and I had big plans for this school of mine.

I must have been functioning on about two brain cells at the time, full of medication, but an inspector from the Education Department visited my studio, approved my set up, and granted me a licence for a school called 'The Shed Art School'. It seems amazing now, considering I also remember that some days I would still be too afraid to leave my bed.

My students were a caring bunch, however, and made allowances for my mad spells. I recall once, when I was heavily pregnant with back pain, three students pushing me up my steep driveway to the house. I couldn't make it on my own.

Dear little inner self, I was driving past the new Eagle on the Hill hotel today, thinking what a shame that lovely old pub was gone, burnt down in the second Ash Wednesday fire, and remembering my time there as a barmaid and waitress.

I started work at the hotel as I was struggling out of the mire of the breakdown. Still very unsure of myself, fragile and frightened, I knew that if I was to succeed in beating the beast of depression I'd have to get out of the house and into society again. A few easy art classes at home was all I had been able to manage. With the extra costs of the new baby and Adam growing too big for his clothes all the time, I needed more money, without too much pressure.

Looking through the local paper I saw a barmaid's job advertised. I'd never worked in a bar, but thought that it couldn't be too difficult. I have to smile when I think about it. One minute I couldn't leave my bedroom and the next I was full of bluff and determination. I rang, only to be told that the job was already taken, but asked for an interview anyway.

I met the owners and explained my situation. I was a teacher who had

suffered a breakdown, and needed a job close to home because I had children. I had no experience in bar work, but could learn quickly and was desperate for a job without too much responsibility as I was establishing a small school. I must have sounded convincing, or competent, or perhaps the lovely couple who ran the hotel, Herman and Ursula, took pity on me. A week later they rang to say the girl they'd hired hadn't worked out, and offered me the job. I learnt the skills of tending bar very quickly, and my willingness to help out in the kitchen, or serving food and drink, stood me in good stead with both my bosses and fellow staff.

At Christmas the dining room was booked out every night, and I was kept on the run fetching and carrying for the drinking hordes. One night a young man, tall and handsome, stopped by the bar for a moment, saying he'd been watching me all night and would *really* like to see me again. He seemed a polite and friendly chap, and on the spur of the moment I told him he could take me out for a drink the following week if he'd like to meet me after work. I was so busy serving the drinkers that I practically forgot the arrangement, and was pleasantly surprised when he arrived before closing on the following Tuesday. He was clean and neatly dressed, nicer looking than I'd remembered. My head full of orders and prices, I had forgotten his name. He would hold this against me for years to come.

To be careful, for I'd learned a few lessons by now, I drove my own car into town while he followed in his. We went to a club for supper and chatted comfortably for a couple of hours. He told me he'd only been out from England for a couple of years – his Yorkshire accent was quite noticeable – and was a partner in a small crash-repair business. He'd not had a chance yet to make any friends as he was shy – he was amazed, he said, that he'd summoned the courage to approach me. He was single, he said, and boarding with an old lady who was a distant relative.

I told him that I was a teacher and an artist, and he looked disappointed. He thought I was simply a waitress. Warning bells should have rung in my head, but I was taken by his unsophisticated manner, his love of the Australian bush and his knowledge of birds and animals.

Any single man who was attractive and sensitive was a find, and I had my blinkers on, desperate for love and a father for my boys. So Ken began.

It's a testament to how ill I was, my dear little pet, that I have no recollection of the first time Ken hit me. It certainly wasn't during the first few enchanted months which convinced me that at last I had found the man with whom I would share my life.

In the beginning Ken and I always met away from the little house at MiMi Road, but once I had truly fallen for him I began bringing him home. Sometimes he'd stay the night, but rarely at this stage. Usually he left in the early hours, saying he needed to get some sleep before work.

One day during those early days we decided to treat ourselves to dinner and a complete night together at a motel. I opened up to Ken that evening, talked about married men and the deceit and the pain. I told him how deeply I loathed men who cheated their wives and mistresses by telling them lies. I told him about Dallas and the deceit. Ken was supportive and understanding, telling me that at least I didn't have to worry about him. He'd been working hard building up his business since he'd been in the country and had hardly even met any women. So reassuring. So caring.

Not long after this I asked him why, even if he'd stayed the weekend, he always left before 5 pm on Sundays. He told me that the dear old lady that he boarded with always cooked a roast for him on Sundays, and he couldn't let her down.

One day, I remember, I called him at work. Things don't feel right, I said. Are you telling me the truth?

Stay right there, he said, and drove up at a ridiculously dangerous speed. He took my face in his hands and looked into my eyes. Believe me, he said, I could never lie to you.

I believed him.

But then came the night, in the pub car park after work, when he said, There is something I must tell you. I have been married, and have two little girls, three and four years old, I see them on Sunday nights and we watch Disney movies together. I'm separated from my wife; soon we'll be divorced. Can you ever forgive me?

I forgave him, of course, so he brought the girls up to see me one Sunday. I'm hoping you will be able to love them, he said, and as I gazed at the two sweet darlings I assured him that I would. Ken had been good with my boys, and the fact that he had his own children allayed my concerns about his acceptance of Ad and Paris.

Then came Easter and a glorious holiday by ourselves to Geelong. But even then, there was one episode in the hotel that should have let me know there was something terribly wrong. The pair of us had been coupling on the floor for hours and eventually fell exhausted back into the big soft bed. I feel wonderful, he said, like a king. I feel magnificent. I wonder, he said, how many other men have felt like this after making love to you.

I told him not to be silly, that he was special, that he *was* magnificent, that this experience could only happen between the two of us. Forget it, he said. And I did.

When we arrived home on the Sunday, and he took me on the bed before going to his girls, the phone rang. I reached across him to answer it and a woman's voice spat into my ear. Send my husband home *now*. Let me speak to him *now*.

Numbed, I passed the phone to Ken and lay listening while he talked to his obviously very much on-the-scene wife. After that phone call, things did indeed begin to go terribly wrong. The wife, Katherine, threatened to leave Ken and take the girls so he'd never see them again. He was torn between his family and his obsession for me. I came to realise that he'd been making love to me in the afternoons and going home and making love to her at night. I felt betrayed, and more importantly, I suppose, I felt dirty – again.

By now, however, I was as addicted to Ken as he was to me, and we were unable to call the relationship off – especially since he told me over and again that he was leaving Katherine and moving up to MiMi Road.

Our sex life was magnificent. Ken had told me that until he met me he thought that fucking was just something men did fairly quickly for a release. He was astonished to discover a whole new concept concerning sex, with me, and was addicted from the first time we screwed for three hours in his car. He could not get enough sex after that, besotted with this new-found pleasure. As for me, I was happy enough to get down to it several times a day, as he was a passionate and exciting lover once he got the taste for it.

For perhaps two years he fluctuated between the pair of us, moving a few things in with me one week, and running back to Katherine and the girls the next. It was during this period that the violence began. Exactly when, I don't know, but once started, it escalated quickly.

Nowadays, little one, I would not let *anybody* lay a finger on me in anger, not for *any* reason. But back then, when I was floundering around on my own, desperate for love and absolution, I repeatedly managed to forget the abuse. After each violent episode, Ken would be full of apology and heartfelt promises that it would never happen again, and I chose to believe him. After all, I deserved the punishment. I was the one who'd known far too many men. I was the slut. Mother knew, John knew and now Ken knew.

I remember one time, when I made a feeble attempt to save myself after Ken had beaten me badly. I have no recollection of what triggered the violence; I know I was wearing a beautiful white, soft chiffon blouse so probably I'd made a special dinner. Adam and baby Paris, tucked up in the room next to mine,

must have been wakened by the noise of Ken's shouting, my screaming and the sounds of heavy blows. One can only *begin* to imagine what fear and rage and helplessness they experienced and what damage they sustained, filled with the guilt of their inability to save their mum. Poor little guys. Trapped in their youth.

Somehow I broke free of Ken and made a dash outside, where I locked myself in my car. Before I could start the motor, Ken was there beside the bonnet and – just like that – he reached in through the windscreen and took the keys from my shaking hand. The power of madness; he didn't slam his fist through the glass at all, just reached through.

Jewels of shattered glass flew all over me and the car's interior. Ken unlocked my door with the keys he'd reached for, then dragged me out, shoved me against the bonnet and beat me viciously about the head. When, nearly unconscious, I was sagging in his grip, he threw me to the ground, got into his own car and drove away.

Adam, hearing the crunching of tyres on gravel, came out, helped me inside to a chair and held my bloodied head gently against his chest. We'll be all right Mum, said my nine-year-old son. You and I can do it together. We don't need anybody.

Seeing his shocked, sad face, I gathered my courage, rang the police and said I wanted to lay charges. Two policemen came and took details but said that I'd have to go to the station next day and sign the papers. Many women change their mind, they said, and drop the charges the next day. Not me, I vowed, and they left after I assured them that I didn't need to go to hospital.

Pam came over straight after I rang her. Once Adam was settled back in bed, the two of us sat talking and drinking, my beautiful white blouse covered in blood and my face bruised and swollen. Before long we heard Ken's car in the drive. Oblivious of Pam, he crawled into the room on his hands and knees and slunk over to my chair nursing his broken right hand against his chest, crying and begging forgiveness. It was a pitiful sight. Pam still talks about it with derision, but I, foolish idiot, felt sorry for him and believed his promises.

Needless to say, I didn't lay charges. Next day Ken, his broken hand in bandages, accompanied me to the police station, where he promised the officer in charge that he'd learnt his lesson and would never hit me again. Ha.

Normally, once Ken had reduced me to a bleeding, pleading mess, he'd want to hold me and make love. He'd whisper promises to protect and always take care of me. Protect me from *whom*? Madness. Most often I let him have his way. I had no strength to fight, and to be held and stroked was far better than to be beaten. But one night I decided to fight back – with disastrous consequences.

I had bought him a new jumper, and gave it to him as a surprise. He opened the parcel and immediately threw the jumper on the carpet. That's where that belongs, he said and knocked me to the floor. That's where you belong, too, he added.

No reason. Completely out of the blue.

He kicked my legs apart and told me that was my place: on my back, on the floor. Then he dragged me by one foot up the passage to the bedroom where he pushed me onto the bed. Furious and shocked, I pushed him off, which only enraged him more. He pinned me down on the bed, shouting obscenities.

So I kneed him in the balls, as hard as I could. He didn't fall down, like they do in the movies, but instead, with a scream of pain and anger, he raped me. Then he beat me with such violence that I knew I could never find the courage to fight back again.

Of all the men who tried to rape me over the years, only Ken, my live-in lover, succeeded. And that, I'm sure, was because of his madness and my fear of it. The hate that I felt for him that night should have struck him dead on the spot. Never had I felt hatred like this. I wondered whether all women who were raped hated with such a vengeance, but decided that betrayal by someone I loved made that hatred stronger.

Next day, nothing was said and life went on. Terror was now part of the mix in my complex emotions. I was petrified, fearing for my life and perhaps the lives of the boys should they ever get in his way.

Another astounding incident stands out in my memory. Things had been coasting along reasonably peacefully for a time and, deciding to give Ken a treat, I prepared a beautiful platter with a large crayfish, salad, nice breads and so on. When he came home late from work on this dark winter's night I directed him straight to bed. The bedroom was spotless, with pillows piled high for comfort, and a bottle of champagne sat in an ice bucket on the bedside table.

We cuddled up together until, half way through the meal, I commented on his hands. I've always loved the look of men's hands: the strength, the nails, the large pores, the hairs on the skin. Ken had superb hands with long, strong fingers and just the right amount of black hair scattered over the back. I stroked his hand and told him how beautiful I thought it was.

He became very quiet and my heart sank as I picked up on his change of mood. How many other hands have you stroked like that, he asked. How many dozens of other hands? You slut. You cheap bitch.

The crayfish platter went flying as he turned to grab me. Then it was on. Smack, smack across the face. Slut. Tart. He dragged me down the passage and

outside to my car, which was covered by a fine layer of ice, and pinned me across the car's bonnet until my bare skin stuck to the freezing surface.

This was one of Ken's favourites tortures. He knew full well my back problems and my inability to cope with the cold.

He beat me brutally that night. This was the most violent episode to date. It made me realise that I had absolutely no chance of redemption while Ken was alive. I would carry the name slut for the rest of my life no matter how hard I tried to be good. After Ken had finished bashing me, he left. He probably went back to Katherine's.

Oh my poor little one, I had absolutely no idea what was happening in the rest of the world. My own life was so all-absorbing that beyond the walls of life with Ken, and the welfare of the boys, the rest of the planet seemed hardly to exist at all. The few friends that knew about the violence, and my family, all tried to tell me what madness it was to stay with him, but for reasons which I still question I made excuse after excuse after excuse.

Love? Fear? Need of punishment? Sex? Passion? A father for the boys? Self-disgust? Perhaps all of the above, each assuming more or less importance depending on the circumstances. A friend asked me recently why I stayed with Ken for so long. In between the violence, life could be satisfying. He grew extremely fond of my sons and intended to adopt them as his own. But then again, he knew that the easiest way to win me over was to be kind to them. Ken had a love of the earth that I understood and respected, and an affinity with animals that I admired. And there was no doubt in my mind that he would die for me. If need be, he would throw himself in front of a car to protect me.

Ken was hardly the fabled wife batterer who stops at the pub every night then slaps his woman about if his tea's not hot. His violence seemed to run in a pattern. I learnt to watch out for full moons, and if I'd not been beaten for three months I'd suspect my time was up – though at any time an incident or word could set him going. But I stayed with him and there were many dramatic episodes while the pair of us tried to sort things out. Sometimes he was out of control and sometimes I was.

An evening comes to mind when I was so frustrated with him and so lost in my emotions that I threw several bottles through the front windows of the lounge room. Indeed, I threw many bottles at different times through those windows, my poppet, achieving bugger-all except the need for one hell of a lot of cleaning up to safeguard the feet of children and animals. Dear Jedda was gone now, but I had a beautiful Great Dane called Kruger and two cats.

Mostly these episodes happened late at night when the children were asleep. They would miss the commotion, but wake up the next morning to ask, What happened? I always told them, but with the mess cleaned up it was not as traumatic for them as it might have been.

But the last time I threw bottles – one weekend when Ken's girls were up to stay – I didn't wait until the kids were asleep. While Ken was putting them to bed, I let loose with a vengeance. All four little ones ran out, shocked and frightened, and I felt truly ashamed.

I'd also given Katherine the fuel for another fight in the courts to prove that I was unfit to have the girls on weekends. This had been an ongoing battle ever since she'd found out that Ken was seeing me, and as he moved back and forth between the two of us, it had become her weapon. If you leave me, you'll never see your girls again, she told him over and over.

Ken and I had spent a fortune on lawyers to fight his case for access. We couldn't afford the money, but I was determined that he would keep in touch with his daughters. I'd seen my own boys suffer because of the absence of their fathers.

Katherine and I were at war. She accused me of being manic-depressive and of having made the girls sleep on the floor of a shed with the animals. Well, I called the house 'The Shed', and sometimes – although they had their own room with bunk beds – we would let Pat and June sleep on a mattress in our bedroom because they wanted to be near their dad. The family cats often slept on their bed – they were not allowed to have pets at home, and cuddling a cat to sleep was a real treat for them. Put like this, Katherine's accusation was nonsense, but it looked good on paper, and I *did* have a history of depression.

After Ken had left Katherine for good she moved a new boyfriend into her family home. They took out a court order forbidding either Ken or me from setting foot on the property. We had to collect and deliver the girls at the gate. One reason for this order was that Ken had thumped the boyfriend's car and put a dent in it. The other reason had to do with me.

The last time Ken had gone to Kath's to collect his belongings, *again*, he had failed to return to MiMi Road. By two am – at which point, beside myself with frustration and *furious* – I made the hour-long trip to Katherine's where I drove my Charger over the front garden and into the bedroom wall, screaming, Get out here you lying bastard.

Not only did he come out, in his pyjamas, but so did all the neighbours. I drove the car back and forth over the carefully nurtured garden, mowing down trees and shrubs and ripping up lawn. Oh, I was a sweet young thing.

Ken arrived the next day with his bags packed and brimming with eternal love. This time he stayed for good.

Why I fought for this man is beyond my comprehension now. It would have been better to let him stay with his wife and family and leave us alone forever, but I knew by then that he'd never leave me alone – and if I was going to have this crazy man in my life, I wanted him *all* the time, not part time.

I was completely under his spell. And quite a spell it could be, too, when he was good. He built me a kitchen at MiMi Road. He chopped wood and dug holes so we could plant trees. He brought home his wages every week. He took Adam to a sale of reptiles, bought him two pythons and helped him organise a cage for them. When the girls were up (finally the judge saw the ridiculousness of the case and gave him overnight access every other weekend), he took us all to the beach and played for hours with the kids.

With our combined incomes, we built a big bedroom jutting out from the front verandah and then filled in the verandah to make a bar room, which he fitted out with shelves and lights.

He never missed a weekend with his girls. He hammered and painted and fixed the little house up until it was solid and tidy. He loved me and made love to me and bought me flowers and presents. He showed me off proudly on his arm when he took me out to wonderful places for dinner. He cradled my head on his big shoulder every night when I went to sleep.

And he beat me.

Bloody hell, poppet, I was a confused woman. My stupidity, now, is incomprehensible, but back then, well, I suppose I just did the best I could under the circumstances.

After one terrible beating, before Ken had finally left Katherine, I went to Dr Hill who put me straight into the local hospital, where I also had the support of the marvellous matron. After talking to these two kindly souls, I decided to write Ken a letter while I was safe in the hospital, which I sent to his business address. I told him I couldn't take any more, that he was killing my spirit as well as my body and that, although I loved him, I refused to take any more bad treatment and never wanted to see him again.

The next day he rang the hospital and demanded to speak with me. The matron took the call and told him I was too ill. He insisted. His speech was slurred and his conversation difficult to follow. He muttered something about pills.

Reluctantly, the alarmed matron eventually brought me the phone. Ken told me, as far as I could understand between the mumbling and the slurring,

that he was going to, or had already, overdosed on pills because he couldn't live without me.

I told him not to be so foolish, that I had decided not to take him back, and he hung up the phone.

Despite my resolve I was worried by his call, as was the matron, so I rang his business to try and talk to his partner. No one answered, so I rang his mate at the workshop next door, said I was concerned for Ken, and asked if he'd seen him that day. He said he'd seen Ken crawling around the backyard of the wrecking shop and thought he must have been looking for something.

The matron immediately rang an ambulance and the police. They picked Ken up and took him to the Royal Adelaide Hospital, where doctors pumped his stomach and put him in the psychiatric ward.

I felt dreadful for him, but was pleased in a way that he too was in hospital where someone could at last help him deal with his problems. A sad finish, I thought, but a finish.

Not so. Ken was so determined to see me that he rang again a day or so later and told the matron he was coming to the hospital at Stirling to talk to me. She said no. I felt safe – he was in was a security ward and zonked out on drugs.

The matron, however, was not so relaxed about his call – she'd heard his tone. She rang the RAH to check that he was still in his room. He wasn't. The attendants couldn't find him anywhere in the ward and had no idea how he'd got out.

The police were called, and an ambulance. Ken had to be found and taken back to hospital. The police, sure that he'd somehow find his way up to me, staked out my room and waited. Two of them watched from my verandah, while a third hid behind the door of the room. I nearly had to laugh. How come there wasn't a cop hiding under the bed?

Well, Ken did turn up and the police did take him back to his own hospital. I was left at last to rest and heal, and the bizarre episode can still sometimes bring a grin to my face. Life with Ken was certainly not boring!

When I'd recovered, Ken's psychiatrist from the hospital wanted to see me. He also wanted to see Katherine. He said there was nothing really wrong with Ken other than that he was a naughty little boy who was at his wits' end trying to choose between the two of us. The psych wanted us both to stay away from Ken for three months so that he could decide, with help, where he really wanted to be. I agreed readily – in my mind the relationship was already over – but soon Ken began ringing and pleading and then driving up with promises and flowers.

Well, I reasoned, he has had all this magical help from the psychiatrist, and

now he's decided once and for all what he wants. Confronted by Ken's charm I melted once again.

My sweet inner child. Since meeting Ken I hadn't had much time to myself for painting. For a while I continued to work at the pub but Ken soon put a stop to that, jealous of my interaction with male customers. Since my classes at that early stage of the school hadn't brought in much cash, I went back to Burns for Blinds. Bob Burns had been most understanding about my breakdown, as were Rae and Kath, and, having already been inconvenienced by my earlier sudden departure, were very generous with their offer of further employment. I worked mainly at after-hours jobs – I had to fit in my art school lessons during the day – and the commission was higher after hours.

I remember this was a dreadful time for nine-year-old Adam, his mother always out, home alone most of the time. Paris, who had been cared for by the Warburtons when he was tiny, now attended a child-care centre in Stirling. The Kilsbys, too, were a great help with the kids when I was stuck for babysitting. It was not the life I wanted for my boys, but necessary at the time. Once Ken had moved in with us for good, and my art school grew, I was able to leave Burns *again*, and spend more time at home.

In the middle of all this I painted when I could, but it was hard going for mostly Ken wanted any spare time for himself. I remember working at my easel one evening while Ken sat by the fire and watched telly. I was working on a large nude, and had just discovered the wonder of *scumbling*. I was itching to finish the painting using my new-found skills to portray the softness of the woman's flesh. My colours, after time and effort, were mixed on my palette, and I was just beginning to scumble the tones onto the canvas when Ken asked, Are you going to be there all night?

Just a while, I said, not taking my eyes off the miracle that was happening before me.

Icy silence filled the room. I stopped to look around and saw that Ken had swung his chair around to face me and was sitting perfectly quietly with his arms crossed, fixing me with such a terrifying stare that I put the brush into the turps and said, That'll do for now. This was a look that breathed danger.

I stopped my precious painting, made Ken coffee and watched television with him, hoping I could forestall a tantrum, but the image of the nude hung between me and the television, my heart was over at the easel, my fingers itched to get back to work. I came close to hating him that night.

I often snatched time for my own work after giving a class down in the studio, and that's where most of my painting was done. But it was often cold

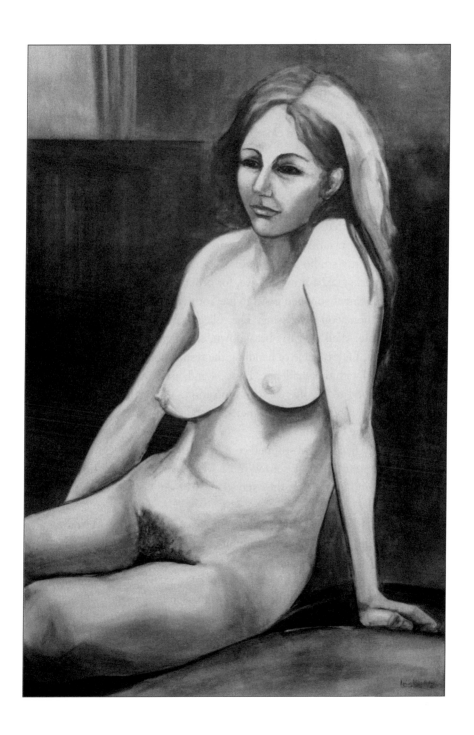

down there, especially at night, and I liked to work sometimes in the bar room where I could hear the kids and share the fire and the record player.

My little art school grew once people heard about it. I had advertised my classes regularly in the local paper and gradually I built up a happy following of students who stayed with me for years. The studio was an exceptional venue for classes, with native scrub to the door there was never any shortage of subject matter. Many students forged close bonds and looked forward to their weekly visits to Mylor.

I had five large regular classes when the College of Further Education (now TAFE) at nearby Mt Barker approached me to take lectures in design and drawing for a new certificate course. The college, which also ran leisure classes in art, pointed out that if I taught for it, rather than myself, all the administration – enrolments, taxation and paper work – would be handled by its office. I could still use my studio for some of the leisure classes, but would need to travel to Mt Barker, a 20-minute drive, for others.

This arrangement sounded good to me, for two years I had hated the admin and spending money on advertising. The college gave me enough classes to earn a decent income. Well over my breakdown, although now emotionally fragile because of Ken, I felt capable of handling the responsibility of certificate classes, and was pleased with the challenge. I was 34 and, after the horror of my breakdown, it felt good to be offered such a position. When the time came to re-register my own school I didn't bother, and ended up teaching for the college until just after the bush fires.

Many of my friends had stopped coming to the house by this time because of Ken's behaviour. He soon sensed those who were a threat to him and made their visits so unpleasant that they stayed away or only called when they knew he'd be out.

For some reason he liked Merilyn. She was always made welcome and I could go out with her occasionally without causing a fight. Perhaps he knew that he'd met his match in her. Even so, there was one frightening occasion when he was so out of control that Merry and I locked ourselves in the bedroom. He began kicking at the door and threatening to break it in if we didn't open up. We knew he could do this, and decided the wisest move was to unlock the door. Faced with the two of us, side by side, he backed down, left us with a mouthful of abuse and drove away with his fury. Had I been there alone goodness knows what would have happened.

Merilyn and Pam were about the only two people I told about the beatings for ages. I was too ashamed – of my weakness, of still loving him – to tell others.

Later I told Mother and Annie, and others guessed, but I hid the facts for as long as possible, taking sickies from work and making up excuses for my bruised face.

Pam loathed Ken, and made her feelings quite obvious. He made her unwelcome at the house but she stubbornly refused to stay away altogether. Sometimes this would lead to trouble, and eventually she and I agreed it was better if I visited her at her house when Ken was at work.

After seeing my wonderful block, Pam had begun looking for a small place for herself in the Hills. Eventually she bought a small home at Hahndorf, only a few kilometres from MiMi Road. She had been through a violent break-up with her third husband, a brute of a man who maltreated her physically and mentally. The separation had broken her heart, and the move to the Hills with her two daughters had been therapeutic.

Pam's daughters Sally and Merrian, 20 and 18, found work at Mt Barker. Pam found employment as chef at one of the local hotels and the three of them seemed quite content in their new home. I'd watched her girls grow from youngsters and was extremely fond of them.

Tragically, in August 1974, while they were driving home from work, the girls' car was hit by the one train that went through Mt Barker and Merrian was killed. Sally survived somehow, but with terrible injuries that kept her in hospital for weeks.

Pam was inconsolable; it was nearly ten years before she shook off the depression that nearly destroyed her. Sally, too, eventually recovered and is now happily married with two teenage boys of her own. They are two gutsy females.

I spent as much time as I could with Pam in the weeks following the accident and Ken, to his credit, made no attempt to stop me. There *were* times when his empathy surprised me.

But poor Pam. My dear friend for so many years, shattered by the loss of one child and the horrific injuries of the other. There was nothing really that I could do. My own problems seemed laughable in comparison.

Dear little inside poppet. Somehow I managed to put together an exhibition of 30 or so paintings and drawings that was held at the Hahndorf Academy in 1975. My records of this show were lost in the fire – which could be a good thing, because I suspect not much of the work was very good.

The drawings, as ever, carried the show, but the few paintings that I've been able to trace are not up to scratch. I'd become fascinated with the intricate web of fibres and seeds inside trombones and melons and had completed a series of semi-abstract drawings on this subject. These were well-accepted and connected

with the major theme of still-life in oils that I'd been working on for years.

There were a few landscapes too, mainly gum studies from the River Murray. These had come about because Ken and I bought a speedboat. One of the girls who worked at the Eagle had a holiday shack by the River Murray at a small town called Swan Reach. She offered us the use of this shack and once we took the four kids up for a weekend break, we all fell in love with the place.

We also made friends with Tony and Faye, the couple who owned the massive farm property where the shack sat, part of a large group of shacks. They invited us to stay at the farmhouse, and we spent many happy weekends there. The speedboat was bought for these weekends.

Sometimes we'd take Kruger with us to Swan Reach. I won't forget the sight of him sitting sedately in the passenger seat of the speedboat, his head higher than the glass windshield and his ears and jowls flapping in the wind as Ken roared through the water.

I did a lot of painting there at the river, inspired by the big old river gums, the lagoon, the swampy edges of the lapping water. At home, Ken treated my

painting almost like a rival, and there were constant arguments about the time I spent at my easel and the money 'wasted' on canvas and paints. But at the river it was different. He had the boat, plenty to do and people to do it with. I could paint as much as I liked up there, and I did. It was heaven. Tony and Faye wanted to buy one of my works and other shack owners were showing interest. Ken would even carry my easel and materials to where I wanted to work and then take the kids to mess about on the river.

John Dowie, the sculptor and painter, opened the exhibition for me and I have a press cutting that includes a photo of John, me and Ken standing together looking cheerful – indeed, Ken looks smug. Pam snorted when she saw the photo. She knew that he made painting difficult for me but liked to be around to share the limelight.

John Dowie said at the opening that the best compliment one artist can give another is to be jealous of their work and that he was jealous of the melon drawings. I admired and adored John, and felt honoured by his remarks. So I had my second one-person show at 34. What had happened to all the years?

There was a good party back at MiMi Road after the exhibition. Rae's husband, Terry, played barman and there was much music and dancing. Rae and Terry had remained good mates even after I left Burns when my teaching load became too heavy. Rae guessed that I was in a violent relationship, but Terry knew nothing about it and he and Ken had slowly built a strong friendship. It

was a relief for me to find a couple with whom we could share time without tension arising.

Ken had begun relating better to my family, too, and was gradually accepted into the fold as my partner. This made it easier for Paris and Adam on the few family occasions that occurred, and dear Patricia and June began to feel a sense of belonging as well. We often took the kids to visit Mother (they called her May) at Christies Beach for a Sunday roast and, on the surface at least, everyone got on reasonably well.

My relationship with May had undergone a subtle change. She was very lonely now that Dad was gone and I felt sorry for her. The boys loved to visit her, and as often as possible we made the long trip to give her company. I still wanted her approval, and it was never forthcoming, but I knew that in her own way she'd done her best for me. I was beginning to realise how grateful I will always be for the normality of my early home life and the benefits of a good education, and felt that in my mother's old age (only her sixties, really) that she deserved some support and care.

Mother and Ken didn't get on at all, but for the sake of the children – and me, I suppose – both of them tried to put up with each other. After a few drinks she would still sometimes whack me below the belt, but she was less likely to do this when Ken was around and most of our family visits were quite pleasant.

My sister Annie had sold her little cottage in the Hills and was living in North Adelaide with Brian Medlin, a university lecturer. He was a controversial, political fellow who had left his wife and children to live with the beautiful Annie. Brian was heavily involved in the anti-Vietnam movement and Annie had become political too, in her art as well as her attitude. Neither Ken nor I cared much for politics and there was little in common between our two families except that Annie and Brian had one young lad, Jake, about the same age as Paris.

Tess and Kevin, with their two daughters Samantha and Kylie, were now well established in the old family house at Somerton. Tess put all of her energies into being the best mother and housewife that she could and succeeded mightily. With all of us busy with our own lives, there was not a lot of contact between the sisters. We would only meet at Christmas dinner, the occasional party or a rare family function.

My brother John and his wife, Liffy, and their two girls, Elizabeth and Joanne, were living at Reynella, south of the city about halfway between Tessa's and Mother's. John had grown tired of motor cars, racing and hill-climbing. He was a brilliant mechanic and an exceptional driver, but by now he'd become a pilot, making the outback mail run in Central Australia and the Kangaroo

Island passenger service. My relationship with John was still awkward, but we only crossed paths occasionally.

Most of my time was spent at MiMi Road with my own family, of which Kruger by now was a much-loved member. I'd found Kruger while on a job for Burns visiting a customer who turned out to be a breeder of Great Danes. I was overcome by the gentle nature of these massive, regal dogs, and from then on the breed would become part of my household. Ken was good with Kruger. I'd always felt that a man who related well to animals would *have* to be all right (there goes that theory).

Adam adored reptiles, and there were plenty to be found in the Adelaide Hills. He was forever coming home with lizards or baby snakes in his pocket or a jar. Once he managed to catch a large brown snake, which he kept in a glass aquarium in the studio. The brown snake, common in the Hills, is one of Australia's most venomous snakes and I was not terribly happy that we had one sharing our home. Ken came up with a good solution. On the understanding that Adam would let the brown snake go, Ken took him to an auction to buy two pythons. We watched the brown snake slide off into the bush and Adam put the two pythons in the aquarium. They were much bigger snakes – one was about seven feet long and the other five feet – but the aquarium was big, and it seemed to do the job.

Ken and Adam bought the snakes on a Saturday morning. I had a painting class in the afternoon. My students had become used to the aquarium in the corner of the studio with the brown snake. Ad and Ken had made a wooden framework to fit the top of the glass case and had stretched wire over it, so there was no threat of the snake getting loose – and brown snakes are ground dwellers, anyway.

During class on the day of the great python purchase, I happened to glance up from a student's work to see the bigger of the two pythons sliding up the brick wall towards a painting that was hanging there. Not wanting to frighten either the students or the snake, I quietly said, There is a snake loose in the corner, no one move, please, while I get Ken and Adam. They came down and caught it and put both of the snakes in a sugar bag and took them out of the studio altogether. The poor students, meanwhile, had stayed frozen in their seats. It sure made for a good story around the college.

Adam taught me a lot about snakes, and I came to quite enjoy the pythons. Their bite was harmless, and sometimes Ad would bring one of the beautiful-looking creatures into the house and let it stretch and exercise its muscles in the lounge room. It was fascinating to watch these massive snakes swing from

lamp to curtain rail to picture frame. I managed to stroke one once, but it tensed at my touch and swung its big, diamond-shaped head in my direction. That was enough for me! They knew Adam's touch, however, and he could wrap them around his young shoulders with ease.

The walls of the house were covered with paintings, and the pythons liked to wrap themselves around the wire at the back of them. Visitors would sit themselves in a comfortable chair without realising that directly behind their head, completely out of view, a seven-foot python was having a nap.

It was an interesting house, that little place at MiMi Road, but when I sold it to move to the lake I did so with very few reservations, for the majority of memories of my time there were heavy with sadness.

Silver Lake, inner child, was a 20-acre property at Mylor that boasted a large lake and hundreds of magnificent river red gums. For years, up to the mid 1960s, it had been a popular picnic ground, with a kiosk, pavilion and eight tennis courts, that was hired out for functions and served as a Hills retreat from suburbia.

As a teenager I'd been there myself but had never had the courage to swim in the icy water, which was rumoured to be bottomless. The property had once been a gold-mine and was riddled with mine shafts. When big machinery had become available, the main working area had been dug out to facilitate the mining, but instead many underground springs had been opened up and the area filled with water, forming the beautiful lake. From the first steps I took onto the property after I found out it was for sale, I was in love. I knew that this would be the place for us to live.

Ken was not happy at MiMi Road. Although divorce was on the way and we were planning our own marriage, Ken was still insecure and unstable. Everywhere he looked, he said, he saw the ghosts of my lovers – hundreds, even thousands of them, according to his imagination. After each reverie, he was likely to beat me for being a slut. Even after we'd built our own new bedroom onto the house, Ken was still haunted by my past loves.

Oh, my sweet, if only he had gone back to Katherine (not that I would have let him) and I had kept the little house at MiMi Road, I would have become financially comfortable. I owed so little on that place, and we were improving it to such a state that I could have lived there happily until I died. But life had been dreadful there at times and a new place that Ken and I chose together seemed like a good idea.

The picnic ground at Silver Lake had been closed as a business for years and the whole property was overgrown and neglected. There was a toilet block

with eight toilets and two showers, from which the overflow used to drain into the lake, which in winter overflowed into the nearby river. This river in turn fed the reservoirs that served the community. All areas that fed the river had been reclassified and had strict rules as to their usage. That is why the picnic ground had to close. No one had shown interest in the property for any other reason in the ensuing years and it was for sale at a very much reduced price, making it just affordable for us if we sold MiMi Road. But it had no house.

All that was left of the facilities was the long cement toilet block, with no water connected, a large, roofed, three-sided galvanised iron shed with a cement floor, and three brick walls of the original kiosk. Plus the disintegrating tennis courts. But the land was breathtakingly beautiful, with the stately gums reflected in the still water of the lake. A mirrored earth and sky. Birds everywhere.

This was too good a chance to miss. This was meant to be ours. So we sold the house at MiMi Road and bought Silver Lake and, after whipping up a fourth wall for the big shed, we moved in, along with the pets.

And there we lived for months in the one big shed while the builder who'd done the addition to MiMi Road laid a cement floor in the old kiosk and built a fourth wall, mostly windows (for this was to be the studio), and added a roof. The room was 60 feet long and 20 wide by the time it was finished.

I had high hopes that Ken's vicious outbursts would cease once we moved away from old worries and for a short while they did. For the first month that we lived in the shed there was no electricity. These four weeks turned out to be the best family time that the six of us ever spent together. The girls were only there a couple of weekends, but all up it was magic.

Candlelight. Toilet behind a bush or dig a hole in the scrub. No telly. No phone. Food cooked on an open fire or the barbecue. Each of us sleeping in beds in view of the other, amid the clutter of boxes and furniture. Possums running wild along the rafters at night, their antics bringing laughter and joy to us all.

There is something magical about candlelight, my little one – perhaps the soft flickering that made the light seem alive compared to the flat blandness of electricity. Wood fires have always affected me in the same way, and it wasn't long before Ken put a cheap pot-belly stove in a corner to take the dampness off the chilly Hills' nights.

The kids used every minute of daylight to explore their bush surroundings, while Ken and I cleared and weeded and planned.

Precious memories for me. I'm sure that all of the children have positive recollections of that first short month too – a bright light in their dark boxes of memories.

Too soon the electricity was connected and water could be pumped to the toilet block – which at first seemed a real luxury after a month of hiding behind trees. The grass was waist high over the entire block and the job of mowing it fell to Adam and me. Our old petrol mowers invariably wouldn't start, and the going was extremely slow. We would constantly encounter hidden snags like fallen branches, large rocks, bits of old machinery and young saplings that were struggling to reach the sunlight through the thick rye grass.

Ken was kept busy sawing up fallen trees, untangling old fence wires and helping the builder.

Paris, who was still a toddler, spent most of his time playing with the dogs or following along behind the mowers, wanting to push. In later years he'd do anything not to push the mower, for that job fell to him after Adam left for Sydney and I was too ill to manage it myself. Both boys ended up hating mowing and still get twitchy if the chore is mentioned.

The plan was to move into the studio and live there while a house, set further back on the block beside the edge of the lake, was being built, once finance was arranged. The studio would be used for teaching as well – the block offered many vistas to inspire my classes.

Not long after the electricity was connected, Ken and I moved into a caravan that we'd borrowed and parked next to the shed. Ken was finding the sexual limitations of sleeping in the shed with the children too frustrating and we both needed privacy. It was not long after the van arrived that everything began to turn sour again.

We'd been enjoying such a pleasant period since arriving at the lake and I'd begun to believe that life would continue on in the same vein; that the move had been the catalyst for a change in Ken's behaviour. I had taken it for granted that once we could indulge in our sexual antics again (still twice or more a day) in the caravan, Ken would be happier than ever. But he turned on me so violently one morning in that caravan that, scared again for my life and furious that the pleasant peace of the place had been destroyed, I took the boys and went into town where we spent the night in a motel. Shocked by this, Ken was docile by the time we returned, but for a while the spell of the lake was broken.

The boys loved Silver Lake, Adam in heaven with his 20 acres to explore, and young Paris usually not far behind. June and Pat came up every other weekend and for them it was one big adventure away from the suburban clutter of their Mum's house in Adelaide's far northern suburbs.

Ken's divorce was protracted and dirty. We spent far too much time running

back and forth from the city seeing lawyers. Even though Katherine was settled with her new man, she was determined to make the business as difficult as possible. She wanted custody of the girls, which was fair enough, but she also wanted their family house and all its contents, determined that we'd get nothing out of the settlement. She made access for the girls as difficult as possible for Ken and it was a never-ending drama to keep their visits hassle free and as pleasurable as they should have been.

Adam and Paris loved the girls. There were plenty of healthy squabbles between the kids, but generally they got on well and became great friends.

When eventually we moved from the shed to the studio, and the caravan was returned, it was quite fun planning the best layout for both living and teaching in the new area. The children's bunk beds were situated at one end of the studio, divided off by a curtain that gave them privacy and hid their clutter. Our double bed was at the other end of the room, with wardrobes forming a wall on one side and cupboards and bookshelves on the other. In between the sleeping quarters this left a large, reasonably tidy area for students' desks and teaching.

We moved the pot-belly into the teaching space, which became a general living area in the evenings with the telly and a sink for washing up. Ken connected a tap through the wall to an old rainwater tank and although there was no plumbing, the sink could be used when there was a plug in it. Beneath the plug in the cupboard was a plastic bucket – when the dishes were finished and the plug pulled, it was simply a matter of emptying the bucket outside on the grass.

Before long I was teaching leisure painting and drawing classes in the new studio. There were perhaps 20 desks in the central studio area, leaving ample room for each student. The students especially loved coming to the lake for the spectacular landscapes. Whenever the weather allowed, we'd take our work outside.

For the family, meanwhile, living in the studio was by no means ideal, but as it was only to be temporary, nobody minded. Our builder Hank said he could build the house that we wanted quicker and cheaper than any of the big companies, so we agreed to let him have the job. We would be moving into our new home, we believed, in about six months or so.

Oh, poppet, sitting writing to you now, my bowel and groin throbbing dreadfully, I wonder if I was ever without physical pain. There are times, when self-pity sneaks up on me, that I wonder. There must have been plenty of pain-free periods, especially in my 20s, but all I remember are the dozens of times when I had to really battle to keep going.

I had constant back pain, and for years following the abortions I suffered belly pain. The pain of child birth, it had seemed to me, was much over-rated. Compared with the other pain I'd experienced, child birth was practically a breeze. And there was an end to it, too, whereas the back and belly pain was relentless.

While I was living and teaching in the studio at the lake, the belly pain became so debilitating that I eventually had to see a gynaecologist. You need, he said, to have a hysterectomy. Immediately. Your womb and your ovaries are full of infection. For months before the operation, sex had proved difficult and painful. Ken had begun sulking about this, throwing blame my way and telling me the problem had been caused by earlier sluttish behaviour. Why should he pay the price, he asked, for the pleasure that I'd given other men? So many other men.

Here we go again.

This was already a worrying time for me. Thirty-five was an early age for a hysterectomy and I'd heard stories of women changing dramatically after this operation. So had Ken. He was very concerned that my wild sexuality would alter and his ever present needs may not be satisfied. Sex was such a major part of our daily relationship and even the slightest chance that I might cease to be a willing partner was horrifying to him.

He plagued me with his concerns, turning all his fears into blame about my past. But amazingly there was no physical violence, as far as I remember. Threats and dramas, tantrums – but no actual bashing. Perhaps, I thought, it had all finished now, since the caravan. Perhaps the land, the new house and the expected marriage had done the job.

And lots of other good stuff was happening too. Ken loved the land and spent every spare minute working away at the undergrowth, clearing rubbish and planting. Always a hard worker, he dug out the footings for the house, ready for Hank to begin the foundations. The pair of them would pore over the plans. His crash-repair business was going well and his divorce all but complete. He loved having his girls on weekends and was growing more fond of the boys all the time.

Paris had taken that big leap from toddler to young boy. Ken did up one of Adam's tiny old bikes for him, pulling it apart, respraying it with luminous purple paint and reassembling it with new bits and pieces. By the time he finished, it was a beautiful bike. Then, with more patience than I'd ever thought possible, he taught Paris how to ride. Watching the two of them together, I was reassured that at last the boys had the father I'd wanted for them for so long.

With Ken's help, Adam had built a superb, wooden, glass-fronted enclosure for the pythons. It was about six feet high, four wide and two deep. They positioned it near the reeds at the edge of the lake – prime real estate – where the afternoon sun would supply the warmth the snakes needed.

Ken even bought a donkey for the kids to ride. He and Adam built a good-sized stable for him. When the girls were up, we had heaps of fun trying to get this donkey to behave as desired. All the children, with Ken's help, eventually managed to ride this stubborn beast, if only for a short distance, before he baulked and sent them skimming down his neck and over his head onto the grass.

There was a path that ran the complete circumference of the lake. The kids would tear around it on their bikes, while I liked to walk it at night when the moon was full. Sometimes I found this rather scary, and often Ken would walk quietly with me. These are treasured memories.

Ken and I had acquired a number of pleasant acquaintances in the district, generally couples whose children were at school with Adam, and we hosted barbecues on the large, flat, grassed area outside the studio. None of these folk knew of Ken's violence – I continued to share that secret with very few people – and many of them liked him a lot. As a couple we were invited to many dinner parties and later, once the house was finished, hosted many such evenings ourselves.

We counted among our friends several of the students who had begun classes at MiMi Road and were now part of the happy bunch at Silver Lake. When time allowed, I kept in touch with my precious friends of old; Anne Honey, happily married with three children; Ilze, remarried to her new love; Rita, settling down again with a wonderful, gentle fellow; Erica, still heavily involved in her teaching.

These long, strong friendships needed only a quick lunch or a visit for the intimacy to reappear. Some of these wonderful women I saw every few months, some every few years, but the acceptance and love between us never changed.

I'd kept up a good correspondence with Anna, my painting pal, who had moved to Sydney with her husband and whose letters were always a joy to find among the pile of bills in the mail box.

Merilyn, in love with the beauty of the property, was a frequent visitor. The two of us often sat for hours on a fallen log, sipping wine and gazing into the reflections on the still water of the lake. She knew all the shit that had happened to me, and it was a great relief to share my doubts and fears with her. Merry didn't believe that Ken had changed. She thought that I was only enjoying a brief respite from his usual behaviour, and that I'd probably frightened him when I'd taken the boys and stayed in town after the episode in the caravan. He couldn't

run back to Katherine anymore, Merry reasoned, so now he was afraid of losing me and was trying to keep his behaviour under control. Maybe she was right.

Pam hadn't softened her stance at all. She still believed that Ken was no good, no matter how well behaved he'd been lately. Whatever the case, Ken was at his best, life was generally easier and I was full of hope for the future.

The art classes I gave at the lake made up a special part of my life. I was dealing with some fine women and a great sense of kinship had developed between students in different groups. Even Pam joined a class. Reluctant at first, she found to her surprise that she had a talent for landscapes. Margaret Drew (my own teacher at high school) also joined a class. To her satisfaction, Margaret produced a collection of delightful watercolours.

Judy Teichert, Judy Ives, Nan Robertson, Pat Paddick, Caroline Brown, Gay Gooden and many, many more. Good students, good company and good fun. Ingrid Windram, who would grow into a very close friend and an extremely successful artist, had her first-ever drawing lesson at the studio at the lake. Many other students went on to more advanced courses, firstly at Mt Barker College and then the Stanley Street campus in North Adelaide. Some ended up at art school and university with diplomas and degrees. I also continued teaching a few certificate courses at the college, and enjoyed the challenge these advanced classes offered.

Every penny was precious with the new house to be paid for, and after the hysterectomy I returned to teaching when I was just two weeks out of hospital. Spread out like a princess (Madam Muck, Mother used to call me) on a lazyboy, I could still manage to teach if the students brought their work to me. Nobody minded. Everyone was fantastically supportive.

Dearest inner self, it's autumn and I've just been out for my evening walk, returning home in time to see the tip of the sun disappear over the back hill.

There are many English and European trees in the area, planted years ago, spattered between the gracious gums. At this time of the year their chameleon hues vary from brilliant chrome-yellow to the deepest maroon. The town is a kaleidoscope of colour. People drive for miles to see our hamlet trooping its colours. An artist's eye could explode, just looking.

I saw a young kookaburra frozen in the act of catching tea in the grass only a foot or so from the track I walked, his big, flat head and strong beak melting into the scrub and grass; a statue until I'd passed.

I did well, little one, to choose this spot on the planet to spend my life. Each evening I walk a kilometre or so along the winding roads and paths, breathing

the clean air and absorbing the spectacular beauty of the land. This area seems an integral part of my being.

The stunning red gums and Silver Lake seemed so much a part of my soul when we moved there that I painted a big note on the studio wall: 'At last I am home'. It didn't work out that way on that particular block, but I've now been in the area for more than 30 years and each place I've lived has been marvellous. But the lake, that was a stunner!

Sadly, a mixture of bad luck, bad judgement and bad health cost us the lake and all the money we poured into it during the five years we were there.

Things began to go awry even before the studio was finished. Some days Hank didn't turn up at all and others he'd come for a couple of hours and disappear. He knew the work was urgent and under the circumstances we thought he was being slack. Then the new studio roof began to leak. We wasted more precious weeks trying to get Hank to fix it.

Once Ken and I had decided on the design of the new house, and plans had been drawn up, we were anxious to get started. Life in the studio had been fine for a while, but stand-up washes in front of the pot-belly soon lost their appeal, as did meals cooked always either on the barbecue or a single electric frying pan. Nobody had any real privacy, and for me, poppet, the perpetual cleaning to prepare the place for classes had become a real problem. My health had deteriorated rapidly before the hysterectomy, and sweeping the rough cement floor and forever tidying stuff away only made matters worse.

Recuperating after the hysterectomy in such cramped quarters was a nightmare. Fortunately Tony and Faye at Swan Reach had taken me in for a week after hospital, and I don't know how I would have managed without that respite.

Ken's divorce had been finalised by now, and the plan was to hold our wedding and reception in the new house. As the time approached, it became obvious that the house would be nowhere near finished and that we would have to use the studio.

Hank, it turned out, had been heading for a nervous breakdown at the time that he should have been starting the house. Before the foundations were poured he was in hospital a broken man. Ken and I visited him there, and he begged us not to take the contract away. Hank was a bear of a man, and to see him in desperate tears broke our hearts.

Well, little one, no one knew the horrors of a breakdown better than I did. The overpowering need for self-worth. Of course I couldn't take the contract away from him! After all, it should only mean a few extra weeks.

After the visit, home again, reality began to sink in. We had limited infor-

mation about the severity of his condition, and the fact that he'd been admitted to Glenside Hospital – a psychiatric hospital – didn't bode well and we both began to have second thoughts.

Next day we went back for a another visit and suggested to Hank that while he was recuperating it would be an idea for us to hire someone else to get the footings poured ready for his release. He agreed, reluctantly, so this was done.

Weeks passed, and Hank was still in the hospital. Regretfully, because we both liked the man, we decided that Ken would sub-contract out the building work himself. We visited Hank again to tell him of our decision.

He was shattered. Please, please, don't do this.

Ken was all for cancelling the contract, but I was still too much aware of how people around me had supported me through my own hard times. I could not look into Hank's eyes and take away his future. So we agreed to give him a little more time. And later, when he was home from hospital, we went to see him again. He was full of promises. This week. Next week tops. This time, Ken said, he's definitely off the job, but once again I weakened in the face of his tears. One last chance, I said, but you must begin this week.

And he did. Timber arrived, the large pile of sweet-smelling wood bringing hope at last, and Hank slowly began erecting the framework. Too slowly. He'd come late, work for two hours and disappear. It was hopeless. Many visits to Hank's later, with much cajoling and sometimes angry words, the framework eventually went up and the large, flat, flooring timber was laid. This had taken months. Ken was furious with me for giving in again, and became determined to take responsibility for the whole job himself. At the last minute, however, Hank got the roof on the house and we both felt as if real progress had been achieved.

But winter had taken its toll on the exposed timber. We begged Hank to get a move on, but he'd fallen down a hole again and was incapable of working. Eventually, driven to despair, Ken and I made our last visit to Hank. Ken will take over subcontracting the rest of the building work, we told him. It was sad, but necessary.

Building management was a new field for Ken, but he rang around, got quotes and advice, and slowly the house began to take shape. Still, there were many, many problems. Hank had not allowed for brickwork in his framework and the brickies had to come up with a new concept that involved extra bricks and extra cost. The nails in the roof had been driven in at the bottom curve of the iron instead of the top and the roof had to be re-nailed. Yet more expense.

This problem had been discovered by the plumber, who was then able to identify – and fix – the source of the leak in the studio. More cost. Some timber

had to be replaced and more added because Hank had not allowed for enough to give the place strength. More expense. By the time the house was finished the work had taken 12 months longer than planned and had cost about $10,000 more – in 1976! – than we had expected. Material prices had soared during the year and the cost of the unplanned alterations had been disastrous.

And it got worse when Hank – who we'd discovered didn't have a builder's licence – sent a bill for his work. We checked what price other builders would have charged for the framework and the roof, and discovered that Hank's bill came to nearly double the average. Wearily, we set about hiring a lawyer to handle the situation.

In the middle of all this drama with the building came the wedding. Full of hope, as usual, I planned the occasion enthusiastically, determined that this would be a far more social affair than my wedding to Lester 16 years earlier. Invitations to this marriage ceremony were sent to a hundred or more friends and family – and grand invitations they were, too, screen-printed by Annie, featuring a photo that Ken had taken of the gums and birds at the lake, and sent out in the form of a scroll.

A willing band of friends helped clean up the studio and arrange trestles for a beautiful buffet tea that Pam catered, topped off with a suckling pig. Some tables and a bar – with large tubs of ice generously filled with booze – were positioned at the front of the studio in a big flat clearing shaded by the high gums. A beautiful setting indeed, and so was the spot we chose for the actual ceremony, the edge of the lake near the boat mooring, where the wedding party – the boys and I, the girls and Ken, the two dogs and a priest in a long white robe – were backed by a stunning landscape of gums reflected in the calm water with swans circling lazily.

For the wedding I wore a long white chiffon frock that Mother had made. Ken put on his beautiful new, pale-blue suit. The boys wore matching jeans and T-shirts, and the girls looked sweet in long blue-and-white frocks.

With the dogs, the swans and the kids we made up quite a wedding group. A whole family. The whole family, in fact, that I'd wanted all of my life.

What a fantastic day it was – even Mother seemed happy – and by all accounts the majority of our large audience were in tears of emotion throughout the ceremony – so happy for me. Settled at last. Then there was the party, a fabulous feast under the trees with my family, our pals, music, sunshine and happiness.

If my wedding night with Lester was a gluttony of sex, my first night married to Ken turned out to be the complete opposite. Ken, like Lester, was normally a voracious lover. Three or four times a day every day of the week, and

no such thing as a quickie. But on our wedding night, after the guests had left and the children had been whisked off for a week, there was nothing. No kisses, no hugs, no sex.

It was many weeks before Ken would even touch me. And he wouldn't tell me why. He simply shut down and would talk only of the new house and mundane things. All I got in reply to my attempts to understand his attitude was sullenness. That entire honeymoon week he spent down at the new house with the builders, while I sat at the edge of the lake and stared into its deep water and cried.

My dear poppet, there have been some caring, competent doctors in my life. But there have also been some idiots and myself probably the biggest idiot of all for accepting their advice when my guts told me there was something dreadfully wrong. I'd been far too trusting. I trusted the builder to be competent. I trusted the lawyer to be competent. I trusted all doctors to be competent.

In the weeks and months following the hysterectomy I found myself suffering more pain than I knew there should be but the doctor I was seeing had little understanding or patience for me and my problems. My fabulous Dr Hill had left the Hills clinic that I had been using and his replacement knew, of course, that I'd had a breakdown. A 35-year-old woman, an artist to boot, who complained constantly of back pain, and had a history of so-called mental illness, was an obvious candidate for the 'neurotic' label.

In the middle of all the drama with builders, lawyers and Ken, when we were still in the studio but expecting the house to be finished any day, the belly pain drove me back to the clinic time and again. For goodness sakes, Barbara, the doctor said, you've just had major surgery. You must expect a bit of pain. I fell further down the ladder of self-doubt as I tried to convince the doctors that I was not at all well. This went on for some months.

Six months after the operation, just after moving into the new house, in desperation I rang the surgeon direct. There have been times since when I should have listened to my body's warnings, and didn't, trusting dismissive medical opinion over my own body's signals.

But back then, thank God, I took action. As soon as the surgeon heard my story, he whipped me straight into hospital for another operation.

During the hysterectomy, they had taken the womb and one ovary. The surgeon told me then that he'd left the other ovary, even though it had a cyst on it, in the hope that it would maintain my oestrogen balance. Often these cysts, it seems, stay the same size for many years. It had been a gamble, but worth it in the surgeon's eyes given that I was still young. Unfortunately, at some stage since the hysterectomy the cyst had ruptured, and my whole abdominal cavity was filled with poisonous infection.

It took the surgeon four hours to try and clean up the mess. After this, with no apology forthcoming from my usual clinic, I changed to another.

That new house at the lake was beaut, poppet. Space! Privacy! There were four bedrooms, so Paris and Adam each had a room to himself. The girls had to share a room, but since they weren't always there, that seemed fair. All of the kids' rooms led off the family room, which was sited at one end of the house. Our

room was at the other end, adjacent to the spacious lounge and dining room.

The house, although bigger than I'd wanted in the beginning, was really only a pleasant-sized family home, no mansion or pretentious abode by any means. It was rectangular in shape, set back about 30 feet from the edge of the water. The frontage was practically all floor-length windows, affording a stunning view down the length of the lake. The back of the house sported a full-length verandah and a view of scores of the river red gums that covered the block. These graceful old trees, each over a hundred feet tall, made a spectacular perimeter for the back lawn.

The house had been planned so that the kitchen windows overlooked the water – thanks to the magnificent view, washing up was never a chore. To save money Ken and I had done all the painting needed, and had stained all the exposed beams and slatted timber walls. It had been hard work, especially with my health so dicey between operations, but when it was finished we felt a sense of true achievement.

The house was full of good things. The kitchen sink and benches had been built especially to my height. The spacious bathroom had a wall of mirror surrounding the white marbled sink. Our bedroom had wide french doors that led onto the back verandah and opened up our room so that it was like sleeping outside. A small dressing area ran off the bedroom and that entire wall was mirrored, presenting a double view of the stately gums. There was even a large laundry – a real joy after dealing with the laundromat.

After the second operation to clean up the mess inside my body, I could recuperate in comfort in our new bedroom. Although it was a dreadful time for me physically, at least I could enjoy the beauty of the view while I was healing. Which took some time. The severity of the operation so soon after the hysterectomy left me extremely weak for months. I was unable to teach at all, and mainly spent my time in bed feeling useless. In a way, though, this was precious time. It was really the first period that I'd had to myself since meeting Ken.

It was quiet time, with the kids at school and Ken at work. Time to think. Time to re-evaluate my situation from afar. Time to begin growing up, my poppet.

That was a time too, with all the love and support of my friends, to question my own value. Rae, Merilyn, Anna, Ingrid, Honey, Pam, Lyn, Rita, Erica. And more. Every one of them a good woman. Every one of them intelligent and strong. A time to question why they wanted my friendship. I must have had some quality that drew these women to me. Something worthwhile. I couldn't be that bad. Stupidity wasn't evil. Stupidity was stupidity. Life had been such a hectic roller-coaster for so long that I'd hardly had time to breathe, let alone think.

Lying alone in that bedroom was like taking a breath of the clean, sweet, life-giving air that filled the room through the french doors. Yes, my pet, I think I needed to be sick. Fate often deals us a winning card among a hand of losers and this was mine. My operation had been so severe that I'd faced that realisation of my own mortality that hits us now and then between the eyes – and makes us glance at the future.

Mine was not looking too good, I realised that now I had the time to see it. A tiny glimmer of reality at last.

The college brought in relief teachers to cover me so luckily I didn't lose my position. But I was only a part-timer with no paid sick leave allowances, and the lack of wages caused us big problems. The mortgage payments were falling behind. We had four children to feed and the usual bills to pay – plus hospital and specialists' fees. Our dispute with Hank was dragging on, which meant the lawyer's bill kept building up. Ken's income couldn't cover the lot.

My health took far too long to improve. After many months, back at work now but struggling to survive each day, I went to see a physician. My back pain had not been helped by the time in bed and my general health was pitiful, even though the wound from the operation had healed well. While he was examining me the physician noticed some massive bruises on my legs. Well, he could hardly have missed them; one, the result of a kick, was as big as an entree plate.

He asked. Grudgingly, I told.

His advice, of course, was to leave Ken. He also suggested I see a chiro-practor. I followed his advice as far as the chiropractor was concerned, but didn't leave Ken. I was ashamed that the bruises had been seen. Ashamed to admit that I'd let this happen.

Ever since our marriage night and the horrible week that had followed, I had realised that the security of marriage was not going to make any difference at all. Ken's violence hadn't stopped after we'd married. My high hopes that he would feel more self-assured had proved a joke.

He was worse. He had begun to have these crazy turns, when for days he would eat like a two-year-old, or drag his feet like an old man, or sit for hours staring into space. Each of these episodes would always conclude with a violent attack.

Up to this time I'd had absolutely no warning before a beating. But these turns were dreadful in that I would know for days what was coming.

The new house was wonderful, but very little else was.

My dearest sweet self. People who came to the lake for lessons or parties must have thought I had it made. And certainly, I played the part of the energetic teacher or the pleasant hostess. Very few people knew what was really going on. If anyone else even dared to suggest there were problems in my relationship I'd strongly deny it and defend Ken like a lunatic. Which, in retrospect, I probably was.

The children's bedrooms were at the other end of the house from ours, so now they were spared the sound of most of our fights. They were busy living their own lives and growing. Paris began primary school at Mylor about the time we moved into the new house, while Adam, who was going to Heathfield High now, was the proud owner of a new ten-speed racing bike that he rode the three miles to and from school each day.

June and Patricia were comfortable as part of our family now, but our relations with Katherine had not improved. But once the marriage settlement was finalised, the girls were allowed to come every weekend as well as holidays (even Christmas Day) and there were no more arguments about access.

Ken received a pitiful thousand dollars from the settlement after the lawyer's costs had been deducted. This was a drop in the ocean as far as our debts were concerned, so we decided to blow it on a holiday. A proper honeymoon; by ourselves. A fresh start after the hassles of lawyers, builders, cramped living, illness and Katherine. We decided on a package holiday to an island in the Whitsundays, off the coast of Queensland, but there was much to organise before we could go.

We had bought Kruger a mate – a beautiful Great Dane that we called Babe. They had adored each other at first sight and were never far apart – as in love as two dogs can be. They had produced a litter of eleven large puppies, each the size of a chihuahua when it was born.

One of the several matings of the two enormous dogs had taken place in the family room and it's impossible to describe the look of embarrassment on their faces when they found themselves locked tail to tail in front of the family, who had come inside. Babe tried to head off to hide in one direction, and Kruger another. They couldn't seem to manage things at all, although they were just about glued together, and after we got over our mirth we trooped back outside so the poor dogs could work out how to separate.

For the birth, we put a single-bed mattress in the laundry with high planks around the edges to keep the pups in. The first pup arrived not long after tea and the kids were all called in to admire it. Then another popped out, and another, and another. The children eventually grew tired of watching the miracle of birth and went to bed. Ken and I got up several times during the

night to check that Babe was all right – each time, we'd see another pup. It was amazing. Babe hadn't looked specially heavy with her pregnancy – where had she stored these eleven perfect little bundles?

They were beautiful – and they grew very quickly. By the time the pups were two weeks old we had to wean them on to bowls. They were draining the life out of poor Babe, who was almost down to skin and bones.

Before we knew it the pups had become soft balls of fluff and trouble, scrambling over the sides of the bed and rollicking around the house. Nothing was safe. It was hilarious. They were too young and the weather was too cold to put them outside in an enclosure, so they would pose a real problem for the babysitter while we were away.

Then there was the magpie. Russell magpie had come to live in the house a few weeks after we had moved in. As a youngster, he'd been pushed, or fallen, from his nest high in one of the gums. He was tiny, hardly feathered, and needed lots of care. Adam had taken over as mother magpie and for many months Russell had lived in a heated aquarium in Ad's bedroom. He fed the bird a mixture of earthworms (collected by all the kids) and pieces of mouse (collected live by me from the pet shop). In the early months these tidbits had been forced down his throat with the help of a hair clip, and his water with an eye-dropper. He grew well and in no time at all he was feeding himself from a dish.

Once Russell was strong enough to walk, he too had the run of the house. He would spend his evenings in the family room cuddled in someone's lap or snuggled on the carpet in front of the heater. Babe and Krug accepted him as one of the household, and even the two cats, who were not often inside, never hassled him. (Indeed, they gave him a wide berth.)

As soon as Russell could fly we had set him free – but he chose not to leave. Ken and Adam made him a stunning bird house at the edge of the back lawn, but he didn't like that either. He liked being inside. Helping peel the vegetables. Helping do the dishes. Having a shower on somebody's head. Sleeping in the ashtrays. Stealing the butter.

As fast as anyone put him outside he'd be back in again – as soon as anyone

opened a door. He used to sleep in bed with me sometimes, poppet, lying on his side on my pillow. I'd wake up to find his little face gazing intently into my own. When he did go outside, it was with the kids and he'd spend all day on Adam's shoulder.

And let's not forget Mr Swan.

Ken had bought a pair of black swans from the zoo, hoping they would nest and raise young by the lake. Their wings had been clipped so they wouldn't fly away. They did nest, directly in front of the family room window, on the edge of the water. They spent weeks building their nest but, sadly, Mrs Swan was killed by foxes before she laid her eggs.

Mr Swan was a real bully. Even before Mrs Swan died he'd got into the habit of chasing someone whenever he felt grumpy. My students were often harassed by this fierce old fellow when they were out painting by the lake. The only way to deal with him when he came charging at you, wings hunched forward, was to stop still and stare directly into his eyes. He would halt and stare boldly back, but if you stayed quiet you could stare him out. After a couple of minutes he'd saunter off and you could go about your business.

Then there were the cats. And the kids (although Pat and June wouldn't come while we were away). What to do with this mob if Ken and I took a holiday?

Well Mother (called May more often than not nowadays) didn't mind coming up for a couple of weeks. She loved the lake and had visited often – especially if Ken wasn't there, and she loved having the boys. She adored Kruger and Babe, and thought she could handle the pups, but had not yet seen how big they were. She'd met Russell magpie and thought he was cute. She wasn't too sure about Mr Swan but thought she could cope. So May moved in and Ken and I flew off to Queensland for ten days on Long Island.

Poor May. Even with Adam's competent help it was too much for her. After she'd been baled up in the wood shed a couple of times by Mr Swan she cracked and rang Pam in tears. Yet again, my old friend arrived to help sort things out. The pups were put out into their outside enclosure. They had a shed, a bed and a run so they were safe – and out of May's hair. But the final straw for Mother was when Adam came down with a severe case of tonsillitis. Poor May loved to spend time with the kids, but this lot was too much for her. She was 68 now, and used to being on her own. I remember how pleased she was to see us home again after ten days of living in our zoo. Because we lived with this menagerie all the time, it hadn't occurred to us that it would be so devastating for somebody else.

May's relationship with Pam had mellowed over the years. In the beginning,

she had been dubious about my friendship with an older woman. Perhaps she was a bit jealous, too, for I went to Pam for advice and understanding. After Pam had proved such a staunch friend to me for all those years, however, the two women became friends themselves, and had even been on a couple of holidays together.

Meantime, Ken and I were having a great holiday – swimming, laying in the sun, eating and resting, away from all our problems. We made friends with a happy couple from Melbourne, Bette and Barney, and the four of us spent time together collecting oysters off the rocks, drinking by the pool and sharing a table at meals.

Ken was more relaxed than I'd ever seen him, and once again I dared hope we'd spend uninterrupted quality time together. Would I never learn?

Each evening a band played in the dining room. Sometimes guests would get up to play an instrument or sing. Ken, who knew that I used to sing in night-clubs when I was at art school, wanted me to sing for him, and Bette and Barney backed his pleas with their own. I said I would, on the last night.

A couple of days before that last night, we went on a day's boat trip to an island that housed an underwater observatory. The sea was rough and I was dev-astatingly sea-sick. By the time we arrived, I was going insane with terror and would have swapped the lake for a helicopter to take me back. But my only choice was to return by boat, and by the time we arrived back at our island, my head was spinning out of orbit and I hardly knew my own name.

This illness lasted a couple of days. I could barely stand up and wanted to die. On the second day Ken took me to dinner. Even though I couldn't eat, he asked me to sing. There was no way. It was impossible. Furious, he grabbed my arm and dragged me from the restaurant, leaving Bette and Barney as astounded onlookers.

Ken pulled me toward our cottage and on the way slammed me against the wall of another unit. You promised, you slut. Won't sing for me, eh? Bet you sang for all the others. Back in the unit, he didn't hit me. Just threw me on the bed. Disappointed beyond belief, beyond fear even, I lost it. Fuck off, I told him. It seems that some sense had been shaken into my brain by the sea. He qui-etened. And we talked.

In the end he said that he wanted to stay and – amazingly – that he would stay on my terms. I need, he said, to accept you exactly as you are. I was astonished to hear these words from Ken's lips.

I think I can do it, he said. If not, I will go.

He seemed plausible and rational. I believed him. But once we were back home the fine words were forgotten. Life returned to normal. As I knew it.

My wild little dancer, my fighter, if my perpetual dancing kept me fit and helped strengthen my back, I'm sure it also helped relieve my mental stress. Ken loved to watch me dance. I would dance on the bonnet and roof of his car, sometimes on the side of the road when there was a good number on the car radio. We danced together when at dinner-dances and parties; slow dancing with our arms around each other. Ken didn't like dancing on his own and probably couldn't. I never saw him try, but he loved to watch me.

One night, kids in bed, Ken and I were in the big lounge of the new house, playing music and drinking in front of a roaring fire. Please strip off and dance for me, he said.

No problem.

Cigarette and drink at hand, he lounged back to watch. But after a couple of songs he said, Stop.

I did, and went to sit with him.

It makes me wonder, he said, turning to me with a familiar, frightening quiet, just how often you've danced like that for other men.

Knowing it was probably too late, I attempted to calm him. Never, I said. Never like that. That was just for you.

And it had been.

How many others then have you danced for? he asked. It turns my stomach to think of it. You're such a slut.

Ken beat me cruelly that night and I never danced again while I was with him. Nor have I danced with the same gay abandon since then. Oh yes, my little one, in the future I would dance a bit here and there, but my gypsy dancing stopped forever that night.

In a weird sort of way, poppet, that incident became the real beginning of my healing. Next day, taking the children, I went to stay with May at Christies Beach. Every time Ken rang (repeatedly) I refused to cave in to his apologies and pleas. I would not return, I said, unless he'd agree to visit a counsellor. This time, I meant it.

After three or four days he agreed, and I returned home. We made an appointment to see a marriage guidance counsellor – and I took my first step towards shedding my victim's cloak.

Once before as a condition of staying with him after he'd beaten me, I'd talked him into the pair of us seeing a psychiatrist. Once there, he sat through the whole session with his mouth closed. Not even an argument or a defensive explanation. Nothing.

The psychiatrist, of course, said that the exercise was a complete waste of

time and money. Which it was. Back home, Ken said, I went, didn't I? I promised to go and I went. I kept my promise. I didn't promise to talk.

This time, after the dancing, I made him promise to participate and refused to return home until I got that promise.

Somehow, my little one, by attacking my dancing, he forced me to realise that my very soul was under attack, not just my body. A spark of true rebellion lit the tinder of the strong resolve that I'd need in the future.

Only a spark, poppet. But a beginning.

Once I was back teaching again, after the second operation, I began to paint for myself for an hour or so after classes in the studio. My energy was still low but while Ken was at work I grabbed the opportunity. I still remember one particularly beautiful tree not far from the studio door, a young gum, tall, straight and elegant. I used a tall canvas, and the painting took ages.

Obviously Ken saw the work I did in these hours I took for myself, and was even proud of the results, but still possessive of my time when he was home.

So many dramatic, berserk memories come to mind.

Shielding the children was easier at the new house not only because the bedrooms were further apart, but also because the boys were older and often away overnight at friends' places. There was one bizarre incident, however, that I could not hide either from them or friends, the majority of whom had absolutely no idea of the sickness behind Ken's pleasant facade.

We had put on a barbecue for several families and their children in front of the studio. Ken's girls were up for the weekend. It was a beautiful day and everyone was happy in the sublime setting. I have no recollection now of what set Ken off. One minute we were all relaxing together, and then bang! we heard a rifle shot. Very close. From the direction of the new house.

I tore down there, screaming at the children to stay away. There was Ken, standing by the house with his rifle. He let off another shot when he saw me running down. Not directly aimed at me, but terrifying all the same.

Instantly I regretted the gun. I'd bought the bloody thing for him. What a fucking dill. Fancy giving a man like Ken a gun. I'd given him the rifle as a present after one of our many break-ups – probably after the first visit to the marriage guidance people when Ken was promising to really try to control his anger. Taking him back wasn't enough? Oh no, I wanted to give him a token of my trust – so I bought him a rifle. He'd been wanting one so he could shoot the foxes that killed all of our chickens (as well as Mrs Swan). Even during the day we'd spy a fox holding a squawking chook by the neck and leisurely strolling

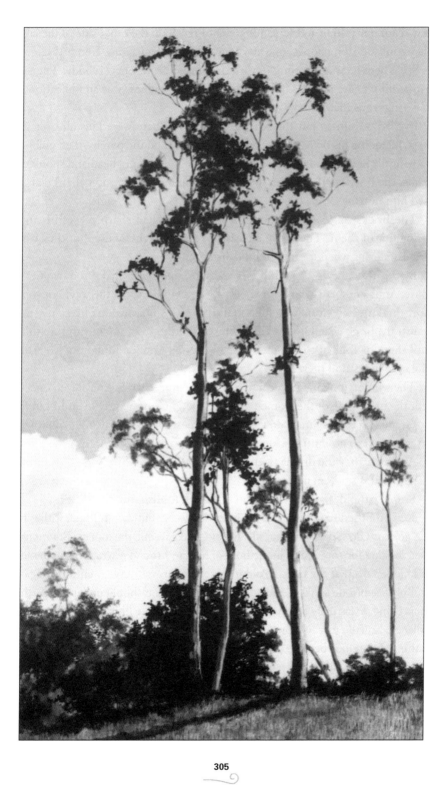

away from our yelling and screaming, out of reach on the other side of the lake. They took a dozen chooks, one at a time. If only I had a gun, Ken had said.

So. There he was, in a mood, with the gun, in front of everybody. The fact that he didn't care that his friends would see his madness was an indication of how dangerous that mood was.

I yelled at him to put the bloody gun away. There were kids all over the block, including his own. He did put the rifle down on the porch – then grabbed me with his hands around my neck and began banging my head and shoulders against the brick wall of the house. He was even more angry now that I'd chastised him in front of his friends.

The bricks that we had chosen for the house had sharp pieces of stone jutting out of them. They gave a pleasant texture to the house, but they were very dangerous when it came to head-banging.

By this time, having heard the second shot, our guests had run down to the house. Anna and Gay, who both knew of Ken's violence, led the way. For some short time they all stood watching in horror as Ken bashed me like a rag-doll against the brick wall. Other than calling for him to stop, nobody did anything until three or four of the women rushed over and pulled him away from me. The men just stood there.

The women took me inside and bathed my grazes while Ken stayed outside with the men. One of the women grabbed the gun on the way in and I hid it.

Gradually Ken calmed down and the guests left – except for Anna, who flatly refused to go until she knew I was safe.

As usual, after the drama, Ken was contrite.

Too bad, I said, no more gun.

Stupid, stupid, foolish man. Stupid, stupid, foolish me.

Ken promised to sell the gun the following week, but didn't. I said, Either the gun goes or I do. So he sold the rifle, he said, and gave me the money. But months later, looking for something in the boot of his car, I found it wrapped up in sacks and hidden deep at the back. I sold it myself and it was never mentioned again.

But the episode shocked me into insisting that Ken should undertake further counselling. I was truly terrified now that he'd shown he didn't care who saw his violence. Equally terrifying was the reticence of the males who stood by and did nothing. I dare not begin to guess why.

Still my own values were pretty off-base, weren't they? I was the idiot who bought a violent, dangerous man a gun. What a nut-case I was.

Little one! How lost I was without you. It sure took me long enough to start standing up for myself and laying down a few boundaries. Leaving Ken over and again achieved bugger-all, because I kept returning to him.

Attending marriage guidance counselling, at long last, was opening my eyes to the madness of our relationship. It couldn't take away the ingrained fear, but I began to realise that my situation was *not* unique; that the premise for Ken's anger, my own unworthiness, was a trick.

Often Ken would refuse to accompany me to a meeting, saying they were a complete waste of time. I went many more times on my own than with him, and these visits were of tremendous value. I started to look at our relationship from an outsider's perspective, helped by my counsellor's clear insight and experience with other cases like mine.

Slowly, over the years, Ken had convinced me that I really was to blame for all his actions. He wouldn't have behaved as he did had I led a different life. If I were a different person. A good person.

Poppet, it's so hard to accept that I believed him. Yes, there were times I had my doubts, but to stay for so many years under such dreadful circumstances surely proves that I was under his spell – and that I was blatantly *stupid*.

Yet I knew, from my school days, that I was not stupid. Supposedly, I was very smart.

But the knowledge I gained from my wondrous counsellor – a woman whose name I've forgotten but whose help I haven't – that many other women were trapped in the same vicious net that I was, was a giant step to freedom. So simple, once I knew it.

And so, after a particularly frightening episode with Ken when I'd told him, once again, to leave, I made a stand, at long last. About bloody time. If he would not go to marriage guidance regularly, he was out. I'd had enough. Now that I knew that I was the *victim* of his violence and not the *cause*, my dander was up and, realising there had been a not so subtle change in my behaviour, he agreed. He would do anything to stay.

It was different from when I'd left Lester. My love had faded then, and there were no more chances. But I still loved Ken's better side and was willing to try to work on a resolution – though I acknowledged that the chances seemed slim indeed.

After a couple of regular visits to the counsellor when Ken actually talked, and more importantly, listened, the centre – at the Central Mission in Adelaide – set up a round-table conference with two extra counsellors. At this conference a contract was drawn up, discussed and agreed to.

The contract said that if Ken ever hit me again, even once, he must willingly and immediately leave the marriage for good. After discussing the financial details of the relationship, it was agreed that when he left he would take his personal belongings only, since it was my house and money that we'd begun with and both of us had since then provided equal incomes. I would ask for no maintenance, and we would go our separate ways. He would never bother me again.

It was an extremely hard, formal occasion. We swore oaths and exchanged hand-shakes.

Ken agreed to everything, although the girls weren't mentioned, and seemed open and eager to change. He apologised formally to me in front of the three counsellors and promised to do his very best to be a good partner. I was truly hopeful that our life together could actually work. And for nearly two years it did.

Poppet, life became so much better after the contract. I was still recovering from the second operation, there were continual problems with the lawyer we'd hired to handle Hank's demands, money was tight – but there was no bashing. Other forms of abuse would pop up out of nowhere – reminders of who was boss. In comparison to being belted I could handle those, but they ensured that fear remained part of the relationship.

I remember Ken taking the fuses out of the power box and sneaking around me, touching me, in the dark. I was terrified of the dark, which he knew, and he would often play on that fear. And how once, driving to town in his Valiant, he gunned it to 100 miles per hour around the curve of the Stirling overpass, looked slyly at me, and asked, Are you scared yet?

I wouldn't give him the satisfaction. No, I said, you know I like speed.

Right then he lost control of the car and the tail began to swing from side to side. I was sure we'd both be killed but by some miracle he managed to hold the car and it levelled out. I said nothing, amazed to be alive, but I was sure, by his silence, that he'd managed to scare the living daylights out of himself as well.

He arranged to sell my Charger and bought me firstly a small Morris and then later, when that broke down, a Datsun 180B. I hated both these cars and my heart yearned for the big beloved Charger. His explanation was that the extra money was needed for the mortgage, and this was true, but I knew the real reason was to destroy my image and try to break my spirit without breaking the terms of the contract.

Life-drawing was another bone of contention. I'd organised a group to meet each Tuesday night for a three-hour session working from a model. The

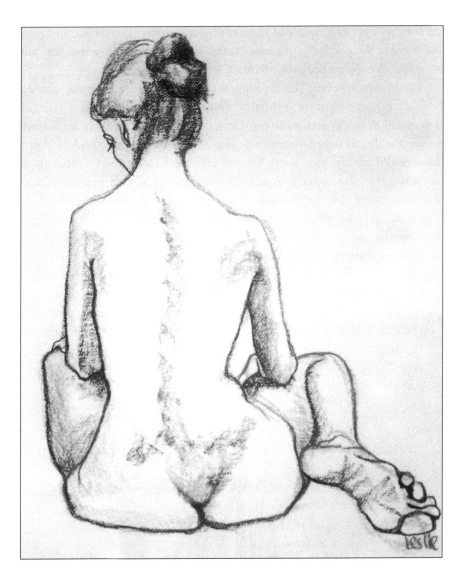

group was keen to develop the skills of life-drawing and I loved these nights. No teaching. My chance to draw on a weekly basis.

By now the studio had become what it had been designed for in the beginning. With most of our family stuff moved down to the house, there was much more room and it made a fantastic venue for life-drawing.

I was teaching six mornings a week. The afternoons were for shopping, chores, lawyers, and so on and when possible some work for myself. Evenings were for Ken and the family – except for Tuesdays.

Tuesday's evening meal had to be ready early so that I could get up to the studio, light the pot-belly, organise heaters to keep the model warm, and put music on. We always had music to work to, mostly modern jazz.

This group met every Tuesday night for about 18 months but it was amazing how often Ken forgot its regularity. Sometimes he'd arrive home late (an urgent job at work) and want tea. On many occasions he rang from work during the day to suggest a romantic dinner out. Just in the mood, he'd say. Thought I'd love the idea. Some Tuesday evenings he was ill and wanted me to stay down at the house and look after him. Sometimes he'd arrive home at 6.30 with flowers and champagne suggesting a quiet evening by the fire. And then, stupid oaf, he'd be offended and hurt when I reminded him it was my life-drawing night and left him at the house with the kids.

He knew that once I was in that studio with Ingrid, Anna and the others, music playing and a model posing, I was a whole person without him. He hated that.

I was getting stronger, my girl. Day by day.

Anna used to say that I'd walk into the studio with Ken on my shoulders. I carried the weight of his displeasure with me as I found my way through the

scrub with a torch. But once inside, with lights on and drawing started, I'd forget his needs for a while and work, work, work.

Happy, happy, happy.

Our financial situation, however, was an ongoing worry. We had fallen behind in our mortgage payments when I was sick and hadn't been able to catch up. The odd painting I sold here and there did little to help. The loan company had extended our mortgage when we'd had to pay more for the house, but we were living from week to week hoping for a miracle.

Instead of working harder at his business to bring in extra money, Ken was actually working less, spending much of the day sitting around staring into space. His business partner was worried and so was I. The stress of building the house and the extra mortgage had knocked Ken around and he was finding it hard to deal with the financial pressure.

Our lawyer required detailed information about the building costs to make our case and it fell to me to make the tedious trips to his office in the city, week after week. The court case kept getting postponed and we seemed to be getting nowhere.

Other than an occasional scary incident, Ken had become docile: where friends and family were concerned he was amiable, and many times treated me

with surprising care. By Sunday evenings I was usually tired after a weekend of cooking and cleaning up after six hungry people. Ken would sometimes run me a bath and put the portable television on the vanity cabinet so that I could relax while he fed the kids. He'd bring me a glass of wine and I'd lay back like a queen, drinking wine and watching telly. Alone for a treasured half hour. What a mixture Ken was.

As my new sense of self became stronger, poppet, thanks to my fortnightly visits to the counsellor, it became far easier to paint and draw. Ken had stopped coming to the sessions altogether but was happy for me to go regularly.

I have no idea what credence Ken put in the contract. Secretly. In his head. I knew what he'd promised. I knew what he'd agreed to. I had no idea what he really thought about the whole business, but my life was certainly easier. I even set up my easel in the lounge of the new house and painted a large canvas of the view of the lake. Ken gave me no attitude about this even though that easel remained there for a couple of months. Visitors to the house praised the piece and Ken showed some pride in his wife. Most of the time, though, he was depressed, displaying no interest in household happenings. His business was going down the tube rapidly and he didn't seem to care. Sometimes he didn't even bother going to work, but sat around doing nothing or locked himself in the shed for hours on end. He began drinking more too, which worried me.

Our lawyer, after twelve months of appointments, told us that if we went to court there was little chance of a judge awarding against a man with mental problems and advised us to settle out of court. I was exhausted by the constant visits to the lawyer in the city and the pressure of our mortgage company screaming for back payments. Each appointment cost more money and the idea of starting the whole business with a new lawyer seemed ridiculous.

With Ken not functioning properly and his income dwindling, I decided to go along with the lawyer's advice, and Ken agreed. As it turned out, our lawyer and Hank's lawyer settled on the original amount that Hank had charged us. Ken and I were horrified by the decision. Now we had to find the $17,000 to pay him. We didn't have it, and had no means of getting it – the only way out would be to sell our precious lake. Our mortgage was so far behind there was no way we could catch up, and the lawyers had imposed a limit on the time for Hank's payment.

Ken became more depressed and his behaviour ever more weird. He slobbered over his meals, to the embarrassment of the children, and moped, shuffling around, for days before miraculously returning to his old self.

Fortunately we had a new member of the family to keep the kids busy – a

baby galah called Heckle. After a large gum had fallen during a winter storm, Adam found two tiny galahs tossed from their nest, so small and naked that they both fitted into one of his hands. He called them Heckle and Jeckle but didn't hold out much hope for their survival. Jeckle died the first night, but with Ad's skill and care young Heckle survived and his nurturing became number one priority in the house. I even used to take him to class with me to give him his hourly feeds. I'd chew up his grain and spit it into his little mouth. My students loved him, of course.

Russell, our friendly magpie, had earlier gone on one of his regular flights and not returned. We advertised in the local papers, but it wasn't until six months or so later that we got a call from a farmer 20 miles away, to tell us about Russell's fate. The farmer had been having lunch in a paddock when Russell flew down to share his sandwich. He went home with Russell on his shoulder and, to the delight of his wife, Russell stayed with them until one of their Siamese cats killed him. The farmer was nearly crying when he rang to tell us.

Mr Swan, meanwhile, had been killed by the foxes. We were broken-hearted, even if Mr Swan had been such a nuisance at times.

The donkey had been sold by now. He'd become unmanageable and dangerous for the children. And it gets worse. Both Adam's pythons had died. The smaller one was the first to go. I shall never forget driving through the gate one day to see Ad, shovel in hand, walking toward the paddock with the big python draped over one arm. He stayed away from the house for hours and we were all miserable about his loss.

So young Heckle was important for all of us – a breath of new life and a cheeky character to boot. He was the ugliest bird imaginable as his feathers grew – sticks of quill poking out from his skinny bare body. His raucous squawks for food were deafening – but we loved him enormously. I began a series of watercolour studies of him as he grew, with plans to make them into a book. They all got burnt, of course. Dear Heckle left us for a joy flight two days before the fire and didn't return. To this day, when I'm filling the birdfeeder with seed, I call, Hello Heckle, pretty boy, to the galahs that hang around Mabel and hope that one of them will answer me with: Heckle, Heckle, give us a kiss. What a joy that would be!

So, sadly, plans were made to sell the lake. Ken was broken-hearted, and never really recovered. The kids were disappointed, but they were kids, busy living and growing, playing and learning, and could cope with just about anything. Personally, sad as I was to part with the water and the trees and the beauty, I could see a bright side.

We expected to get a good price for the property. It had been a jungle when we'd bought it and, thanks to our work and the money we'd invested, we had turned Silver Lake into a remarkable family property. The land agent who we chose to handle the sale agreed that $120,000 was not an unreasonable figure to expect; quite a price for 1979, but it was an exquisite property.

Back problems had made teaching increasingly difficult for me, and I was seriously thinking about giving it away. Now that I was able to spend some time painting at last, I was itching to have a real go at it to see if I could attain the excellence that I desired. To do that, I would need to paint daily, not once in a blue moon, and with the profit we expected to make on the sale it seemed likely that I would be able to afford the time off teaching that I needed.

I loved to teach and knew that quitting would leave a hole in my life. Teaching seemed as much a part of me as breathing. But to teach well, you need to put a day's energy into each three-hour session – and this left me with little energy for my own work.

Over the years I've met many art teachers who complain of the same problem. Art is not a viable profession, unless you're lucky or brilliant. Many artists teach to survive, but find they have no fuel left to paint with. Often their talent is never used, and many retire early in order to attempt their own work. It's an age-old problem.

Leaving teaching would be a leap into the unknown. I knew that I was a good teacher, but had no idea if I could be a good painter. But at least with painting, I could pick my hours and rest when needed. I cancelled the majority of classes for the following year, 1980, keeping only two as an easily managed safeguard. While Ken grew glummer by the day about the impending sale of our property, I began to get excited about the change. Now, at last, I would have the chance to paint.

Ken had very little to say about my decision to leave the security of teaching. He had withdrawn deep inside himself, and my decision that we should buy a cheaper, smaller home met with no opposition at all. I was determined that I'd never again carry the stress of such a big mortgage and began tentatively looking around to discover what real estate was available in the area at the price we wanted to pay.

A smaller property, perhaps an acre or so, would be ample for the family's needs, I decided, and was lucky enough to find a cottage a mile or so down the road that would fit the bill. I approached the owner quietly and he promised to give us first option as buyers. He was in no hurry to sell, and was happy to wait until the lake was sold.

Someone was looking after me, poppet. Or, perhaps, I was beginning to look after myself.

Wouldn't you know it? The sale of the lake was a complete disaster. It left us worse than broke.

An auction had been scheduled, and an advertisement placed in a booklet for prestigious homes. Because of production problems this booklet wasn't completed until nearly two weeks after the auction took place. Only half a dozen people turned up and nobody offered anywhere near our price. So Silver Lake went on the market.

And in the meantime the builder's lawyers were screaming for money. The mortgage people were screaming for money.

When no buyers had surfaced after a few weeks the lawyers said we must pay Hank within seven days or he'd force us to go bankrupt. I would have gone to court and fought for more time, but Ken was horrified by the thought of bankruptcy. It would have been the last straw for him. So we advertised for the following weekend and had to take the first cash offer that came along. Or so we

were led to believe by our lawyer, and our knowledge in this area was poor, less than hopeless.

The lake was sold for $80,000. By the time the mortgage and the lawyers and the land agent took their cuts, we were left with $5000 and all our other debts. Things looked bleak.

In desperation, I approached the owner of the cottage that we had looked at and explained our predicament. This generous fellow, Ralph Turner, agreed to take the $5000 as deposit and carry the mortgage himself.

How lucky we were. Ken's business had folded and I'd quit most of my classes, so we had a snowball's chance in hell of getting a mortgage from a bank. Without our kind benefactor, we would have been in deep shit.

This gentleman, a farmer from neighbouring Echunga, was in no need of money immediately. He and his wife had fallen in love with the cottage and had begun renovating it as a retirement home, but after she had died he lost interest in it. Ralph was a beaut bloke who understood about dicey builders and the trouble that they caused. He believed that we would get our lives back on track and that his mortgage would be paid.

So we moved into the cottage – tiny, after the house at the lake – and began a new way of life.

The cottage was around 100 years old and originally would have had the usual four small rooms. Many similar places can be found dotted throughout the Hills. Two of the interior walls had been removed, making an L-shaped room, with two fireplaces in the end brick wall (one would have been for the original living room and one for the kitchen). The remaining fourth room became our bedroom. The farmer had built a large new room onto the side of the cottage and this was big enough to convert into a sleeping area for the four children. Not much privacy for Adam, with one end blocked off with wardrobes, but he'd lived in the shed and the studio at the lake, so this was a bit like coming home.

The property sported two acres of land that was heavily wooded with old gums, pines and wattles. There was an apple orchard and an assortment of shaky galvanised-iron outbuildings, one of which served as a laundry and bath-room. It was not nearly big enough for a family of six and there was a lot of work to be done, but it was cute and the block itself was stunning. And, number one priority, it was cheap.

Ken was too enmeshed in his depression to look for work, so it was up to me to find a job to keep the family going and pay the mortgage. Before long I got a job as a barmaid in a small hotel at Hahndorf – the German Arms – and I worked

nearly a forty-hour week there, mostly at night, until after the first bushfire.

The hotel, now a large tourist complex, then consisted of a front bar and a compact, L-shaped dining room. It was the drinking-hole for all the local sports clubs and, during the week, after practice, the crowd at the bar was often four and five deep.

How I hated that work in the front bar. It was busy, busy, busy from the time I started at five o'clock, until after eleven and I was utterly exhausted by the time I went home. The work involved continual bending and lifting – you can imagine the state of my back. But it gave me an income that, when combined with my wages for teaching two classes at the college, gave me just enough to get by on.

In the meantime I tried to get Ken motivated to begin some renovations on the cottage. Once I had the job at the pub, I was able to secure a small second mortgage from the bank to buy timber, paint and plaster. Slowly Ken began fixing a bit here and a bit there. He filled the cracks in the stone walls and replastered the inside walls. He repaired the broken chimneys and knocked down the back tank.

This tank was fascinating, by the way. It had been built of stone and then cemented and intruded six inches into the kitchen. The tap, down very low as the tank had been built directly on the ground, was hidden in the bottom cupboard of a sideboard. When we moved in, this was the only inside tap and there was lots of laughter every time water was needed. Life was easier, but we were all a little disappointed when Ken connected a new outside tank to an inside sink and removed the old cement tank.

Ken was one of those guys who could turn his hand to anything. He did a remarkable job fixing up the cottage when he was in the mood – but that wasn't very often. The episodes of child-like behaviour were regular now, and he was becoming even more moody – and often pretty nasty.

He hated the fact that I put on tidy clothes to go to work and became jealous of the customers at the pub. It's all right for some, he'd say as I left for work, Going out for a good time while I have to stay home and mind the kids. If only he knew how much I hated that job. I would tell him over and over but he didn't listen.

One night, arriving home just after midnight, I found him waiting in a furious mood. The day before he'd put up a massive beam to support the ceiling, and the first thing I noticed when I walked in was that this beam was hanging loose from the ceiling at one end. Then I saw a broken chair, smashed to bits against the wall.

My heart stopped and my insides contracted in fear.

Since we'd made the contract, and I'd decided to honour it come hell or high water, I'd not succumbed to that dreadful fear. Whenever he became angry, I'd dealt with it calmly. On the few occasions when Ken's anger had threatened to escalate into violence I'd been able to reason with him and pacify him. I could live with verbal abuse. I could live with his drinking and I could even live with unfaithfulness if it ever came to that. But I would not live with his violence. Never again.

This night, staring at the beam and the chair, I felt real terror. I was terrified that he would hit me and I'd have to leave him. I didn't want to leave him. The idea of a beating didn't terrify me so much, nowadays. It had been such a long time, nearly two years, that I'd forgotten about the pain. But I knew, without a doubt, that if he did hit me, it would be for the last time. I'd promised myself and I wouldn't break that commitment.

He didn't hit me that night. Instead, ranting and raving about men and my past and my character, he pushed me into the big swivel chair, held my head back against the cushion and pointed a bloody great screwdriver, half an inch wide, at my left eye. Slowly he moved the tool closer until the metal was just touching my eye. One false move or word on my part and that screwdriver would have gone through my eye straight into my brain.

Obviously, I didn't move. Or speak.

After a minute that seemed like an hour Ken put the screwdriver down and moved away.

Next day, talking calmly to him about the incident – which I'd never been able to do before – I warned him how close he'd come to breaking up the family. I reminded him of the terms of our contract.

But I didn't hit you, he said.

And he hadn't. Scared me beyond description, but no hitting. So I let it go, but with a warning it must never happen again.

I was stronger than him now, and he knew it. Within weeks, he found a job, worked on the alterations at weekends and seemed to return to his likeable, easy-going self.

The children adapted to their new home with ease. When the girls were up they had no problem sharing the bigger end of the new room with Paris. Indeed, they had a lot of fun in that room, which included two bunk beds and lots of floor space to muck around on. The girls shared one bunk and Paris had the top bed of the other. Babe and Kruger, of course, slept beneath him.

Paris had been putting together a train set, adding new pieces at Christmas

and birthdays. Ken and Adam helped him set it up on a massive board that could slip behind one of the bunks. This train set was Paris' prize possession and occupied him for hours.

Ken had made friends with a chap at his new place of work – a welding and metal business – who introduced him to the sport of racing pigeons. Inspired, Ken built a big loft way down by the back fence of the block and began stocking it with pigeons. He found an instant pleasure in this sport (which I couldn't understand at all), and began racing some of his better birds on Saturdays. He managed a few wins, and I was thrilled to see him so involved in something for himself. Soon work on the cottage took second place to the pigeons, but that didn't matter. We were comfortable enough, anyway, and the renovations seemed unimportant compared to his happiness. He'd found a new group of friends through the pigeon club, and was often out at club meetings or on visits.

Ken's occupation with his hobby gave me a chance to get out on my own now and then without causing a drama. I went for a couple of overnight painting trips with Anna and Ingrid. These were the first of my days of clambering about sandhills with easels and paint boxes and the all-important tent. Marvellous days with the complete freedom to lose ourselves in the spacious beauty of the Coorong.

I'd given up my teaching load to have the luxury of painting full time, but up to now I'd barely had any time to paint at all. The pub job ate up most of my time and what was left was needed to keep the little cottage in order. And money was still tight.

The pigeons and the loft had eaten into our precious finances, even though all the building materials had been second-hand. But I was not about to complain – it was the first time Ken had shown any real interest in anything outside our relationship.

Friends were welcome at the cottage and our social life, when I was free from work, was hectic.

Adam had changed high schools from Heathfield to the bigger Mt Barker High, which afforded a wider, more progressive choice of subjects. Not long after we moved to the cottage, Ad began work experience. His first sortie was a week with the local vet. He received a glowing report, but felt that a vet's life was not for him. His second bout of work experience, in middle term, was at the Adelaide Zoo. This was more like it! The powers-that-be were so astounded by his rapport with the animals that they offered him a job on the spot. There was a gigantic waiting list of people wanting jobs at the zoo, many of them with degrees, but Ad's talent was so obvious and so special that they didn't want to lose him.

Sadly, Ad hadn't found the pleasure in high school that I'd enjoyed. He was an extremely bright young fellow and his teachers were at a loss to understand why he refused to apply himself to his studies. I was pretty sure that if he stayed at school he wouldn't matriculate.

It was a hard decision to let him leave school and take the job at the zoo, but I knew that animals were his love, and his gift a rare one. So, at 15, just before his 16th birthday, Ad became a keeper of birds and reptiles. And was in heaven.

He'd already begun building a giant aviary – 30 or 40 feet long and 12 or 15 wide – at the side of our block. It had big wooden nesting boxes for the birds and a flight area large enough for them to really spread their wings. As people heard of Adam, they started bringing to him injured birds or caged birds they'd become tired of. Ad took all these birds, mostly galahs or cockies of some sort, and gave them a good home.

Later, when he'd been working for a while and had money for proper equipment, he bought two smaller aviaries for particular species or birds that needed to be separated. Even when we were at the lake he'd held a licence to keep birds, and by the end of our first year in the cottage he had a large collection including sulphur crests, major mitchells, gang gangs and pheasants.

Often it would fall to me to feed the birds while Ad was at work. I'd pull on one of Ken's old overcoats, gum boots and a beanie and sit singing to the birds for an hour while eight or ten of them climbed all over me. This was one chore that I enjoyed. I became very fond of the birds, each with its own character.

There was a lot happening at that cottage in the year that we were there, and most of it was good.

Now, poppet, about Merilyn. She was my constant companion during those days at the cottage. Anna, Ingrid, Rae, Lyn and many others were frequent visitors, but Merilyn and I became extremely close during that year.

She'd been upset over our loss of the lake, but appreciated the cottage's charms and was as excited as I was about our plans to build onto it. Sometimes I would visit Merry at her little unit, which she was renting in Adelaide, for a quiet evening of talk and music.

One evening, she invited me down for dinner. These days, such invitations produced no opposition from Ken, and I was looking forward to a relaxing night of Merry's company. She had made a favourite dish for me, which we washed down with a nice wine, and then the two of us sat on the lounge room carpet with glasses of whisky and went through the record collection, enjoying our old favourites; Sinatra, Streisand, Lady Day, Cleo Laine.

It was a lovely evening. Merilyn was always fastidious, and it was a pleasure to visit her immaculate, beautifully decorated unit. She even allowed me to smoke inside – waiving the strict no-smoking policy she'd adapted since she'd given up herself. I accepted this as the gesture of deep friendship that it was.

I stayed until about two then headed off after the usual hug goodnight. It wasn't until I was home in bed that, for no reason I could identify, I began to feel anxious. I woke Ken and said, This is going to sound really stupid but I think Merry is going to kill herself tonight.

Why do you think that? he asked, and I had no answer. Merry had given no indication whatsoever of anything untoward. I considered ringing her, but guessed she'd be in bed and asleep. Anyway, what would I say – Are you going to suicide tonight? So I told myself that I was just feeling anxious because of the booze I'd drunk – but decided I'd ring Merry in the morning for peace of mind.

I rang at 6.30, for I knew she was always up early to make herself presentable for her prestigious job as a private secretary to an important doctor. There was no answer. Probably in the shower, I decided, and rang again in half an hour. Still no answer. Perhaps she's out the back watering her pot plants. I knew this was part of her morning routine – but by now I was really worried.

If she's not there in another half an hour, I decided, I'll ring her at work. Sometimes she goes in early to catch up. If she doesn't answer there either, I'll drive to her place to check.

Towards nine o'clock I found myself banging on the door of her unit. Peering through the bedroom window, where the slats of the venetians offered a limited view, I could see her in her bed. This was not right. She should have been well and truly up and about by now. I banged and yelled at the window until eventually I saw a slight movement in the bed. It's Barb, I shouted, open the front door. Open the door.

People were appearing from the neighbouring units, alarmed by the racket. I was just about to use one of their phones when Merilyn opened the door and fell into my arms, practically unconscious. I sat her in a lounge chair and held her. She couldn't speak. As I picked up the phone to dial 000, I suddenly realised that the last thing she would want was to be carted off in an ambulance. She would want to be left alone to die.

I hesitated only a moment before ringing, instinctively aware of her right to make the decision that she'd made, but found it impossible to leave her in that state. In no time the ambulance arrived and took her away to hospital. The neighbours stood watching as they carted out my best friend strapped to a stretcher.

I knew Merry would be furious with me, and mortified that police and ambulance men had scrabbled through her rubbish bin to establish what she'd taken. Enough, said one of them, to kill several men.

But not Merry. When I went to the hospital that afternoon with a box of red roses she was still unconscious, but the nurses said she would survive.

After a couple of days there she was transferred to a psychiatric hospital. I went to visit her there also. Conscious now, but still dopey, she let me know in no uncertain terms how angry she was with me. I guess this was only to be expected. She had told me many times about her deep desire for death – but I'd never accepted it as reality.

After some weeks in hospital Merry was allowed home. Ashamed of her failure, ashamed to face anyone who might know, she decided to move inter-state. She came only once more to the cottage, to say goodbye. During this sad visit she forgave me for my interference. We'd discussed it at length while she was in hospital, and eventually she'd realised that I'd really had no choice. We parted with our friendship undamaged and promised to write regularly.

She was as sorry to leave me as I was to see her go, but she was a proud woman and I could easily understand her reluctance to stay and suffer pity.

Ken had been a marvellous support throughout the drama of her suicide attempt and my hopes for the future were becoming more positive by the minute. I was stronger in myself than I could ever have hoped. The marriage was at a stage of pleasant companionship, interwoven with passion, and I had high expectations that it could only improve. The children were happy and relaxed. Life looked good. I was on a roll.

In the two years since Ken and I had signed our contract, Ken's violence, and the dreadful fear that went with it, had subsided so as to become almost non-existent. Life was busy – the lawyers, the builder, the sale, the move and now the hotel, teaching, drawing and always, of course, the children – and I had nearly forgotten the shocking events of the past. Pam, Merry or Anna would some-times remind me to take care but, except for the scary screwdriver incident, Ken showed no signs of reverting to violent behaviour.

Then one day, in the kitchen of our dear little cottage, he gave me a back-hander across the face. It was to do with food, but the reason is unimportant. I was stunned. One blow. After two years.

Something stopped him from hitting me again after this one whack.

The two of us stood there facing each other. You fucking, stupid bastard, I said quietly, do you realise what you've done?

I'm sorry, he said, taking me in his arms, I didn't mean to do that.

Leave me, I said, pulling away from him. Leave me alone.

I went outside and walked and walked beneath the gum trees, crying and thinking, thinking and crying. Remembering the years of horror. The fear. There was no fear now, only anger.

With one blow he'd wiped out the family. The future. Love. Marriage. Hope. With one blow he'd destroyed not only my world, but the four children's as well. Stupid, stupid, stupid!

Ken was waiting for me on the front verandah when I returned. Sitting on the rickety wooden steps smoking. Are you all right, he asked. Humble and contrite.

Do you realise? I said. Do you realise what you've done? You've broken the contract. You have to leave. You've fucked everything up. I was furious.

I'm so sorry, he said. Can't we talk about it?

Talk about it we did, for three days. He didn't want to go. I didn't want him to go either, but he had to. The contract, *my* contract, was my life-line.

I took myself back in my mind to every violent episode. To the fear, the indescribable terror. Yet, in the middle of all of that I could see the good times. The love. The sex. The children. The fun. But beyond the memories and the mixed emotions they gave me, there was the contract. The rational document, hammered out to safeguard my body and soul. Two years without a blow, Ken pleaded. It won't happen again, I promise. But he didn't know what power that contract held for me.

I knew, without any doubt at all, that if I forgave this slip (as he called it), I would never again have any pride. I would become a nothing. I would be a victim forever.

How could I ever have loved him. How could I still?

My mind was tumbling over and around like one of those stunt motor bikes that races madly inside a steel cage. Too many answers to find too quickly.

Throughout my life, poppet, I've always pushed way past the sensible limit, and then a little more and then more. But there was always a point of no return, and once I reached it, there was no give or take, no next chance. Finish. Forever.

In most cases these decisions had been emotionally based. John. Lester. But this was different. My emotions would have given Ken another chance. This was my mind. The very survival of my soul. The gardener's shed was long forgotten, too deeply buried to even be considered, but somewhere along the line, and it had taken a bloody long time, I'd begun to accept that I deserved better. If I

stayed with Ken, no matter how well-behaved he might be, I'd be breaking the contract that I'd made with my deepest self. I'd be giving up, giving in and going under. And I deserved better.

I didn't expect Ken to leave immediately, of course, although that would have made it easier on us all. He had to find a place to live. He had to sell or relocate his precious bloody pigeons. He had to pack his things. And the girls. I would lose the girls. Practically my own children by now. And sisters to my boys.

Paris had been so young when I'd met Ken that he could only remember life as a family: Ken and I, one brother, two sisters. The word step-sister meant nothing to him. His reality was the complete unit.

The breakdown of the family would be easier for Adam, although he and Ken had become mates. Ad had his job now, and a love of music that occupied much of his leisure time. He was besotted by birds and reptiles and had spent every hard earned dollar of his wages on a grand collection of expensive books on the subject. Ad, at 16, was already a man, and he was busy shaping a life outside the family. Besides, he carried some terrible memories of the past – in some ways, I felt, he'd be relieved about the split.

But what about the girls? Where would it leave them? They had their own mum and a new dad at home. They had that security. But a big chunk of their lives had been spent with us and, after Ken's bitter separation from their mother, this break-up could only mean further trauma for them.

As for Ken: Well, bugger him, I thought, this was all his fault. But then, I did still care. He was a poor, sick bastard. How would he survive without his home and his Barb?

This line of thought, however, led me to envisage what Ken might actually do if he stayed.

I knew well, my little one, what he was capable of. There was every chance he would kill me. During one of our conversations in our three days of talks, he announced, quite calmly: If I'd known that one little slap counted, I'd have whammed my fist so hard into your face it would've come out the other side.

I was not going to relent, my sausage. Not out of love and not out of fear. I am so proud of myself! But what a risk I was taking. I would never know whether he was out there watching me, stalking me. Would I ever be able to sleep again? Only a battered wife could understand that risk, that fear. People who have never known the fear that is suffered by women in violent relation-ships can have no idea how overwhelming it is. It fills every second of the waking hours and makes a mockery of intelligence and resolve.

I knew that fear as intimately as if it were an organ within my body. And I

knew that when Ken actually left, I would have to live with it forever. I knew that I could take the boys, run away, and hide. But I didn't deserve that, and neither did Adam or Paris.

I didn't know where my strength had come from, but I was determined that Ken would go, and the boys and I would stay in the cottage and build a new life together. I knew it would be sad, difficult and dangerous, but I was steeling myself to face down the dragons.

And then, three days after Ken's whack, with the future in perilous jeopardy, fate sent me the bushfire.

book three

April 1990

Dear Merilyn, my sweet friend. Thank you. Thank you for giving me back my Paris. He came home from work today, stood as usual with his back to the pot belly, and calmly told me that he'd been electrocuted this morning. He showed me the burn on his left upper arm where he'd been touching the metal beams and the burns on his right hand where he was holding the pliers that hit the live wires.

My heart stopped, and my eyes went automatically to the space just below the ceiling where your spirit has been lying since you died – and you were gone. I knew instantly then that you were the force that threw Paris off the circuit.

He was saying that he had enjoyed a miraculous escape – nobody can break that fatal circuit once it has given birth to its own power.

Merilyn did that, I said to him, foolishly I suppose, because how can I expect someone else to have my own beliefs?

He looked over at me seriously and said, Yeah, perhaps she did.

The day your brother, Merilyn, rang to tell me you were dead, I became aware of a force, or a being, or a vision, say, of you lying peacefully, looking down, just below the ceiling of the studio. And there you stayed until today. Three days.

Over those three days I have been amazed, not that you came to see me, but that you could stay for so long. I was always led to believe that the human spirit could only linger for a very short time – but there you were, seemingly quite comfortable, for days. Always there when I looked, as if you were patiently waiting.

And now I know what for. For Paris.

He always was partly yours, wasn't he? I remember during that ghastly pregnancy how you'd say, I want to share this baby. I'll never have any of my own and I want to feel a part of it all. Well, hon, you've certainly done your bit. Shit, he would be dead for sure otherwise.

Paris tells me that he knew he was dying and was almost resigned to it – then some almighty force knocked him backwards, breaking the circuit. His heart was beating so fast and so hard that he was waiting for it to burst.

When he came to on the floor, he thought for a minute that he *was* dead. His heart wasn't beating at all. Then it gave one thump. Then a couple of small ones. Then a few more, and gradually, as he lay there, his heartbeat began to form some sort of rhythm again, and he realised that he was going to live.

I can't tell you, Merry, what it would do to me if I lost him. But you know that.

I'm sorry that you had to live such a miserable life and that you had to die so young, but if the reason for it all was so that you'd be there for Paris, I have to

be grateful for the overall plan. I'm only sorry that I didn't know while you were alive so that I could have held you more and eased your pain a little.

He's a strong little bugger, Merry. Did you see what he did afterwards? When he regained consciousness and realised that he was alive and so were all the wires in the building? He taped up the live wire that nearly killed him before going downstairs and switching off the current.

That would take guts. If it were me, I would have needed an ambulance and lots of reassurance before I'd thought about the safety of my colleagues.

You can be proud of him, Merry. Thanks, my friend.

May 1990

I miss your letters, dearest Merilyn. I don't believe that you're really dead. I'm mortified that I couldn't get to your funeral. Now I want to see your house. I need to see it. You sent me photos, but they're two-dimensional. I need to stand at the gate where you stood every night. I want to stand in the doorway of your living room and touch your furniture and sit where you sat.

I never did get to visit your little house. And now I can't. It's already on the market. One occupant dies and another moves in. The world marches forward. Strangers will soon occupy your space, and will impose their will over yours, and the fabric of your chosen environment will disappear forever.

May 1990

I've been thinking, Merilyn, about my solid belief that you pulled Paris off that circuit. Most folk would think I'm crazy. Not everyone believes in spirits, of course, and generally speaking I'm not so sure that I do. I'm not sure about much at all. I'm certain, however, that you were lying there just below Mabel's ceiling for three days – and just as surely that you were gone straight after Paris's accident.

Paris believes it, too, but I don't think either of us would swear to it in a court of law.

I think most people tend to disbelieve spiritual stuff – ghosts, UFOs, premonitions, psychic healing – until it's proven to be true. Being my contrary self, I tend to believe everything until it's proven to be untrue.

Why some of us are open to these beliefs and some not, I've no idea.

Anybody reading this letter could easily think I'm delusional. But Paris and Adam have the same openness to belief and most of my friends do, too. Well, Merry, millions of people believe in God, don't they, and you can't see Him (or Her)! So what's the difference, other than society's ingrained acceptance of the norm?

There are no answers, but I believe you were there, kiddo, and can only once again say thank you. Thank you.

June 1990

Two in the morning and I've just finished painting for the night and too high to go to bed yet. A scotch and a fag. I felt like writing to you, Merry, like I usually do when I'm like this. Settling into my rocker with pad and pen, I suddenly took a massive blow in the pit of my stomach with a wooden mallet. You are dead. It felt like fear.

I guess because I didn't get to your funeral there's been no real closure for me. And it's been so long, anyway, since I've seen you. The thought that I won't ever see you again is incomprehensible. You've been there for me to unload on for so many years.

I know there's no real reason why I shouldn't continue to write to you, if I have the need to purge, but it's pretty odd. And right at the moment, very bloody sad.

When I'd write to you before, I always pictured you sitting in a soft, pink, upholstered chair, with a small, round table at your side covered in those dinky tablecloths that you loved. A tastefully small bowl of flowers, perhaps a glass of nice wine in a beautiful crystal goblet. I could see your face as you read my letter and feel your empathy. I'd see a tear or two, or a little smile at the corner of your mouth.

You were absolutely real to me. In my mind your room was as you'd described it (although not necessarily a true rendition), the pink of the chair confirmed by a photo that you sent. It's impossible now to get that image from my mind, even though your room no longer exists. Some other bastards have refurnished it and everything that was you has been removed.

How quickly others move into the shell of our existence when we die! Live in our house. Drive our car. Wear our clothes. (So that's why the Egyptians buried the dead's possessions along with their bodies.) These gruesome thoughts (other people even fuck our loved ones) makes life seem a ridiculous farce. How can we take ourselves so seriously?

I will be gone soon, too. I don't mean tomorrow. But I'm 50 now and most of my living is done. Even if I live to be old, I'm on the gentle slope toward death. Yet while I'm still alive I'll keep holding on with tenacity. How can your mother begin to deal with your death when I can't accept it as reality? She saw you reasonably often, was there at your funeral and must have had the task of disposing of your possessions. It must be shockingly real to the poor darling.

Your death must have been real to your friends who were at the funeral, too. But I wasn't. I was five thousand miles away, or whatever. A world away. And you are really gone.

I knew that for a moment, sickeningly, when I sat down, but as this pen moves across the paper, the knowledge is softening (how the fuck could it, it was such a terrible blow) and I am once again speaking to your tender ear and nothing has changed.

Of course it's changed, Barbra, you stupid!

But while I still write to you, you are still alive in my mind. This moment that I'm holding here on this solid piece of paper is my reality. And I will keep on writing to you, and so you will keep on existing. There is a tear or two on these sheets but, like everything else, they will dry up and disappear. XX

July 1990

Whoa! Do I feel good! I'm just back from a trip to Mulca Station, up the Birdsville Track, with Ingrid and Peter. We camped in the middle of endless sand dunes on the banks of the Cooper Creek, which by now will be in flood. The spot where our tent was – and miles either side – will be part of a great inland lake for the moment.

Ingrid has been dying to get up there, and we knew there was only a week or two before the flood moved to our spot, so we jumped in their new 4WD and went. Ingrid is friendly with the fabulous couple who own the Station, Gabrielle and Dennis, and she'd been up there visiting before, but has been waiting until she and Peter got their own 4WD before setting out on a proper painting trip. It would be impossible to get to the river from the road without one – the area is mile upon mile of rolling sand dunes and is dangerous country. We could not have made the trip without Dennis there to guide us out and back.

Oh, Merry, I love the outback. The biggest skies in the world. If I were a young, strong man with no ties, I'd be out there in every desert of Australia. Camping and painting. Fuck, it's beautiful.

I have to thank my lucky stars that Ingrid and Peter don't mind taking me on these trips. I've always been a nuisance thanks to my infernal back problems, and now I'm fragile after the gall bladder operation. But Ingrid and Peter look after me wonderfully.

We took a two-room tent that included a floor and zip-sealing doors and windows. Neither Ingrid nor I want any of the zillions of bugs crawling around us when we're sleeping, or on our food. One of the rooms of the tent was the bedroom and the other the kitchen, which had an annexe as well. We did all the

cooking on the camp fire, which is grand fun and usually makes for excellent tucker.

We did sketches and took hundreds of photos. We've found now, after many trips together, that as long as we stay in a place long enough to absorb its spirit, and make a few pertinent quick studies, we can recapture the mood back in our studios. We both work fairly slowly and I for one am long past the days of squatting on the ground in the same position for hours, fighting the wind and the goddamn flies.

I have to admit, Merry, that I'm rather jealous of Ingrid. You know I'm not often visited by that little green beast, but I can't help myself sometimes when I see that she's in an enviable situation for a female painter. Peter is entirely supportive of her work. He prepares her pastel boards and makes her canvasses and stretchers. Since Ingrid got deeply involved in painting – she is exhibiting and selling now – Peter has done a course in framing and has in fact opened his own framing shop near here in Stirling.

Peter is happy to be the driver on painting trips. He lugs stuff about and stops every time we see something we want to photograph or draw. I would love to have a partner who was happy (and able) to do all this for me, but the truth is, Merry, most of the time I'm perfectly happy on my own. In fact, I love it. Since Paris has moved to town in a share house and I have the whole place to myself to spread out, I find I'm working more. I don't have to shift stuff around. Don't have to tidy and clean. Don't have to cook. Can sleep when I want and work when I want.

You can hardly move in this place now for easels and tables and papers and paints. I don't ever want to lose this freedom. I don't ever want another relationship – but if I had one, I'd want a Peter to prepare stuff for me, support me while I'm working, and then frame my paintings! Oh well.

If a man is an artist, he's taken seriously and he, along with everybody else, looks upon his work as a kind of business. His wife looks after the kids, answers the phone, cooks his meals, does the shopping and keeps out of the way when he's working. When he goes away for painting trips, it's looked on as work. If he wants quiet time to himself, he gets it.

If a woman is an artist, it's a lovely hobby for her to have, and isn't she lucky if she can sometimes make a bit of money out of it? But she must still raise the kids, clean the house, cook and so on, as well as cater to the needs of her husband. Without time, she can never get in the practice she needs to develop and perfect her art.

I know there are exceptions, Merry, but in the circle of artists that I know,

this is generally how it works. I even know a couple of male artists whose wives run around organising the business side, managing the exhibitions, marketing and so on. Lucky fuckers.

Anyway, about this trip up north. I saw a sand storm. Looks like nothing, when you write it down. But a sand storm is fucking *amazing*!

When the storm hit our camp we realised we had better pack up quick smart. Ingrid and I went into the tent to start gathering our bedding, while Peter got the trailer ready. Everything outside – the camp table, cups, mugs, coffee, frying pans and so on – went flying, a lot of it lost into the creek. Then came a bloody great wind that somehow got in underneath the tent, which we'd anchored securely, and lifted the whole shebang off the ground – Ingrid and I inside along with heavy cases and boxes – and folded it up on itself like an envelope.

Scary! We knew that we had to move quickly or the tent and everything in it – including Ingrid and yours truly – might end up in the river. Eventually we found our way out and got that situation under control. We bundled everything into the trailer, the sand cutting into our skin like miniature bullets.

The sandhills were actually moving before our eyes. Searching for wheel-tracks, we'd come over the top of a rise to be faced with a wall of dirty white sand. While we watched, a hill of sand would subtly shift to the right. The horizon was changing before our eyes. Where there'd been a hollow, suddenly there was a hill, and vice versa. When we'd driven over these hills to come in, they were solid. Now they were dissipating. It was mesmerising to watch nature play with itself. Frightening too.

The noise was tremendous as sand pounded against our vehicle. It reminded me of the fire: the power of the elements, the greatest power on earth. After five days in the outback of this startling country of ours, Merry, now that I'm back in the warm security of Mabel my head is filled with such images that I feel a little crazy. Off to bed.

Next night

Been painting again. Can't settle again. Wonder where Mike my fireman is tonight. One of the advantages of our relationship, beside the obvious, is that most of our trysts, at his place or mine, occur in the middle of the night. He might ring at one or two in the morning. And I can ring him then as well. I don't usually finish painting until the middle of the night, and need knock-off time before I can get to sleep. Having an affair with someone who also works odd hours is a bonus.

I won't ring him tonight though. Don't ring him very often, actually. It's better if I let him ring me. I think, Merry, that if I ring too often he'll become frightened that I want to get too involved. He needn't worry, I sure wouldn't mind the sex more regularly, but physically I'm not up to it anyway.

It's very nice, though, to have such a good lover. Handy for me, too, as far as my work goes. I'm right into an erotic series and even though I've got heaps of ideas and images to work from, a fresh hit of sex and sensuality can only enhance my involvement.

I think because my fireman is much younger than me and has a great body that he makes *me* feel young again, and attractive. I'm 50 now – and with my run of bad health often feel like I'm 70 – so it's very good for the ego to feel young and attractive and vibrant and desirable now and again.

This is probably my last shot of youth and I'll miss it when I'm put out to pasture. I know you had no problems finding youngies, Merry, but my body's been knocked around more than yours and those ten years between 40 and 50 is a big jump for a woman.

Oh well, out with the twin-sets, pearls and sensible shoes. But not just yet!

July 1990

God, I feel old, Merry. It's taking me forever to pick up after that bloody gall-bladder operation. Five months on and I've only put on a stone. I look okay, because of the swimming, but I'm thin. I'd rather put my energy into painting, but without the swimming I'll never get back my strength. I can feel it doing me good, but hate the way it eats up my day.

Pam has left on a trip today. She's sixty-fucking-five and she's gone off on her own in a bloody old campervan to drive around Australia. I'm green with envy – not of the trip (although I'd have loved that), but of her courage. I'd never have the guts to do it and, realising this, I feel like an old, sick, tired, skinny wimp. Can you *imagine*? Pottering over this vast, empty country *on your own*, miles from anywhere and anyone? And Pam knows bugger-all about engines and stuff. God, she's game. Good on her.

She's off to Alice Springs first, then up to Darwin, across to the Kimberleys and down the West Coast. I'd be scared silly of the car breaking down, or being harassed by some nutter, or getting ill miles from help. Pam's got arthritis, too. She's amazing.

And I'm not. Bugger. Bugger. Miss you.

September 1990

Merilyn, Merilyn, where are you? I know you're around, because I can feel your presence, watching me paint. I'm so excited about this exhibition. Thanks to Veda Swain at Greenhill Galleries I have the chance at last to show my erotic work. And thanks to you, my love, I'm able to afford to paint it.

When I got the letter from your lawyer about the money that you left me, my first reaction was that I didn't want it. It felt like I'd be grave-robbing. I wanted *you* back, not your money. I was really quite *angry*! I didn't know what to do, so I did nothing, and gradually I came to accept it for what it was, a gesture of friendship. Now that I've adapted to the idea, I see this money as the goodbye that we never exchanged.

I'm going to use your gift as a means of painting this show, which I know you'd be tickled pink about. I don't have to paint saleable watercolours while I'm doing it because your money will not only buy me canvasses and frames, it will pay the household bills. To be able to spend a whole year painting exactly what I want, on whatever size canvas I choose, is the absolutely best bloody gift you could ever have given me.

And you knew that I've always wanted to paint this erotica. I don't expect it will sell. Most people, even if they like it, will be too gutless to hang it, but this time it doesn't matter about selling because I won't have to recoup the cost of the materials. It's as if you have patted me on the back and said, Go for it Barb, do your stuff, then sat back with a grin on your face and watched me.

Are you grinning? Where the bloody hell are you? What the fuck am I doing spending the money you worked so hard to earn? It's weird, mate, weird.

I've written a few letters to your mother, and she always writes back immediately, wanting answers – she really wants me to say your death must have been an accident. So I talk around the subject, and of course can't tell her some of the facts you shared with me. I can't even try to imagine what I'd do if either of my boys died, let alone took his own life. Your mum must be feeling shockingly guilty and there's little I can say to ease her pain.

All of my energy at the moment, though, is directed at this exhibition. I gathered five other artists together, all very different but all interested in erotica, and then went to find a gallery that would risk putting on this kind of show. Barry Newton (where we had the *Naked Not Nude* exhibition) was interested, but in the end the gallery said no, so I tried Greenhill Galleries in North Adelaide.

We had a dinner meeting at Ros Barker's house, with Veda and her director, and discussed our ideas. I had a pile of work to show, including an oil of five

dicks pegged out on a clothes line, which got the party started, and from there the concepts got wilder and wilder.

We have Robin Turner's wood sculptures, Ros Barker's ceramics, Rita Hall's prints, Tony Graham's collages, and paintings by James Aldridge and me. It's going to be a visual feast of titillation. Our biggest problem will be keeping it down to just the six of us, because every artist and her dog will want to be a part of it once word gets out. I don't want any more than six contributors, because I'm using it as a vehicle for my own stuff – I want to do about 20 pieces myself. Still, it's a big gallery, so we'll see.

I plan to organise a few dinner meetings with the other artists as we progress so that we can feed on each other's ideas and enthusiasm. It's amazing how powerful a group like this one can be after many bottles of wine. Ideas get tossed around like juggling balls. We have to be careful that we don't get filthy or the show won't work. There's a very fine line between erotica and filth, and when you consider that some galleries in dear little Adelaide won't even hang a nude, and many people won't look at one, we're playing with fire here.

Anyway, it's all happening. On with the show. It's for you.

September 1990

Believe it or not, Merry, but it's the middle of the night! Strange but true. I'm so exhausted I can hardly move this pen but I need to empty my head.

Got home tonight from a three-day trip to Port Lincoln with Ingrid. I'm nearly insane with all the stuff we saw. Ingrid's the same. How we ever managed to drive back safely is a mystery.

On the second day we got up early so we'd see the dawn (we shared a unit in a caravan park that overlooks the sea) and then drove, walked, climbed, sat, looked and absorbed until the sun went down into a magnificent seascape miles from town. We sat in the sand dunes until the breathtaking light had turned to charcoal grey.

Driving back from the bay in the dark, we were like a pair of drunks. Every couple of miles we had to swap at the steering wheel. No matter which of us was driving, we were barely able to steer a straight line, and had to crawl along.

Back at the unit, without a sound, we flopped into chairs and sat staring at the little telly to empty our heads. It was an hour before we could rouse ourselves to get a drink.

When we leave on a work-trip like this, as soon as we leave the city and hit the highway, our minds open up like sponges.

See that cloud? Ingrid will say.

Did you see the foliage on that tree? I reply.

Cop the light falling on that paddock.

Wow, look at the blue of that scrub.

Soon we are a part of it, seeing everything in everything, and the doors of our perception stay wide open all the time we're away. We grow ever more quiet, each focused in her own tunnel, or wide-angle, vision.

On the way home, we start closing the doors in our heads one by one –

Fuck, look at that cloud.

Yeah, but what's on the radio?

Do you want your camera? Look at that!

Can't be bothered. Keep driving.

Until at last, by the time we hit the first set of lights in the mundane city, we are ourselves again. Still seeing all the time, but with an ordinary (for us) eye and not with all-consuming vision.

It's a queer business, my friend. If we could see so broadly at all times, just exactly what could we do, perceive, achieve? I think there's no limit, Merry. One merely needs to be in the right situation in the right frame of mind and anything is possible.

Do we all have the same ability to open these doors? Are some people simply too scared to try? I don't fucking know. But I think about scientists and inventors and composers who can hear their music before it's written. Too hard for me. Stuff it, I'm going to bed.

October 1990

My dear dead friend, I'm sending a spirit up for you to look after. My friend, my dog, my Karma. Can you keep an eye on her for me?

Karma had to be put down tonight, because she killed some sheep, but she was a good soul, I know, and had no idea of the damage she was doing. She's been a pal to me since I've had her. She could talk to me with her eyes, and if I was ill or unhappy she wouldn't leave my side, watching me with those big brown eyes. I'll miss her something shocking.

There's one hell of a storm tonight – thunder, lightning, heavy rain flying horizontal – and it's cold, cold, cold, with a bitter wind – so strong that it blew open the gate in Karma's yard. She was probably hyped-up by the storm and, by the time we realised that she'd gone, the damage was done.

I say we, because Brian is living here at the moment. He's my rock 'n' roll harp-playing friend who works in the mines – the one who took me on that trip to Kalgoorlie. When he's between jobs – like he is now – he likes to come to Adelaide to visit his daughter. He'll be staying in the loft out the back until it's time for him to move on.

Brian helps out with jobs around the place while he's here, and brings with him a couple of extra bonuses. Firstly, he owns a massive motorbike. He took me for a ride through the Hills down to Reynella, then, for an extra thrill, up and down some steep dirt roads. Years ago he used to race, and he still rides fast. It was wonderful to be on the back of a big bike again. Shades of my youth, except that back then you didn't have to wear a helmet and a girl would bury her nose into a sweet leather jacket and let the wind push through the pores of her skin, and send her hair flying.

Brian's other advantage is that he's thinking about putting a blues band together and often sits in with bands around town. I go with him, and that's led me to visit some really interesting venues. I won't go to pubs and clubs on my own, too many hassles with guys, but Brian sits with me in the breaks and makes sure I've got a drink.

Brian likes my art and I like his music, and Mabel is buzzing with creative vibes. Hope she doesn't burst at the seams.

Indeed, when Mike came up the other night, he became quite disconcerted,

and even said that he felt inadequate when he walked in to see not only my studio cluttered with easels and wet stuff drying, but Brian sitting there playing along with his guitar to some videos of his old band.

Tess, the homemaker, said sadly to me once that she was very aware that Annie and I, her artistic sisters, knew something that she'd never ever know. I tried to get her to explain her feelings further, but she couldn't. It seems that a lot of people are in awe of creative folk. Well, I guess I'm in awe of people in other fields, too, like surgeons and disabled achievers and pilots, for instance.

But back to my Karma, poor Brian is desolate. He had got to adore Karma, and he was the one who had to accompany the vet when she took Karma to her surgery to put her down. I couldn't.

Karma had rocked up at the front door of a neighbouring farm, friendly as ever and looking for a pat. They kept her there until the vet arrived.

We have a great vet here. She is tiny, like a doll. She came out in the early hours of the morning and with Brian, me and my neighbour Peter (a great bloke) spent a couple of hours by torchlight in the dark of the storm, looking for injured sheep so that she could give them a lethal injection to end their pain.

Merry, it was terrible. Ripped sheep everywhere. Fourteen of them that we know about and maybe we'll find more tomorrow. Who'd have thought that gentle Karma could do this? I know it's a risk having a mixed-breed dog in this area, and will not make the same mistake again. But Karma? I know her soul was good, Merry. Please love her for me.

December 1990

Roberta Flack on the stereo. 'The first time ever I saw your face'. Beautiful number. Do you remember? This will be a heart-breaking Christmas for your mum. I sent a card, but what could I say?

I have a bit of pain myself at the moment. Or rather, a vague sense of doom. I spent the night with the fireman last night. He said nothing, and I didn't ask, but I've got a feeling that he's met somebody he really cares for. He was his usual charming, physical self, but you know what women's intuition is like.

I know that I keep telling you that I'd love for him to find a woman he could settle down with – but that leaves my own pleasure out of the equation.

He sees at least two other women regularly. I know that, and I've had my fair share of others too. We've been playing Russian roulette, with AIDS and other diseases about, and have been lucky so far. I've been having regular check-ups at the sexually transmitted diseases clinic for years now (I refuse to even touch a condom) and I think he does the same.

My feeling is that it's probably not either of these two regular women who has captured his attention, but somebody new. His mind, I'm sure, was somewhere else. But not his dick! That little instrument, I reckon, would screw just about anything that moved if it was female. God, I'm glad I'm not a man. It's much easier being a lusty female than a lusty male – at least our heads help us a little with selection.

Anyway, I guess I'll find out one way or the other, and deal with it then. Besides, I have two other suitors in the picture, one very serious. More on that as it develops.

For now my work is number one priority. I'm thinking, living and breathing erotica – which is an odd situation given that I'm too busy to be bothered much with sex. I've just finished a big oil painting of a girl with her hands tied. A dicey subject. Could be read a hundred different ways, this painting, but I love it. I've put her next to a bed on a beach. I wanted a brass bed and super-soft manchester. Lainee's got a beautiful quilt and I've used that one. It's perfect. I'm thrilled.

The painting has taken months and I don't expect anyone will ever buy it. Utter madness. But I needed to paint it; to put this statement down. And there it is, it exists, until such time as the piece is destroyed. Even then, it will still exist in the minds of people who've seen it. It's pretty powerful.

Can you see it? It's your Christmas present, my friend.

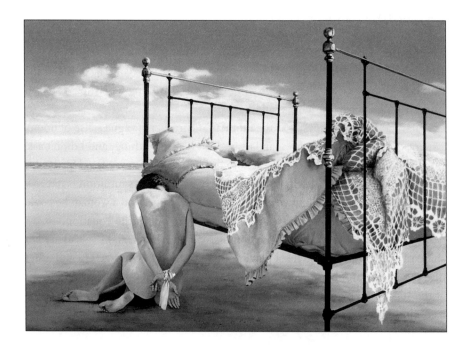

January 1991

Hiya pal. I have a new dog! Another Great Dane. I sweated over the decision, looking at every breed available. Everyone said that a Dane is too big for fragile old me to handle, which is probably true, but a Dane is what I wanted. They're so placid that I expect no problems with sheep and they've got a short coat, which is essential up here.

Lainee and I went down to look at some pups that were advertised. I fell in love with one, of course, and came home with him on my lap. He's six weeks old, all ankles and paws and awkward legs. Stripey. I think it's called brindle. He's absolutely gorgeous. I've called him Buster.

He's curled up on my feet as I sit and write, as close to me as he can possibly get. He's still (just) small enough to get on my lap in a lounge chair, but that won't last – he grows a foot a week! Or so it seems.

Life is pretty fucking wonderful at the moment. Dog. Painting. The boys. Painting. Friends. Painting.

I love having the place to myself. Brian has moved in with a great woman called Robyn who he's known for years but has just realised he loves. I'm thrilled for him.

May is pretty good, although her health is up and down. We get on amazingly well now, considering all. Now that I'm mellowing with age myself, I try not to stir the pot so much. As long as I keep the conversation to kids, family and such we have a reasonable day together when I visit.

By going to Mum's I get to see a bit of Tess and her girls, who have grown into beautiful young women. Tess's baby, Luke, is a young man now, busy with sport and high school. Nice kid. Gee, I like Tess. She's so constant and reliable. Always pleased to see me. Always smiling. Always gentle. I admire her greatly.

Don't see much of Annie, and when I do she's generally had too much to drink. She's very unhappy. I suppose I must have told you that she left Brian years ago and settled down with a gentle artistic guy called David. They had a little girl, Jessie, who must be about seven now (I can't keep track of ages) and is beautiful, but shy like a fawn.

Annie's oldest boy is still living at home. I gather he can be a bit of a problem, but saddest of all is the trouble she's having with Bruno, the middle child. He's about 14 now and unreachable and violent. He has just left home for the streets. To make matters worse, Annie's relationship with David is not too good. She's desperately unhappy and I hope this drinking will not turn into a habit.

Artistically, however, she's doing extremely well. She'll be a famous Aussie artist one day. I accept that I'll never be one, and anyway wonder if the fame is worth it if it involves such sadness of spirit.

My brother John is still some big-wig pilot-manager-something in Queensland and I never see him.

Ad, Verne and Belle are all well, living in Melbourne. Belle's the most gorgeous kid you've ever seen. She's three now, but going on thirty. She's going to be some stunning number when she's grown!

Paris, who will be 20 this year, is looking such a hunk. His unresolved anger still surfaces occasionally, but all in all he's doing pleasingly well.

It's been a busy holiday season. I've caught up with Honey, Rita, Zev, Kate, Erica, Marg, Elizabeth and Tess, and Murphy. Spend a lot of time with Lainee and Ingrid. Paint with Ingrid once a week. I'm so busy this summer that I've hardly had time to become anxious about bushfires. I do know, however, that it's too goddamn hot in here to work during the day. An air-conditioner is on the list, but in my wonderful new uncluttered life I tend to sleep in the day and work in the cool of the night when the phone doesn't ring and people don't drop in.

I've just finished a painting that includes my wonderful nasturtiums. It's an extravaganza of colour – I nearly went blind painting the background. Yet another painting that I've spent weeks on and will never sell – but *I don't care!* Thanks to you, I'm having a great time!

P.S. There's a bloody scary war happening in the Persian Gulf. Iraq has been naughty and someone's decided to teach it a lesson. No one can hazard a guess as to how far the war will escalate. I get the feeling, watching the news on the telly, that ordinary people like me are only allowed to know a certain amount. Would we feel better or worse, I wonder, if we knew all the details and problems and likely scenarios?

It doesn't sit well in my stomach, however, and if World War III breaks out and all our young men have to go and fight, I'm going to get hold of my two boys and hide them in a cave. So there!

April 1991

Writing from Innaminka, in the outback. Hot, hot, hot. Ingrid and Peter have gone off taking photos and I'm too buggered even to sit in the car.

What a trip! To get here we had a 500 kilometre drive on the worst road in the world, the Strezlecki Track. It's a vague dirt trail full of pot holes filled with bull-dust and corrugations. My back must be broken in several places, and my head's so shaken about that I'll never be the same again. (Could be a good thing.)

Along this road (I use that term extremely loosely) is *nothing* but desert. At the roadside about half way along you'll find a single shade tree with a cement seat and table under it, but other than that, zilch, except for scattered low scrub, skeletal dingoes, withered trees, red earth and *millions* of blow flies. What do they live on?

Dust. Heat. Drought. It's wonderful!

Innaminka's township itself consists of one pub, one general store, one

small runway, one old ruin of a hospital, a half a dozen houses, and a few units for travellers.

We nearly got lost. The track near the town was flooded (yes, flooded) so we had to make our way along a path through the scrub. It was nearly dark and we thought we'd be stuck in the desert all night.

At last we came over a small rise in the flat land and, hey-ho, there was the town. Lights. Not many, but out here it seemed like a big city beckoned. We stopped at the pub, of course, and found the bloody place packed, wall to wall, with soldiers, townies, travellers of all description. About 40 people out here in the middle of nowhere. Fucking amazing.

But the whole place is amazing. You should see the *sky*! And while there is dust all around us, on the other side of the pub, covering the track that runs from here to Birdsville, a goddamn flood stretches for miles.

What a country. Just had to write that down. I'll have a drink to that.

May 1991

When I go for my daily walk under the gum trees, Merry, I find myself saying, Fuck, look at that piece of bark, or, Fuck, how about that colour! Out loud. If anybody heard me, they'd think I'm strange. Perhaps I am. Sometimes, driving, I will turn a corner, or come over a hill, and see an explosion of light or spectacular cloud formation, and I say, Fu-u-ucking hell, look at that! It bursts out of me.

Maybe I'm one of those loonies who enjoys talking to herself. But, Merry, I want to thank you for allowing me to write down my feelings in my letters to you. That's another gift you've left me: the gift of writing. I don't have the discipline to keep a journal – and, anyway, although I talk to myself, I reckon I'd feel odd writing to nobody. But while I miss your letters, I feel entirely at ease writing to you still. This writing, these statements of the moment, give me profound pleasure.

It's autumn now and the weeping willows along the bank of the river are changing colour in anticipation of winter. Today, full of clean, warm, autumn air, they were dripping in fine stripes of yellow and green. Very subtle. Astoundingly beautiful.

And guess what I said. *Fuck*, look at that!

June 1991

Just had the most wonderful experience and want to share it with you. If only I could.

Miss Eartha Kitt was doing a show in Melbourne last week. She's not

coming to Adelaide, but you know how I feel about Miss Eartha Kitt so you won't be surprised to learn that I decided to fly over for the show and take Ad and Verne to see it with me. Extravagance! Luxury!

Verne has a major role on a soapie being made in Melbourne called *Chances*. Through the PR people she managed to get us a good table – and a limo!

On the afternoon of Eartha Kitt's show Verne took me on location to the *Chances* make-up caravan and we sat there in front of those mirrors with lights all around them (just like you see in the movies) and had our make-up and hair done. She does that every day, of course, but for me it was a buzz. Then we went home and tizzied up, clambered into the limo when it arrived for us, collected another actor, Tim, who wanted to see the show, and arrived at the Hyatt in style.

The foyer was full of people. Ad and I got the giggles when some of them, recognising Verne and Tim, rushed up to get their autographs.

The show was fantastic! Miss Kitt, at 60, is as good as ever. What a woman. What energy. What talent. Verne had wangled us passes to the after-show party, so I even got to talk with the lady herself. Like a kid, I asked her to autograph my program.

Miss Eartha Kitt proved to me that life doesn't stop at 51. It doesn't stop at 60! There she was, bright as a fucking button, still doing her stuff, and will probably continue to do so for years. What a night.

Next day I sat in on a taping of the soapie and watched Verne do her stuff. TV studios, sets, cameras and so on. Fascinating. Little Belle came with us. Quite often, it seems, she goes to work with Verne and amuses herself while Verne's on the set.

What a fantastic childhood this poppet is having! Adam with his music and art, Verne with her acting. Both of them are avid readers and the house is full of books of all description. Belle gets dressed up and dances to a tape of a song that Ad wrote and sings. A bevy of culture. She's a lucky kid, and I'm a lucky gran.

Home now, and it's time to do *my* stuff. I have a share show next month at a new gallery for me called Reade Art, near the city. The other artist is an up-and-comer called Dieter Engler.

My great gallery at Burnside – Studio Z – has closed. Annie Guthleben, the owner, was not well and was finding the physical work involved in running a gallery (people don't realise), too demanding: not only the hours, but the lifting, hanging, moving, unwrapping and so on.

This gallery will be a great loss to many artists. I sold heaps of stuff there and found Annie and her husband Brian a pleasure to deal with. Anyway, the new gallery is nice and Elsie Reade, who runs it, is a darling. She used to have a

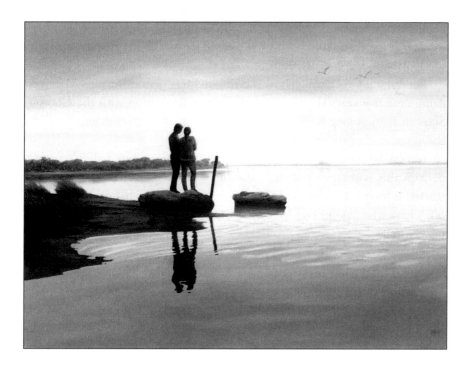

gallery in North Adelaide called the Jolly Frog and Ingrid had some stuff with her. That's how I got onto it.

Speaking of Ingrid, I'm still painting with her every week – have to do some other work besides erotica! We both spend a bit of time with another artist called James Ainslie. He's very much on our wavelength and is thinking about giving up teaching to paint full time. A hard call for him with a wife and child, but he's good, so I hope he can do it.

We have dinners and barbies together, mostly at Ingrid's, and grizzle to each other about the problems of being artists. It all helps.

In between doing the erotica I've also been painting landscapes for this show: the Coorong, the Murray Mouth, Innaminka, the Gawler Ranges. All the places I love. I haven't had a proper show since my share exhibition with Barbara Evans at Studio Z (Burnside) in 1989, so I better pull my finger out. Goodnight, my lady.

August 1991

Dear Merry. Sad, sad, sad. Mike the fireman is no more. He's met someone else and wants to have a proper relationship with her. How do I feel? The last time he rang me was in April to say he was going overseas for ten weeks and would

be in touch when he returned. At the time I thought, great, that'll give me a solid go at the erotic stuff. And I was pleased for him about the trip – though I was looking forward to his return.

His call was lovely, really; he was caring and very gentle. But hell, Merry, it's damn near five years since I met him at Port Broughton with the Coorong Show in 1986. A long time – never regular, never any commitment, always for the moment – but still, five years.

I guess he must have met someone while he was away. I didn't ask. Or perhaps this is the girl I sensed hovering around last Christmas. It doesn't matter, as long as he's happy, I keep telling myself. But what do I feel? Pissed off. That's what. Will I ever have a lover like that again? I'm fifty-fucking-one, for Christ's sake!

Couple of days later

I'm still distraught, and trying to work out exactly why. Michael has been a big part of my life for a long time, so I suppose I have to grieve. But there's something else in all this that I can't put my finger on.

Not long ago I bought a beautiful hand-made drum from a guy called Jerome, who makes all sorts of tribal instruments. It's a long drum with skin at both ends, custom-made so I can play it without bending my back. I've started bashing out my pain on that drum to the beat of a song that I play when I'm full of self pity. 'When Will I Be Loved' – I'm sure you know the words.

Ingrid patiently taped the song over and over on a long tape so I could bang away for three-quarters of an hour. Which I've been doing – naked, because it seems the best way to do it – for days now. Ingrid's agreed to take photos because it occurs to me that this could make a good painting. Naked Barb, banging on her drum to 'When Will I Be Loved'.

With the fireman's passing I suddenly have to face the realisation that I am not young anymore. Oh shit, Merry. I'm old.

Michael was the first bloke for a long time to treat me decently. Go for it, my boy, and good luck to you, I say to him – but me, well, I'll have to grow up, I guess, and face the inevitability of old age. I'm only 51 and these days that's not *old*, but soon I won't be up to the kind of physical gratification that I've been used to. You will never have to face this ending of your youth. You saved yourself from that one.

Ah well, I'll go and bang shit out of the drum for a while and maybe I'll feel better. Drumming naked in a studio full of erotic paintings – how can I possibly be old! Goodnight, from old lady Barb.

September 1991

Merilyn, Merilyn, Merilyn. Hey ho, are you sitting down? (Whoops, you're dead.) I've met a man like no other. This could be dangerous, but I feel great. It's like coming home!

Happened like this. The firefighter rang me on the Saturday to tell me his good (or bad) news. During the following week John Jenkins, who owns the Aldgate Pump Hotel with his parents, rang to invite me to a luncheon he was putting on so he could catch up with a few folk. John and I have been pals over the years. He's another one who finishes work in the middle of the night and sometimes, when he feels like unwinding after the pub has closed, I'll head into town with him. We night owls need to stick together.

Well. I'd had an emotional time coming to terms with the Mike business and was also busy trying to finish off work for the erotic show, which opens next month. I was exhausted, so when John rang I said, I'd love to come but won't stay long if you don't mind. I'm right in the middle of a heap of work. He understood, of course.

So off I went the next Sunday – a week after Michael's goodbye call – planning to eat and run. After introductions I stood around with three or four others enjoying pre-dinner drinks and waiting for other guests to arrive. I started talking to this interesting guy called Ron, who's a sub-editor for the city morning paper – and therefore another night-worker. Nice guy, I thought. Easy. Unpretentious. Obviously very intelligent. We talked until we sat down for the meal, which was several scrummy courses washed down with many bottles of excellent wine. Ron and I were not sitting close to each other – it was one of those long tables – and I found myself wishing he was nearer. I wanted to continue our conversation, which had been far more interesting than any I was having with people next to me.

I drank too much. We all drank too much. I got very loud, like I do, and began a bit of drunken stirring, like I do. You know it well. Five hours later, when we eventually left the table, we all went into the saloon bar and began drinking in earnest. I'd forgotten about leaving early by now. I was having a good time.

At the bar it was a simple move to pop on a stool next to Ron. He was obviously keen to chat again and this we did until, at about seven, I was so drunk that I thought I'd better go home. Everybody looked set to carry on, but I was too exhausted to hold my booze well and felt I'd better get out while I could. But I didn't want to leave this quiet, gentle, easy fellow. I suggested he could come home with me if he liked, and stay the night. No sex, I said, and meant it – I was far too drunk. We could crawl into bed and watch telly and talk until we passed out.

Well, to my utter amazement, he declined. He'd ring me during the week, he said, and home I went. He rang on the Wednesday, from Kangaroo Island where he was holidaying for a week, and invited me for dinner on the following Saturday. I couldn't go because rock 'n' roll Brian was having a birthday party, so we settled for lunch.

I met him at the pub and we talked up a storm over lunch. Then he came home for coffee (yes, coffee) and looked at my work and we talked some more. Talk! We couldn't stop, either of us.

I was going to Brian's party with Ingrid and Peter and asked him if he'd like to come along with us. No thanks, he said, cool as a cucumber, I'd like to get to know you a little at a time. Can you believe that? He hadn't even tried to kiss me. No groping, no innuendo. Un-bloody-believable.

So we decided on dinner the following Wednesday. He came back to Mabel again after that and there we sat, in front of the fire, drinking scotch and talking, talking, talking. Eventually I asked him for a kiss. Out of practice, he apologised, but you wouldn't have known. Great kisser.

He's lost his licence for drink driving, so I'd brought him home in my car. By the time we were ready to crash I'd had a lot to drink. He lives nearby in Aldgate, but I wasn't keen to risk even that short journey. I suppose he could have called a cab, but I said, Why not stay here? I don't want to have sex yet, but you can sleep in my bed and we can cuddle if you want. *And that's what happened*! I don't think I've ever met another man who could contain himself under those circumstances.

The more I found out about Ron, the more I liked him – okay, more than liked. Felt right about. Felt at home with. Perhaps I drummed him up, like voodoo. Spooky.

Let me describe him to you. First off, he's a bachelor. Forty-six years old. Plump and short (well, five-six – short to me). Gorgeous crinkled-up eyes. I think they're dark brown, but they're so crinkled and so often smiling that it's hard to tell. They simply disappear. He's been with the *Advertiser* for seven years and thinks it's time he moved along. He's a loner. A rolling stone. I gather that he's never stayed too long in any one place. He's a New Zealander. He drinks and smokes and loves good food. He tells me that he loves to cook. A real hedonist – like you, like me!

He's studied agriculture and has worked on farms – and at anything he needed to or felt like. Some years ago he and three mates worked their way across Australia from Sydney to Perth where they built a boat 42-feet long with a steel hull (I don't quite understand the meaning of this). He and one of the guys sailed it across the Bight to Adelaide as the first leg of a round-Australia

trip. Then he got the job at the *Advertiser* – he's been a journalist on and off for ages – and ended up staying here. He bought out his mate's share in the boat and lived on it for years, berthing it at Outer Harbour (near Port Adelaide).

A couple of years ago, visiting a friend who's got land on Kangaroo Island, he fell in love with the wild bush and water over there, and sold the boat to buy a 90-acre piece of scrub that he's planning to build on.

He loved my paintings. He's an avid reader and has a mind like a steel trap. I can talk to him about anything. I don't have to explain. I don't have to leave anything out. I don't have to make excuses. He's got a wicked sense of humour. He's cheeky. He's accepting. He's completely non-judgmental. Merry, he's fucking marvellous. Thank God that he's moving on soon, or we could both be in trouble.

And Merilyn, he's not afraid of me! You know that glitch in some men that makes them afraid of strong women? You met it too. I still can't understand it, but it's been a bother over the years. (Recently I bumped into a guy who was at uni when I was at art school. I had a huge crush on him at one stage but he wouldn't come near me. Now he tells me that he adored me back then – can even remember the clothes I was wearing at particular times – but was terrified to ask me out. Stupid.) But Ronnie's not afraid of me at all. He seems to love my strength and my honesty and my outlandish behaviour. He's not even scared by the fact that I'm an artist – and that can frighten off even the strongest male.

I'd never have thought, Merry, that I would fancy a short, round, garden-gnome of a man. You know my taste in men: hunks, bodies, muscles. But this Ron is something else. Seeing him for dinner again on Sunday. Can't wait.

December 1991

Well, Ronnie didn't move on, he moved in. It seemed such a natural step, to both for us, that it would have been stupid to put it off. I think we both felt, from the very first day, that this bond we have, this easiness, this peace, this acceptance, was pre-planned and somehow meant to be.

If anybody had suggested, even one day before we met, that in a couple of months I'd have a man living in my house as the love of my life I'd have told them they were fucking crazy. I had my life all set up – a studio, a bedroom, a Dane, a pool and a sports car – and I loved my solitude. I knew there'd be no more young studs in my life, but there are always plenty of men around if I wanted a fling. Not so now babe! I'm so committed to Ron that I know I'll never look lustfully at another man for the rest of my life. I know this so well that it's a part of me, like my skin.

Other people – lots of them – are worried, though. Even some of my friends are worried, and certainly most of his. Take Colleen, for example. She's John's mum, the licensee at the local pub. She adores Ronnie and had practically adopted him into her family. Colleen has seen me in that pub with an assortment of men over the years. I know she likes me, she makes that plain, but she's not sure that she likes me for Ronnie.

It turns out that he had moved to the Hills about a year before we met. Like me, he used to spend time at the Aldgate Pump, but because of his hours, four to midnight, we never met. Even so, given that we were both drinking buddies with John, it's surprising that we never bumped into each other.

I find it hard to explain, even to you, Merry, what this relationship is like. I don't love this man for his body, nor his mind – although of course I love both of these things. I love him for his *soul*. He's gentle and sweet and manly and empathic and non-judgmental. He's brave.

The second time he met me at the hotel, for dinner, he brought a huge bunch of flowers, for all to see, and asked Colleen to keep them fresh in the cool-room until I arrived. Next time, be brought a red tulip in a pot and plonked it on the bar. For Barbra. A firm statement of intent, for all the regulars to see and make fun of. For a man that's brave.

We ended up in bed, of course. At dinner after two weeks, he asked me back to his place for coffee. I've been to the laundromat today, he said. There are clean sheets. Clean sheets. A bachelor's statement of love. Ah, Ronnie.

It's been a busy time, Merry. Ron was on holidays when I met him, just back from Alice Springs the night before and off to Kangaroo Island the following day. Then, in two weeks, his mother was arriving from New Zealand to stay. He was planning to take her to the island for one of the weeks she was over. He asked me to go with them! Hell, we'd just met, and here he was not only wanting me to meet his mum, but to go on holidays with her. I was taken aback, but then talking and thinking about it, it seemed the most natural thing to do.

But first I went with him to meet his mum at the airport. We hit it off immediately and were firm friends by the time she went home. She's a fragile little darling, with Parkinson's disease, and doesn't get to see much of her only son. Ron's two sisters both live in New Zealand, but Ron left the country at 26 and has only been back a few times, one of them for his father's funeral.

I loved Kangaroo Island, and Ron's block is breathtaking. Ninety acres of virgin scrub with a river and little waterfalls and wildflowers and stunning trees. He was planning on starting a marron (you know, like lobsters) farm there and had begun setting up a tank and clearing land for a house.

I have a show booked at Reade Art for April next year on the theme of Town and Country. Kangaroo Island is brimming with landscapes, and I wanted to go back there, without Ron's mum, to wander about, make sketches and take photos. So the week after Iris went back, and Ron moved in, we went over for three more days on our own.

And now he's here – well, at work at the moment, so I can sit by the fire with my scotch and my fag and my dog and write to you.

Merilyn, this is a whole man. You know how we always needed a few on the go at once, to get mind from one, sex from another, tenderness from another, and so on? Well, this Ronnie is the whole caboodle! I know I've made dreadful life-partner choices before. Some people will presume I've done the same this time. But I have grown. This is not blind passion. This is more than passion, this is knowledge.

I'm not dealing with a severely damaged personality here. Ron has been places and lived a rich life to 46 by himself, though for the life of me I don't know how some dame hasn't snapped him up before now. He may have been lonely at times, but he's experienced all sorts of adventures that have brought him to this point. And I've experienced all sorts of adventures that have brought me to this point. We've talked about the fact that we should have met years ago, but both realise that if we had it couldn't possibly have worked. We were meant to meet now. We feel we've known each other before, and maybe we have. Some other life, some other time. Who knows?

Ron adores Buster and Buster adores him. They go for walks in the middle of the night, after work, and wander about the Hills together as if they're the oldest of mates.

Paris, who got sick of city life and is living in the loft with a grand girl called Mandy, likes Ronnie too and is happy to have him living here. Adam hasn't met him yet, but will soon.

This is what Ron brought with him: a good queen-sized bed with (clean) sheets and a quilt; 8000 books and a couple of book shelves; two changes of clothes; a Bang & Olufsen tape player with cassettes; and a briefcase with his whole life in it. As you can tell, he's not into material possessions. We-e-ll, he's going to live in Mabel!

Know you are pleased for me. Did you send him?

December 1991

Happy Christmas to you, my dearest Merry, wherever you are. I've had a couple of drinks and am feeling pretty bloody good. Ronald, Ron, Ronnie has

proved to be a real find. When we met I told him that I've done the cooking and housework business and am never going to do it again. Washed filthy socks. Sewn on buttons. All that boring jazz.

No worries, he says, I've been doing it for myself all my life, why should I change now? And he's a fabulous cook. I've struck gold. How do I deserve this man when I've been so damned stupid throughout my life? I think I won't ask that question too often. Seems like tempting fate.

Just got back from Tessa's Christmas party. Ron's at work. Part of the job, working Christmas Day. Doesn't worry either of us a jot. At Tessa's I bounced out to the back lawn high as a kite, in love with Ronald and life. Tessa's daughter Kiley was there. You look fantastic, she said, and I did. Looked like I felt. I've met this man, I told the throng, and started laughing, trying to explain Ronnie to the family. He's short, I said, laughing with love, and looks like Father Christmas. With the tummy. He wears these jeans, I said, with so many holes in that they're held together only by the seams. His favourites. Laughing, laughing. Everybody could see my happiness.

May has already met him. When Ron's mum was over, we took the pair of them out to dinner – it was killing two birds with one stone, because after going to Kangaroo Island with Ron's mum I felt that I ought to introduce him to mine. Mother seemed to like Ron, but (after flirting with him over dinner) on the quiet she said, He reminds me of that Ken. I was horrified, but Mother is Mother and if she could ruin it for me she would, so I ignored it. Tess has met Ron, and likes him, but the rest of the family have not yet had the pleasure.

All of my friends have met him. Pam, back from her trip after car and then medical problems in Darwin, grudgingly admitted that he seemed all right. Time will tell, she said.

When he first moved in, I hosted an evening to introduce him to friends. It went well, though people were surprised by how quickly love had bloomed – and wondered if Ron was too good to be true. So that went okay, but the erotic show was an absolute horror for him, Merry. He came with me to the opening – and in one fell swoop had to face absolutely everybody that I knew.

It was a wow of an opening, packed wall to wall. Peter Goers, a critic and journalist, made an hilarious opening speech. We'd called the show *The Erotic, the Bawdy and the Sensual*, and fully expected the cops to turn up. Disappointingly, they didn't.

In general the exhibition got a good reception. Veda told me that the gallery had more people through it than for any show in its history. But, as I predicted, there were not many sales. I sold a couple of small drawings, but people are funny

about buying erotica, especially big statements. Some said, If you've still got that piece when the kids have grown I'll buy it then. Understandable, I suppose.

After the opening we all trooped to Pam Cleland's for drinks and nibbles, and then Ron and I stayed the night with Bruce and Ros so that we could get happily pissed and not have to drive. You would remember Ros Barker from parties. She's been around since the old days. I think she was a year ahead of me at art school. She's a brilliant potter who did some fabulous sculpture pieces for the show. Penises, boobs and such. She and Bruce have been together since the year dot and are a tonic for the soul because they still get on so well together. Remember the bonza show they used to host at Christmas? Well, it turns out that Bruce is a subby at the *Advertiser* too, and he and Ron know each other well. So Ron will know at least one person when I take him out on my rounds.

My sense of anti-climax after this show is even greater than usual. We artists (and the gallery folk) all got so involved in it that it will take a while to come down from the buzz of seeing our erotic thoughts up there on the wall on public display.

Anyway, hon, it was great and I'm glad I did it. It's out of my system now and I can get to work on Town and Country. Back to landscape, but this time more of buildings and the city. There are some stunning old facades around

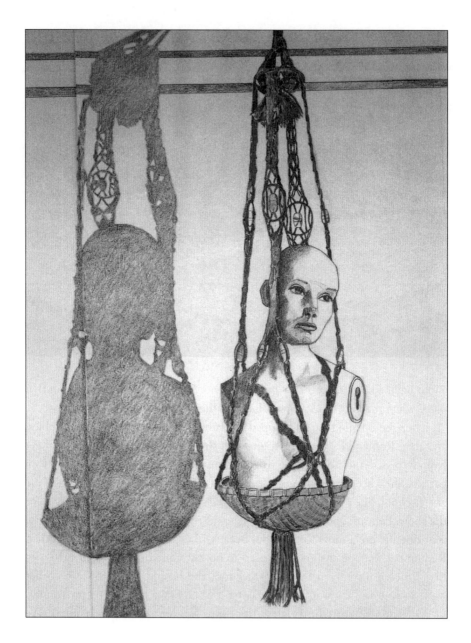

Adelaide that I'd like to paint. Shadows of back staircases thrown against walls, reflections in glass-fronted buildings. Heaps of stuff.

In November I was asked to open an exhibition of work by final-year students at the Stanley Street Campus. Quite an experience, and a great honour. The students' work was fantastic. Better than my own, I thought. How strange

to speak as the voice of authority about their wonderful work when I felt so humble by comparison.

Ronnie came with me and I could feel his pride bursting out of his skin. At last, Merry, someone who's proud of me for a change!

But I've had health problems, surprise, surprise. I've been getting some nasty pain in my gut that the doctor thinks is diverticulitis, a fairly well-known bowel disease. This is a new city doctor, Bill Morrison, who I met when I went into Lainee's hospital with back pain. I'm never going back to that local clinic. Dr Morrison's very thorough and very supportive. He's given me a couple of courses of antibiotics but the bloody abscess keeps recurring. It's compromised our sex life. When it's there, the pain's so great that I can hardly walk, so, much of the time, sex is a no-no. What a bummer!

Ronnie and I have been at it ever since the first time in his unit at Aldgate. He's insatiable. I think he's making up for all those bachelor years in one hit. But while he's happy to play a few games, he wouldn't do anything – nothing what-soever – that might cause me pain or discomfort. His touch is so gentle it brings me to tears. I know I am *loved*.

I've been charging him 15 cents a pop, just for fun. Feel like spending 15 cents? Or he'll walk past me, casually put three five cent pieces on the table and we'll be off to the bedroom. Or the pool. Yummy, warm water and stroking! I've got a white china coffee pot in the bedroom already three-quarters full of five-cent pieces and one cheque. At this rate, we won't need superannuation, we'll be able to retire on the five cent pieces!

So, other than the bloody gut pain, life is good, good, good. And I *know* it's going to stay that way. I *know*, Merry. Good night my friend. You would have loved him.

January 1992

My dear friend, here we go. I'm engaged and we'll be married in a month or two. Seems silly not to do it since we both know we'll be together forever. Ad was over from Melbourne for a visit when we decided, and we all went down to the pub for tea and a few drinks to celebrate. Ad definitely approves – but who wouldn't?

Paris, however, although he likes Ron, was a bit funny about the idea of marriage. He doesn't mind Ronnie living here, but marriage, that's something else entirely. He and I have spent many years together – just the two of us, after Adam went to Sydney – and we're extraordinarily close. He's been the man of the house and my protector for so long that he almost feels usurped, I suppose, by this new man in my life. Adam must have felt the same when Ken moved in.

I know, however, that once Paris adjusts to the idea it will take a great weight off his young shoulders. He'll be pleased to pass the burden of Mum onto someone else.

So here I go again, for the third and last time. There are no warning bells even tinkling, let alone ringing. I know this is right.

The fly in the ointment, as ever, is my health. We're going ahead with our plans, perhaps a March or April wedding, but who knows what might happen to mess this up? My gut pain has grown much worse. Dr Morrison sent me to a gastroenterologist, who said I have a massive abscess and that, if it bursts, it could cause peritonitis. Pretty nasty. I'm allowed no solid food, just soup. Ron, my angel, has been cooking up all sorts of tasty soups for me. If all the love that's gone into them doesn't fix me, nothing will.

Sadly, Ad is over here for a trial separation from Verne. They've been having problems and needed a break from each other. Verne is like me, driven by work and success, and I think she's finding Ad's lackadaisical attitude to life unrewarding. I hope they can work it out. Adam's 29 and adores Belle unreservedly. It would break his heart and spirit to lose her. If you can work magic up there, kid, get to it!

February 1992

Well, that's it! Another bloody operation. Have to go in next week for a bowel re-section. They have to cut out a segment of the lower bowel that's badly damaged by the bloody diverticulitis. As scary as this is (the surgeon has warned me it's a nasty operation with a 20 per cent chance of infection), I must admit that in a way I'm pleased. My whole large bowel is weak and it's simply too dangerous to leave. As fast as one abscess went down, another one came up. The pain was phenomenal!

This diverticulitis, which affects many people, is caused, I gather, from there being too much fat for the body to process. I reckon, Merry, that the problem goes back to the damn gall bladder business. Not only was my body unable to process fat because of lack of bile (the poor old bile duct being blocked by stones for years before it finally fell to bits), but when I started losing so much weight my friends cooked up rich meals to try and put some weight on me. Exactly the wrong treatment, but at the time it seemed sensible.

God I was stupid. If only I had gone to another clinic when the gall bladder was so bad, all of this trouble might have been avoided. But I didn't think, then, that all three doctors involved could be wrong.

Anyway, here I go for another four-hour anaesthetic. As well as getting

over the operation, I'll have to deal with the after effects of the anaesthetic. Hate that. But it must be done.

Thank God I've got Ron to look after me like I'm a queen. I hope I don't drop dead on the table – I want to enjoy some life with my Ronnie (as well as the boys, of course). If willpower alone can get me through this, everything will be all right. I'm going to have yet another scar on this poor old body, one from belly button to pubes. We'll be able to play chess on my stomach – if I could play chess. Have never had the time for that one. Wish me well, my friend, this one's a big one.

March 1992

If you've been watching me, have you been laughing or crying? I can hardly believe it myself. Survived the operation, four days in intensive care and two weeks in hospital, so, so sick and so, so sore. You would think that'd be enough, but once again the universe is testing me. Just how much can you take, Barbra? I thought all that bullshit had finished.

I'm having great difficulty writing. It's slow going, but I'm so angry I need to do it even if I make myself sore.

The bloody nurses fucked up my drip and I ended up with a bloody great, bloody dangerous blood clot in my arm. I've spent three weeks with my arm – my right (write) arm, my painting arm – hanging from the ceiling in a sling so the damn clot could drain away. And *now*, my whole arm and shoulder are giving me hell.

It's been bad enough coping with the after-effects of the operation without all this as well. At least now that the sling is gone I can sleep in a slightly more comfortable position. My back's been so sore, firstly in the hospital not allowed to move for a week, then stuck in dreadful positions coping with this arm stuck up in the air all the time.

Bloody nurses. I was too ill to know, or care, but every day when Ron came to visit he'd tell them that the drip wasn't working properly. They'd fiddle around with it and next visit he'd complain again. When the doctor noticed the swelling in my arm, he was ropeable. I bet those nurses copped heaps from him. He had them raise my arm immediately, and said I need to stay in hospital for another week. By now, we didn't trust the nursing staff at all, so Ronnie brought me home and fixed hooks above the bed, and later, when I could sit up, above my chair.

The nurses may have been slack, but I have tremendous faith in my surgeon – he's the same one who did the gall bladder operation. He had to take

out a foot of lower bowel so now the small bowel will have to do the work. I'm afraid that I could always have problems with this.

Still, I'm alive and safely back in Mabel's womb. Ron, the boys, my friends, Mother, Tess and Annie have all been beaut. Gotta be thankful for what I have.

11 April 1992

Merilyn, I'm writing this to you as a married woman. Tired but happy at the Grand, a whopping new hotel at Glenelg, on our honeymoon. We got married this morning and arrived here mid-afternoon. I'm resting on the bed, too pooped to join Ron who's downstairs at the bar for a drink. We've promised ourselves fish and chips at the end of the jetty at sunset and I'm not going to miss that.

I wish you could have been at our beautiful morning wedding. I'm so happy, Merry. It was a lovely day and I have a lovely husband and my boys were there and my family was there and my friends were there. I felt physically dreadful but the rest of me, the major part of me, is content. I'm lying here in this hotel room, smiling.

Later

Home again tucked up in my (our) white room. Our short honeymoon at the Grand was grand. We did sit on the jetty at sunset, dangling our feet like children and watched the fishing boats coming in. Holding hands. Talking. On the second day we did the proper dining-room stuff, and then had a real treat thanks to one of Ron's friends at the paper who sent two masseurs to our room.

But I didn't tell you about the wedding. We had the ceremony under the gum trees outside Mabel. The boys were our witnesses and we had a minister from the Uniting Church to do the business. He was an extremely nice bloke and didn't care that we're not strictly Christians. We both felt the whole deal needed a minister rather than a celebrant.

Verne came over, which was special, and made me up so that I looked quite reasonable. I wore a white pant-suit with a wide-brimmed white hat, and didn't scrub up too badly for a sick chick, though I had difficulty standing for the length of the ceremony.

Ronnie wore black pants, white shirt and a whitish summer hat and looked very dashing. My favourite part of the proceedings was when he had to reach up on tippy toes to kiss me. Fucking gorgeous!

We had around 90 guests; a nice mixture of both our friends. They stood around behind us in a semi-circle, forming a wall of love.

After we'd tied the knot, all 90-odd of us traipsed to the Aldgate for a proper wedding breakfast in the dining room. Croissants, bacon and eggs, the works, and all beautifully done.

May came, of course, and seemed pretty happy. She's still a good-looking woman at 82. I think she has hopes for this marriage after seeing a bit of Ron over the last few months and watching him care for me so lovingly through my medical trials. Now I have to concentrate on getting better so we can have a decent life. Merry, we even managed to have a proper wedding night, although I could only manage a short spell of sex because I'm still very sore. Ronnie was so gentle. So sweet and so caring. I love him. And I am loved. I'm the luckiest duck in the world.

September and November 1992

Lots has happened, Merry, but I've been too sore to write. My upper arm and shoulder are terrible and sometimes the pain shoots all the way down to my hand. Not too bad today though. Been back to the surgeon a few times with nasty bowel pain. The operation went okay, but my insides don't want to work properly and I've been having nasty bowel spasms. Sex is practically impossible. The surgeon says it should settle down eventually. I bloody well hope so.

Thank God for Ronnie's soups, for I've been back on the soup and jelly diet for a while. I nearly had to cancel the Town and Country exhibition. Can't paint at all with this arm. Ingrid and Ron took everything I could dig up down to Reade Art and they still put on a show with supporting artists. I was able to fill about one-third of the gallery with what I'd already done. That was April.

In January I had a show of all the Coorong panels that I've got left at the Adelaide Town Hall. Ron and Adam had to do all the work, including the hanging. I was too ill with the abscesses even to go in there while it was on. Generally, I'm feeling pretty useless.

Adam came to live in Adelaide in January, and even though Verne joined him for the wedding that relationship is on the rocks. I hope and pray they can work it out.

I did manage a lovely lunch in July with the group of writing girls. We've been meeting for lunches for a year or so now. I don't think I've mentioned them before. I was invited to join this group after Erica, who I've kept in touch with since we were teaching together at Thebby Tech in 1961, introduced me to Elizabeth Mansutti, who is a professional writer, and then later to Tess Young, who teaches and writes. Erica's specialty is poetry. I feel honoured to be included in these lunches, not being a writer myself. These women are toying

with putting a book together about teaching and felt that I may have some ideas to offer. I always come home from these get-togethers full of enthusiasm and energy, and usually paint like mad for weeks. This lunch, however, left me frustrated because of my fucking arm.

It's getting worse, not better. I can only write in short sessions, but still have to do it. It's a good habit, and I like it.

On a positive note, I've taken on a private student for a few months. Makes me feel as if I'm useful for something! And I've caught up with lots of friends now that I've got so much time on my hands: Honey, Rita, Marg, Ilze. I'm taking May for lunch and shopping usually every fortnight if I can. She loves every visit she can get – she's already had one heart attack that we thought would take her out – but my mother is a fighter. As you know.

Later

Ronnie and I get on like Darby and Joan. Nothing's been too much trouble for him, and I think it's entirely unfair that he has to be stuck with sick Barb instead of enjoying life with crazy Barb. Still, it will happen.

Ingrid and Peter have moved to Broome. Their shop at Stirling failed and they went through a very tough time. Broome is a new start for them and so far they

love it. Ingrid's painting like crazy – that top corner of Australia is astonishing.

Been seeing Theresa, my shrink, now and then, learning to deal with this frustration and my *anger* at the hospital staff, and fixing up a few bits and pieces hanging around from the past. Nothing too heavy.

I've had to go to an arm and hand specialist and will probably need (you guessed it) another bloody operation. Ultrasound showed that the ligaments are catching in the shoulder, but the doctors can't see under the bone, so the surgeon will have to go in with a little camera. The ligament is swollen and I'm on morphine tablets until the operation in January. I had a pre-op AIDS test which, thank my lucky stars given my lifestyle, came back negative. But shit, Merry, am I ever sick of pain!

Later

I'm so angry about this fuck up. This time, I reckon, I'm going to sue the hospital. The surgeon's warned me that I'll have bad pain after next January's operation for six months, grading off to nine months. That's two years without being able to paint, two years' loss of income. And there'll be the cost of lots of physiotherapists on top of that.

Fucking incompetent nurses. I'm so scared of hospitals now that I'm seeing a hypnotherapist next week to help me deal with the fear. Not my usual hypno, but one who works with the arm surgeon. And that's not going to be cheap, either! Poor Ronnie's wages are going down the drain with all the medical bills. Not that he complains – he only wants me to be out of pain. What a honey.

He's getting practically no sex now, poor love: I can't get into a comfortable position thanks to my shoulder and arm, and anyway I'm still suffering belly pain that makes penetration unbearable.

Wait. There's more. Since the bowel operation I've been suffering migraines that sometimes last for days. I've never had migraines before and am horrified how bad they can be. Will it never stop?

Dr Morrison says that I must not think about suing the hospital or I will bugger up the healing process. I can see the sense of that. I have to go to a different hospital because I'm too scared to go back to the first one. The surgeon's very understanding about all this. Ah, shit. Thank God poor old Barb can grizzle to you.

June 1993

Is there a world outside my white bedroom? It seems like I've lived here forever, wrapped in my pain, oblivious. I don't know how I've managed to stay sane.

The pain after the shoulder operation was phenomenal, far worse than I could have imagined. Thank goodness I've had the hypnotist to help me. He's been expensive, but great. He made me a tape to play every time I do my exercises and I've managed to get through them without screaming out loud – lots of crying, though. I've been determined to do the exercises as often each day as prescribed, even though it hurts like hell. I *must* get full use back in this arm. I can write for a bit, now, but still can't lift my arm above my head. Getting there. Also doing hydrotherapy once or twice a week.

I'm still really angry with the hospital, but have had a good talk to my doctor about suing and he said I'd win the battle but lose the war. Inside myself I know this is true. The years and money that I wasted trying to get justice from the builder taught me how much stress is involved in litigation. And I saw people die from that stress and anger after the fires had ripped through their lives. Somehow I have to let it go.

Ronnie agrees that the stress is not worth the money. We've spent so much on this bloody arm that we couldn't begin to total it up and we're not going to. What's happened has happened, I guess. Put it behind you Barb.

Still can't paint, of course, and that's driving me nuts. But today for the first time, I feel that I will be able to again one day.

Later

Bit at a time, bit at a time. I forgot to say, Merry, and you're not going to believe this, but now I've got glandular fever. A massive dose, the doctor said. I thought my lack of energy had to do with pain and self pity, but back in March I got so low I had a blood test and discovered this latest illness. Nothing I can do about it but rest.

I suppose that if I have to put life on hold for a while, now is a good time to do it. But between the glandular fever and the arm and the goddamn migraines, Ronnie has not had a lot of fun in this relationship.

Migraines. Rotten fucking things. Nothing seems to help except bed and warmth and darkness.

Later

The *worst* is that intercourse has become such a problem that we've just about given up on it. I'm having spasms in the lower bowel area still – the doctor thinks it's adhesions caused by all the operations – and suffer hideous pain after we make love and then get the runs for a couple of days.

Poor, darling Ron is practically afraid to touch me. His life is not too

wonderful and I'm amazed that he's stayed. No, that's a lie. He's such a honey that he wouldn't do anything else. Fuck, am I lucky I found this supporting, caring man. Or he found me.

Later

Adam and Verne are no longer together and that's a great sadness. Verne has Belle with her in Melbourne and Ad is living over here at Middleton, near the coast, where he is making furniture for a fellow. He seems in reasonable shape, but of course I'm worried about him. At least I get to see more of him now.

Belle flies over sometimes for a holiday, all of five now and already a jet-setter, and she and Ad stay here sometimes. So I see more of her, too, than I did before. Belle's a stunner: tall, pretty and very smart. She'll be something special when she grows up.

Paris and Mandy have split up and Paris has moved back to town. He seems okay and has a new lady called Lane who's very nice.

May's not well. She's had a couple of nasty frights with her heart and is on angina pills. We're getting on all right. She's become very fond of Ronnie and often gives me a lecture about being faithful to him. I have to laugh. Not only wouldn't I stray, I couldn't. May still doesn't really know me. How sad.

July 1993

Merilyn! The most unbelievable thing has happened. I was sitting in my rocker watching telly the other night when a documentary on child abuse came on. It was showing how the kids themselves are interviewed. I watched it, of course. I always watch anything to do with child sexual abuse and wonder at the fact that my own minor experience, long ago and nearly forgotten, hasn't seemed to have had any lasting effect on me. Anyway, they were talking to this boy of about six or seven. The camera was trained on his little face, which was devoid of all emotion. He sat there, stony faced, and simply answered all of the carefully framed questions. Then they asked him to describe the man's erection. His face froze. His little mouth grew tight and he wouldn't be cajoled into answering any more questions. You could see the shock and pain in his eyes.

Well, Merilyn, my patient friend, I nearly vomited. One minute I'm idly watching telly; the next I'm in some bizarre world of fear and loathing. I have no idea why that particular moment opened up the wound, or why it has taken so long, but my hatred and fear of that dreaded erection hit me shockingly deep and is still with me. It was as if someone had reached inside me with a bloody great hand and screwed my insides into a tight ball.

I couldn't speak and just began crying like a baby. Ronnie asked me what was wrong. I couldn't tell him. I didn't know. I just sat there looking at that little boy's tortured face – I can see it still, I don't think I'll ever forget it – and his tight lips, and bawled, shaking all over like a jelly.

After a while, able to speak again, I said to Ron, who was very worried: That erection. That erection. Too terrible to describe. Too terrible to remember. Too terrible to face.

But I remembered it, suddenly, out of the blue, 48 years later. I remembered that erection and instantly became that little five-year-old girl in the shed. I wanted to faint, vomit, die, kill.

Once I'd gathered myself together I rang Theresa, my wonderful shrink. Come down tomorrow, she said, this is important. This is good. It didn't *feel* good, but by the time I went to see her I realised that some sort of healing was about to happen. I felt more positive than I can ever remember. I felt like a massive weight had been lifted from my heart.

Theresa was tremendous. In among all the clever things she said, she reassured me that my recognition of this memory was a major instrument of healing.

I have begun.

Later

Still slow at the writing, still in a state. But excited. Thinking about it, I believe that this revelation, or whatever you want to call it, could only happen because for the first time in my life I am secure in someone's love. Ronnie's. Safe under the blanket of his care. Safe enough to face my demons.

Theresa said that, in my own time, I need to go back and look after that little girl. She knows my self-hypnosis skills and my gift for visualisation, and is sure I can do it.

I want to hold that little boy on the telly and stroke him and soothe away the horror from his face. Since I can't hold that child, I'll work on holding my own and gentling her until her pain is gone.

Merry, Merry, Merry, this is fantastic! Whatever life I've lived until now has been one thing. This is the beginning of a whole new life.

What will my new paintings be like when I eventually do them? Perhaps I won't need to paint pretty, peaceful, facile images anymore. Perhaps they've been for my own protection. Who knows? Who cares? I'm on the way. So good to write all this stuff down.

October 1993

Life marches on, Merry. Physio, chiropractor, doctors. Arm's slowly getting there, can reach higher every week.

Just been to a modelling graduation dinner for Paris' lady, Lane. Not quite my cup of tea and Ron had to control himself to keep from laughing. Our quiet world under the gums is miles away from fashion and beauty and all that hype. But Lane looked great and Paris was bursting with pride. She is a stunning piece of goods. I think he might be falling in love.

I see May at least every fortnight, which is a lot for me. She's 83 now and frail, but not doing too badly for her age. I get to see Tess when I go down, which is really more of a pleasure. I only run into Annie at birthday dinners now. She's still very unhappy, still drinking too much. Doesn't stop her painting, though.

Our social life is getting busier and I'm getting better. Been seeing a lot of Rob Turner, the wood sculptor from the erotic show, and his lady, Cedar Prest, a fabulous stained-glass artist: great couple, great company. We've a lot in common (definitely not fashion pageants) and often dine together.

Darling Ron is wonderful. All my friends love him. They have forgotten the worries they felt when we got married.

Headaches are still bad, groin's still bad, but arm's on the mend. Glandular fever's a bastard.

Ad seems to be all right. He loves working with his hands, but sadly his creative side is not being put to good use. Most of the furniture that he's making is production-line stuff.

I've been working on my little inside girl when I can. It's hard to concentrate with headaches and pain, but there's no real hurry, I feel. It *will* be done. Perhaps I'll have to wait until I'm more healthy. It's probably all working itself out in my head while my poor old body's mending.

So life potters along. Rather an anti-climax after the erection incident, but I feel really strongly that I mustn't try to rush this.

I love jotting down these notes to you. It brings you very close, my friend.

December 1993

Oh, Merilyn, what a sad Christmas this is going to be. Went to see a gynaecologist today and was told that intercourse is no longer an option. Never again! He's going to contact my bowel surgeon for a chat, but said he couldn't really give me any hope. It seems that there is lots of scar tissue in the bowel and the groin, sticking it all together. He thinks that my vagina and bowel have become attached, and that all the problems have stemmed

from that, especially since the bowel is so sensitive since the operation.

I won't give up hope yet. Maybe they can work something out – I'll find out in January. But the gyno warned that the risk of micro-surgery – to try to cut some of the adhesions – is very great. And cutting me open again, to try and clean it up, would probably in itself create more scar tissue.

Poor Ronnie. As far as I'm concerned, I have so much pain down there that I don't feel amorous at all. But I still want to pleasure my man. I told him he could leave, with my blessing, and find a woman who's not sick all the time and with whom he could make love. He just looked at me and smiled. He didn't have to say anything, that smile said it all. This is some man, Merry. But shit, it's unfair. And I'm going to have a lot of drinks to that. Unfair!

January 1994

Saw the gynaecologist again today and he said *nothing* can be done. I sat across the desk from him and bawled. Even though I'd been prepared for the news since the last visit, it was so bloody final. And when I walked out into the waiting room and Ronnie saw my tear-stained face, he knew too.

I love him deeply, Merry, and he's been astoundingly patient during all my physical trials. He deserves a whole woman and a good life filled with fun and sex. How can he stay with me?

Well, as I've said before he loves me like I love him: one hundred per cent. If the positions were reversed, of course I would stay with him. But I still find it hard to believe that he loves me so much that he will stay for my soul rather than my body. I would never ask this of him, knowing the needs of men. But he's made it clear that leaving me is not an option for him. He loves me.

He loves me. He loves me. He loves me.

Once again, out of all the shit, comes a shining light. Ron is my shining light. After the tears of today I feel peaceful, because I'm so loved. I think if any man ever had to prove to his woman the extent of his love, this situation would be one of the strongest tests. At least where you are now I know you too are loved.

Later

Just thinking: poor Ron's had to burn his bridges behind him and really has nowhere to go (not that he would ever leave). After we got married he had to sell his block on Kangaroo Island to help pay my medical bills. We simply couldn't afford his mortgage. He was sad at the time, for he loved the place, but we couldn't have built there anyway because I'd never have been able to deal with the fire risk. Still it seems unfair at the moment. What doesn't?

February 1994

Lots of stuff is happening, Merry. Healing stuff. I saw my wonderful hypnotist, Russell, last week to talk about dealing with my groin pain and also to keep him up to date with the erection business. Russell is the same hypnotist I saw for back pain, but he's also a psychologist. With another specialist, he's doing a study on child sex abuse and is very interested in my experience and how I've dealt with it – or not dealt with it.

We did some work on the pain that will help me at the really bad times, but only touched on the other stuff. That will need another visit or two. But a wonderful thing happened. Russell told me, under hypnosis, to take myself deep, deep inside my centre to my very inner core, and to see what strength is there. And to fortify it if need be.

Well, I had no idea what my inner core would look like. Would you? I suppose everybody would have a different concept. It's an extremely nebulous area. Anyway, when I went deep into myself and actually found this inner core, it was a fucking great steel column! So solid and so strong that I couldn't imagine strengthening it any more. Just to be safe though, I chucked a great metal bolt around the top. This core is so strong it could survive an atomic blast!

Next, I was staggered to find I could see inside the steel column and that tucked in there, smiling so cheekily at me that I laughed out loud, was this little being, hugging itself in glee. So cheeky!

The sight of this being at my core made me feel really good. Invincible. I've done a rough sketch of it (it's not male or female, or even human, I suppose – it just is). I've caught it fairly well in this sketch and intend one day to do a water-colour because the black (somehow transparent) rod is surrounded by warm oranges and reds that make everything feel very warm and secluded in there.

So I've seen inside my deep self, Merry, and discovered that I'm cheeky, which explains so much of my life and why I've been able to survive. And now that I've revisited hypnosis, and have reinforced my own skills, I'll be able to work on helping the little girl that I was at five.

All this is not only productive (I hope), but extremely interesting. I can't wait for the next event. It seems that I can't control the when and the where of the healing, but that it will all happen in its own time. I'm hoping, though, that I can manage more control over the pain. One of the major nerves in my groin seems to be trapped in the scar tissue and has been giving me hell. The inside of my thigh is as dead as a doornail – when I scratch it, it feels numb like your face does after an injection at the dentist's.

There's little medication available for nerve damage and what there is, I can't take. Had too many problems with stomach ulcers since the gall bladder business. Most pain killers are a no-no. Bloody hell, Merry, I'm like the walking dead most of the time. Ronnie not only has to deal with seeing me in pain, but he has to do far too much about the house as well. He had a triple bypass when he was 40. He's now 49. Like me, he's cheeky; still smokes too much, drinks too much and loves rich food. It's like he's thumbing his nose at death – which worries me, but it's part of Ronnie and I can't change that.

We did both try to give up smoking, but we're useless! Still, we've had a lot on our plates since we met. Maybe when my health improves we'll have another go at it. Puff, puff. Exhale. Luverley!

Still miss you after all this time, kid, but these letters bring you back.

March 1994

Dearest Merilyn, I've been doing some painting again. It feels really good to be working and I'm extremely pleased with the amount of movement that I've got back in my arm – probably about 95 per cent I reckon. I can't work for long periods yet, but I can see the day coming.

I've completed a piece that I've been wanting to paint for some time. It's about violence in the home, and I did it for an exhibition about women's suffrage being put on by a new little place that has opened over at Bridgewater called the John Dunn Gallery. The gallery is owned and run by a woman called

Sheila Whittam, an artist herself, she and her husband run it together. I can see it doing very well.

Sheila invited me to submit a couple of paintings but my health only allowed me to do one new piece, so I put in 'Identity' from the erotic show as well.

This new piece is a good one, and very different from my usual stuff. I've had lots of calls from people who really like it and that doesn't happen often. One woman, who's doing her doctoral thesis, was so affected by it that she wants to include me in her study of four female artists. She's a lovely woman (been to see me already) quite a lot older than me, called Phyl McKillup. I think we'll become close.

Anyway, this domestic violence painting, called 'Behind closed doors' – similar in its surreal direction to 'Identity' is really about myself. With this form of painting I can express and confront the painful elements of my own life as well as make general social observations. Amazingly it's taken 14 years since I left Ken to put this image of violence in the home on canvas. Perhaps now that I've had to acknowledge the past, I can open up the future. I wonder what else is in my head. We'll see.

March 1994

Hiya kid, I'm writing from New Zealand. Ron's just whipped down to the pub for a beer. His mum's having a lie down and so am I, but can't rest properly. Bit hyped up.

Ron's mother, Iris, has had a heart turn and really wanted to see us both. I think she needed to see that we are still happy together and that her boy will be all right. Well, you just have to walk into a room where Ron and I are together and you'll see how happy we both are.

This country is astounding. First we went to Ron's home town, Dunedin, where Iris still lives. It's right at the bottom of the South Island. Then we drove (I drove, Ron still hasn't got back his licence) up to Wanaka, near Queenstown, where his sister lives and we're going to stay here for a while. Everywhere you look it's beautiful, beautiful. Too beautiful for me. I like Australia's harsh deserts, gums and scrub. But it's good to see this land that will always hold Ronnie's heart.

Iris has recovered pretty well from the heart business and is all the better for seeing Ron, but her Parkinson's is a dreadful problem, poor love. Maintaining her house has been difficult for her, so she is going to move into a retirement village. We took her out to see the one she likes and have been helping her decide what kind of unit she wants. We're so far away in South Australia: we feel

better to know that she'll be well cared for in her own private unit and medical help will always be available.

I've met lots of Ron's family and spent time with his two sisters, both of them strong, good women. They all seem a great bunch and have made me feel very welcome.

Later – home

Ecstasy. We had three days between leaving Iris and catching our plane, and Ron had booked us into a chalet at Mount Cook, which he wanted me to see. Oh, it was so beautiful. Snow-capped mountains outside our window. I've never seen snow before.

We flew in the tiniest plane, a four-seater, up to the top of Mount Cook and landed on a glacier shelf right at the peak, skidding along a runway of ice. We got out to discover a landscape of white, white, white, with a few crops of dark rock here and there. The bright colour of the plane and our clothes seemed completely out of place. Merry, it was stunning, and the memory of it made our dinner in front of the fire all that more romantic.

We stayed at the chalet for two nights, then had a lazy drive back to Christchurch and our plane home. Got a shocking hit of glandular fever on the second night and am glad to be home again, safe in this white bed. But I wouldn't have missed it for quids!

April 1994

Bloody glandular fever. It knocked me flat just before we left New Zealand, although I was high on beauty and anxious to get back to Mabel to whip up 10 or 20 paintings. It wasn't pretty pictures of New Zealand that I had in mind. I wanted to splash some paint around and experiment with something loose. I turned 54 a few weeks ago and need a new charge.

I know it must seem stupid to you, and all the others who wish they could paint, that I get so bloody dissatisfied, but I know that I'm capable of achieving so much more than I have. What I need is heaps of time, and space, and greater physical strength. I can't see it happening in this lifetime and I'm jealous of those who are fulfilling their talents and all the dead who have left a legacy of innovation and beauty.

You know that I'm not usually envious – it's just one of those nights. And I get so frustrated by my physical limitations.

I've never gone often to galleries to see other artists' work. If a friend has an exhibition, I'll go to offer personal support at the opening, but otherwise I keep

away from the galleries. I've always thought that if I have enough energy, or my back's reasonable enough to get in and out of the car, drive, and stand around for an hour, then I better use it to make my own paintings. When I do go for whatever reason, I get really pissed off and come home utterly depressed. If the work's really good I feel that mine's so bad by comparison that I might as well give up. If the work's ho-hum or really bad I still get pissed off because the artist has at least finished such a large amount of work and I'm not physically capable of doing the same.

Grumble, grumble. Shit, bugger and crap. You can't win in this game!

I was just thinking – I've got a wry smile on my face as I write this, but it's true – that my own exhibitions always piss me off too. If I sell a lot, I think the work must be so facile that everybody and their dog can relate to it, and if I don't sell much I think the work must be so bad that nobody wants it. What exactly does my ego need? A pat on the head every minute of the day?

I do know, Merry, that I'm lucky to have the talent and the drive to keep pushing away at it. I'm well aware that heaps of people would give anything for what I have. But I want more. More time, more energy, more knowledge, more experimentation, more equipment. More energy is the most important one: if I had that, I could get the rest.

Did I ever tell you about the surgeon who came to the studio with his wife to buy paintings? This brilliant guy saved my life twice – he did the gall bladder and the bowel operations. They'd been here a while looking – you know about Mabel, paintings hanging ceiling to floor – when I came out of the bedroom where his wife was absorbed to find him standing in the middle of the studio gazing about sadly, apparently close to tears. Concerned, I asked him what was the matter. He looked past me to some area on the wall and said: I am just a mechanic. With such melancholy and despair. I was shocked.

How many lives have you saved this week, I asked him, but he shook his head and turned away and I had to let it go.

I see this need to create in so many people, and I guess I should count my blessings. But tonight, Merilyn, I can't. Tonight I feel the gift is a cruel joke. Fancy giving me this ability and then sabotaging my capacity to fulfil its potential (or allowing me to sabotage it).

It's a good thing I believe there's another life or two after this one, or I'd be tempted to give up my art as a lost cause.

Perhaps where you are now, your soul has found an outlet for your own creativity. I wish this for you. But then, since I've just been mouthing off about the frustrations involved, am I wishing a curse on you? Deep inside, underneath

all the surface depression, I know that's not so – that any form of creativity, no matter how simple it may be, is worthwhile.

Three scotches later

I had this dream of turning into a proper artist when the boys left home and my time was my own. I pictured canvasses and paper wall to wall. Paint everywhere. Experiments. Splashing. Working flat, working drunk, working upside down. Was going to try drugs. Coke and LSD. And I was going to paint while I was stoned. And never clean the house. Wash only once a week. Eat take-away and have nothing in the fridge except booze and caviar. I was going to have hard rock belting out full blast on the stereo and I was going to *create*!

So, what did I do? Fell in love and got married. Got sick. Got sicker. And what do I paint? Detail after careful detail. Bugger and shit.

April 1994

Hooray! Ron's got his licence back. This will save me from driving when I'm not up to it. He's pleased as punch, too. We've bought a WB Holden ute (his love) for him to take to work and to lug about my big canvasses.

We're all in pretty good shape at the moment. Ad is going strong with a smart and beautiful girl called Lucy, and Paris and Lane are still an item. Ronnie and I are still comfortable together – my rotten health problems are the only negative.

I can't believe that we've been married for two years. It's all been so easy. Sometimes we disagree over money matters or his drinking but they're not even arguments. We talk it over and work it out. Ah, Merry, this is good.

But as for my goddamn health ... In February, I went to see a healer called John Henderson, who gave me the names of experts I should visit. I started with the first of these, a chiropractor, for the most annoying problem, back pain. I've seen him a few times now, and he seems to be good for me. I was very happy with Kevin, who's been looking after my back for years and who pulled me through some really bad times, but if I'm going to see a healer like John, I have to be willing to follow his advice or the whole exercise is a waste of time.

Next month I'm going to the naturopath he suggested, and later a reiki healer who practices and teaches hands-on healing. John said I should have one consultation with her and then do the reiki course myself. Ordinary medical healing must have its limitations and if I don't try alternative methods, I'll never know.

I've organised a small show at Greenhill Galleries for September on the topic of family. This is the year of the family and since the theme is so close to

my heart it's too good an opportunity to miss. Another woman is having the major show at Greenhill; Sheila Whittam (who runs the gallery at Bridgewater) and I will be the supporting artists.

Most of my paintings will be watercolours but maybe there'll be time for an oil or two. Have already started on a surreal portrait of Paris that is going well. I'm hoping to do about 20 pieces.

Oh, it's good to be working. I feel whole again. Bugger the migraines and the back ache and the belly pain. I am *me*. I am working. I am happy.

June 1994

I've been browsing through the albums tonight and came across some photos of June and Patty. I haven't seen the dear little ducks for years now. Wonder how they are.

Years back Patty turned 21 and invited me to her party. Katherine was going to be there so I told Pat I didn't think it was a good idea for us both to be at these functions and that, since Katherine's their birth mother, I felt I should stay away. It's not fair for the girls to be in the middle of our bickering.

At a couple of earlier parties, Katherine had made an effort to be friendly, but I can't stand talking to her after all that's happened. Truth be known, she probably hates talking to me as well. There'll always be bad blood between us.

During the week after her 21st, Patty and her young lad came up to stay for a couple of nights and we had our own little celebration. Other than that, the only time I've seen her was once when I visited her house and at a Christmas Eve party here when I'd just met Ron. She brought a young fellow that night who she's since settled down with and they've had a baby girl. She tells me on the phone that they're very happy.

Merry, I've never seen her little girl! It's pretty sad.

Where Patty's living now, at Elizabeth, is a 90-mile round trip and I just never seem up to it. June is further away. But the biggest problem I suppose, is that we've nothing in common now except the past, and that brings bad memories back for all. I believe that June had a breakdown not long after Ken's death and I expect that seeing me would be difficult for her. I know, from my own experiences, just how damned difficult it is to shelve the past, and I think that the girls need a lot of time before we'll be able to meet without it causing pain.

Perhaps I'm wrong. Perhaps they'd love me to ring. But they don't ring *me*, and I see that as a message that they want to get on with their lives. They both have kids and partners, and don't need me anymore. I don't know Merry, it's a mess. Part of life I suppose. Ah, shit.

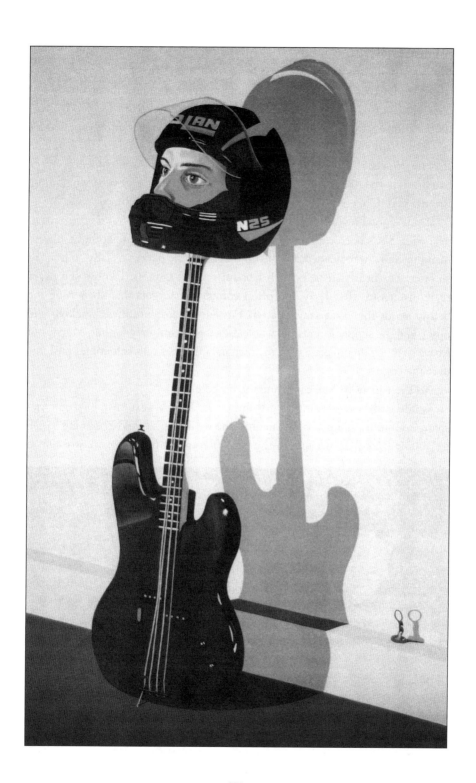

August 1994

My dear friend, this letter comes from Ayers Rock (Uluru). The very heart of
Australia. Did you ever come here? I don't remember us ever discussing it. I'm
here with Ingrid, who is artist-in-residence for the month at this bloody great
tourist complex called Sails in the Desert. She has accommodation supplied for
two in a neato unit and since Peter was too busy with his framing in Broome,
she rang to see if I'd like to join her for a couple of weeks. As it happened, Annie
had been on the phone for a bit and I was stressed out of my ever-loving mind.
Ronnie said, Go, go, go! Get away for a while and restore your energy.

Annie's got a real problem with alcohol. Very sad, my sis, and very hard to
deal with. She's been ringing several times a week, always late at night, always
maudlin, and always loaded. By the time I get off the phone, usually an hour or
so later, I'm nearly in tears with frustration and sadness. I know she never
really listens to what I say and often completely forgets that she's rung me
before about the exact same matter. I'm left an absolute mess, shaking and
upset, and she simply forgets the whole exchange. I am sorry for her, Merry, but
I have so much on my plate with my own pain that her calls sometimes push me
over the edge.

So I've run away. She can't ring me up here.

Annie and I are sharing an exhibition in March next year. It's our first
share-exhibition, and probably the only one we'll ever have. We're going to call
it *Crossing Boundaries* because of the two different art fields that we work in. It

should be an interesting show for the public. We're going to have it at the big gallery at the SA Royal Society of Arts.

And there is miraculous news on the health front! The migraines have stopped. I'm still seeing the chiro that the healer recommended and finally got around to seeing the naturopath, a lovely woman called Lyn who has rooms in the same clinic as Dr Morrison.

She said my body was completely toxic, probably as a result of the gall bladder business and exacerbated by the bowel operation. Reasonable enough. She's put me on a really strict cleansing diet for six months. No meat, no fish, no dairy products, no salt, no wheat products, no caffeine, no alcohol, no nicotine. Nothing out of a tin or a box. Everything must be as fresh as possible. I even have a new hair brush with natural bristles and a similar item to scrub the dead skin off my body before showering. Also a few natural supplements to my diet.

It's very extreme, Merry, and you know how much I love good food! *But* within a week, the migraines stopped and I've not had once since. Unless you've had these bloody headaches, you can't possibly perceive the wonder of not having them. Two years of hell trying every drug on the market with no results. At the end the migraines were coming in clusters – one on top of another without a break. Too dreadful to describe. But now they're *gone*! It's like someone's given me a fucking great diamond. Better!

After a while I can start introducing a bit of fish into my diet and one egg a week. Other than that I'll stay on it for a few years I think. I've brought a heap of ingredients up here to the Rock with me because I don't want to break the diet.

Did you, I hear your question, stop alcohol and nicotine? Well of course I bloody well didn't, you nut! I don't have that much self-control. Truth is, though, I can hardly drink at all. Knocks me sideways. Must be the cheapest drunk in town.

Ron, as usual, has been bloody marvellous. He has hunted up breads made from rice, rye and barley, and has managed to contain his need to present me with scrumptious meals. He's been working hard to concoct tasty dishes from the limited ingredients.

This place, Merry, is fantastic! Not the hotel, but the country. Red and flat, flat, flat. Blue bush and salt bush. My favourite landscape. Uluru itself is breathtaking, as are the Olgas, a massive rocky outcrop called Kata Juta by the Aborigines, although I couldn't really appreciate them fully because you need to walk through them and I haven't the strength.

Ingrid's in her element as artist-in-residence and is selling well. This is her country too. They usually invite one painter and one craftsman or sculptor into residence, and there's been a wood turner up until now. Silvio Apponyi's just arrived with his amazing animal pieces. Such a beaut bloke and fantastic sculptor.

This gives my creative arse the proverbial kick and I've been working away in the unit while Ingrid's over at the gallery. I've started on the series for the year of the family and have finished a few good watercolours and pencil pieces since I've been here. This landscape is inspiring me. Earth mother stuff. As you can guess, Ingrid and I have had plenty of boozy chats in the evenings.

Later

Home after an inspiring three weeks – I've booked in for a stint as artist-in-residence myself next year.

Had all my fillings changed when I came home (from something to something else) because Lyn felt I was allergic to the old stuff. I've also booked in to see a reiki healer in September – third on the list of healers to see.

The lass who runs the gallery at Ayers Rock is into reiki herself and gave me a fabulous relaxation session one night. I was floating. It was marvellous. Really given me a taste of it and I want to know more.

Well, back to work. Just having a break between watercolours. Must get this family exhibition finished. Good night, my sweet.

September 1994

My dear Merry, I've just been for my first reiki healing and it was *wonderful*. My healer's name is Christina Matthews. Perfectly ordinary woman, with extraordinary powers. I don't know where to start. I'm quite light-headed. And light-hearted. This was magic.

I went basically because of my physical problems, but instead we ended up healing emotional stuff. It was like hypnosis in that what happened was a complete surprise. I can't wait to learn reiki myself, so that I can combine it with self-hypnosis! The boundaries will be limitless.

Christina put her hands on my belly and said she could feel pain there. Of course, I said, that's what I've come for, the pain in my groin. No, she said, this is emotional pain, and I found myself telling her about that dreadful abortion and my guilt.

Well, I put that little aborted soul inside a soft mauve balloon and we put him back inside my belly and he's quite happy. I could feel his happiness. I knew it for a fact. That little soul doesn't blame me and never has.

How I know this, Merry, is a mystery to me, but I know it now as strongly as I love my boys. And that's strong. No more guilt. All gone.

And I spoke to Ken in my inner space. Well, I didn't really have to speak to him. I just called him down and only needed to see his face to know that I don't have to forgive him. It's done already. His face was so gentle and so understanding and so wise that I knew (felt?) that his job on earth had been to help me learn my lessons in this life.

This sounds *mad*, writing it down like this, but I swear, Merry, that's what happened. And Christina didn't pre-empt any of it. She simply suggested that I call him down to talk to him. Now I feel grateful to Ken for doing what he had to do to help me learn to take care of myself.

How can that be? But that's what I feel.

I called Mum and John in, too. As soon as they arrived it was obvious to me there was nothing to forgive. It's all okay.

All of this happened in one session, Merry, and I practically feel reborn. I must reiterate that Christina didn't do any of this and that I was fully conscious the whole time. She simply had her hands on me and suggested that I might like to call Ken, Mum and John into my inner space (and where the hell is that? Or what the hell is that?). My own head did the rest. It seems like a lifetime of guilt and anger has dissipated in a two-hour session. Un-fucking-believable!

The concept, or whatever you call it, of reiki, as far as I can gather, is that the healer acts only as a sort of medium. The subject's mind and body has an open

channel to the universe and all it holds via the healer and the healer's hands. I suppose the subject needs to be receptive to this form of healing. And believe that anything is possible.

As we've discussed, I have no set religious beliefs, other than I *know* there's a higher power. There has to be. Look at the trees. Or a flower. Or a baby animal. I just can't put a name to it. People with a strong, orthodox Christian faith, should they ever read this, will think I'm ten bob short of a quid. But we are all born by chance into different countries and different faiths. From what I've read about different religions, it seems that the crux of them all is recognising a higher power, and accepting that part of that higher power lives within us. We must learn how to tap into that power, it seems, and often we need the help of a healer of some sort – a priest, an idol, a reiki healer, a guru.

This is too hard for me to work out, Merry. I am only me, after all, but I know something pure happened today and I feel cleansed.

Can't wait to see Mum again and give her a hug. Can't wait to learn how to do this reiki thing myself. Rei-ki is Japanese for 'universal life force'. Can't wait to get on with life. But, at the moment, bugger it, I have to go to bed. I'm stuffed. Love and love.

P.S. Year of the family show – Sheila and my part titled *Fertile Fragments* – went really well. Sold a few – very personal stuff. Loved doing it.

October 1994

My dear friend, Ronnie's working tonight and I'm having a lazy evening by the fire with Buster, fag in hand and scotch by my side. Feeling very mellow. Put Streisand on – haven't played her for a while now – and of course you come immediately to mind.

My gut is sore but, well, there you go. I could be blind, I could be lonely, I could have a toothache. Instead, I have a drink in my hand and a good friend to write to.

Went to Tessa's eldest daughter's wedding yesterday and got a rare hit of family. It was lovely. Samantha, the bride, looked stunning. She's a real beauty – a carbon copy of Tess, with dancing dark eyes and a perpetual open, wide smile.

Anyway Merry, the thing is this. At the reception they'd set a large round table for us in front of the bridal table; a setting for nine. Mum and her four children and their partners. John and his wife Liffy were sitting to her right and myself and Ronnie on her left.

It's the first time I've seen John for quite a while; he's mostly in Queensland now. Certainly the first time I've seen him since my reiki experience, and I found it easy to be pleasant to him – even kissed him goodbye when we left. Mum is a piece of cake now. I feel absolutely at home with her. I still don't talk to her deeply because she doesn't understand the way I think but it's easy to hug and kiss her. I've been doing that for years, but it's different now somehow.

I did ask her last week, when we went out to lunch, about the gardener's shed. First time we've *ever* mentioned it since it happened. Oh, she said, do you still remember that? I thought you'd have forgotten it. You were only five. It was nothing to do with you really. You were just one of many.

So I told her a bit (a very small bit) about my recent efforts at dealing with the incident and the subject was put away. She didn't remember any details.

Anyway, this wedding. All of us together at once. A firm statement: This is our family. We're a good-looking bunch too, for oldies. Annie was sober, which was pleasant, and is still extremely attractive.

I was thinking, Mum could just sit back quietly and savour the moment. What a chance to enjoy the results of her work and her life. She'll be 84 next week and is living on borrowed time given her run of heart problems. But silly old Mum spent practically the whole time talking to John and ignored the rest of us. We all know that he's the light of her life and she doesn't see him often.

None of us felt hurt, but it seemed to me a waste of a precious, rare moment. I know I get high whenever I have both boys with me at the same time.

If it were me, I was thinking, I'd be happy to stand in a corner somewhere and just watch. Or hang upside down from the ceiling and listen to the four of us and our partners. The sadness, it seems to me, is that Mum doesn't know her children. She doesn't know me. She certainly doesn't know Annie. I don't think she even really knows Tess, despite having lived with her all these years.

Truth be known, she probably doesn't even know John, his dreams, his regrets, his hopes and his loves. Maybe I'm wrong here. Maybe she and John talk about these things when they're alone, but I doubt it. He's a pilot, for Christ's sake, flying up there in the clouds. What does he see up there? What does he think about? Does she know? Has she asked?

John has that magic creative eye. When he was in his teens he used to make immaculate, intricate drawings of engines. Perhaps he'd like to have been an inventor. How does he feel about colour? The sea? Music? Baby lambs? Moonlight? Death? Who knows? I certainly don't. And I don't think Mum does either.

I used to be sad that mother never knew me. But last night, Merry, I was sad for her. Surrounded by the children that she's never really known and very little time left. My heart bled for her loss. Goodnight my friend, who I knew well. And loved.

27 October 1994

Oh, my dear Merilyn, Paris has had a motorbike accident and I feel sick with horror. He's all right. He's alive. He's not badly damaged. He's fucking lucky. But still I'm shaky. Ron and I have not long been back from the hospital. We were able to bring Paris home with us and he's tucked up warm by the fire on a couch bed, fast asleep, knocked out by the drugs and exhaustion and pain.

My baby! Twenty-three now, six foot two and gorgeous. Probably I'll still think of him as my baby when he's 50. I hope not. I try hard to recognise that both my boys are men now, and don't want mother fussing and pouring endless advice into their not always receptive ears.

I can remember when I was 23, and felt I was quite capable of making my own decisions. Even with Belle I try to think back to my own life at her age and treat her with the respect that I thought I deserved then. But it's not always that simple. When it comes to a situation like today's accident, I fall straight back into a protective mother role.

Both of the boys have had several minor accidents in cars and off bikes.

Some I don't hear about until they are brought up casually in later conversations. Adam (he's 31 now) and Paris know what a worry-pot I am.

They both love motorbikes – as I did in my youth. If I had ever been strong enough to ride a bike on my own I might even have bought one. But I can't even hold a motorbike upright.

Anyway, Paris was riding along an ordinary winding Hills road. He wasn't going terribly fast – these side roads aren't suitable for speed. As he rounded a corner, a car turned right into a driveway across his path. His bike slammed into the side of it. Fortunately his groin got caught in the handle bars and petrol tank of the rearing bike, which slowed his flight through the air.

Instead of being catapulted right over the car, which seems to be the major killer, Paris flew upwards and landed on the windscreen. I think this is what saved him – although at the moment, with his groin area swollen and painful, he probably wouldn't agree that he was lucky. His back is knocked about, too, and I fear that like me, he might end up with chronic back pain. Still, there are no broken bones and as far as the doctors at the hospital are concerned, he's a very lucky boy.

When the police rang to tell us Paris had been taken to the hospital in an ambulance, I was nearly sick. Once we were there, though, and could talk to him between X-rays, Ron and I were reassured that he'd be all right. How parents survive the death of a child is way past my comprehension! Anyway, he'll be all right in a few months. The massive tissue damage will take a long time to heal but I thank all the gods, all the angels and the universe for giving him back to me.

I think of your mother; you would still have been her baby.

February 1995

Finished what I can do tonight on my work for the exhibition with Annie and am waiting for Ron to get home from work. Hot, hot, hot and I'm mildly anxious again. There have been lots of smaller fires and a couple of big ones, but the CFS get them out pretty quickly now and we tend not to worry quite so much. A water-bomber usually goes over before the siren's even finished its terrifying wail and we know there are units from surrounding districts on the way. These volunteer units do a marvellous job and calm our nerves. We all know, however, that if fire strikes on one of those freak days with ultra-high temperatures and gale-force winds we'll just have to get out and run away, run away.

Erica, Elizabeth and Tess (the writing girls) came up for lunch today. As usual, I've been left high as a kite. Because I generally work on my own since Ingrid went west, I'm forever doubting my ability and my worth. But these three

389

dames treat me as an equal and I don't even work in their field. They validate who I am and what I do. Erica and Elizabeth have each bought several of my paintings and I feel special when I'm with them, that I belong. And that's always been one of my biggest problems. Trying to find exactly where I belong in this world.

Tonight I've just finished a painting of a black angel that was inspired by one of Eartha Kitt's songs. I used a Botticelli angel as my base because I didn't want a stylised image. The model for this painting was a stunning Mauritian girl who's working at the pub at the moment. I'll put this one in the exhibition.

This show I'm doing with Annie gives us both the free rein to do whatever we like. We're hiring the gallery so we don't have to answer to anybody about content. The exhibition room at the Society is massive and we'll display Annie's work in one half and mine on the other so there will be a clear definition of our styles.

Annie's art world and mine are poles apart. Annie's work is political in both context and execution. She moves and works within the circle of innovative and contemporary art and artists. She is accepted by critics and peers as a serious artist. She *is* a serious artist. I just paint pictures and would be unknown to the majority of art writers and critics. We both feel that all art is valid and have named the exhibition *Crossing Boundaries* to underline this fact.

We're each painting a life-size portrait of ourself and one of each other. These four pieces will hang side by side and they should make quite a statement. I'm pleased with my self-portrait. I've done it in tiny jigsaw pieces with a lot of white on white and called it 'the most difficult jigsaw of all'. Since I feel as though I've had to rebuild myself, and each piece has been hard to find, the self-portrait shows where I am at the moment, nearly whole. Could be an extremely egotistical statement!

I've left two pieces missing. One in my mind, where there is always more stuff to learn, and one in my outside environment where there is always the chance of something happening beyond my control that could affect me. People will read this painting in many different ways, I suppose, but that's how I see it.

My portrait of Annie is a strong observation and I'm not sure how she feels about it. She hasn't said she doesn't like it. I've surrounded her with the clutter that she hides behind (in my view) and have put a bloody great hole in her guts to show how empty and sad her life really is. This is my baby sister, who I loved. I don't know who she is anymore. I fluctuate between anger and pity when she rings. Sometimes my heart shatters when I put down the phone, and I stay upset for days. Other times I just say, Fuck her. My sister. All I can do is give her

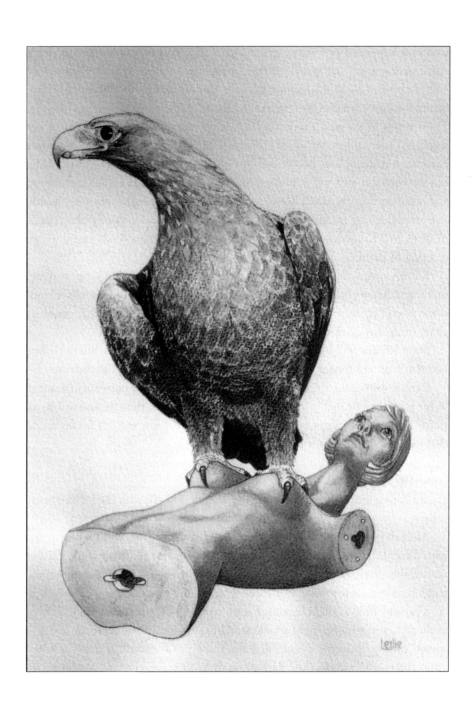

whatever support I can at any given time and keep pushing for her to visit a clinic and stay on the wagon. I feel so bloody helpless. I can't imagine the complexities of alcohol addiction because I'm not there – though I could have been given my own excesses over the years. I can't even give up fags.

At times in the past I've envied Annie for the quality and quantity of her work, not to mention her job at art school, but seeing her abject misery now I envy her nothing. How, people ask, given her success and her love of teaching, can she have so much self-doubt and misery? And she is so beautiful. I could cry, and often do. I worry about her so much that it's beginning to affect my health. I've started going to AlAnon – AA's counselling group for family and friends of drinkers – to learn how to cope with her endless phone calls and my own reaction to them.

But it's a pleasant night here, my friend. Full of the love and support of my mates and happy, for a change, with some of my own work – especially a landscape piece I've nearly finished – stripey layers of subsoil on a cliff that gradually changes to stripey cloth. It's good to be so pleased with a piece.

Soon Ronnie will be home and we'll have a drink and I'll fall into our white bed while he and Buster go off on their nightly stroll around the district.

Paris is well again after his accident, but will have some permanent damage to his groin and probably his back. He's in good spirits, though, and will be all right. He'll get a compensation pay out eventually, for it was not his fault, and that will help make up for his months of pain.

June 1995

Hi, ho kiddo, lots happening. Been busy healing myself, with the help of many others.

After the year of the family show I booked a major exhibition for next year with Greenhill Galleries. Been wanting to have one for some time. But my gut was terrible, back was bad, glandular fever still a problem. My stomach ulcers and gullet problems were getting worse due to reflux and my neck was giving me hell.

This was all too much. I couldn't seem to overcome the pain, even with hypnotherapy, and realised that I should stop pushing myself like a lunatic and give myself time to heal. So I cancelled the show at Greenhill, which I'd lusted after. Horror of horrors. And have given myself two years off to get better.

The trapped nerve in my groin was, and still is, definitely the worst problem. Nobody's found any answers yet, but we're working on it. I'm still seeing the naturopath and sticking to the cleansing diet and I haven't had one single migraine since I started it.

Physios, chiropractor and acupuncture. It's boring talking about pain and health all the time. I try to put on an act for others but that eats up precious energy. Anyway, I can't fool my good friends and family, who can tell when I'm suffering by the pain lines on my face. The skin around my mouth goes blue, and that's a bit hard to miss! Others tell me it's my eyes that give me away.

Anyway I'm sick to death of grizzling, so I expect everyone else is too. Thank God I can write shit to you now and then.

The good news is that I've done reiki 1, which proved to be a massive emotional healing. It wiped out excess worries and pieces of rubbish I've been carting around. The course, or whatever you might call it, is a strange mystical deal that supposedly opens up your mind to the universe (and I have no doubt about that even though I don't understand it). It took two days at eight hours a day. These courses are normally done in small groups, but I was lucky enough to have a one on one with Christina and, Merry, it was a marvellous experience.

Somehow or other I can now do reiki on other people. They get healing warmth from my hands, becoming relaxed and often experiencing a release of pain. Don't ask me to explain this, Merry. Probably only believers can get any benefit, I had thought. *But*, I've been doing it for Mum, and she's not one to believe in hocus pocus. She's failing fast and is in hospital often for a week. She can't move about, because of the angina pain, and is getting far too much fluid in her lungs. Her worst pain, though, is gout in her feet and when I go to visit, mostly weekly now, I do reiki on her poor swollen feet and she loves it. Last visit she said, I wish you could stay there doing that forever, it feels so good. I put my hands on her chest, too, and that also seems to bring some relief. Of course, the very act of caring touching may have something to do with this. She's never been one for touching, yet she accepts my hands without question.

The other really magical thing is that I can hold my hands a foot away from a tree and feel its energy. Or hold them up and feel the energy of the air. I can find no explanation for this after only 16 hours of some form of meditation (I suppose you'd call it), but I love it and feel marvellous and I guess that's all that matters.

I put my hands on my tummy and my groin when I go to bed each night and the heat that comes from them is very comforting. Do you remember that my hands are always icy cold? Always have been. Still are, in fact, except when I'm doing reiki.

Ron's had an accident in his ute, which is a complete write-off. Some idiot kid ran a red light and ploughed into him. Luckily Ron was not hurt at all and – would you believe it – after the cops had been he caught a bloody taxi and *went*

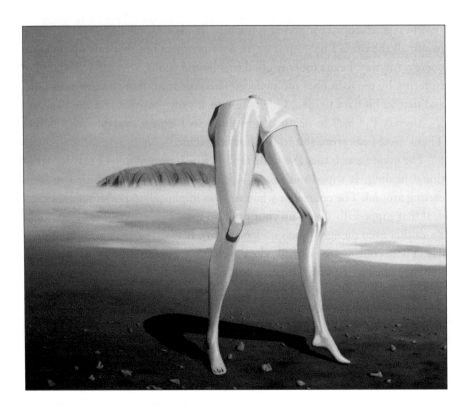

to work! He's a trooper. But he loved that ute and we'll be lucky to find another good one for the money.

In May we took the ute, with a trailer, to Uluru for my artist-in-residence stint and she went like a beauty. Better than I did, in fact, for I had to come home after two weeks with severe abdominal pain. The Flying Doctor Service, which runs a clinic up there, was concerned about my bowel, and said I should get home immediately to my specialist. Turned out to be just a nasty episode of the usual.

We spent time at the Rock with Silvio Apponyi, who was doing his sculpture, and we both have great admiration and love for this gentle giant. Stunning work.

Dear old Aunty Isobel, Dad's sister, has died. She was the matriarch of the Newmarch family. She was pretty old, older than Mum, and went fairly quickly. Isobel was the last of Dad's family and it's a strange feeling not having her here. I only saw her occasionally, but there was always a birthday card from her in the post with a $20 note. The end of an era.

Time's funny, Merry. When I'm in pain it goes so slowly. Then I look back, and see it's gone far too fast.

Ronnie will be 50 in a couple of weeks. Can you believe it? We'll have a party and Mabel will be full of drunken journalists, music, food, laughter and conversation. Gonna be great. It's a good life we have, he and I.

21 August 1995

Mum has died. Today. I feel calm at the moment but I guess, later, it will really hit me. We'd become pretty close towards the end. Well, as close as I could ever get to her. It was a nice sort of relationship at last.

She died peacefully and somehow it was a beautiful experience to be there with her. Sadly, however, John couldn't get to the hospital on time. He arrived ten minutes after she was gone. Tess had rung him and he flew down from Queensland as quickly as he could, but there was a plane strike in Brisbane. It would have helped John's grief a lot, I think, if he could have been with her at the end and witnessed what we saw.

Mum had another heart attack during the night a couple of weeks ago and didn't tell anybody about it. When Tess went out to check on her, as she did every morning, she realised how ill Mum was and called for an ambulance. Mum was supposed to ring the ambulance if she needed more than a certain number of angina tablets in a given time, but she could be as stubborn as the rest of us.

This time the attack had done irreparable damage to her heart and there was little doctors could do for her. They sent her home, where she deteriorated quickly. Soon she was bed-ridden, which was what she'd dreaded. She'd had enough and was ready to go, and I know she was wishing for it.

Kiley, Tessa's youngest daughter, has been expecting a baby. Stubborn old Mum kept herself going until she could be propped up in her chair to hold her great-grandchild, then fell apart and had to go to hospital again. She knew, as Tess and I did, that she wouldn't be coming home, so she went into a nice room in a private hospital where she could be comfortable and private for the end. Today was just her third day in there, and it seems the doctor told her this morning that it would possibly be her last.

Tess had an intuitive feeling at lunch time and rang Mum from work. As soon as she heard Mum's voice she knew to get straight down there. Mum was still conscious, but very low. Tess rang John (and Liffy, who is still in Reynella) and me. I went straight away, planning to sit with Mum for however long it took. I sent Ronnie off to work – we had no idea how long it would be and too many folk hanging around the bed could be horrible for Mum.

She was nearly unconscious by the time I got there, but she squeezed my hand to acknowledge my presence. She'd managed a few words to Tess before

she began slipping away and we both knew she was pleased to be going. Tessa told her that John was on his way, so she knew that he was coming and could rest easy. Liffy was there too.

We decided to ring Annie at college to let her know what was happening. It's hard to know, nowadays, with Annie. Her personality has changed with all the drinking. Her world is one of make-believe now; she only sees what she wants to see. Anyway, she came and she was pissed – and I am so angry with her that I can hardly bear to even write her name at this moment.

Mum. May. Mother. Dear old Mum. Lying there so frail and delicate and defenceless. I have to say, Merry, that other than the fact that John wasn't there, her death was one of the most beautiful moments that I've ever witnessed. It was one of the finest gifts she's given me.

At the beginning, before she became totally unconscious, she looked every bit of her 85 years. Her skin was transparent and pale; there was no colour in her tired face. By the end, though, a miracle had taken place. The blue of her lips had turned to rosy pink. Her whole face took on a beautiful pink hue and her mouth wore the most peaceful, beautiful smile that I've ever seen. For four or five hours we took turns at holding her hands, and I did reiki on her poor swollen feet. Her hands, at first, were blue, but when she died they were pink and beautiful.

Her friends Marg and Roy by chance called in to see her this afternoon. Margaret brought a small bunch of the first violets of the season. We put them in Mum's hands – they were her very favourite flowers – and she lay there, holding these violets and smiling gently, like an angel. Truly, Merilyn, she looked young and beautiful and oh, so peaceful when she went. A peace we were lucky enough to share. Mum and her violets.

November 1995

I'm sitting in front of our big new window. There's a baby magpie poking about in the grass for insects and dunking bread scraps into the water bowl. He's all soft greys and very hesitant and cute, with that piercing squawk that belongs only to baby magpies and which I love – it slows my heartbeat and softens my day. Nevertheless, I'm carrying much melancholy today, hence this letter.

Somehow I have to come to terms with the loss of my sexuality. You know, more than anyone, how much an integral part of my being sex has always been, and I now find myself bereft of any sexual feeling, behaviour or thought. If you'd have told me five years ago that I would be this way, *ever*, I would have said it was an absolute impossibility. I fully expected to be sexually active, and I mean active, at 80 or 90.

Can you imagine the irony of this after my life of obsessive physical passion? Choosing insecure babies attached to big penises. Thirty years of fucking myself stupid with every good stud I could find and hoping there would be something more than their bodies to satisfy the rest of me.

Well, here I am at 55 (still about 30 in my head) and I have absolutely no sexual feeling. This has been a gradual process, since the bowel operation I suppose, and the most upsetting part is the unfairness of it all where Ronnie is concerned.

Here is my husband, who loves me as I do him, with no reservations, no conditions. And I can't make love with him because of the pain.

Oh, Merilyn. I feel I am not me anymore. I even walk differently. No sassy swinging of the hips nowadays! I dress differently, lest I look inviting and make Ronnie's cross harder to bear. I stand differently. No chin up in challenge. No holding my body against the air as if it were velvet, or water. No more proud statements to the world, with a look, a gleam, a stance, an attitude. I am woman. I was woman. Every inch of my six feet was woman. The air around me smelled of it, vibrated with it and rejoiced in it.

Now, I don't exist anymore! The Barbra who I was so familiar with does not exist. The Barbra who you knew does not exist. The Barbra who moved so sensually to music, in her soul. Even listening to music, still as a stone, I vibrated with the sensuality of it. In my bones. I remember the first time I had an orgasm listening to music. It was at the Cellar, do you remember it? Lower Rundle Street? I would have been about 20. There with Lester at four am, the musos letting off steam after their night's music for money. Bobby Jeffery was playing a solo on sax. Don't even remember what number it was. Just the shock. Can even tell you what seat I was sitting in. Such an experience! Too scared now, to really listen to my music. I listen differently, with my ears rather than my soul.

What a loss. I hadn't realised until I actually wrote that. Music. Makes me want to cry. Come to think of it, I even wash myself differently. Mechanically. Scrub, scrub. No sensual movement of the soap over my tummy, no sliding of silk against slippery skin.

So what is left of me? A brain that is too sad to get excited about much. A sexless body that still walks around making out it's alive. You will understand, Merry, better than those who think they know, that I hardly exist anymore. I think, and this is a daring thought, but truthful, that even your suicide was a sensual act.

I bet you bathed your beautiful body in scented water, washed and brushed your lovely long red hair until it shone and made up your face. French perfume,

immaculate nails, satin sheets, the lot. Like the Egyptians, preparing their queens for burial. I think you would, my friend, have made sure that you were at your best for the biggest event.

I read somewhere that when a man hangs himself – or is hung by someone else – he gets an erection. I even drew it once, a thought for the erotic show, a man hanging by a rope with his hand around his erection, smiling. I tore up the drawing because of the warped nature of it all.

I don't know much at the moment except sadness. Strangely not bitterness. Just a slow, deep sadness. I cried when the surgeons told me they wouldn't risk operating to cut the adhesions. But I haven't cried since. I suppose this letter is my cry.

Next week
I'm still obsessed with the realisation that I'm no longer a sexual being, my friend. Trying to adjust to it. I used to think often, with sadness, about my friends who don't have partners, or even casual lovers, who often have been without sex for 10, 15 years, and who would dearly love someone to hold them, stroke them, and satisfy their needs.

And here I am with a man who walks around daily with an erection, and I can't let him even hold me in bed, for fear of making his need stronger. I bleed for him, and I bleed for my friends, but only recently have I begun to bleed for myself.

At least Ron and my friends all have sexual feelings. Ron must feel like a man when he's carrying an erection, and he must feel like a man when he's stirred with desire by a quick glimpse of me changing, or when he sees a good-looking woman on the street. The women, too, feel like women when they long for a man's touch. They can get stirred up when watching a love scene in a movie. But suddenly, after writing this, I don't even envy them that awareness of sexuality anymore! It's as if the whole sexual area of my mind has been anaesthetised.

I suppose that wherever you are now you understand exactly what I'm trying to say. Surely you are not now male or female. More likely you have become shimmering atoms in the universe. If you could be bothered to look back on your life on this planet, you must grimace (or chuckle?) at your sexual exploits and wonder at the shocking waste of precious time that went into this obsession.

I know that as animals we must procreate to keep the species alive. But so often we allow sexual need to obliterate opportunities that exist to develop our magnificent minds. Absurd.

Anyway, between my 50-year-old, hidden loathing of the male erection and the loss of my sexuality since the bowel operation, I find that I am a sex-less being.

Purely a *human* being. Of no specific gender. Perhaps, just perhaps, I have been given a gift. The gift of non-sexuality for the rest of this human life, so that I might, maybe, find the true reason for my existence on this earth, in this form.

January 1996

God, am I fucking angry! Instead of bottling it up, I'm writing to you. Again. I'm shaking so much with anger that I can hardly hold the pen.

I've been seeing alternative healers as well as medical people, determined to find some relief for this fucking groin, and have come across a woman who works with kinetics and ortho-biology. Don't ask me what that means – something to do with electric impulses – but I would put her down as a psychic healer.

I don't know if I believe in what she's doing or not – I'll just wait and judge the results I guess. I don't understand, Merry, why I can't simply heal myself. I'm so close, but just don't have the skills to break down the final emotional barriers. I know that some of my physical pain has to be tied up with all the old emotional stuff. Anyway, this woman was working on my pelvis yesterday and was picking up tension and stress. She said I would feel a release of this tension in the immediate future. Before I even left her rooms, I found myself thinking how angry I was at Mum, and this morning I've woken up with such a fury that I can't even be civil to Ron.

I can't believe how angry I am with Mother, who only died five months ago and was a real sweetie at the end. I thought I'd dealt with all that, but this healer said my body's still carrying emotional trauma about the abortion and that I need to deal with it. So that's what I'm trying to do. Didn't think, though, that this fierce anger within me could still be to do with Mum.

Of course I'm angry with Lester, but I've always been angry with him. I just can't understand how Mum could have told me to have that abortion! I mean, as a woman, wouldn't she have known that it was just not on? I was only beginning to show – you know how I carry my babies, tucked deep away inside me – and to be fair to her she wouldn't probably have believed that I was more than seven months pregnant. But she must have known I was at least five months and she must have known that it was risky!

She was not worldly-wise, but in your guts, as a woman, you'd know, wouldn't you? And backyard abortions are notoriously dangerous. I can't believe that she wouldn't have heard horror stories about them. Why the fuck didn't she say, Come home and have the child then you can decide whether to keep it. Why the fuck didn't someone tell me I had options! I was 19 and very naive, having spent all those years in learning institutions.

The three people I loved, Lester, Mum and Dad, all told me that I had to do this thing. And Mum must have known that I wasn't eating and was very sick. You just know those things about your kids. Why the fuck didn't she take me home and feed me and look after me? As it was, I couldn't leave Lester. Not only did I love him, though Christ knows why, but I was pregnant, sick, had no money and absolutely nowhere to go. Perhaps there were options. I couldn't see any.

The kids at art school had told me about girls who had died having backyard abortions. Those who lived, it seemed, had gone mad from the pain. I was scared shitless. Of course, the final decision was mine, and I have to take responsibility for it. But, sweet Jesus, why didn't somebody help me?

And then I think about the sexual abuse when I was five, and how badly that was handled. I've made excuses all these years for Mum, because there was so much sexual abuse in her own home as a child, but now, *now*, I'm thinking, Christ, if anybody should've known that I needed comforting and nurturing, *she* should have! But everything in Mum's life was *Keep it quiet. Don't let people know. What will they think!* I'm well aware that back in 1945 sexual interference with a child was not talked about. (Now it's the subject of a talk show every other day.) Nevertheless, surely a mother would instinctively know the guilt a small child would carry. I don't suppose that I ever mentioned my fear of hedges to either Mum or Dad, and I most certainly wasn't going to bring it up in case they remembered that I hadn't been punished yet. All I've come to realise is that when the abuse was happening, I knew that it was a very, *very* bad thing, and that I was cursed for just being there. I knew that whatever I had done, it must have been wicked if my best friend wasn't allowed to talk to me anymore.

Oh shit! I'm angry at all of them. Mum, Dad, John, Helen Belle's father, all the boys who called me slut, everybody! Why I'm even writing this now is beyond me. You'd think by 55 I'd have my bloody act together. And I believe in acceptance and forgiveness. It's just that *today* I'm furious about the whole goddamn mess! Perhaps if I'd been nurtured at five, my whole life would've been different. No Lester. No Ken. No attempted murder and rapes that I didn't report. No breakdown. No abortions.

I've always said to myself, Merry, that if my life had been different, I wouldn't have had Adam and Paris, and I wouldn't swap them for anything. But why the fuck couldn't I have had them and a nice life as well? Other people do!

Anyway, woman, that's my shit for today. You're such a good listener, dead or not, and Christ knows you had a belly full of your own pain.

Later

There's the bloody accident as well! It's all coming tumbling out. Poor old Mum, not long gone, and I'm writing all this shit about her. I still do love her, Merilyn, but I need to rid myself of this anger. It's like a cancer and I don't want it anymore. Perhaps getting rid of some of this crap will enable me to remember the good times later.

I remember Mum saying, often, in regard to the accident, that she was more concerned about the guy who hit me, because he was in a hurry to get home to his wife who was having a baby. The poor fellow, she would say, he was so worried about you, but wanted so desperately to get on home.

Now, when I think about it, her lack of concern for me was callous. Much more important to her, it seems, was to keep everything sweet by removing me from the scene as quickly as possible. I had head injuries, and gravel rash on my right thigh nearly to the bone, so it must have been obvious that I was hurt. Yet she walked me two hundred yards to the house.

My God, Merry, her actions could have caused me to become quadriplegic. It was a miracle that I wasn't dead or suffering a broken spine or neck anyway. I think of what my own reaction would be under the same circumstances. For starters, I wouldn't be the least bit sorry for the guy, I'd want to smash his head in. I'd make him stay until the ambulance and police arrived, and my child was safe as possible. I wouldn't give a stuff about his goddamn wife. I might say, Go into a house and ring a taxi for her, but his needs would mean nothing to me if my skinny 12-year-old was lying covered in blood on the road.

Surely she must have known, as a mother, not to move a child with such obvious injuries. How could she not have known? Even though she mentioned the guy and his expectant wife many times, she never once said, Perhaps I shouldn't have walked you home. Perhaps there is a chance that I inadvertently caused some of your back problems. Perhaps I'm sorry.

Am I being unfair to her? Maybe she was in shock and reacted stupidly as a result, but I can't fucking well believe that a mother, with her gut feelings for her child, would move her a fraction other than to cushion her head, or cover her up until the ambulance arrived. Maybe, just maybe, I might have been spared some of this pain if I'd been kept still until carefully stretchered and bedded in the hospital.

Poor Mum, I'm sure laying a load at her door. It seems to be the in thing to blame all of our inadequacies on our parents these days. I don't want to be just another member of that flock, and God only knows that Mum did lots of good for me too, but right now I'm filled with too much anger to balance the budget. And I'm learning that anger is better out than in.

I would have liked some support, and acceptance, and encouragement to follow my dreams. Not hers. Not society's. Mine. I would have liked to have spent my life liking myself, not feeling dirty, ashamed and worthless. Unfit for decent loving and deserving to be punished for something that I didn't comprehend or remember.

Anyway, I feel a little easier now. I wonder how much more anger I have to release before I've healed myself. I want to say sorry to Mum for feeling this way but, wherever she is now, I'm sure she knows exactly what I'm writing, and why I'm writing it, and understands. There really is no blame, I know. A different child would have reacted differently to all of these events. Our personal frailties and sensitivities must have a great bearing on our reactions to situations. Mum did whatever she did, because of who she was. I have reacted the way I have because of who I am. Mum will understand, wherever she is.

And you, my sweet lady, reacted to your own circumstances because of who you were.

February 1996

I'm sitting by the studio window as the first rays of sun slant through the trees in great yellow stripes. The birds are wakening and calling to each other. The sky is taking on its blue for the day, and the trees are flaunting the brilliance of their foliage in the first rich light. It's going to be a scorcher, but the house is still cold from the night air and I'm freezing.

I woke up while it was still dark with visions of Lester and blood whipping around in my head like cyclones. Couldn't get back to sleep. Memories were flooding back in such a torrent that I had to get up and have a smoke and a hot drink to calm myself. Might as well write some of it down, or I'll never be able to get back to sleep.

I'll be 56 years old in six weeks, and I'm still turning over the past like a pile of old dirt, unearthing new painful memories with each shovel full. How I've managed to stay sane, or at least my version of sane, is amazing to me. Looking out of the window now, at the peace and tranquillity of Mylor, the astounding beauty of dawn in the Adelaide Hills, disturbed only by the birds' chatter, my past life seems so far away and disengaged from the reality of the moment.

A young rosella just came to the window, fluttering his colours against the glass. Now he is feeding around the bottom of the shrubs, the green of his back becoming one with the leaves. We humans seem so complicated and stupid by comparison. My need to write down old painful memories is bizarre in the light of the new day dawning in front of me.

Nevertheless, I have to do it. Perhaps if I can unearth the trauma and expose it to the light, I too can begin a new day. The beauty I see now outside this window brings a strong sense of peace, and I know that I will be all right and my soul will soon be healed.

I've spent the majority of my life in a state of denial. Had to, in order to exist. Now, for some reason, it seems as though I need to clean out the fungi and infections and pain, and give both my body and my soul a fresh start. I don't quite understand, Merry, why the need to do this is so great. Why can't we just let the past be past? Yesterday is gone, and today, as I can very well see before me, is a brand new, clean day – a day to go out, and forward, and breathe in the cool clean air.

Yet still I have this need to purge. I suppose if that beautiful bird outside ate something bad yesterday, he would either have to get rid of it, or die. I've carried so many memories buried deep inside me for so many years that they must be beginning to fester now. I know I must clean them out and be rid of them forever.

My rosella has been joined by a mate, and they are breakfasting in the grass. They belong so solidly in the landscape. Man, it seems sometimes, is the only animal that does not belong here. We are so alien to this beautiful planet, and so destructive. We march through it, and over it, destroying everything in our path, so involved in our own psyches that we don't see where we're treading in our ridiculous quests to achieve, impress, and leave our mark. Who needs to make a mark on what is already perfect?

And we all take ourselves so bloody seriously! Me especially, at the moment. Ah well, with the morning in front of me – now the bark on the trees has turned bright orange – I think I'll leave denial and self-indulgence for later and go back to bed.

February 1996

My dear friend, this is probably the best letter I will ever be able to write to you.

I wrote about being angry with Mum. That anger was released by a kinetic healer, who must also have opened up other channels too because I started experiencing, after first seeing her, fierce soul-wrenching spasms that threw me right out of control. One night my back had been bad and I'd gone to bed to rest when a gigantic spasm hit me in the chest, forcing out groans and tears that I couldn't control. Ronnie rushed me over to the doctor, who gave me a pethadine injection that worked well enough for me to come home, although she was talking about hospital if it happened again. I had no control over the noises I was

making, or the tears, and you know damn well that my whole life's motto has been *cry quietly*. Don't cry at all really, but if you have to, cry quietly. Well, this was anything but quiet, and very frightening.

Then, not long after I spilled all that anger out to you about poor old Mum, I had more chest and upper back pain that became unbearable. I was having difficulty breathing. Another spasm. I didn't want to go to hospital so Ronnie took me down to my city chiropractor, nearly an hour's drive. He brought me some relief, but next morning, when I woke up, the pain was back again. I don't usually get chest pain and all this was most unusual.

The next time it happened, I went to my local physio who is much closer. Again I felt better, but next day it was back again. Terrible pain, terrible spasms and difficulty breathing.

Before going back to the doctor, in desperation, we decided to try a new chiropractic clinic that has opened in Stirling. We'd been meaning to check it out because of the time wasted travelling to my usual guy. Ron rang and explained what was happening and they said come immediately.

I had dreadful trouble lifting myself on to the table because I was so stiff and sore and shaking with pain. The chiropractor gave me a pretty good workout and said, Go for a walk and then we'll check it again – which I did, and I felt a hell of a lot better and came home.

I felt somehow, Merry, that my body was leading me to some form of enlightenment. When I went to bed that night, I did reiki on my chest and asked my Spirit Guide and my Guardian Angel to please help me hurry the healing because I was getting frustrated. I was lost and my body was playing up because it knew it was time for a major step forward. Sounds screwy, I know, but I strongly felt as if I should follow my feelings.

In the middle of the night, whammo, it happened again. Ron and I sat up for hours with him rubbing cream into my back and making me cups of tea. We rang the same local chiro first thing in the morning and I went straight over there. I left Ron to sleep because he'd been up all night with me and still had to go to work. Well, I started going into amazing spasms again, shuddering and shaking, my breathing coming out in a groan or a yell or a scream. I had no control at all.

One of the practitioners, an Indian chap, Andrew, had started with me on his own, but when I began all this terrible groaning, two others came in and held me and stroked me saying, Let it out, great, let it go, you're doing a marvellous job. I don't know how long that spasm lasted. I had tears pouring down my face. I wasn't sobbing, but tears were bucketing out of the sides of my eyes. The receptionist was mopping them up with tissues.

The episode was *very* frightening, but somehow or other I knew it was really important. I couldn't possibly drive home, so I asked the chiropractors to ring Ronnie to come and get me. By the time he arrived, I had gone into more spasms, shaking and crying and carrying on a treat. I asked them to bring Ron in to hold my feet. They were freezing. They'd put a blanket over them and brought a heater in but nothing would help those feet. The top of them was all right, but the soles were unbearable. Ronnie put his hands on the bottom of my feet and they became instantly warm.

One practitioner was massaging my neck and shoulders. A couple of them put their hands on my sternum and I put my hands on top of theirs. The receptionist was still mopping up the torrent of tears. Poor Ronnie was really panicking. He asked if I wanted him to take me to the hospital, but I knew I was in the right place, with the right people.

After a couple of these dreadful turns, when I'd stopped shaking, the chiros propped me up and gave me several glasses of water. I was like a wet tissue myself! They sent me home to bed and rest and said, Come back this evening and we'll see how you are then.

I slept all day. Ron had to go to work and I worried over exactly who I could get to take me in the evening. Paris? Adam? Lainee? I had no idea what could happen. In the end I decided on Paris. I felt I should follow my first gut feeling. So I rang him and he came to get me.

I told him what had happened in the morning, that it was very scary and he didn't have to come in if he didn't want to, but that I might call for him because I knew I needed all the love around me that I could possibly get. I explained that it was healing and would help me a lot and he said, Look Mum, I've watched you near death so many times already that it doesn't matter. I know this is positive and that I can handle it. Wow!

So Paris drove me into Stirling and off I went again. Spasm after spasm, forced out of me. I'd worn thick mohair socks this time but they made no dif-ference at all to that bitter cold, so I asked Paris to hold my feet. It felt like I was standing on blocks of ice, but as soon as he put his hands there, the cold went away. Once again, three of the chiros were holding me and saying, Let it out, good girl, let it go. And out it came, groan after groan after groan. Ripped out of me. The cups of water again and they said, That's about all you can take for today, so go home to bed.

I felt there was one last spasm there and asked them to lay me down again, that I had to do it now. My temples were pounding as if there were two people in there hitting them with hammers and I asked Andrew to put his hands there.

So Andrew was at my head, Paris at my feet and two others with their hands on my solar plexus with mine on top. I had one more God-almighty spasm that went on for ages and then I knew it was over.

The only experience I could compare this to, Merry, would be an exorcism, which I've never witnessed. All this pain, physical and emotional, being forced out of my body. Shit, it was amazing. The chiropractors said I needed to eat a pile of steamed veggies and darling Paris, who's probably never steamed veggies before in his life, fixed them for me. Then, exhausted, I dropped into bed like a stone.

Paris was bloody marvellous. He had to help me walk to and from the car and must have been in shock himself after what he'd seen and heard. And the healers were fantastic. Supporting and caring. The morning visit and the evening one took an hour and a half each and they only charged me for a normal consultation.

I have to laugh, Merry. If any clients in the waiting room heard the racket I was making, surely they'd have run away.

The healers wanted me back the next morning so they could keep a check on what was happening. They did all the same things – manipulations and pressure points and whatever they do – but there were no more spasms. Nothing. It was as if there was nothing left to come out.

I've been back a couple of times since, and each time they go over my whole body, front and back, and the same trigger points in my sternum, but it's all gone – whatever *it* was. I needed a few days in bed afterward but that was all, and I didn't have any pain.

I don't know exactly what's happened, but I know it's good!

February 1996

Hi Merilyn. Just got home from a teaching trip to Ceduna. Ron's still at work and I thought I'd jot this down while I'm still high. Teaching! I haven't done any real teaching for ten years, just the few workshops I did when travelling with the Coorong painting, and one later at the Gawler Ranges. I've had offers since to conduct country workshops, but haven't felt up to them. Yet when the organisers rang me weeks ago I immediately felt yes, I should do this. Why exactly, I don't know, for I was feeling fragile. But I committed myself to it and, as it happened, the trip took place on the weekend following all the magical stuff with the chiropractors.

Do you remember where Ceduna is? It's about half-way across the Great Australian Bight, with water on one side of it and the Nullarbor Plain on the

other. Ceduna can be a *very* hot place – while I was there it was 42 and 43 degrees. We were working in school prefab classrooms cooled merely by overhead fans and boy, it was stinking in there. The country women who come in from farms miles away are always greedy for knowledge and teaching them is exhausting work at the best of times.

I thought, after the tiring week of healing, that I'd have trouble getting through the weekend – but here I am! I needed a quick lie-down during the lunch break, and by the end of each day of bending, walking, leaning and so on, I was absolutely buggered, but I got through it. The women are wonderful, strong dames and their enthusiasm is uplifting.

It made me feel wonderfully alive and able to give for a change. I feel like I've been taking from Ronnie (and everybody else) for the last few years since the operations started, and it was rewarding to be able to give something back.

I think Ronnie expected me to be carried off the plane on a stretcher – he'd been worried about me going at all. But I walked off smartly, marched to the car and chattered all the way home. I'd booked in to the clinic, before I left, for that afternoon, because I thought I'd need it. Well, the chiropractors couldn't believe how I walked into that office, ran up the stairs and jumped on the bed. Andrew's face lit up with joy.

I can't express, Merry, how knocked out I am. Yet at the same time, it seems a perfectly natural process. Mate, I know I'll always have some backache, but my life is changed and a new era is opening up before me.

My gut is still sore, and may always be. That's a different problem: the physical result of a physical operation. But even that I think I'll be able to handle better from now on. Didn't stop me teaching! God, it was good!

March 1996

Merilyn, I went to see Theresa, to tell her about my physical healing experience and she just about clapped her hands with glee. She said that I'll probably never suffer the same amount of back pain again. There'll always be trauma from the accident, which is causing osteoarthritis now, but the pain will never come with the severity that I've experienced up to now.

Theresa suggested, now that I've released my anger about Mum, that I should go back and comfort my inner child. And that's what I've been working on. I've been going inside myself with hypnosis and reiki.

Yesterday I went back to my bedroom in the big old house at Rose Park. I haven't even thought about that room in a zillion years, but I discovered it exactly as it was.

John and I used to share the bedroom. On his side there was a window over-looking the driveway, while my side had the door to the passage. There was a fireplace in the room opposite our beds.

Everything was in place. It was just like I was there. I could even hear sounds from the passage. I could see this little girl standing against the wall just inside the door. She was not exactly cringing, but was obviously terrified. She was holding her clenched hands together down in front of her, her head to one side. She (I) was standing there waiting to be punished, and I realise that I've been standing there waiting to be punished for what happened in that bloody shed for 50 years.

So there I am back in this old room with myself as a child. I didn't go to her – I knew she was frightened, so I just talked to her. I stayed across the other side of the room by my old bed and told her it was all right and I was there to help her. Please come to me, I said, and I'll hold and cuddle you and soothe you. Gradually, step by step, she ventured over. I put my arms around her and held her close and then I asked her: How do you feel?

Suddenly, I left my own body and went into my child's body, and could feel her fear. I came back into my grown-up self and tried to explain to her that she hadn't done anything bad. Next I zipped back into this child again, and I could feel her doubt. She didn't trust what I was saying.

This process repeated itself a number of times. I can't remember the exact conversation, but I kept holding her and soothing her and she began to relax a little. She softened against me and I picked her up and carried her like a baby in my arms. I carried her across deserts, down the Coorong and through trees, walking for miles and miles holding this child against me with my left arm and cradling her head against my shoulder with my right. Yet I knew there was still doubt in there, and fear. I wasn't clever enough to deal with that. So I'm going to my brilliant hypnotherapist tomorrow. If he can put me deep enough into hypnosis, I might be able to help my little girl.

I have also revisited the accident with the help of reiki and hypnosis. I could see exactly where I was lying on the bitumen and how far from the edge of it I was. There was dirt on the side of the road. As Mum was coming to me to lift me to my feet, I pushed her out of the way and protected myself – protected this bent, bleeding 12-year-old on the road. I didn't want Mum lifting her up. I wanted her to stay there until the ambulance came, but I wasn't sure whether I should cradle her head – might that cause head injuries? I didn't know how to handle that, and I couldn't talk to her because she was unconscious. I had to leave the scene as it was, kneeling beside her with my arms outstretched, shielding her.

I'm going to try to deal with that situation under hypnosis, too. I'd like to go with her in the ambulance and sit with her so she's not on her own – I remember waking up in the ambulance half-way up Anzac Highway and that was scary. I'd like to be with her in the hospital because I remember that being scary too. I want to sit by the bed with her.

All this must be difficult for Ron, even though I explain everything to him. He understands that I'm going through some form of healing. If I can achieve what I'm pretty sure now that I'm going to achieve, I probably won't be quite the same woman he married. In fact I'm already feeling so hopeful that I must already be changing.

The day before yesterday we were going to a party. I was feeling good, and had a go at him about something in a real tongue-in-cheek, laughing way. He said that he was going to send me back to all of the healers to make me crook again. You're getting far too cheeky, he said.

And that's what I feel like. Cheeky. But this cheekiness hasn't got any aggro in it, like it used to have, it's just pleasurable. I don't have to fight anymore. You hear people say all the fight's gone out of him or her. I always imagined that left an empty shell. Well, all the fight's gone out of me but what's left is the full bottle. Full of life.

Theresa says I'm a lucky woman to have experienced all this and to have dealt with all the shit. Well, most of it anyway. Stay tuned for the next instalment. With much love, Barb.

March 1996

Merilyn, Merilyn, Merilyn! I went to the hypnotherapist yesterday and told him that I needed to help the little girl who was molested at five, deal with the accident and comfort myself after the abortion.

Russell said, When you tell that five-year-old that it's not her fault and that she's not to blame, look at her face and watch it changing. Watch the look of trust, see the change in her face.

He also said that he wanted me to look at my situation from a number of perspectives before I worked on a solution. He wanted me to be myself, who I am now as well as the little girl telling me what she needs. And also to see how Mother fitted into all of this. He wanted me to be the mother I am to my boys. From these shared perspectives – the child, the daughter, the mother and myself – and under deep hypnosis, I was to resolve what I was going to do with this little girl and her pain.

So under I went, deep into my psyche, but nothing happened like I expected.

Firstly, I found my five-year-old and she threw herself into my arms, buried her head in my chest and sobbed like I've never known anybody to sob. And when I went inside that little girl to see why she was crying in such a manner, it turned out that she had been absolutely *terrified* in that shed. Terrified beyond any measure that I could imagine now.

I tried to compare it with the fear I felt when Ken became violent. But that was nothing compared to the terror this little girl felt. She wasn't frightened, she wasn't panicking, she was *terrified*. And she hadn't had a chance to tell anybody. No one had ever asked her.

She snuggled into my chest and sobbed, her little body shaking, and shaking and shaking. I can still feel the wet patch on my left breast where tears went through my clothes and soaked me. I was surprised: I had presumed that I was waiting to be punished.

So now, 50 years later, my little girl has at last let the terror out.

Recently, since I've been journeying back with the help of reiki and hypnotherapy, I've glimpsed images of the back of this little girl. I've done sketches thinking that I might paint what I've seen, but I don't think I can.

This is what I've seen: the back of this little girl, with her plaits, sitting rigid on the edge of the table, faced with this man's huge, monstrous, red, revolting, erection. Bigger than herself, it seemed. And she just sits there, her little shoulders square.

I could see the back of her. Couldn't see the front of her. Couldn't see her face. But if I did, I imagine it would have shown nothing. I don't remember being terrified as a five-year-old. I don't remember much at all. I do remember being frightened but I'd forgotten the awful terror all of these years. So I decided (under hypnosis) that I had to protect this little poppet in some way. I had to make sure that nothing would happen to her again that could create the same terror. So I put a thick, metal cylinder around her and popped her inside me.

And then I thought, Well, while I'm doing this I'll put a metal cylinder around each of the boys, too, to protect them. But I couldn't put a whole cylinder around each boy. I had to leave a quarter of their cylinders missing, I know that I can't protect them absolutely. They have to make their own mistakes and go through their own hells. Their cylinders had to be open.

And Mum? Well, I realised that she's just Mum. So I stroked the side of her face and put my hand against her in acceptance. We are fine together now.

So now I had my five-year-old self tucked away inside me safe in this steel cylinder. And then I realised that, while she's inside me, she doesn't need the cylinder. My body will be her protection. I took the cylinder away, and she immediately expanded to fill my whole torso. She is completely happy in there – warm, soft, loved, cherished, nurtured and, most of all, protected. By me. And there she will stay for the rest of my life. Happy. I could feel that, I could feel that she was happy.

I was smiling as she wriggled around getting settled, happy that I'd come to a conclusion. Russell, who could see by my expression that I had achieved my goals, said, Take your time, finish off what you have to do, then bring yourself out of hypnosis and we'll talk about it. So I gave Mum another stroke on the cheek, checked that the boys were semi-secure in their semi-cylinders, came out of hypnosis and told Russell what had happened. He was as amazed as I was. Like me, he had thought that I was going to reassure this child that she didn't have to be punished. I didn't have to deal with any of that because the final cure was the most important thing.

Now that she trusts me completely and has given herself to me to be protected, the issue of punishment doesn't exist anymore. She knows she's going to be okay. And because that child is safe now, we (she and I) didn't bother dealing with the accident or the abortion. My inner self will always be safe now, it's not necessary to revisit those other issues.

I am now whole. I have my now-self in my outer body and I have my inner child tucked away warm and happy inside. As a grown-up, I am loved and protected and warm and happy with Ronnie. But only *I* could make my little girl feel like that. For the first time my inner child is warm and happy and loved and protected. It's wonderful.

Russell was just as pleased as I was. He and a colleague have recently finished writing a book for teachers about sexually abused children. He said: The sad fact we have to get across to teachers is that they cannot promise abused kids that it won't happen again. There's no way that they can protect them for the rest of their lives.

But I can protect my inner child for the rest of my life. And I shall do just that.

I don't think there's a hell of a lot more I have to do in sorting out the past and my pain. From now on, I can just go on living. Doing what, I don't know. I feel no need to prove anything to anyone anymore. I've realised, with Russell's help, that I've always had to prove myself to the world, prove that I deserved respect.

I never got real respect from Mum. I didn't have any respect from John, who sent me into that shed. Certainly I received no respect from the man in the shed. My feelings weren't respected afterwards. So I guess that's why my school days were the happiest of my life. At school I was respected.

Russell suggested that my painting was partly motivated by a desire to prove my value to the world. So that I could resolve the mess I've made from a detached perspective, I had decided to stop painting.

And now I don't have to prove anything to anybody. I'm whole. My inner

child and I are one at last. If I so choose, I can happily do nothing for the rest of my life. Don't have to prove anything to anybody. But I'm working on a water-colour of roses at the moment, for an old school friend of mine, Joan, who you never met. And I'm enjoying it no end. So I'm sure I will keep painting. But it might be for different reasons.

Anyway we'll see. Whether I do, whether I just paint flowers for the rest of my life, or whether I paint nothing. Whether I write. Whether I sculpt. Maybe I'll garden. Maybe I'll simply sit outside and admire the beauty. Never felt so happy, Merilyn.

My back pain has improved so much I can't begin to tell you. I'm walking every day. I'm swimming every day. I washed the car today! I still get tired and have to have a lie-down but, unless I do some serious damage, I don't think the pain will ever be so severe.

I wonder what happened to your inner child, Merilyn? When you killed yourself, perhaps you automatically joined together, and you took her with you. Perhaps you're two separate spirits wherever you are. I'd like to know. I hope she did join you on your way out. For you to have been so unhappy she must have been as lost as my own inner self. Sadly, you didn't hang around long

enough to find out why you weren't happy, or to solve your problems. You might have found this happiness.

I was about to say that I hope you're happy now – but I know that you are. I can't imagine, after life on earth, that there could be anything but happiness waiting for you. Perhaps that's why people say, in death notices, At peace at last. It must be a saying that has come down through the generations. Somebody along the line knew that what you get when you die is peace and happiness and love.

On that note, I'll say goodbye now, my happy friend.

May 1996

Dear Merry, I've got so much to say to you. I'm sitting on the ledge of a rocky sandhill looking across the ocean. It's mid-morning, there's a warm breeze, with a fresh blue sky and fairy-floss clouds. The water is striped in deep blues and delicate pastel greens, and the sea birds are out for brunch while the tide is out and the fishing easy. Seaweed is piled on the shore beneath me and its aroma wraps me sweetly.

Ronnie and I are on a laid-back five-day camping trip with another couple. Each couple has a gypsy-type caravan and an extremely large horse to pull it, and the plan is to jog gently along the coastline of Yorke Peninsula around Hardwick Bay, stopping for the night to cook over campfires, drink, and enjoy ourselves. The horses are gorgeous – big, gentle and easy to handle – and the vans comfy, so it's an easy way to travel. Plod, plod.

Our vans are parked looking directly out to the ocean, and last night the moon was full. Whenever strange night noises woke me, I could look straight out to a sea that was lit with the biggest spotlight of all, especially for our pleasure.

Sweetheart, this is what you miss out on when you kill yourself. The butter-yellow moon rising over the far horizon. The last sliver of setting sun behind the sea. A night by the campfire under the umbrella of stars, easy conversation, friendship and love.

I tell you, Merry, I wouldn't be dead for quids. My back is so much better that I truly can't believe it, and I'm entirely at peace with myself now that my inner child has come home. My concept of life has changed. I'm not sure where I'm headed, but at this moment, I'm content to sit here, whole and warm in the sun, and just exist.

If I painted this seascape before me, I'd draw myself very small on the shore, a tiny part of the picture. If I did a panorama, like the one I did of the Coorong, I would be smaller still, a speck among the bevy of other life forms.

After that I'd just be a microscopic dot on the crusty surface of this ball of earth spinning about in space. And then, if our universe is simply a single molecule of a larger *anything*, which of course is quite feasible, well . . .

If you were alive Merilyn, would you be here? Could you bear the sweet smell of fresh horse manure, and the sand and the flies? Could you manage without showers, mirrors, make-up and absolute cleanliness? Probably not. But you know, there's a kind of cleanliness to this experience that you can't find in the most immaculate bathroom. It gentles you. The outside of your skin is wind burnt and sun-damaged, but the inside is relaxed and healthy as it should be.

Last night we sat on the edge of this rise, not 60 feet from the water's edge, and drank beer and ate olives and were treated to an hour of the most magnificent sunset. It's been ages since I took the time to watch a sunset from beginning to end, but even if you only do it every other year, you can't risk being dead, my love, in case the next one's just as good.

I think that *now* is the first time that I'm really angry that you did it. I always thought it was your right: you were so unhappy, blah, blah, blah. But now I know a different kind of living than either of us ever enjoyed. Of course, if you never found the answers, life would have continued eating away at you like a fungus and that would have been hell. I'd hate that for you. But for me, well, I can take in a large mouthful of this sea breeze and it fills me with a knowledge that I can't express and a gentle pleasure that I know is my birthright.

I know that you're here with me, you're in my heart and that makes your existence beyond denial. I don't think about you every day. Not even every week. But Easter has just passed, the anniversary of your suicide, and of course you've been on my mind. Six years now! What were you thinking as you lay there in bed, waiting? Were you crying, or just resigned. Very tired, I imagine. Too tired to think about thinking. I'll never know.

It occurs to me, sitting here, that I never told you what actually happened in the gardener's shed. Well, the truth is that I don't know, other than pieces.

I remember being taken into the shed by one of John's mates. I remember sitting on the edge of a high wooden bench faced with that massive, terrifying erection. I remember John's friend squatting on a cupboard in the corner, watching. I remember the man who was attached to the penis asking if he could kiss my special place, and I remember, frightened, nodding numbly.

Then nothing. Next thing, I remember 'coming to' when I was about ten yards from the shed, walking towards the playground.

I still have no idea what transpired in between. I could, with counselling and

hypnosis, find out I suppose, but Theresa tells me that now I'm nurturing and protecting my inner child there is no reason to revisit that area of my past again. She's right, of course. Whole again, I can let the past go completely, and I have. I have forgiven myself for all my mistakes.

I would never presume to put myself in the same bracket as those poor souls who have been severely abused over a period of many years. But for me, that one instance, combined with the subsequent behaviour of family and friends, caused me 50 years of self-doubt.

I'm finding now, Merry, that I can have *fun* for the first time. For all those lost years I envied people around me having fun. It may seem to others that this is a ridiculous statement considering some of my antics but to me life was always a deadly serious business.

I laugh differently now, too, a real belly-laugh, Ron says, which he adores. On many occasions I find myself wondering why I feel so good and then I realise that I'm having *fun*.

For instance, I went sky-diving. Let me tell you about it.

We jumped from 12,000 feet – and that feels pretty high when there's no door on the plane and you're standing like a spider's web in the doorway, heels just on the solid floor, toes hanging out into the rushing air. You can grip the doorway for a last fleeting second of security, and then have to cross your arms over your chest and cling to flaps on the upper arms of the flying suit.

Now the instructor, to whom you're well fastened (you hope), is behind you. He still has a firm hold on the plane's interior. He teeters you back, then all the way out with a rush, a roar, a shock, a breathless speed. An excitement which is fear and a fear which is excitement. There is no way to describe the exhilaration of this moment, so I guess you'll just have to do it for yourself next life round.

Once the parachute has opened, after a free-fall of about 5000 feet in ten seconds, the world, and your relationship to it, changes yet again. Now your ride is gentle and the view sweet.

We were so high. And floating. Exactly what I'd dreamed about for years.

When I fly, or float, in my mind, I'm usually close enough to the earth to see roof-tops, trees and roads, or else I'm so high up that when I look down the earth is just a vague, inconsequential ball of blue.

This parachuting was very different. While we were floating down, my instructor told me to stand on his feet while he loosened some of our harnesses. I held the parachute ropes while he did it. What a bizarre experience – standing on someone's feet, 7000 feet up in the air. Then, after he had taken control of

the chute again, he told me how to adjust the thigh harness so that it formed a kind of support, like a seat.

There I was, sitting quite comfortably way up in the sky, arms folded, surveying the patterned landscape below. It was a clear sunny morning and the squares and circles of tended countryside were gently muted in tones that I'd be hard put to paint. Because we jumped at Strathalbyn we could see the Murray Mouth and the Coorong sandhills fading softly away into the haze of morning light.

I belonged there in the sky. I belonged on the earth below. I belong with my Ronnie, who was waiting for me at the hanger. I belong.

Merry, whenever I'm low I'll just have to remember that comfortable, weightless angel-view, and I'll find instant peace. Do you exist in that zone of peace now, my friend? Can you zap down when you're needed and zap back up again when you want? Is this only a taste of what's waiting after death? Multiply this feeling by one billion! Sit above hundreds of planets simultaneously! Wow! Hope you're there.

Later

I'm sitting by the big window at my desk. The landscape that is mine, if I care to lift my head, is a myriad of greens, yellows, whites and browns, with a touch of cerulean blue. Hundreds of different shapes – every one beautiful. Strips of light and shade, faultless in composition, and the new buds of this spring, bursting with growth. It's bloomin' blooming!

My boys are both happy with their lives at the moment. Paris is planning to spend his insurance money on a trip to Africa to learn about the rest of the world and about himself. Adam is a super dad to Belle, who is growing tall and beautiful and talented.

Ronnie is a treasure – I commend myself on having the good sense to snap him up. Our life is good.

The other day Erica gave me three yellow freesias, which I've put on the table in a tall thin glass vase. Yesterday I glanced over at these flowers, and *saw* them for the first time – the way I sometimes see things a hundred fold. So very luscious and rich. The three of them were in perfect relationship to each other, and they're on their last legs, so last night, tired and sore of shoulder and neck, I had to draw them at one in the morning in case they dropped overnight. It's stupid, in a way, to be so driven still – I can always get more freesias – but I may not see that same ideal relationship between them again.

My drawing skills are pitiful at the moment, not having done much for such a long time, and my lines are wobbly and uncertain. Nevertheless, the flowers are drawn, and will be there for future reference – or to get chucked in the rubbish bin one day. It doesn't matter, either way. They had to be recorded. And that's my pleasure.

i l l u s t r a t i o n s

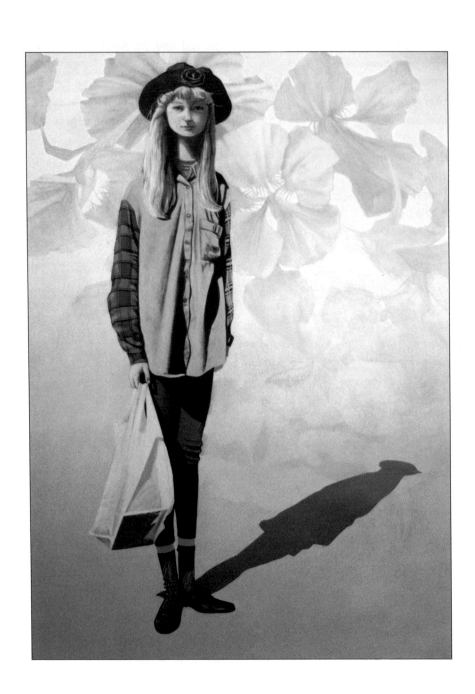